UNNAMABLE

Unnamable

The Ends of Asian American Art

Susette Min

NEW YORK UNIVERSITY PRESS
New York

NEW YORK UNIVERSITY PRESS
New York
www.nyupress.org

© 2018 by New York University
All rights reserved

References to Internet websites (URLs) were accurate at the time of writing. Neither the author nor New York University Press is responsible for URLs that may have expired or changed since the manuscript was prepared.

Library of Congress Cataloging-in-Publication Data
Names: Min, Susette S., author.
Title: Unnamable : the ends of Asian American art / Susette Min.
Description: New York : New York University Press, 2018. |
Includes bibliographical references and index.
Identifiers: LCCN 2016047747| ISBN 9780814764299 (cl : alk. paper) |
ISBN 9780814764305 (pb : alk. paper)
Subjects: LCSH: Asian American art—Themes, motives. |
Asian American art—Exhibitions. | Curatorship.
Classification: LCC N6538.A83 M56 2017 | DDC 704.03/95073—dc23
LC record available at https://lccn.loc.gov/2016047747

New York University Press books are printed on acid-free paper, and their binding materials are chosen for strength and durability. We strive to use environmentally responsible suppliers and materials to the greatest extent possible in publishing our books.

Manufactured in the United States of America

10 9 8 7 6 5 4 3 2 1

Also available as an ebook

CONTENTS

Introduction: Lingering Thoughts on the Last Asian
American Exhibition in the Whole Entire World 1

1. Unnamable Encounters: A Phantom History of Multicultural
and Asian American Art Exhibitions, 1990–2008 33

2. Formal Actions: Reevaluating the "Cultural Work" of
Tehching Hsieh, Byron Kim, and Simon Leung 85

3. Gleaning the Art Practices of Simon Leung and Mary Lum 125

4. The Vanishing Acts of Nikki S. Lee and Tehching Hsieh 167

Acknowledgments 205

Notes 209

Index 245

About the Author 259

Introduction

Lingering Thoughts on the Last Asian American Exhibition in the Whole Entire World

Asian American art has been and sometimes is still conceived simply as art created by an artist of Asian American descent, or misperceived as Asian art, or presumed to contain some kind of "Asian-looking" motif, design, or symbol. Such presuppositions have led to miscategorizations, oversights, lapses, and deaccessions of works by Asian American artists at major institutions despite a long history of Asian American artistic production within the United States and transnationally.[1] Since the nineteenth century, Asian American artists have been prolific and active in creating their art and having it displayed at major venues, including the Museum of Modern Art (MoMA) and the Whitney Museum; collaborating with internationally known artists such as Richard Diebenkorn, John Cage, Constantin Brancusi, and Damien Hirst; and teaching at prestigious universities within the United States and abroad. But due to a combination of systemic racism, racialization, and marginalization, such histories and accomplishments have been subjugated, repressed, and forgotten. In response to these negative forces, much of the scholarly and curatorial focus on Asian American art over the last two decades has revolved around either excavating, archiving, or displaying marginalized and overlooked artworks by Asian American artists. Such endeavors of making visible Asian American art have been in one sense productive. Asian American art is now on the verge of institutional legibility and legitimacy as (1) something to be collected by museums such as the Smithsonian and Asia Society and (2) a field to be engaged as more than a special topic once a year at the conference of the College Art Association.

Continuing in this trend of mainstream visibility, a set of exhibitions emerged in the first decade of the twenty-first century, an extension or

2 | INTRODUCTION

reprisal of exhibitions that first emerged in the 1990s, dubbed by some as the "multicultural" era. While ethnic-specific exhibitions have been around since the advent of the world exhibitions in the nineteenth century, in the 1990s—in correspondence with a resounding rejection of Reagan's promotion of color blindness in combination with the radicalization of multiculturalism and its aims to reallocate and distribute downward the structures of power and capital—these kinds of exhibitions became the primary vehicle for showcasing an unprecedented number of marginalized and minority artists. Merging aims to fight back against cutbacks in arts funding and other austerity measures with a broad anti–racist/sexist/homophobic agenda, including the demand for access to the apparatus of representation, artists and organizations across a wide spectrum came together, creating coalitions, collectives, and alternative art spaces, as well as pressuring major art institutions to "[broaden] their horizons" and open their doors and collections.[2] Feeling the pressure, but also wanting to get on the bandwagon, a number of museums across the nation hosted multicultural (such as the *1993 Whitney Biennial*) or gender- and race-specific exhibitions. These institutional gestures of inclusiveness were quickly pegged as "accommodating," and the exhibitions were bashed as shallow displays of liberal guilt and political correctness, with critics treating the artworks as *not* art and/or making whining complaints and inappropriate demands. While the exhibitions were seen as a passing trend of style and subject matter, multiculturalism became, in the words of art critic Christopher Knight, part of the establishment, recoded as pluralism, then depoliticized and repurposed as what Christopher Newfield and Avery Gordon have aptly dubbed "diversity management."[3] Museums appear more than ever to be enriching a global audience in their diverse presentation of art forms by artists from all over the world, and on a local level, broadening their outreach to communities of color through educational—note *not* curatorial—programming.

While a number of international Asian artists are currently "Scene and Herd" in the latest pages of *Artforum*, representation of artworks by Asian Americans remains incommensurate with yearly tallies of permanent collection acquisitions, critical reviews and articles in journals and magazines, exhibition programming, art survey books, dissertations, and course syllabi—all barometers of a continued practice of exclusion. Against this backdrop of global pluralism and racial disparity, a

resurgence of racial- and ethnic-specific exhibitions began to reemerge, beginning with *Freestyle* (2001), followed by *One Way or Another: Asian American Art Now* (2006) and *Phantom Sightings: Art after the Chicano Movement* (2008–2010) (figure I.1). Recursively addressing the shortfalls of the art world's engagement with multiculturalism, the racial and ethnic exhibition returned as a default and necessary "curatorial artifact" making visible and displaying a startling array of must-see-but-still-marginalized artworks.[4] In contrast to the 1990s, when the reception of such exhibitions became quickly "unfashionable," these exhibitions were well received, seemingly successful in negotiating the contradictory attitudes towards race and art and in making more broadly appealing artworks by Black/Chicano/Asian American artists.

The emergence of a cosmopolitan and diverse global art scene is one of the interrelated factors and material forces accounting for this shift in attitude towards such exhibitions, but the untimeliness of Asian American art's formal recognition is something that I would like to unpack here. Given the enduring history of the absence and marginalization of Asian American art in mainstream institutions, there is an understandable impulse to quickly accept this recognition in order to secure a space and place for Asian American art in perpetuity. But how does this same recognition correlate with the "postracial" era or the "disappearance" of race and racism by which, if the logic follows, categories such as Asian American art should be seen as obsolete or anachronistic and no longer relevant? Looking back at the reviews and aftermath of the exhibitions within the context of neoliberal globalization's effect on the production and reception of art in general and Asian American art and exhibitions in particular, a troubling reading emerges that threatens to fix Asian American art as a site of reconciliation and containment, a filter and point of entry for select artists to enter into the art market or an exhaustive repository that absorbs those artists who are on the threshold of fading into obscurity. The book makes a case for refusing this end and predicament—a pause before the threshold of visibility and legitimacy—by recasting the categorical imperatives of Asian American art as more than a historical recovery and conservation project and by contemplating an alternative to previous approaches to Asian American art, considering it less in terms of its aspirations to be seen and more in terms of how it can forge conditions for a politics to come.

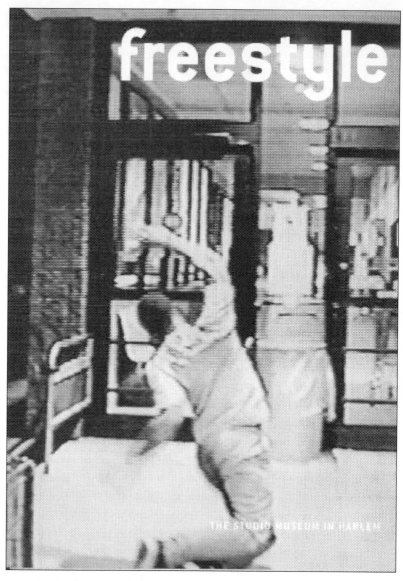

Figure I.1. Catalog covers for *Freestyle: The Studio Museum in Harlem*, *One Way or Another: Asian American Art Now*, and *Phantom Sightings: Art after the Chicano Movement*.

In the words of Trinh T. Minh-Ha, the political has been "obsessively guarded and reassigned" by a number of "gatekeepers" who consciously and unconsciously maintain the ways Asian American art is conceived and received.[5] Curators serve as one of the central gatekeepers in making visible, but also determining the meaning of, Asian American art. I begin the introduction with a schematic overview of these recent racial- and ethnic-specific exhibitions, and the challenges of curating such exhibitions in light of shifting attitudes about race and art. The rest of the book, organized as mini-exhibitions on paper and case studies, explores alternative approaches to reading and curating select artworks, situating them as propositions and future encounters—a process that includes a letting go of the way we curate and name art as Asian American.

While much of the following section will be on *One Way or Another*, an exhibition I co-curated with Karin Higa and Melissa Chiu at the Asia Society, I would like to begin, chronologically, with a few words on *Freestyle*, the first of Thelma Golden's "F" series that opened at the Studio Museum in Harlem in 2001, and a sampling of responses to the exhibitions. Golden's curatorial premise was simple and straightforward: to introduce to the mainstream art world a younger generation of Black artists, who were engaged in "complex investigations of blackness" but were "adamant about not being labeled 'black.'"[6] Organized nonthematically, the diverse array of artworks was foregrounded as "post-black, post-multicultural, post-identity, and post-conceptual."[7] In contrast to the very mixed reception of Golden's controversial *Black Male: Representations of Masculinity in Contemporary American Art* (1994) at the Whitney Museum less than a decade earlier, in which the selection of artworks was arguably similar in theme and form—steeped and deeply invested in redefining complex notions of blackness, race, and power—*Freestyle* was seen as being fresh and "hardcore without being hardline."[8] The success of the exhibition revitalized the Studio Museum of Harlem as the leading cultural institution in redefining African American art and reconfigured the venue as a destination museum for a broader community.

As part of the Asia Society's seventy-fifth anniversary celebration and recommitment to promoting the development of contemporary Asian and Asian American art, *One Way or Another: Asian American Art Now* (henceforth, *OWOA*) presented seventeen Asian American artists, almost all born after 1970. *OWOA* was initially conceived as an

extended conversation with the exhibition *Asia/America* (1994), which centered on art by first-generation Asian-born American artists who engaged issues of identity and immigration. The exhibition, however, centered instead on art by a younger generation, less as a survey than as a broad sampling of Asian American artistic production. Organized without themes and curated on the lower and third-floor galleries and along the staircase wall of the Asia Society, and spaced apart with plenty of room devoted to each artwork, *One Way or Another* presented an eclectic mix of pieces that included Laurel Nakadate's videos and Kaz Oshiro's trompe l'oeil retro reproductions of trash bins and kitchen cabinets made out of stretched canvas and acrylic paint.

Viewers and critics alike, such as *SFGate*'s Jeff Yang, seemed flummoxed on how to approach Oshiro's paintings and Glenn Kaino's *Graft* (2006), a cluster of Damien Hirst–like taxidermy sculptures, including a stuffed salmon made of sharkskin patches, located at the entrance of the main exhibition: "a Trojan horse . . . a disguise . . . an awkwardly synthetic mash-up? . . . Or are they placed there simply because they're beautiful and strange . . . exemplary of the exciting cacophony of the works represented in this new exhibition?"[9] Rubbing against his own preconceptions of Asian American art and presumptions of the Asia Society as a neo-Orientalist space, Yang proceeded to describe Kaino's cluster of sculptures in his review of the exhibition "as pleasantly uncategorizable . . . like a pig in a cow suit." In an analogous response to *One Way or Another*, Roberta Smith, too, in her *New York Times* review, initially described the compendium of works in *OWOA* as uncategorizable, "shape shift[ing]" against her expectations, to the point where "identity" seems to "drop entirely from sight."[10] Smith further notes that the best efforts in *One Way or Another* are "complexly and intractably engaged with both issues and materials," citing Anna Sew Hoy's "elaborate, almost violent tangle of glazed clay, knotted rope and twisted fabric [that] references . . . ceramics, scholar's rocks and endlessly recycled scraps of textiles mix[ing] cultures, crafts and social classes" and Mari Eastman's pastel-colored "delirious" and "nervous" pixie-like canvases that draw from high and low culture, European and Asian sources—"calligraphic brushwork and sprinkles of glitter."[11]

At the time, I read Smith's positive review with a sigh of relief. Instead of reductively dismissing or homogenizing the artworks, she seemed to

8 | INTRODUCTION

refreshingly engage the art on its own terms. Yet as I look at the review now, with some distance, together with its title, "A Mélange of Asian Roots and Shifting Identities," which served as an organizing rubric, Smith's review seems to imply that within the artworks by Sew Hoy and Eastman there lies something culturally, intrinsically, essentially "Asian." Rather than approaching their "confident blending of form, decorative arts, and patterned abstractions" of Asian visual motifs as an oblique and playful commentary on the fetishizing and Orientalizing of decorative arts, the review approached such elements as sourced from their Asianness—visual characteristics or indexes of "Asian" self-expression, authentically drawn from some kind of Asian tradition. In contrast, out of joint or illegible were artworks by Mike Arcega and Binh Danh, whose poignant visual commentaries on U.S. imperialism, dispossession, and class disparities were characterized as "outmoded engagements of identity."[12] In correspondence with her review of *Frequency* (the second show in Golden's trilogy), Smith cites how identity is something we are all searching for in a lifelong endeavor to negotiate our differentiated, fragmented selves. Universalizing this search and the concept of difference—collapsing regimes of difference into sameness—and forgetting the hostile responses to engagements with identity in the 1990s, Smith concludes her review of *OWOA* with an understood assessment that Asian American art is heading in the right direction towards a path of formal autonomy and universal truth in which race and its intersection with other forces do not matter. [13]

In contradistinction to Smith's review of *OWOA*, which embraced identity and color-blind liberalism, rejected politics, and bypassed identity politics altogether, Ken Johnson's tepid *New York Times* review of *Phantom Sightings: Art after the Chicano Movement* zeroed in on exactly the opposite. Opening two years after *OWOA* at the Los Angeles County Museum of Art, *Phantom Sightings* was touted as the "first comprehensive exhibition of Chicano art in almost two decades" due to the "persistent underrepresentation of Chicano art and artists in mainstream exhibitions."[14] In contrast to the concise and circumspect wall texts of *OWOA*, which barely referenced the institutional history of the Asia Society and Asian American art (an absence noted by Jeffrey Yang in his art review and in a comment in a visitor's book near the elevators of the Asia Society), the thoughtfully crafted introductory

wall statement by the curatorial team of Rita Gonzales, Howard Fox, and Chon Noriega was intrepid and straightforward about their curatorial premise and motivations. The curators positioned the artworks as "phantom sightings"—a cultural absence on the mainstream art scene—in which "ghosts of Chicano art . . . the urban Chicano, and the ghost of the avant-garde" haunted the wide array of conceptual artworks that were very much present and timely in the contemporary moment, "engaged in global issues and international art movements *as well as* innovative contributions to new genres and formal developments."[15]

Bypassing the curators' clearly stated selection process, designed to display artworks as conceived and produced "after the Chicano art movement," Ken Johnson's review in the *New York Times*—sardonically titled "They're Chicanos and Artists, but Is Their Art Chicano?"—opens by immediately remarking upon the absence of art related to protest and the Chicano movement, as well as upon works replete with Mexican and Latin American indigenous traditions.[16] Blatantly refusing the curators' invitation to "encounter each artwork on its own terms . . . to come away with more questions than answers,"[17] Johnson barely engages any of the art, and uses the space of the review instead as a soapbox to reductively characterize *Phantom Sightings* as an "identity-based show . . . an evil whose necessity would disappear in a more equitable world," while at the same time acknowledging that "questions of equitable representation will never go away."[18] Declaring the déjà vu of racial- and ethnic-specific exhibitions as a consequence of the multicultural agendas of "museums and grant-giving foundations" and "various interest groups," Johnson concludes his review by calling for the "last rites" for such exhibitions.[19]

His remarks as well as Smith's review of *OWOA* highlight on one level an entrenched way of approaching such exhibitions. They show, on one end of the spectrum, how racialized and ethnic-specific art continues to be narrowly read as authentic or essentialized reflections of identity and experience, while on the opposite end of the spectrum, reductive ideas on identity politics and what constitutes political art still hold sway. Breaking through this set way of perceiving such works as either/ or were the majority of reviews, which perceived all three exhibitions as resoundingly successful in presenting a diverse array of artworks that "freed" a younger generation of artists from labels like "black artist" and, in the case of *OWOA*, were "freeing . . . Asian American art

10 | INTRODUCTION

from itself."[20] Missing a shared aesthetic and coherent ethnic or racial sensibility, as noted in reviews by critics Christopher Knight and Kelly Klaasmeyer, and even implied in Johnson's review, the artworks in all three exhibitions were seen as contemporaneous stylistically with, and topically in dialogue with, other works of contemporary art outside of a racialized and ethnic-specific context. In contrast to Johnson's dismissal of identity politics, Klassmeyer expresses in her review an appreciation of *OWOA* as a "chamber of congress for artists of Asian heritage," stating quite frankly at the end of her review, "I know the curators want to make sure that work by Asian American artists is seen and they want the art world to acknowledge the strong work they're producing. If catchall groupings of artists based on ethnicity are the only way I get to see it, that's still preferable to not seeing it at all."[21]

In her review, Klassmeyer made transparent our sublimated motivations, and at the same time provided justification for the reasons why *OWOA* was mounted. I could end here and move on, but as I read the reviews together now with hindsight, a more troubling and somber reading emerges. While diametrically opposed in tone and perspective, the two different types of reviews—for example, Johnson's and Klassmeyer's—share an awareness and acknowledgment of the existence of two parallel art worlds, an acceptance of the exclusion-yet-retention of these kinds of exhibitions. Not at all post-multicultural in its inability to create leverage, the success of *OWOA* could be seen ironically as the liberal outcome of multiculturalism that according to Slavoj Žižek is racism in a different form: "[A] disavowed, inverted, self-referential form of racism, a 'racism with a distance'—it respects the Other's identity, conceiving the Other as a self-enclosed 'authentic' community towards which he, the multiculturalist, maintains a distance rendered possible by his privileged universal position."[22] This formulation may be strident, but is it not accurate as one way to describe the way racialization continues to inform the making and receiving of such exhibitions?

Constantly and consistently misapprehended and deployed semantically in art-historical discourse as external to aesthetics or as a fixed term with a specific meaning, instead of as a signifier whose meaning is attained through and contingent on shifting social and historical relations of encounters with difference, race needs to be understood as central not only to representation in general but also to differentiated forms

of access to the art world. Race is oftentimes indiscernible and takes shapes in many forms. Within an art context, racism is rarely blatant or overt, and instead manifests itself as racial bias in what scholar and filmmaker Robin Hayes has coined "racial etiquette," a recombination of tolerance and a deployment of unremarkable nuanced gestures. These micro-aggressions and unspectacular acts—thoughtless actions and offhand disparaging comments—are pervasive and occur in everyday intimate interactions and assessments that are often ignored or down-played due to pressures "to succeed by both keeping it real and being respectable."[23] Nimble and mutable, race as "a trope of classification and identification" transforms and sublimates its meaning and appearance in various modalities through active social relations that pertain to specific and shifting macro- and micro-moments, appearing in and out of view in daily interactions and everyday decisions.[24]

Coded in various forms, race has historically, culturally, and econom-ically always played a part in the selection, presentation, and interpre-tation of art, and continues to matter in the judgment and selection of works of art. Yet such unconscious bias manifests itself in such a way that it is hard to pinpoint or is dismissed and/or concealed. Evaluations of art are understood as not discriminatory, but rather discriminating. There remains a need for candid conversations about how race is not only black and white, about the role race plays in cultural gatekeeping within the art world, and yet the only location within an art world mi-lieu where this conversation can currently take place seems to be within the racial- and ethnic-specific exhibition; this is an extra-aesthetic de-mand, one that conflicts with the pressure to make these exhibitions more modular and appealing to a broader audience.

During our studio visits in search of artists for *OWOA*, such con-versations either never took place, as in the case of Paul Chan, who immediately declined our invitation to even meet, or, if they did take place, the visit was less a discussion on racism in the art world than a conversation about how "different" *OWOA* would be from previous multicultural ethnic-specific exhibitions. Younger artists such as Laurel Nakadate were more intrigued by than suspicious about being included in an Asian American art exhibition, finding such a prospect "kinda fun" and admitting to Melissa Chiu, "I've never been in *a show like that* be-fore."[25] Taking into consideration these contradictory shifts in attitudes

12 | INTRODUCTION

and approaches towards issues of identity and race, especially the latter, in which a younger generation of Asian Americans view or approach the issue as "always there . . . part of the air they breathe . . . kind of no big deal: It can be laughed at, toyed with and teased; it can be gently celebrated, cheekily exposed or simply allowed to fade gently into the woodwork," we aimed to create, within a white cube, a neutral and open-ended space, an exhibition without themes or agendas.[26] Emblematic of this mode of engaging race was Laurel Nakadate's art practice, in which she neither foregrounds nor mentions her biracial identity in her bio or her videos. Leaving room for the viewer to respond to her provocative posturing and risky encounters with older men in her *Untitled* videos, we sought to elicit interpretations of them as more than just a reversal of misrepresentations of Asian women as submissive or a representation of yellow fever. Nakadate's series of staged playful encounters belie a sense of uneasiness, loneliness, longing, and vulnerability. We were overly concerned with imposing frameworks that would overshadow or foreclose such a reading, conveniently forgetting about the ideological connotations of the white cube. It is clear now how we missed an opportunity to gesture towards and guide the audience not only to engage Nakadate's work more deeply but to engage the other artworks as well. With a video still from Nakadate's *I Want to Be the One to Walk in the Sun* (2006) serving as the cover image for a number of OWOA's publicity photos, another opportunity was missed to underline how Nakadate, as well as the exhibition as a whole, were challenging preexisting racial and aesthetic categories. Looking back at the circumscribed ways and rhetorical gymnastics of curating *One Way or Another*, mediated by an anxiety over triggering terms that might lead the work to be read reductively and tendentiously, highlights the way racial- and ethnic-specific exhibitions are monitored and circumscribed by a conjunction of multicultural and neoliberal forces and pressures.[27]

Neoliberalism is generally defined as an economic theory, hegemonic policy, and ideology that promotes unfettered free markets, strong property rights, individual autonomy, and entrepreneurial freedom—the latter translating for artists of color into a freedom "to pick, choose, manipulate, and reinvent different kinds of languages and issues, both formal and political."[28] While it will be important to avoid overstating the effects of neoliberalism and the ways it has trickled down into the

art world, approaching the exhibitions within a neoliberal multicultural context nonetheless makes sense in explaining the ways such exhibitions are now curated as well as received. For example, Roberta Smith's implicit approval of Asian American artists' belated pursuit of autonomy in prioritizing individual self-invention and expression over collective identity needs to be understood within a neoliberal context that is less about freedom than a promotion of self-reliance and the pursuit of self-interest.

Parallel to the ways in which race was folded into culture, and antiracism into multiculturalism, neoliberal multiculturalism's valorization of racial and cultural difference welcomes inclusion for all, which, at the same time, subordinates and covers over contradictions and hierarchies of differentiation. Taking into consideration these shifting economic and sociopolitical conditions, I question, in hindsight, whether *OWOA* really succeeded in liberating the racially marginalized artist, or rather inadvertently revised a set of burdens of Asian American representation or, put another way, a set of contractual binds on the curator invested in Asian American art. Analogous with neoliberalism's efficient and rational deployment of asymmetrical politics and austerity measures on local cities and populations, which in part also serve as a means to discipline individuals and entities to take on more personal responsibility—diverting attention away from institutional failures and/ or negligence—the Asian American curator is now burdened with the task of brokering and preserving works of Asian American art. Under pressure to racially profile and filter, discover and display a diverse array of "new" Asian American artists, and at the same time to link older artworks to a historical avant-garde or to some other received art-historical tradition in order to maintain upkeep and increase the value of such works, I am, as a curator and writer about Asian American art, experiencing a disquieting ambivalence.

How does one weigh a call and desire for inclusion against the very logic of neoliberal multiculturalism that will co-opt this inclusion? How can we accept the terms of Asian American art's legitimization, one that is predicated on being tied to and invested in a contemporary art portfolio that is increasingly more diversified but also specialized, relegating Asian American art onto the margins and into isolation, apart from this supposed inclusive and cosmopolitan art world? Asian American art cannot not want to be seen in an established space of appearance. The

14 | INTRODUCTION

tremendous efforts by individuals, organizations, and institutions (such as Japanese American National Museum, Wadsworth, Kearny Street Workshop, Margo Machida, Karin Higa, Mark Johnson, Godzilla, Asian American Arts Center, Asian American Women Artists Association— not at all an exhaustive list) to present artworks by overlooked and marginalized Asian American artists have had a significant impact in making Asian American art visible to a broader audience and providing access for artists to resources and cultural capital. Much work still needs to be done in presenting and preserving overlooked and forgotten artists and advocating, for all artists, the right to representation and freedom of expression. Listed below are some intermediate strategies and objectives that are already underway:

> update and/or use as a model Howardena Pindell's groundbreaking profile of the New York art scene in the *New Art Examiner*, which documented the number of artists of color curated and/or represented;
> following the spirit and tactics of Black Emergency Cultural Coalition, the Guerilla Girls, PESTS, and other similar groups, boycott particular spaces, and protest the systemic racism of major art institutions that continue to exclude Asian American artists;
> build upon established archives and secure funding to build a museum that focuses specifically on Asian American art and issues;
> following a wide range of models, including Alfred Stieglitz's and Edward Steichen's 291 gallery, Asian American Women Artists Association, and Godzilla, revitalize and/or create new networks and spaces on the grassroots level, arranging studio visits between major curators and collectors, and through social media and traditional outlets, publicize Asian American art exhibitions and disseminate articles, reviews, and interviews that focus on Asian American art;
> actively make appeals to curators of international exhibitions, for example, of the Venice Biennale of the U.S. Pavilion, and advocate for the selection of Asian American artists to represent the United States, and/or lower rates for smaller galleries that represent Asian American artists to participate in art fairs such as Art Miami Basel.

While these actions do address and ameliorate the persistent problem of underrepresentation of Asian American art to different degrees, it is

crucial to acknowledge that making visible Asian American art and expanding its parameters by way of steady inclusion and integration into the mainstream—through identity politics and an additive process—will not lead to racial parity, and cannot be its endpoint.

As underlined by Peggy Phelan in her often-cited book *Unmarked: The Politics of Performance*, there are perils and "serious limitations to visual representation as a political goal."[29] The present book grows out of this crisis of purpose. While there are differing opinions regarding how to frame the problem, how to mobilize, and what should be first on the agenda, there is agreement that works of art by artists of Asian descent have been and continue to be underrepresented. The day after the publication of Johnson's review of *Phantom Sightings* was an opportune moment to speak outright about race and art, the existence of a segregated art world, and the delimitations of the racial- and ethnic-specific exhibition. Silence on the matter and desultory efforts since then have resulted in a tacit acceptance of Asian American art's racial formation and sequestration. *One Way or Another* will not be the last Asian American exhibition in the whole entire world, as I somewhat polemically claimed in the catalog essay for the exhibition. How might those curating the next Asian American exhibition proceed in a way that breaks free from the political and institutional conditions in which Asian American art has become visible, and resist the disciplinary ways it is currently being mobilized in maintaining the appearance of the art world as inclusive and cosmopolitan?

<center>* * *</center>

While Golden's neologism "post-black," used to describe the works in *Freestyle*, was misconstrued as "postracial" rather than an exploration of how younger Black artists were defining blackness as "a hollow social construction and a reality with an indispensable history," the exhibition was successful in presenting blackness in complicated ways. Extending Golden's endeavor, in which the prefix "post" signifies not so much closure but the extent to which race affects all readings of Black art, and the need to go beyond reductive interpretive paradigms, Darby English's *How to See a Work of Art in Total Darkness* pushes against and past prefabricated and sedimented ways of interpreting Black art historically. His rich readings of works by Kara Walker, William Pope.L, Glenn Ligon,

16 | INTRODUCTION

and Isaac Julien, who "creatively decline blackness as an ambivalently lived category," challenge the ways "black representational space"—a discursive regime that polices Black art and has "a tendency to limit the significance of works assignable to black artists to what can be illuminated by reference to a work's purportedly racial character"—forecloses alternative approaches to doing African American art history.[30]

Asian American art could be perceived in ways akin to English's conception of Black representational space, but in the aftermath of *OWOA*, how might we take advantage of its mixed reading and reception as an opportune moment through which to build traction and further unsettle the meaning of Asian American art? The signification of Asian American art is not a fait accompli. Recounting Golden's sustained project of deconstructing blackness and English's challenge to recontour the interpretive frameworks of Black art, I am reminded of the discursive flexibility of Asian American art as a historically constructed term, and am keen to seek alternative pathways to curate and interpret Asian American art alongside those who are "doing" Asian American art history, a field that is emerging and expanding in exciting ways.

While the term "Asian American" emerged in the late 1960s, "Asian American art" arguably did not appear until the early 1990s, an outcome of identity politics and multiculturalism. In contrast to the confluence of scholarship on Black art history, diaspora, and transnationalism, which was developed in combination with well-documented debates on blackness and the Black aesthetic by the likes of Alain Locke, W. E. B. Du Bois, Ralph Ellison, Amiri Baraka, and, more recently, Paul Gilroy, Stuart Hall, bell hooks, Kobena Mercer, Darby English, and Thelma Golden, Asian American art continues to be understudied and emerging, and among those who engage Asian American art, there persists a lack of consensus regarding its status as a disciplinary object.

Although this view was never directly articulated in Asian American movement newspapers and Third World Forum manifestos, artists, writers, and musicians were tacitly seen as part of a cultural revolution, indirectly tasked to shape "a new moral vision" that would raise pan-Asian consciousness, build solidarity, and motivate political action to combat states of class and racial oppression.[31] Over the years, this task has been interpreted and translated to mean many things, including an expectation for cultural works labeled "Asian American" to represent

Asian American history and experiences that have been occluded due to injunctions, laws, and misrepresentations, all of which have disenfranchised Asian Americans from determining and shaping their own destiny, identity, and culture. Despite a number of works of art by Asian Americans that fit into this description, such art was not reflected in *One Way or Another*. That is, while the exhibit presented a heterogeneous array of artworks, it did not represent the diverse and complex constituency of Asian America, nor did it delineate different forms of Asian Americanness. Artworks by Asian American artists have always been an anomaly, in excess of any kind of disciplinary or aesthetic parameters, which is one of the many reasons for their marginalization within the field.[32] Compounding the perception of Asian American art as elitist, self-serving, complicit with the market, noncommittal, and apolitical is the catachrestic status of Asian American art, which, like Asian American Studies, is a fictional discursive juridical construct that has no literal referent. The need to constantly and strategically adjust its own articulation of itself and "the inner contradictions of the term and to enunciate its representational inconsistencies and dilemmas" has consistently been deferred or negated by scholars and curators of Asian American art alike, resulting in a misunderstanding of Asian American art as loosely and inherently connected to something culturally or biologically "Asian," or a catch-all label for a wide range of artistic activity, so capacious that Asian American art is anything and everything created by an artist of Asian American descent.[33] Analogously to English's project that explores and opens up multiple interpretive methods to engage Black art, I want to rearticulate Asian American art so that it is configured less as a set of objects than as a critical hermeneutic and negative dialectic, an object of knowledge, and a discursive experimental space.

Since the 1990s, much of the scholarship on Asian American art has centered attention on an artist's life, sometimes more so than on his/her works of art—a move that opens up new spaces of Asian American subjectivity and/or is mobilized as evidence of self-determination and resistance against misrepresentations of Asian Americans as noncreative automatons. More recently, there has been, as in Asian American Studies, a turn to expand the parameters of Asian American art to include the Asian diaspora, a rubric that gets away from national and identitarian boundaries and turns the focus on multiple nationalisms and

affiliations as well as issues of U.S. imperialism and European colonialism. However, too often the Euro-American side is placed as the initial point of comparison or the scholarship is focused less on a hybrid form of transnational art making and more on an identity of origins or some naturalized form of kinship that purportedly transcends hegemonic structures. That said, without at all wishing to dispute or disregard this kind of work, as the question of representation remains important in terms of who is represented and who is denied representation, I want to suggest a supplementary way of approaching Asian American art that highlights the way it engages beyond a politics of representation and identity politics. My aim is not to establish the works featured here as constitutive of the Asian American movement or as part of an activist or social protest tradition; rather, I want to suggest how art may be indispensable in the pursuits of racial and social justice—a counterintuitive move especially in light of contemporary art's altered status in relation to the political, in which art is understood as ineffective in creating change or is quickly co-opted and commodified. Shifting the categorical aims of Asian American art away from a politics of recognition to a reformation of perception, reorienting the futurity of Asian American art, I introduce in the following section and throughout the book some works of art that undo embedded and received ways of seeing the world.

Although their art is neither protest art nor a socially engaged art practice, I would like to foreground how select works by Maya Lin, Byron Kim, Simon Leung, Tehching Hsieh, Mary Lum, and Nikki S. Lee are politically resonant. Sharing no unifying characteristics beyond the commonality of their Asian descent, the artists do not necessarily self-identify as Asian American, nor are they part of a social movement, or weighed down by psychic attachments or investments in identity politics or the politics of representation. What they do share is a rich conceptual art practice, situated at the interface between multivalent art-historical traditions and trajectories. Outpacing reviews and readings of their artwork by curators, critics, and scholars, their art practices recall for me the case of Yoko Ono, who was well ahead of her time in her refusal to be neatly categorized throughout her career. For example, her performance *Cut Piece* (documentation of which is available now on outlets like Vimeo and YouTube) continues to move, disturb, and inspire new generations of artists and students.[34] In *Cut*

Piece, we first encounter Ono sitting still on a bare stage with a pair of scissors by her side (figure I.2), inviting each audience member to come up and cut away a piece of her clothing. Together with the rest of the audience, we witness stranger after stranger coming on stage and snipping off a piece of clothing, until Ono is barely clothed. At the time of her performance, Ono offered the viewer no context, clues, or hints about its nature or meaning, except for the straightforward task of cutting. Setting up an intimate and unsettling viewing experience, Ono describes how during the performance of *Cut Piece*, "people went on cutting the parts they d[id] not like of me" until only a "stone remained of me . . . but they were still not satisfied and wanted to know what it's like in the stone."[35] This cryptic and disturbing recounting highlights the cutter's desire to get to the essence of Ono's body by penetrating it with vision and evisceration.[36] The literal stripping down of a poised, yet vulnerable Ono not only exposes a precarious

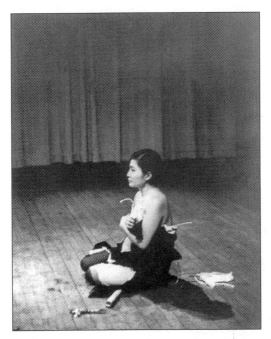

Figure I.2. Yoko Ono, *Cut Piece*, 1965. Performed on March 21, 1965, at Carnegie Recital Hall, New York. Photo: Minoru Niizuma. Courtesy of Yoko Ono.

situation and a widening gap between herself and the cutter and the audience but also implicates the latter in an aggressive and voyeuristic act of unveiling a body and subjectivity that Ono refuses to make transparent. Resisting subjection through a strategic combination of passivity and waiting, Ono defers the meaning of her performance, transferring it onto the participants, who are left with the ragged remains, cut-up pieces of her clothing. The act of cutting enacts multiple divisions and interrelations of power across race, gender, and sexuality while also addressing a specific historical event, the aftermath of the atomic bombings of Nagasaki and Hiroshima. Over the years, Ono's performance and its iterations have been read in multiple ways by art historians and feminist scholars, some of whom have read the fabric cutouts as memento mori pieces or symbolic forms of reparations that incisively comment and open up a dialogic conversation on issues related to gender, violence, rape, and the Vietnam War.

Like Ono, the artists showcased here resist easy categorization by blurring genres and styles, deploying a wide array of aesthetic and conceptual artistic strategies that split realities and render alternative schemas of the world, unsettling commonsense understandings of time and place, appearance and reality. Centering attention on their engagement with aesthetics, I am interested in how their work engages the senses in ways that open new fields of meaning, and invite unsettling and discomforting experiences.

Foregrounding aesthetics to reconceptualize Asian American art at first might seem counterintuitive. Until recently, aesthetics has been conceived within Asian American Studies discourse as diametrically opposed to the political, narrowly approached as formalism or dismissed as a philosophical and exclusive discourse complicit with metaphysical meditations on racial difference—an appeal to norms, values, or metaphysical notions that are ideological or repressive.[37] For some, this turn from figuring Asian American art's engagement with the political as a politicized aesthetics of "confronting, resisting, and violating" to figuring it as an aestheticized politics of "appropriating, complicating, and destabilizing" might seem short-sighted and compromising.[38] I aver otherwise that aesthetics and politics have been mutually constitutive of each other. For example, Plato's thoughts on the real and Aristotle's writing on tragedy as civic politics both explicitly formulate aesthetics' close

relation to politics, and how in some cases, aesthetics is more a matter of politics than of anything else.

Jacques Rancière's translated writings on aesthetics and politics, and recent scholarship that complements and extends his theories, are instructive in reading the artworks featured here in ways that help clarify this relationship.[39] In *Disagreement: Politics and Philosophy*, Rancière defines politics proper as not about representation, where a visibly select group makes decisions for the common good. Nor is it a site of rational debate and compromise between a diverse array of conflicting interests or opinions. Rather, politics is a miscount that leads to a redistribution or sharing out—as implied in the French term *"partage"*—of the sensible and a dispute about the way we see or understand something as given and legitimate. Politics occurs when those who have no part not only question the governing system and the status quo of who can be legitimately seen and heard, but also stand in and identify with the whole of society. Politics begins with a disagreement, defined as a

> determined kind of speech situation: one in which one of the interlocutors at once understands and does not understand what the other is saying. Disagreement is not the conflict between one who says white and another who says black. It is the conflict between one who says white and another who also says white but does not understand the same thing by it or who does not understand that the other is saying the same thing in the name of whiteness.[40]

In other words, politics as dissensus begins with the supposition that "we are all equal" and evolves when those who are uncounted or who have no part (surplus subjects) become aware of the gap between their outsider position and the supposition that "we are all equal." Politics occurs when those who are legitimate see how the surplus subject can stand in and identify with the whole of society. Subjectivization enables them to appear on the stage of politics as subjects, which then leads to a rupture of the sensible and a redistribution of the relations of power.

Rancière warily concedes that politics, in this sense, rarely occurs. Within a given distribution of the sensible, such disruptions are covered over and inequities are quickly naturalized. Moreover, only those who are unnamable and unregulated—surplus subjects located outside

of society's performative order as well as the purview of the police—have the potential to instigate politics. Not just a repressive apparatus of the law or a formal entity such as the state, the police take on multiple forms of power that govern appearance and create consensus in and through policies, laws, and practices—naming and assigning rules, and regulating ideologies.

Art, like politics, is a form of dissensus that suspends or breaks away from rules of engagement and assigned places, and acts in correspondence with the processing of a disagreement in the form of a tort, unraveling and revealing the folds of a twisted or torqued logic that governs the appearance of what is visible and sayable. Art engages the excess of this tort to create a semblance of reality, one that reveals a gap or disjunction between it and the commonplace apprehension of the world. The perceptual features of this otherly world reveal what is excluded or unimagined, the limits of a given social order. Ranciere's reenvisioning of art as constitutive of politics produces not only new knowledge and shifting perceptions of society at large but also radical ways of reimagining democracy, freedom, community, and art itself.

Likewise, Lisa Lowe characterizes Asian American culture as a material site of struggle, resisting the role of U.S. culture to resolve inequities and displacements by way of seamless narratives and coherent images that reconcile the contradictions forged within the realm of the economic and the political. Lowe's conceptualization of Asian American culture shares with Rancière a critical outlook on the foundations of democracy and the contradictory ontologies and mechanisms of liberal traditions of rights discourses, for example, in the collapsed separation between national and civic rights in which all human beings are now citizens, and in the case of Asian Americans, second-class members of the U.S. nation-state.[41] "Betwixt and between the positions assigned and arrayed by custom," to borrow a phrase from Victor Turner's description of liminal space, Asian American culture is constitutively formed through the exclusion and abjection of the Asian immigrant subject, situated apart from official U.S. culture and history, and in between the conflicting imperatives of the U.S. state and the demands of the economy.[42] Lowe has extended her initial conceptualization of Asian American culture, as have a number of scholars inspired by her, including Kandice Chuh, Karen Shimakawa, Victor Bascara, Gayatri Gopinath,

David Eng, and Cathy J. Schlund-Vials (not at all an exhaustive list). While some of them have deepened her approach, and others have critiqued the parameters of Asian American culture initially set by Lowe in essays she wrote in the 1990s, all of them share an assertion of how Asian American culture has the potential to expose the inequities and contradictions of abstract citizenship and the false pretenses of the nation as a space of formal equivalence.

Lowe and Rancière part ways on questions not only of who can enact this mode of disruption but also of how this mode of disruption takes place. The surplus subject is recoded in Lowe's example as the Asian immigrant, or the daughter of an immigrant, such as Maya Lin, or a fictional proxy, the protagonist in a work of Asian American literature, such as the character Dr. Hata in Chang-rae Lee's *A Gesture Life*. In much of Asian American literature, the protagonist, as both Lowe and Christopher Lee note, goes through a journey of decolonization that then leads to resistance, and action—a twist and play on the structure of the bildungsroman. In *The Semblance of Identity: Aesthetic Mediation in Asian American Literature*, Christopher Lee specifically focuses on the Asian American realist novel, tracking an author's representational strategies and aesthetic decisions in creating a fictional world, narrative arc, and profile of the main character that map the development of a character's consciousness of his/her oppression. On another level, Lee pinpoints the novel's formal breaks with realist conventions that an author deploys in order to manipulate and make sense of a character's cognitive ability to intervene and transcend structures of power. Serving as a strategic site of Asian American identification, subject formation, and empowerment, the Asian American novel has been and continues to be key in constructing and politicizing Asian American subjectivity and underlines in turn the relevance of identity politics. In lieu of presenting a course of action, the Asian American novel serves on one level as cultural critique to expose the contradictions of liberal principles that abstract and subordinate difference, and on another level, to inspire and provoke a reader, in the words of Kandice Chuh, to imagine otherwise, and take action and demand full access to equal rights.

Although Asian Americans may have been surplus subjects at one point, according to Rancière's formulation, they do not qualify as such now due to their recognition as a legitimate constituency. Now that they

24 | INTRODUCTION

are no longer outside established social structures by way of a politics of rights (civil rights movement, Asian American movement, identity politics—what Rancière and Slavoj Žižek characterize as a politics of consensus), the potential for Asian Americans to enact politics is forestalled and foreclosed. This logic makes sense in light of the aftermath of *One Way or Another*, and the way the art world and the market accommodate Asian American art, if we accept Rancière's conceptualization of politics as not about reparations or reapportioning power between existing or recognized groups, but rather as the moment of subjectification in which radically new subjects appear on the political stage.

Similarly to the ways in which Asian American authors create a semblance of reality that is on one level continuous with real times, places, and conditions but not bound to them, the artists featured here also create formal discrepant schemas that raise consciousness, but do so not by imparting information or conveying a message in order to make a grievance or claim a proper place but instead by interrupting or destabilizing a particular order or commonsense understanding of a person, place, thing, or idea. Not narratively driven, the text in some of the works is not there so much to convey knowledge about an event such as the Vietnam War, for example, as to create cognitive dissonance about who can represent the war. Conjoining and cribbing the different approaches offered by Rancière and Lowe as a point of departure to recontour Asian American art, I want to pay close attention to an artist's engagement with aesthetics and artistic strategies in order to hint at this production of politics at work, in process. I do not intend to posit the artist as a proxy for the surplus subject or as an agent of social change. Rather, what I want to highlight is how their work is already setting up the conditions for dissensus, pursuant to the spirit of the Asian American movement, but in ways departing from the actions of building consensus and coalitions.

Loosely organizing the chapters as a series of curatorial proposals on paper, I want to highlight how an arrangement and analysis of select artworks through various lines of aesthetic engagement is relevant to Asian American Studies, but also offer alternative takes on familiar themes in the field: labor and capital (chapter 2), space, history, and memory (chapter 3), identity and community (chapter 4). Against a backdrop that loosely tracks the ascendency of neoliberalism—from its experimentation in the 1970s to its full implementation in the 1980s and 1990s—the

second chapter points to the value of Asian American art beyond representing the Asian American experience or producing an object destined to circulate in the market. Playing with the double meaning of "occupy," I want to suggest how Tehching Hsieh, Byron Kim, and Simon Leung not only occupy different physical spaces—the office, the street, and the nation—but also resist to different degrees the occupation of the artist as a certain kind of laborer, an agent of representation and service provider of experiences.

Amidst increasing distraction and information overload, the third chapter focuses on the art practice of Simon Leung and Mary Lum, who glean the "remains of what cannot come under a present," constructing situations and spatial imaginaries located in between the thresholds of representation and on the "psychic border between fiction and history." While distinctly different in their artistic output, both Lum and Leung create a new form of apperception and an ability to read and respond to the built environment and more generally to the other that sets up conditions of possibility for new subjects to appear.

The last chapter compares the last three one-year performances by Tehching Hsieh with Nikki S. Lee's *Project* series—snapshots of herself masquerading as and mimicking various subcultures ranging from punks to senior citizens—and her film *a.k.a. Nikki S. Lee* in relation to their foray into the art world and its limits as an inclusive community. In contrast to the other chapters, where I focus on the background against which their work takes place, in chapter 4 I want to suggest how as strangers and unstable subjects of enunciation, the artists vanish into the background. They do not disappear, but they give the art world the slip from their consigned spaces, and in the case of Hsieh, this exit entails a double negation and resets his relation not only to the art world but to the community writ large.

While I present the different chapters as thematic "imagined" exhibitions in order to reorient familiar themes within Asian American Studies as a way to highlight the different ways Asian American art can be curated and interpreted, in practice, we hit again the impasse of racialized ways of seeing Asian American art, and the limits of the ethnic-specific exhibition as truly a space of freedom and critical open exchange. A great thematic group exhibition, as curator Ralph Rugoff and others have noted, is one that does several things at once; it can

26 | INTRODUCTION

create wonder, catch an observer off guard, generate insights, but also raise questions about how things, ideas, concepts, and the other appear.[43] But what does it mean to have a great exhibition on paper when in practice such curatorial intentions and artworks will continue to be misrecognized and misread within narrow parameters of interpretation? On another level, recalling critic Michael Kimmelman's observations of how "an exhibition is not a book, and a work of art is too unruly merely to prove a point about race or anything else," curating on paper is not the same as exhibition making in a three dimensional space in which there are indeed a number of "unruly" factors at play.[44] In the process of writing this book and reading across the chapters about their aesthetic engagement, I realized how Hsieh and the other artists have all along inspired an alternative and oppositional course of action, one that reconfigures not only Asian American art but also the exhibition as an interstitial space.

The exhibition is more than a discursive event; it is also, according to Paul O'Neill's statement towards the end of *The Culture of Curating and the Curating of Culture(s)*, "a relatively new contemporary space for dissensus."[45] Taking up this idea and ideal of how exhibitions and art together can offer the viewer—a sentient being—a singular experience that has the capacity to engage, enthrall, and/or upend one's sense of being in the world, I want to approach the exhibition as an assemblage and a space of disagreement—contingent, fluid, and interdependent on the actions of the curator, the artist, the observer, and the larger community. This way of thinking about the exhibitionary space is not new but had some precedent in the "multicultural" and racial and ethnic exhibitions mentioned earlier. In the opening chapter, I return to center my attention on these exhibitions, including four landmark multicultural and Asian American exhibitions—*The Decade Show*, the 1993 *Whitney Biennial*, *Asia/America*, and *Asian/American/Modern Art: Shifting Currents*. Much has been written about their shortcomings and failures to serve as correctives or spaces of contention due to a combination of factors, including racial fatigue, an inadequate vocabulary, or, to put it bluntly, indifference or laziness. Thematically organized, the exhibitions were also perceived as pushing forward a problematic agenda of political correctness. I want to suggest otherwise and point out how the exhibitions were initiating a set of arguments that caught the art establishment off

guard by raising questions not only about certain "issues" but also about the roles of art and politics. Due to a lack of conviction and conflicting imperatives between an institution and the curator, and a host of other factors, the arguments were both murky and unpersuasive. Included in these exhibitions were a number of "Asian American" works of art, many of them circumscribed and racialized, illegible and unnamable at the time due to circumstances that marginalized the artwork or foreclosed alternative readings. I want to take a look at select works by Asian American artists who were aesthetically setting up encounters with the observer in ways that both aesthetically and thematically complemented and conflicted with the curatorial premise of their respective exhibitions.

While the opening chapter centers on the role of the curator and considers exhibition making not as a matter of one-off events but as a process that keeps in view the *longue durée*, I have set up the rest of the chapters as case studies as a way to move towards reconceiving "Asian American art." The second chapter explores the role of the artists as cultural laborers in relation to artistic value, offering us tactical strategies in their art making that invite us to see the world differently. The third chapter focuses on the observer and underlines that for the conditions of politics to occur, a transversal effort is required of all "observers" to be active, sentient beings. In the final chapter, which addresses both the art community and the Asian American community, I extend a discussion from the second chapter on Tehching Hsieh's refusal to take his rightful place as model minority, ethnic artist, and U.S. citizen—unsettling the proper ordering of fields and identities. His art making is political insofar as it presses against the limits of given forms of subjectivity. It is also "Asian American" if we approach it within the context of Lowe's conceptualization of Asian American culture. But need we claim and name it "Asian American"? I want to question whether we can leave artworks such as Hsieh's unnamable. In general, once we name something, it comes into existence, becomes visible and legible, and we can never see it the same way again. The politics of naming art "Asian American" at this historical juncture within an ethnic-specific exhibitionary framework subjugates or constrains the work, burdening it with a ready-made set of interpretations already embedded in the collective imagination. While I understand that no name can describe fully what a work of art is doing or evoking, at this time, to name and claim a work of art as

political and "Asian American" forecloses alternative readings of the artwork and stops the momentum of an ongoing encounter, undercutting the possibility of a politics already underway. While Rancière focuses on politics as that moment of enunciation, as in his example of Auguste Blanqui, who, when asked his profession at the Trial of the Fifteen, responded "proletarian," thus resignifying the meaning of a worker and his/her membership or relation to society, I want to focus on the stage and interval before this moment of enunciation. Conceding that politics as disagreement is a rare and exceptional event does not mean, however, that it is not evolving and ongoing, a point that can be considered in light of Giorgio Agamben's and Jose Munoz's writings on potentiality and Raymond Williams's conceptualization of emergent culture—forms and practices that cannot yet be named or fully grasped, an effect of processes through which "new meanings and values, new practices, new relationships and kinds of relationships are continually being created."[46] In *Cruising Utopia: The Then and There of Queer Futurity*, Munoz writes that "unlike a possibility, a thing that simply might happen, a potentiality is a certain mode of nonbeing that is eminent, a thing that is present but not actually existing in the present tense."[47] Resisting the impulse to name and claim the artwork as "Asian American" not only opens up the meaning of a work; it also supports this liminal stage of a politics of becoming, until an artwork's next iteration in another exhibition.

The proposition to leave the work unnamable may for some seem inappropriate, premature, or at cross-purposes with other recent scholarship and writings about Asian American art, an abandonment of past endeavors enumerated earlier. Or there is a fear that any discussion about race will be superseded when, already, the term is used interchangeably with "identity" and "ethnicity" in discussions of Asian American cultural productions and the pertinent question of who is qualified to make art. I want to argue on the contrary that leaving the art unnamable is on one level a refusal of neoliberal multiculturalism's deleterious promise of representational visibility, and on another level breaks away from narrow modes of entry into art history that bind the curating of Asian American art as a residual practice.

The proposition to reconceive Asian American art in this way is not meant to be a prescription that will lead to some programmatic cure and resolution to eliminate racism in the art world or end the misreadings

of works of art by Asian Americans. Rather, what I want to point out is how Asian American art can incubate and/or set in motion artworks in an expanded field of social engagement. And while I employ strategic essentialism—a "negotiat[ion] between identities, essentialisms, positions through which to speak, strategies through which to act"—in my exclusive selection and analysis of work by artists who are of Asian American descent, I do so as a means to show that we don't have to look very far for such art, and to hint at this process of politics of becoming already at work. Too often, these kinds of artworks are dismissed as not political enough, or not engaged because they are not legibly "Asian American." And while strategic essentialism remains useful, what I want to ultimately encourage is a strategy of withholding, for example, taking pause to consider how foregrounding certain details of an artist's bio can interfere or impede a viewer's engagement with the artwork.[48] I am not at all advocating for an injunction against curating exhibitions on race and identity—in fact, now it is timely (again) to engage these issues— what I want to underline is that while race and ethnicity may well be visible in the artwork and might even be relevant, they are always part of or woven into something that outstrips it or exceeds its determination.

Understandably, there remains an impulse to curate exhibitions in which the main priority is to display the work in ways that place these artists in a rightful or legitimate lineage and/or highlight precedence in their formal innovations or choices of subject matter in order to have such artworks be counted and recognized as deserving of canonical attention. We need to shift these priorities as well as expectations that an artwork designated as "political" can do so many things at once, which, art historian Rachel Haidu wisely reminds us, puts the work in a bind. An artwork that is presumed to "be politically 'effective,' . . . subjects [the artwork] to a series of problematic assumptions about the wholeness of the subject, about the sanctity of truth, and knowledge, about the heroic nature of means that are effective as opposed to those that are not."[49] This way of thinking does not change the status quo, but adheres to received ideas about art and political art and does not disassemble the willful assumptions that continue to condition the way Asian American art is seen. Asian American art shares with Asian American literary discourse a "flexible orientation." The recent interdisciplinary scholarship by Baki Makranthi, Sarita See, Ikyo Day, and Vivian Huang, among others,

which draws from Asian American Studies, queer studies, cultural studies, psychoanalysis, performance studies, postcolonial studies, Marxism, and critical race studies, in combination with scholarship that looks at art from an art-historical point of view or through a sociological lens, has been integral to the reconception and expansion of Asian American art's discursive formation. Their scholarship both extends and challenges the history of modern art, which Grant Kester characterizes as "nothing if not an ongoing struggle to develop a compensatory response to the dehumanizing effects of modernity whether through the agency of a well-crafted object, paintings of bucolic Polynesians, or the therapeutic disruption of a viewer's perception."[50] From another valence, this recent body of scholarship expands the multiple references of an artwork, giving some latitude for curators to focus their efforts on finding alternative ways of curating these works not as "proper" objects but in ways that set up the works as invitations to a future encounter. The search for more radical experimentation in exhibition making beyond thoughtful juxtapositions and innovative forms of display needs to be an imperative—a challenge that I do not cover here, but scholars such as Paul O'Neill have, documenting and analyzing exhibitions that are, not surprisingly, led by artists or curated collaboratively by a wide range of actors, including curators, exhibition designers, activists, scientists, and youth.

At the risk of being tautological in my positing art as an encounter, I want to underline how Asian American art is not about just giving information or communicating a message, but leveraging an encounter that is ongoing and uncounted. Not immediately confrontational or transformative, this iterative encounter is contingent on an open engagement of art and embrace of its heterogeneity. Throughout the book, I want to keep in mind artist Simon Leung's instructive reminder in the making and presentation of all artworks: how art is formed by a relationship between the self and others, "constituted out of the continual and mutual imbrication between the reality of such material conditions and a mortal sense of the world."[51]

In the second chapter, I discuss further what Leung means by this in relation to his appropriation of Marcel Duchamp's concept of the ready-made and the concept of responsibility. Part of the ethicopolitical task of the curator and the scholar is to cultivate this responsibility, or, put another way, to encourage the ability to learn how to respond and

hear the call of the other in and through one's encounter with art—to be attentive and present to the ways these artists create otherly worlds that enable us to see our world differently. Asian American art can also be a space to consider and acquire these ideals and ideas. While the "outer" appearance of Asian American Studies within the university and the mainstream causes it to be seen as a discipline that solely focuses on personal identity and historical experience, within the field, there has been almost since its inception an understanding of the need for scholars to constantly "articulate the inner contradictions of the term [Asian American Studies] and to enunciate its representational inconsistencies and dilemmas."[52] Sharing this similar dilemma, but within the museum and artworld too, this book is an attempt to articulate and recontour Asian American art. I anticipate that the interpellation of Asian American art is ineluctable and will continue to be misrecognized as always doing something else. Likewise, art is always doing something else, and this is precisely what we should be attuned to and embrace. Shifting the category of Asian American art in this way neither fixes nor diminishes the richness that these works have to offer, but rather, envisages Asian American art beyond its own limits.

1

Unnamable Encounters

A Phantom History of Multicultural and Asian American Art Exhibitions, 1990–2008

Introduction

The power of the exhibition to guide, condition, and produce knowledge and universal subjects—and in this case, the very category of Asian American art—cannot be overstated. Despite the drawbacks of multicultural and ethnic-specific exhibitions, as foregrounded in the introduction, and acknowledging the museum as a colonial and imperial apparatus with its legacy of Orientalizing Asian American subjects, art making, and artists through an ensemble of disciplines and techniques, administration and governance, the museum survey "remain[s] the primary means of visibility" for many Asian American artists.[1] This chapter offers an overview of four landmark multicultural and Asian American exhibitions that took place between 1990 and 2008: *The Decade Show* (1990), *1993 Whitney Biennial, Asia/America* (1994), and *Asian/American/Modern Art: Shifting Currents* (in brief, *Shifting Currents*; 2008). Aware of the numerous multicultural and ethnic-specific exhibitions that were curated in alternative spaces and municipal museums in this time period, I focus on these groundbreaking exhibitions because they included a number of artworks by Asian Americans, operated on a national and international scale, and garnered widespread publicity and reviews in mainstream newspapers and magazines.[2] Grouped together as "Asian American art," and/or framed around themes of identity, race, and the body, these works by Asian Americans, however, received responses that were muted at best; they were reviewed, not for the formal properties in their work or their engagement with art history, but as expressions of personal identity or didactic expressions of political protest, or they were not mentioned at all.

In contrast, the exhibitions as a whole were either well received—acclaimed for democratizing art—or derided as liberal promotions of a multicultural agenda. The import and impact of these exhibitions continue to resonate and rebound in ways that have yet to be adequately addressed within art history, except as examples of an identity crisis within the field or nostalgic artistic rebellion, as in the New Museum's recent *NYC 1993: Experimental Jet Set, Trash and No Star* (2013). Narrowing its art selections to a particular cross-section of New York artistic production at the time, *NYC 1993* attempted to reenact the convivial and politicized activity that took place in New York's alternative scene in the aftermath of the Culture Wars. But missing from the exhibition was a discussion on the pioneering, innovative potential of these large-scale exhibitions that focused on issues never before presented in an art museum. While issue-focused exhibitions containing art created by diverse artists from all over the world are now taken for granted, at the time, they were new and unfamiliar formats for an observer "who [did] not yet exist, whose competence could not yet be identified."[3] In contrast to the process of curating a solo or thematic exhibition, these multicultural and ethnic-specific shows necessitated an alternative mode of exhibition making.

In this chapter, I explore the curatorial processes of making these exhibitions: what the curators did differently, how they addressed and engaged their primary and secondary audiences, and what methods of display they deployed.[4] More than just selecting, categorizing, organizing, and displaying works of art, exhibition making entails constructing a framework, what artist Mary Kelly describes as "a crucial intersection of discourses, practices, and sites," an initial context in which a work of art is first seen.[5] It also entails managing and incorporating a multiplicity of objects, actors, and discourses to create a narrative "with a beginning and an end, one that develops over time, marked by specific rhythms and particular events that emerge in the interaction between the visitor and the objects."[6] In these four exhibitions, the curators adopted different strategies of exhibition making, but due to structural and institutional constraints, the exhibitions also shared similar challenges and predicaments. My analysis is not meant to critique the shortcomings of a particular curator, as exhibition making entails contending with a number of external forces and internal politics and pressures, unexpected and

unforeseeable factors and limitations involving artists, collectors, and donors, as well as the loan and shipping of particular works. I am interested in how these exhibitions framed the included works in particular ways that predicated a certain kind of looking, and offered a viewing experience that necessitated both the telling of a story or a set of histories about subject matter unfamiliar to art history—institutional power in relation to systemic racism, U.S. imperialism—and the making of an argument to shift the art world's mindset about how to see, display, and live with difference.[7]

By beginning to reassess these exhibitions, I hope to show how the curators were not only grappling with a crisis of representation but were also un/consciously engaged in an ongoing dialogue with each other, responding to or extending each other's take on multiculturalism, race, and art. For example, *Asia/America* was organized partly in response to the format and display of the 1993 *Whitney Biennial* but also seemed to be conceptualized as an addendum to *The Decade Show*. Whereas *The Decade Show* in 1990 could be seen as inaugurating multiculturalism into the contemporary art landscape, the 1993 *Whitney Biennial* was conceived as the culmination of multiculturalism. While *One Way or Another* (discussed in the introduction) was assumed to be a response to *Asia/America*, I would argue that *Shifting Currents* thematically responds to and extends *Asia/America* in ways that *OWOA* did not and could not address.

The exhibition catalog, usually understood as documentation of an exhibition and an artist's work, has become, in the case of these exhibitions, a pivotal source for understanding in depth an exhibition's curatorial premise, and the logic of selection, inclusion, and exclusion of particular works and the ways they were displayed. Engaging these catalog essays alongside brochures, reviews, and, whenever possible, copies of wall labels, gallery maps, and my own contemporaneous notes from visiting some of these exhibitions, I approach these shows as an intertextual space that reveals not only the gaps between the conception of an exhibition and its reception but also how some readings of artworks were permissible at the time and how other meanings were foreclosed. On another level, I approach the extratextual material, as well as odd selections or juxtaposition of artworks, as supplementary remains or excess from the floor of an exhibitionary space. My rereading of these

exhibitions and attention to these instances of excess are designed not to re-create an "optimal" situation in which to experience these exhibitions, or to "redo" an exhibition, but to seek modes and models that challenge fixed and reductive ways of viewing and experiencing Asian American art.

In "Asian American Exhibitions Reconsidered," Alice Yang analyzes the viability and shortcomings of Asian American group exhibitions in the 1990s. I want to do the same here, and to parse the conditions in which select works of Asian American art were made visible—a tracking that traces and mirrors a ghosted history of identity politics.[8] A temporal strategy to be deployed, in the words of Gayatri Spivak, "only to achieve interim political goals without implying any deeper authenticity," identity politics or strategic essentialism was mobilized by museums as a kind of affirmative action in response to pressures to be more inclusive.[9] Such gestures were, however, cosmetic and not at all inwardly reflective of nuanced thinking about cultural difference and the legacy of discrimination and exploitation of the other. Rather than approach art through interlocking categories of race, class, gender, and sexuality—let alone aesthetics—these categories of analysis were approached superficially and/or separately, apart from structural issues of racism, capitalism, and colonialism, and used as organizing rubrics that narrowly categorized a work of art as about being female, queer, black, etc.

Visible yet illegible, the specific works by Asian American artists analyzed here were at the time of their initial emergence either passed over and overlooked by critics and scholars or seen as extraneous or in excess of the curatorial premise and their assigned places. I want to amend this reception or lack thereof, and point out how the artworks in these exhibitions were in their own way reworking, destabilizing, and/or exceeding the curatorial premise and framework, their assigned place in art history, and the role of art, which may partly explain why many of the encounters with these specific works of art remain not invisible but unnamable. Rereading these specific artworks not as Asian American per se, but through an Asian American art lens, highlights how works of art engaged with and/or confounded particular themes in an exhibition, and set up the conditions for a possibility of a potential politics. The readings of these works in conjunction with a rereading of these exhibitions underlines the importance of approaching these exhibitions not as

one-off events but as assemblages—a "product of multiple determinations that are not reducible to a single logic [of] forms that are shifting, in formation, or at stake . . . [but as] heterogeneous, contingent, unstable, partial, and situated."[10] I begin the chapter with a summary and review of *The Decade Show*, followed by a reading of the 1993 *Whitney Biennial*. The second half of the chapter focuses on *Asia/America* and *Shifting Currents*, and concludes with some thoughts on art practices by Group Material and Maya Lin as alternative models of exhibition making oriented toward setting up encounters and future rendezvous.

The Decade Show: Frameworks of Identity in the 1980s

Flush with a surplus of ready-to-spend cash, the beneficiaries of President Ronald Reagan's tax cuts and supply-side economics formed a new class of art collectors who saw art as both a speculative investment and a means of symbolic uplift, inflating the art market with their multimillion-dollar purchases of paintings by an exclusive group of white male painters. Amid a promotion of color-blindness and rollbacks in civil rights legislation and advances made by the new social movements, artists of color had had enough of an indifferent and insular art system and world, and took matters in their own hands to gain control of the means of representation. Joining forces with artists fighting against neoliberal and neoconservative policies, including a retrenchment of public art funding and the lack of support to treat AIDS, collectives and artist-run spaces were formed, such as Gran Fury, REPOhistory, Women Artists Coalition (WAC), Artists Space, and Minor Injury.[11] Presenting art by African, Caribbean, Latin American, and Asian American artists on a shoestring budget in big and small alternative art spaces and storefront galleries—for example, Alternative Museum, Art in General, Jamaica Art Center, the Kenkeleba House, and INTAR—publicizing these exhibitions through word of mouth, and documenting them in newsletters and small press publications, artists and curators together took part in a larger initiative to seriously address the intersections of race, class, sexuality, and gender. Initially, these exhibitions drew small audiences, but over time, they attracted larger, broader audiences. Collectives such as PESTS, Guerilla Girls, and eXile engaged in other kinds of actions, including leading demonstrations in front of major museums, creating

38 | UNNAMABLE ENCOUNTERS

fliers, circulating manifestos and monthly newsletters, and engaging in letter-writing campaigns protesting institutional exclusion of artists who were not white and male.[12]

The conception and framework for *The Decade Show* emerged out of this flurry of activity through a series of informal conversations, hard-hitting, consciousness-raising strategy sessions, and formal gatherings among a trio of museum directors who were part of the Fantastic Coalition of Women in the Arts—Nilda Pereza, director of the Museum of Contemporary Hispanic Art; Marcia Tucker, director of the New Museum of Contemporary Art; and Kinshasha Conwill, director of the Studio Museum in Harlem. In the spring of 1990, *The Decade Show: Frameworks of Identity in the 1980s*, an ambitious multicultural extravaganza, opened with fanfare in New York City. Presented simultaneously in three different museum spaces—the Museum of Contemporary Hispanic Art (MoCHA), the New Museum of Contemporary Art (New Museum), and the Studio Museum in Harlem (Studio Museum)—*The Decade Show* aimed to present, in the words of Peraza, "a very generous and open environment" of artworks that were "issue-oriented rather than driven by pure aesthetics or formal concerns," by artists from all backgrounds.[13]

On one level, *The Decade Show* was a survey of artistic activity against the status quo and systemic oppression. On another level, the exhibition was a platform that foregrounded the importance of race, class, gender, and sexuality as critical terms of analysis in constructing multivalent forms of identity. Co-curated by Julie Hertzberg, Laura Trippi, Gary Sangster, and Sharon Patton, *The Decade Show* presented more than two hundred works—by men, women, artists of color, gays, and lesbians—that paid attention to social concerns, including the AIDS epidemic, the threat of nuclear war, democracy movements, globalization, U.S. militarism, the global environment, and the ongoing experiences of disenfranchised and marginalized minority artists. Part of a succession of thematic exhibitions that examined the 1980s, *The Decade Show* stood out not only for its focus on a diverse range of issues, but especially for its selection of artists.[14] In contrast to exhibitions that claimed to present artists from the margins, like Jean-Hubert Martin's globally inclusive, but Eurocentrically flawed *Magiciennes de la Terre* (1989), *The Decade Show* offered a space for a wide range of artists to "construct a multivocal art world," in the words of Eunice Lipton. In a similar spirit, the

accompanying catalog included essays by a diverse group of curators and artists, including Lipton, Margo Machida, Judith Wilson, Lowery Stokes Sims, Susana Torruella Leval, Jimmie Durham, David Deitcher, C. Carr, and Micki McGee.

On one hand, *The Decade Show* was reviewed as "electrifying" and "provocative." Many critics promoted the show as "well worth seeing" or a "must-see." Critic Cassandra L. Langer described the selection of works as creating "real dialogue" and praised the curators as "performing near miracles of critical morality."[15] Organized loosely around specific themes at each location—biography-autobiography and sexuality-gender at MoCHA, myth-spirituality-nature and discourse-media at the New Museum, and social practices–cultural criticism and history-memory-artifact at the Studio Museum—*The Decade Show* included a number of Asian Americans: Tomie Arai, Tom Nakashima, Margo Machida, Ken Chu, Albert Chong, Ben Sakoguchi, the Epoxy Art Group, Y. David Chung, Roger Shimomura, Dan Kwong, Bruce and Norman Yonemoto, Sachiko Hamada and Scott Sinkler, Shu Lea Cheang, Pok Chi Lau, Martin Wong, Yong Soon Min, and Tehching Hsieh. While the Asian American artists in the show were not overly diverse in terms of representation—mainly artists of Chinese, Korean, and Japanese descent—their artworks were diverse in both medium and subject matter, engaging not only identity, assimilation, and racial discrimination—as reflected in the works by Yong Soon Min and Ken Chu—but also alternative forms of community and the everyday, as in the examples of Pok Chi Lau's intimate photographs of homes in San Francisco's Chinatown and Martin Wong's lively paintings of youth skateboarders in New York's Lower East Side. While grouped together in the catalog, in the exhibitionary space they were dispersed throughout the three venues—parallel to the convivial cross-cutting action in alternative spaces that inspired *The Decade Show*. At the same time, many alternative connections were overlooked, as in the case of Martin Wong, who not only identified as an Asian American artist but was also part of an active East Village art scene, creating alliances and collaborating with graphic artists and poets like Miguel Piñero, founder of Nuyorican Poets Cafe, whom he met at ABC No Rio.

The spirit of inclusiveness was also *The Decade Show*'s "Achilles heel." Because of the scale and scope of the exhibition, it became a random

introduction to artists of color who had one or two works at the most displayed, as if these works were representative of an artist's entire oeuvre. Many of these artworks were given short shrift, or not even seen because there were just too many works of art to take in, placing the works in competition for the viewer's attention. With the exhibition divided into three separate locations, the effort to get to these different institutions proved to be a major challenge for both local audiences and art aficionados. But even within the discrete museum spaces, the exhibition was sprawling; in her review in the *Village Voice*, Elizabeth Hess wrote, "[T]o put it simply, there are too many artists (not too much work) . . . and as a result, everybody suffers. The problem is not quality versus quantity, but depth. Six general categories are stretched so thin to cover disparate objects that they just collapse."[16]

That is, while the exhibition was structurally conceived through multiple and overlapping social relations, the juxtaposition of specific works seemed to be overlooked or approached as an afterthought. Viewers had to forge their own paths and come up with their own meanings to make sense of the pairings of artworks. For example, at first glance, Cindy Sherman's sultry and suggestive large-scale color self-portrait and Richard Ray Whitman's intimate portrayal of homeless American Indian men, whom he called "resistors," in downtown Oklahoma City seem to have little in common (figure 1.1). A quick drawing out of shared and contrasting formal approaches to photography and portraiture and thematic subject matter—constructions of gender in relation to displacement and abjection—on a wall text would have at least provided a context, or started a dialogue, but this kind of contextualization and guidance was lacking, resulting in missed opportunities with reverberating consequences.[17]

Losing sight of the multilayered premise of the show and the different categories that the works were assigned, many reviewers seemed to see the works in isolation, lumped together or paradoxically invisible through the lens of the varied themes; at the same time, they were evaluated by contradictory and inconsistent criteria. Pointing to how "sincerity, alienation and just causes don't necessarily make convincing artworks," critics approached many of the works through a predetermined hierarchy of concepts and criteria, chiding artists for engaging "the heart and mind more than the eye."[18] For other critics, the

Figure 1.1. Installation shot of *The Decade Show: Frameworks of Identity in the 1980s*, at the Museum of Contemporary Hispanic Art, May 12–August 19, 1990. Image courtesy of Hostos Community College. Cindy Sherman's self-portrait is in the far background, with Richard Ray Whitman's four photographs next to it.

exhibition was less a display of artworks than a platform for raw rage and multiple grievances concerning AIDS and gender, sexual, and racial oppression, on which, Kenneth Baker noted, "[S]peaks is the operative word here."[19]

Anticipating the unprecedented museological nature of the exhibition and its focus on unconventional art-historical subject matter, artists Jimmie Durham and Guillermo Gómez-Peña, in their respective catalog essays, pressed for the need "to find a new terminology, a new iconography, a new set of categories and definitions... a re-bapti[sm of] the world in our own terms," in which indigenous traditions would be considered alongside "postmodern" strategies of appropriation and bricolage "for completely different purposes than what the art world might expect."[20] By not experimenting or pushing the boundaries of exhibition making, beyond selecting a diverse array of works of art that engaged unprecedented subject matter, *The Decade Show* became less a liminal space, or what Guillermo Gómez-Peña describes as an "intercultural

border zone," than an entropic space that neutralized the works of art—an instance of the "museum effect" that David Deitcher describes as depoliticizing the artwork and, for many, unintentionally positioning a number of works of art through narrow prisms of race and identity.[21]

The overarching theme of the exhibit—as indicated by the show's subtitle—was identity, but not in the sense of representing and finding the self. Rather, identity, as underlined in the exhibition and highlighted in Trippi's and Sangster's catalog essay, was understood to be constituted through multiple axes of difference and a dialogical and provisional construction across difference, with the same kind of arbitrary or fictional closures "required to create communities of identification—nation, ethnic group, families, sexualities."[22] Yet despite this poststructural approach towards identity that challenged selfhood as stable and fixed, many of the artworks were seen as mimetic self-representations, evaluated on the basis of authenticity, or according to terms such as those spelled out by Roberta Smith: "[W]hen dealing with issues of oppression and difference, let's hear it from the oppressed and different, from artists whose sensibilities have been shaped by being Asians or women or homosexuals."[23]

Mentioned in a number of reviews (although her name seemed impossible to remember, as it was misspelled on several occasions in different publications as Yung Soon Min and Yong Sook Kim), Yong Soon Min made an impressive debut at *The Decade Show* with her conceptual piece *Make Me* (1989). In *Make Me*, six black and white self-portraits, against a background of three different shades, picture Min's bisected face in various poses. In one photograph, one hand covers her eye and the other hand covers her mouth (figure 1.2). Superimposed on each photograph are words and phrases, stenciled in white, all in caps: ASSIMILATE/ALIEN, MODEL MINORITY, OBJECTIFIED OTHER, EXOTIC EMIGRANT. In MODEL MINORITY, in an image arrayed like a fan, we see Min's hands placed on her face in a disarming way. In contrast, in OBJECTIFIED OTHER, Min is seen pulling at the corner of her left eye, exaggerating the way Asian eyes are perceived, with her other eye closed. *Make Me* reveals the way stereotypes are encoded and imposed on Asian American women, a reading that is also inflected in the title. In the last image, Min blankly stares at the viewer in a manner reminiscent of a photo found on an identification card. This image in

Figure 1.2. Yong Soon Min, *Make Me*, 1989. Photograph and printed text on paper, six panels, 96" x 120".

particular acts like a mirror, inviting the viewer to identify with Min. Asymmetrical and not perfectly bifurcated, the image seems to be closing or folding in on itself, not only a commentary on the way such identifications are misperceptions and misrecognitions but also a defiant gesture by which *Make Me* could be read also as a taunting imperative.

These kinds of connections of racial and gender subjection and subject-formation, which now seem easily discernible, were at the time overlooked or not seen at all. Needed somewhere in the exhibition space—wall panel, audio guide, or pamphlet—was a set of working definitions, a quick précis on, for example, how race operates, as concisely outlined in Jimmie Durham's catalog essay "A Central Margin," in which he clearly describes the process of racialization and the way "the other" has been conceived as foreigner, rendering those colonized "here at home" invisible.[24] While binary oppositions of primitive/modern, Western/non-Western, center/periphery, inside/outside seemed to be overturned, essays and artworks by artists such as Durham's that reveal the colonial legacy of violence and exclusion were key in understanding the invisibility and belated entry into the exhibitionary space of artists

UNNAMABLE ENCOUNTERS

of color as "artists" and not anthropological objects, but such discussions were dismissed or sublimated.

While the exhibition was successful in making visible a number of artists once marginalized by the mainstream, the belatedness and questionable terms of entry of these artists were not addressed by the curators or critics, which led to another set of problems and challenges—a "new" taxonomy of artists provisionally and problematically placed under the rubric of "multicultural." But as the "first" "multicultural" exhibition, *The Decade Show* revealed an acute and clearer picture of what needed to be done, motivating artists "to rise from the ashes" and form collectives such as Godzilla: Asian American Art Network.

1993 Whitney Biennial

In July 1990, fed up with the art world's recurring and systematic marginalization of Asian American artists, Ken Chu, Margo Machida, and Bing Lee formed an alliance that would later morph into a welcoming space, a platform, and a collective. Godzilla's many objectives included creating a safe space of camaraderie and support, as well as addressing the lack of Asian American representation in museums' exhibitions, collections, and boards of directors, with the aim of propelling Asian American art (which they defined as the making of, curating of, and writing about art by Asian Americans) into the mainstream.[25] Pan-ethnic, cross-disciplinary, and multigenerational, Godzilla was a critical convergence of art and art professionals (administrators and curators) and a loose, diverse (even "odd," according to Godzilla member, curator, and art historian Karin Higa) assortment of older and younger generations of activists and artists who did not necessarily share a deep-seated bond or kinship (though close friendships were indeed forged), but rather were committed to an art of dissent that defied assimilation and refused to remain marginalized in a cultural nationalist countersphere or ghettoized category—but at the same time was, in the words of Karin Higa, open to diverse formal practices and nonjudgmental approaches to Asian American identity. Coordinating a wide range of activities that included organizing critical discussions on Asian American art and arts advocacy in public symposia, self-publishing newsletters on all sorts of topics, and curating exhibitions such as *A New World Order III: A Curio*

Shop, Godzilla made it one of the first items on its agenda to address a letter to then newly appointed Whitney Museum director David Ross, previously a director and curator at spaces known for alternative and cutting-edge programming, including Boston's Institute of Contemporary Art, the Berkeley Art Museum, and the Long Beach Art Museum.[26] Despite reviews lauding the inclusivity of the Whitney's *1991 Biennial Exhibition*, once again very few women and Asian Americans were represented.[27] Candid and direct, the letter opened with the following line: "We feel the Biennial fails to live up to its intention, as stated in the official brochure, of providing 'a framework for better understanding the diverse creative vitality that characterizes the art of this period.'"[28]

In response to the letter, Ross to his credit quickly arranged for a meeting, inviting Whitney Museum chief curator Elisabeth Sussman (formerly chief curator of Boston's ICA) and several Godzilla members to discuss their letter and demands, in particular, the systemic ways in which Asian Americans were underrepresented. Higa summarized the meeting as follows:

> While at a basic level, we talked of inclusivity and representation, our larger argument was more nuanced. Curators and museum professionals make value judgments that are based on spheres of knowledge. What if those spheres are limited because of race? Ross sympathetically and succinctly observed in our meeting that, "People tend to order what's on the menu." We proposed to expand the choices.[29]

Expanding Ross's choices, the members of Godzilla presented him with slides of works by Asian American artists, organized studio visits for the curators, and coordinated roundtable discussions through the Whitney's education program, led by its then director Constance Wolf. While not game changing, Godzilla's efforts had an immediately visible impact: ten Asian American artists—visual artists Byron Kim, Simon Leung, Shu Lea Cheang, and Bruce and Norman Yonemoto; filmmakers Roddy Bogawa, Christine Chang, Janice Tanaka, Trinh T. Minh-ha; and performance artist Kip Fulbeck—a record number, were invited to participate in the *1993 Whitney Biennial*.

The sixty-seventh Whitney biennial broke all kinds of records and traditions, especially in its selection of artists: among the eighty-two artists,

many were nonwhite, gay, and women, a stark contrast to years before and to what would follow in the 1995 *Biennial Exhibition*. Reconfiguring the format and organization of the biennial in order to tackle "issues of individual and community identity . . . that extend well beyond the art world," Ross appointed Sussman to lead a team of seasoned and emerging curators—Lisa Phillips, Thelma Golden, and John G. Handhart—in assembling an exhibition in consultation with an advisory committee of prominent curators and scholars, including Loris Bradley, Coco Fusco, Mary Jane Jacob, Larry Rinder, Chon Noriega, B. Ruby Rich, and Eugenie Tsai.[30] Going outside of the museum for the first time in the biennial's history, Ross also commissioned a set of scholarly essays by Fusco, Rich, Homi K. Bhabha, and Avital Ronell to accompany the essays by the Whitney curators.

The biennial opened amid bleak economic forecasts and intense racial tensions following the Los Angeles Uprising, with "communities . . . at war, both with and at their borders," and against this backdrop Ross positioned the Whitney Museum as not just "a place of sanctuary for a war-weary world" but a "site for the contest of values and ideas essential to a peaceful society; to serve as common ground for many intersecting communities."[31] Historically serving as the bellwether of new trends and styles, this biennial was a presentation of two very different trends and styles: two exhibitions sharing one space, in which half the artworks were deemed "polemical" and the other half were described by curator Lisa Phillips as "pathetic" or, in the words of *The Decade Show* curators, Trippi and Sangster, "trivial."[32] Tying these two worlds loosely together were the themes of identity and community. Envisioning the biennial as a "community of communities," Sussman and her team presented different manifestations of community, a microcosm of the world outside and of the art world, described similarly by Pamela Lee and Paul O'Neill as an "an ostensibly unified place in which creative and cultural differences can be integrated while retaining a diversity of existing identities."[33]

Critic Eleanor Heartney thought otherwise, describing the biennial as a battlefield and the Whitney Museum as "under siege" by Charles Ray's larger-than-life sculpture of a forty-five-foot hook-and-ladder fire engine parked at the curb in front of the museum and Pat Ward Williams's large-scale mural portrait of five young Black men with the title *What You Lookn At?* graffiti-scrawled on the bottom half of the image,

setting a tone of crisis and confrontation.[34] Upon entrance to the museum proper, a visitor was given a piece of art, one of Daniel Martinez's museum admission tags, a fragment of a larger sentence that read, "I can't imagine ever wanting to be white," and down below, in the basement, was Coco Fusco's and Guillermo Gómez-Peña's parody of an undiscovered Amerindian couple—the cultural other—caged and put on display. In the foyer of the museum a video loop played empowering and sobering documentaries by Youth Organizers Television (YO-TV) that introduced not only the voices of New York City's high school youth but also some of the biennial's sub-themes: AIDS, race, the body, violence, and class. The jarring and clever mix of in-your-face seriousness with humor and absurdity in Charles Ray's fire engine was not immediately apparent to critics and patrons of the Whitney Museum, who instead saw this opening arrangement as setting on fire the museum and art history.

Perceptive in anticipating this misreading, the members' guide and opening catalog essay, "Coming Together in Parts: Positive Power in the Art of the Nineties," could be read as an apologetic overture to the Whitney's primary audience. Sussman describes the artworks as unconventional, beyond received understandings of form, and imbued with "sensuality, contradiction, visual pleasure, humor, ambiguity, desire or metaphor."[35] She goes on to say that "although sexual, ethnic, and gendered subjects motivate the content of recent art, these identities fragment but do not destroy the social fabric."[36] Inviting members of the Whitney and the art world to recalibrate their approaches and see "unfamiliar" artworks, leaving behind their expectations and prejudices, Sussman offered little, however, in terms of how they should proceed and navigate the cramped space of the Breuer building, filled with installations, new media, and video artworks, where the sheer number of such works felt "sometimes assaultive," as described by curator and critic David Deitcher.[37]

Now commonplace, installation art such as Pepon Osorio's representation of a Nuyorican living room was a relatively new artistic form at the time.[38] Inviting observers to another community, an otherly world, Osorio's *Scene of the Crime (Whose Crime?)* was a reconstruction of the site of the murder of a woman, a possible victim of domestic violence. Osorio's controversial appropriation of clichéd crime scenes on TV and Lorna Simpson's incisive take on the Los Angeles Uprising highlighted

48 | UNNAMABLE ENCOUNTERS

the power and impact of mass media—its construction of events—on society and contemporary art practices.[39] Even included was George Holliday's recording of the eighty-one-second beating of Rodney King, an incident of "police brutality, often referred to but never seen." By the time the video was displayed in the biennial, it had been widely seen and was one of the most recognizable works in the exhibition, but the logic of its inclusion was obfuscated. An excerpt in the gallery from John Hanhardt's excellent catalog essay regarding the inclusion of Holliday's video would have provided much-needed context.[40] Juxtaposing the Holliday video with another biennial selection, Not Channel Zero's *Nation Erupts: Parts 1 and 2* (1992), and the archive of Black Audio Film Collective (which was not seen on the Whitney's main floors but was part of its ongoing video program), Hanhardt highlights in his catalog essay how "ordinary citizens" together with artists were accessing video, television, and other forms of media technology in extraordinary ways, capturing not only the disciplining of society and the regulation of culture but also the eruption of social unrest and potential for social change.[41]

Perhaps because of the seeming accessibility and legibility of Holliday's video, its wall label was concise, in comparison with the verbiage used to describe many of the other artworks in the biennial, a challenge Sussman hints at in her introduction in the catalog. In contrast to the exhibition-making strategies of *The Decade Show*, the curators of the biennial front-loaded many of the wall labels with too much information or not the right kind of information to engage the work. Spread throughout an already crowded display, many of the wall labels that accompanied the art were arguably too close to the work, and too pedantic, as reflected in Andrea Fraser's acoustic-guide contribution to the biennial—a parody of a docent talk (understood as a proxy for the curator)—which highlighted an undercurrent of anxiety and impatience with the artwork, emphatically stating at one point during her walkthrough, "This is what you are looking at, this is what the artist is doing, this is how you should read it, this is what you should be thinking about, this is how you should be reacting."[42]

In his essay for *The Decade Show*, Gómez-Peña's articulation of cultural difference as "painful and scary," akin to "getting lost in a forest of misconceptions [and] walking on mined territory," aptly describes what

ensued on the floors of the Whitney. A number of artworks, including Daniel Martinez's museum pins, marked and subjected those who identified as white in uneasy and revealing ways. The pins were a form of institutional critique—a negation of the art institution and art world politics—but also a turn away from previous iterations of this kind of art making or genre. Collapsing the distance and proximity of encounters with the other in order to open dialogue about the structural conditions underpinning the art world and how those conditions affect the ways we see artworks by artists of color, the pins were instead seen as an affront, an exemplar of what was wrong with *this* biennial. Excoriating the art and its display as patronizing and confrontational, critics such as *Time's* Robert Hughes described the biennial as "a fiesta of whining"; and in Roberta Smith's words, "clearly pleasure is not what the '93 Biennial had uppermost in mind."[43] With the exception of a few reviewers, such as *New York* magazine critic Kay Larson, who described the biennial as "a wild ride . . . an explosive self-examination shaking American society," the 1993 biennial was perceived as a site of unleashed grievances full of gravitas that made critics feel insignificant or, in the words of Hilton Kramer, were engineered "to make us feel bad."[44]

Rather than opening up a space of multiple horizontal encounters that cut across race, sexuality, and gender, the works were seen as heavy-handed and the exhibition as a melee, "a battlefield" as described by one critic, or in the words of Mary Louise Pratt, a series of contact zones "where disparate cultures meet, clash, and grapple with each other, often in highly asymmetrical relations of domination and subordination."[45] With a lack of precedent and inadequate vocabulary to engage these artworks, a number of critics were put on the defensive, confronted by what they saw as not art but political correctness, according to which a critic or art historian who was being aesthetically discriminatory was instead perceived to be discriminating against an artist's ethnicity or race.[46] While a number of artworks were not directly about race, it was central in understanding the conception and reception of the exhibition and some of the artworks, but both critics and curators were unwilling to delineate how race, class, sex, and gender operate and overlap, and refused to acknowledge race's shifting perceptual status as affect and intuition.

With Sussman bypassing the discussion of race altogether, Lisa Phillips's catalog essay becomes key in understanding one of the ways race

was conceived in the curatorial logic of the exhibition. Describing race as a passing trend and framing device, an art-historical phase, Philips writes, "Today everybody's talking about gender, identity, and power the way they talked about the grid in the late sixties and early seventies. The issues of context and presentation are paramount and formal invention has taken a backseat to the interpretive function of art and the priorities of content."[47] Approached in a way that abstracts the historical specificity of how race as phenomenon and form emerges in relation to an unstable, decentered complex of constantly changing social meanings and relations, discourses and practices that subjugate a particular group, race was presumed to be visible on the body, and an unchangeable essence, and racism to be an epiphenomenon of real phenomena that existed only outside the museum.

Challenging misperceptions of race as not-white and a temporary condition, Thelma Golden grounded her essay on race as a politically and culturally constructed category, beginning with how whiteness is unmarked, privileged, and positively valued by difference. In contrast to Sussman's reassurance to the members of the Whitney that the social fabric would remain intact and that race was superficial, and Philips's description of racial difference as a trend, Golden's essay underlined how race is "internal to the biopolitical state, woven into the weft of the social body, threaded through its fabric."[48] Conceiving the biennial as "trash[ing] the monolithic and homogeneous in the name of diversity, multiplicity, and heterogeneity," Golden implicitly called for an unraveling of the social fabric in order to reimagine living with difference.[49] Misreading her text, however, as polarizing, a demand for a reversal of power, critics dismissed her contribution together with some of the artworks she was assigned to describe and cover. One of these artists was Byron Kim, whose selected paintings in the biennial were in part playful commentaries on race, unsettling the meaning of race as a fixed and positive phenotype.

Kim's *Synecdoche* (1992–ongoing), a grid of 204 monochromatic panels in various muted shades of browns, ivories, beiges, and pinks, was centrally displayed on the second floor of the Whitney (figure 1.3). Made of oil paint mixed with wax additive, each eight-by-ten-inch panel was an approximation of the skin color on the inside of an arm or the back of a hand of someone whom Kim met on the steps of the

Brooklyn Public Library, all hung in alphabetical order by surname. Playing with the genre of the portrait and the idea of the grid as pure flattened autonomous space, a means of organizing knowledge, and the tension between representation and abstraction, Kim's *Synecdoche* satirized the arbitrary process by which phenotypical markers categorize individuals, but was here seen reductively, as a one-liner about race as "skin deep."[50]

More than a commentary on how race is understood through the signifier of skin color, Kim's paintings and art practice were in dialogue with the likes of Brice Marden and Agnes Martin but also engaged the biennial's other themes of the body and community.[51] As part of *Synec-doche*, Kim included a list of names that, on one hand, serves as insistence on the participants' subjecthood and, on the other hand, describes *Synecdoche* as a heartfelt process of a coming community, defined by Giorgio Agamben and Jean-Luc Nancy as a process in which a community of people appear by being-with one another "without end."[52] In an interview with his biennial mates, Glenn Ligon and Janine Antoni, Kim states, "What is most dear to me is the signage . . . which is composed of all the people's names. There was a time when I could remember the several hundred people with whom I spent twenty minutes, most of them strangers . . . [T]hat was very important to me, definitely more important to me than a discussion about race, and more important than questioning art and Modernism."[53] Departing from Sussman's idea of community as "many in one," and at the same time capturing the "spirit" of being part of a community of communities, Kim renders in *Synecdoche* a community as ever evolving and in constant flux. Opening himself to a stranger's arrival on the steps of the public library, Kim commemorates the occasion by recording the stranger's name and simultaneously inscribing but not imposing this encounter onto canvas.[54] Challenging presumptions about the skin as a visible way of defining individual identity and cultural difference and Ad Reinhardt's call to get rid of all extra-aesthetic associations, Kim's selected paintings in the biennial were located at the nexus of competing notions of abstraction and representation, community and race, a positioning that entailed reading across different discourses, including the growing field of visual studies, seen at the time as a "dangerous supplement."[55] His multi-layered selections, while not perceived as victim art, were reductively

and insipidly read as simulacra of pluralistic inclusiveness rather than as re-forming the contours of community and painting.

Due to a number of presuppositions about artworks by artists of color and their inclusion in the biennial, the artworks were not approached as offering a "universal" spatio-temporal experience or engaging in institutional critique, but instead were racialized, identifiable and legible only as solipsistic self-reflections and confessions. In contrast to the ways minimalist and conceptual works were understood as highlighting a viewing subject's social matrix and positioning, in the biennial, the artist's body became front and center, as verification that the artwork was "authentic."[56] Differing expectations of artistic criteria were also imposed on artists of color who engaged community. Such artworks were evaluated on the basis of an artist's ability to successfully represent his/her own community, and the ability of the observer to interpret the artist's representation of this community, in contrast to Robert Gober's and Charles Ray's artworks, which were approached and praised as satirizing new forms of communities and families.[57]

Some of the artworks depended on some back story or knowledge of colonialism to make the viewer aware of asymmetries of power, and the history of race, gender, and sexuality in the United States. This burden of explanation was relegated to the artist and the visitors to the museum, who were invited to a makeshift reading room on the top floor of the Whitney's Breuer building. This supplementary space, filled with a number of reference books on critical race theory and postcolonialism, is now a standard component of many exhibitions, but at the time was seen as pretentious, pointless, irrelevant, and external to art-historical concerns, with some scholars and critics calling for a return to form and a strict adherence to received art-historical conditions. Unable to find a point of entry to engage the artworks by way of art-historical precedence and with an unsatisfied need to have this foregrounded in combination with contextual clues, critics found this supplementary form of mediation to be a flaw of the artwork—diverting attention from their own lack of knowledge and/or the shortcomings of art-historical approaches to engage the artworks.[58] For example, unable to see how some of the artworks set up new or alternative formations of community, critics missed such encounters or marked them instead as "political," outdated extensions of 1930s agit-prop or 1960s protest art.[59]

Homi K. Bhabha's commissioned essay for the Whitney catalog was vital in countering these criticisms, illuminating how the artworks were setting up the conditions for a potential politics and new or unrecognizable forms of representation. Anticipating the apprehensiveness of their curatorial actions, Bhabha begins his essay by commending the biennial curators for their bold move to stage cultural difference differently through their choice of artists and selection of works. Conceiving the tear of Sussman's social fabric as interstitial spaces of past and future encounters, Bhabha proceeds in the rest of the essay to discuss how select works displace such historical encounters, but in ways that were not yet possible to apprehend. While not offering a prescription for how to curate, I suggest how Bhabha's essay offers some initiatives, underlining the importance of foregrounding local and global histories of power relations, including the different forms and stages of colonialism and racism—a

Figure 1.3. Byron Kim, *Synecdoche*, 1991–present. Oil and wax on panel, 10" x 8" each. Overall dimensions variable. Photo: Dennis Crowley. Copyright the artist. Courtesy of the James Cohan Gallery, New York/Shanghai.

54 | UNNAMABLE ENCOUNTERS

primer that was missing for this kind of exhibition. Although it is true that many visitors bypass such materials, at least they would be there, if and when one wanted to read and understand the way power and images can form relationships between past and present, between art and viewer, and the way both can dislocate the art and the viewer temporally and spatially.

From another perspective, Bhabha's essay suggests how these hybrid encounters were new sites for subject formation and new subjects to emerge. Specifically, he writes how the artworks were engaged in "strategies of selfhood—singular or communal—that initiate new signs of identity, and innovative sites of collaboration, and contestation, in the act of defining the idea of society itself," a process that not only reconsiders and reopens the binds of community but reforms its contours in unpredictable and unforeseen ways.[60] One example of this kind of strategic art making was Simon Leung's *Marine Lovers*. Described by Lisa Phillips as part of a generation of "confident, self-identified gay artists who believe that art must make issues of gay and lesbian sexuality overt," Leung produces work that, I suggest, does not so much represent a queer encounter but rather queers notions of identity and community.[61] Installed near Kim's *Synecdoche*, and across from Charles Ray's *Family Romance* (uncanny fiberglass sculptures of an anatomically correct nuclear family in the nude), *Marine Lovers* comprised fifty-five pinpricked works on paper placed atop rows of clear Plexiglas shelves (figure 1.4).

Inspired by Marie Antoinette, who purportedly wrote her last letter to a cousin by pricking words into a page with a needle, as she was denied the use of pen and ink in the Bastille, Leung proceeds in *Marine Lovers* "to prick my way to the limits of inherited ideas of sexuality." *Marine Lovers* is made of sheaves of translucent sheets, and Leung punctures onto these sheets a series of quotations culled from tombstones in Macao—passages from various philosophers and scholars—and from his own writing that explores his outsider status as Chinese American and queer. In contrast to the barely perceptible text, the observer can see through the pinpricked holes a partial image of a whirlpool, "two symmetrical images of a wave, based on the 19th-century [Japanese] woodcut." Inviting the viewer to become intimate with the work and peer through a set of minuscule pinpricks, Leung draws upon Marcel Duchamp's conceptual art practice and *Étants Donnés*. The pinpricks, Leung suggests, become peepholes or, in the words of Leung, they take

Figure 1.4. Simon Leung, *Marine Lovers*, 1992. Fifty-five pinpricked works on paper, with Plexiglas shelves and wall paint: fifteen drawings, 16" x 24"; ten drawings, 16" x 17"; thirty drawings, 16" x 10". Collection of the artist.

on "a different form, an aperture and a glory hole, in which the observer becomes a witness to a possibly illicit encounter, or from another perspective, an anonymous subject meeting up for a rendezvous." Substituting the pinprick with "the phallus that creates the orifice which defines the prick in its void," Leung analogizes how the "Self and other can likewise be seen to have a similar relationship: one is already indebted to the 'other' in the constitution of self."[62]

Transforming the glory hole into a glory call, *Marine Lovers* becomes more than a representation of queer identity or a fleeting intimate exchange and encounter. *Marine Lovers* is a call to a rendezvous that invites the viewer to assume the positions of both voyeur and object of desire, a process that entails both proximity and distance, in order to inhabit this embodied intersubjectivity. By doing so, the viewer enters into a wave of undulating desire and displacements in which the gaze rebounds to constitute a difference between the self and the other. Informed and inspired by Duchamp, the palimpsest of sheets, which narrates the journey of dispossession of Leung as a queer diasporic subject, also becomes a

56 | UNNAMABLE ENCOUNTERS

partition and a boundary that in turn creates an inside and an outside. The erotic encounter of *Marine Lovers* becomes simultaneously one of self-discovery and an ethicopolitical encounter, in terms of inviting the viewer to consider how certain bodies, marked by the Law, come to take shape in relation to others.

Marine Lovers reveals how seeing an image of the other is not about knowing or possessing; rather, the act of seeing an image means accepting an invitation to an encounter and being accountable, responsible, for this action. Jean Luc Nancy describes how seeing an image binds us to it—an experience equivalent to being branded, tattooed, and marked in a way that shifts one's own orientation. Similarly, Leung invites the viewer to see difference not as something to see or know but as determined through historical relations and between others, challenging the raced and queer body as a signifier of difference.[63] At the time, Leung's *Marine Lovers* was overlooked by critics, an unfortunate and missed opportunity to see difference in a way that did not signify race in its most reductive form and queer identity as a form of sexual diversity.

Some have suggested that the negative reviews of the biennial were not about the art but a no-confidence vote by the art establishment against the political smugness and moral arrogance of outsider and newcomer director David Ross, and his lack of forthrightness regarding the Whitney's own dismal institutional record and systematic exclusion of artists of color.[64] I want to suggest too that it was the Whitney Museum's failure of imagination to think about art beyond tradition, undermined by its lack of confidence in and trepidation about the artwork and a willful refusal to take these works of art seriously, that cut short the groundbreaking potential of the 1993 *Whitney Biennial*.

By recalibrating and recognizing difference, the Whitney Museum took risks in mounting the 1993 biennial that seem to have paid off institutionally. After the brouhaha following the "worst" biennial ever, the Whitney soon became known as *the* "multicultural" art establishment; at the same time, the museum went back to business. In a statement about his selections and curatorial process for the 1995 *Whitney Biennial*, where artists of color were again noticeably absent, guest curator Klauss Kertess wrote,

> [D]iversity will be one of many considerations, but . . . at the end of the day, good art will come to the attention of the astute curator. . . . [Y]ou'd

like to say that the show should be half gay artists, half female artists, half male artists or whatever, but early on I made a fairly conscious decision not to think about that, to trust that it would take care of itself. . . . I don't think anyone's been cheated.[65]

Disregarding the long history of systemic racism and racialization in the art world, his own unconscious bias, the number of exhibitions and symposiums about the multicultural turn and "crisis" of contemporary art, and the special issues of art magazines and scholarly journals that addressed the cultural politics of representation and difference, Kertess approached the curatorial process in a manner that reflected the Whitney Museum's "back to business" approach to curating contemporary art. Naturalizing and depoliticizing racial inequities, and neutralizing the once radical demands associated with multiculturalism into calls for diversity or, from another perspective, crushing the spirit of conviviality and intercultural dialogue that underpinned the alternative exhibitions that led up to the 1993 *Whitney Biennial*, the biennial itself fixed the terms, critical debate, and ways of seeing such works of art. The 1993 *Whitney Biennial* marked the beginning of the end for such large-scale multicultural exhibitions in the United States, establishing a pattern in which a number of exhibitions that followed seemed to be a recombination of the same themes and rearrangement with the same group of artists. While Godzilla had made inroads interfacing with the art world, and succeeded in being part of a watershed moment, it was disappointing and disconcerting how in exchange for mainstream visibility, artworks by Asian American artists became knowable only through delimited frameworks and terms. The project of making visible Asian American art became even more complicated—a challenge curator Margo Machida was more than ready to take on.

Asia/America: Identities in Contemporary Asian American Art

Asia/America: Identities in Contemporary Asian American Art (1994), the first Asian American art exhibition mounted on a national scale, opened first with much fanfare at the Asia Society in New York City and then traveled widely across the country.[66] The landmark exhibition featured paintings, sculptures, photographs, and mixed-media installations

by "twenty artists from eight Asian nations"—Ken Chu, Yong Soon Min, Y. David Chung, Pacita Abad, Sung Ho Choi, Marlon Fuentes, Jin Soo Kim, Hung Liu, Takako Nagai, Long Nguyen, Manuel Ocampo, Hanh Thi Pham, May Sun, Masami Teraoka, Mitsuo Toshida, Tseng Kwong Chi, Toi Ungkavatanapong, Zarina, and Baochi Zhang—who were "born in Asia, but [who] now live in the U.S. and who are engaged in exploring the questions of bicultural identity." Noting "the unprecedented growth of the Asian American population in the last three decades," since the 1965 Immigration Act, guest curator Margo Machida loosely organized the exhibition around the processes of coming from Asia to America, focusing specifically on an artist's engagement with generational differences, East-West hybrid practices, and coming to terms with the past or reconnecting with roots.

Although Machida was one of the cofounders of Godzilla, *Asia/America* was not a Godzilla project: few artists from the collective were included. Instead, Machida's approach to curating *Asia/America* was consonant with her own vision of and approach toward Asian American art and her curatorial endeavors in the late 1980s and early 1990s, including her catalog contribution to *The Decade Show*. Consistently centering attention on the making of Asian American art as in and of itself a political act of resistance and a historical event, Machida was critical of the ways Asian American art had been presented thus far. A response and remedy to *The Decade Show* and the 1993 *Whitney Biennial*, *Asia/America* offered literacy and context about Asian American art by way of centering attention on the unique positionality of the Asian American artist and the conditions in which an artwork was made, highlighting the diversity of not only Asian American art but also the American experience.[67]

A couple of months after the opening of *Asia/America*, *Time* magazine published a special issue, "The New Face of America: How Immigrants Are Shaping the World's First Multicultural Society," which centered on how the ethnic makeup of American society was becoming nonwhite. The underlying narrative of the special issue was the crisis of identity, specifically U.S. national identity. *Asia/America* could be seen as Machida's response to this crisis (one that was hinted at already in the 1993 biennial) or, put another way, as part of an expansive and multilayered conversation about subjectivities and identities-in-process.

Conceptually in tune with Lisa Lowe's 1991 essay "Heterogeneity, Hybridity, Multiplicity: Asian American Differences," in which Lowe defines identity as "hybrid and multiple, fictional and fluid, exposing and challenging the artificiality of imposed definitions on the self," Machida's selection of artworks was not representative of any one group or ethnicity, but rather a display of multiple and heterogeneous lived experiences and hybrid identities.[68] Specifically, she organized *Asia/America* under four overarching themes: "Traversing Cultures," "Situating," "Speaking to and of Asia," and "Addressing East-West Interaction." "Traversing Cultures" focused on the transitional period experienced by migrants between leaving Asia and arriving in the United States, as articulated by Sung Ho Choi, Long Nguyen, and Zarina in artworks that explored the physical and emotional effects and material circumstances of migration.[69] "Situating," the largest section of the exhibition, explored questions of being, claiming, and settling in America. Included in this diverse array of works was Y. David Chung's *Mega Morning Calm* (1994), an installation that featured large-scale charcoal drawings integrating myths of both Korea and the United States with Korean history, chronicling the history of Korean American immigrant experiences. Implicit critiques of assimilation and reflections of attempts to reorient and find a sense of place and identity were represented by such works as Pacita Abad's mixed-media painting *How Mali Lost Her Accent* (1991) and Hanh Thi Pham's *Number 9: Expatriate Consciousness* (1991–1992), a hard-hitting series of performance photographs mixed with text challenging the racial and gender oppression of Vietnamese American women. "Speaking to and of Asia" and "Addressing East-West Interaction" focused on artworks that engaged the long history of relationships between the United States and Asia and the incorporation and appropriation of traditional Asian forms and techniques like Japanese woodblock prints, or ukioy-e, as exemplified in paintings by Masami Teraoka.

In contrast to the *The Decade Show* and the 1993 *Whitney Biennial*, the works of art presented in the Asia Society galleries, in both the lower- and upper-floor galleries, were installed to give each work sufficient breathing space, so that no work of art would be overlooked. In each area, an introductory wall label explicated the different themes, with smaller text panels accompanying each art piece. Presented in a bullet format, the text panels included an artist's personal history or, in the

words of Machida, a form of "interethnic interpretation: a mix of trans-local descriptions and specific socio-cultural matrices that highlighted an artist's bicultural identity."[70] Using the artist interview as research methodology and cross-cultural tool through which to interpret or, in her words, "decipher" Asian American art, Machida approached the exhibition as a means not only to make visible the artworks but to release the artist's voice from years of repression. Although conceding that such a strategy might be seen as "old fashioned," Machida's unconventional exhibition making and her decision to place the artwork's engagement with canonical and avant-garde forms as a secondary concern was perceived by some as bold, as pointed out by art critic Jenifer P. Borum, who described Machida's curatorial strategy as "an articulate response to the failure of the art world to adopt a truly multicultural agenda."[71] Yet in the same review, Borum acknowledged, that "only a few works address the question of cultural identity through specific imagery," a case in point that created disjunction between the text and the works of art. That is, while the back story of their absence, presence, or deferred entry into the mainstream art world is in part a story of "artists' struggles to define themselves as people of Asian descent living in America," the artworks in this particular exhibition were not necessarily about that, resulting in misreadings of the work as simplistically representative of an Asian American identity, or a conduit of diasporic cultural transmissions of an artist's inner experience translated into outer form: an inflection of an artist's life story.[72]

Sharing much in spirit and content with Lucy Lippard's *Mixed Blessings*, a foundational book that surveys the intercultural process of art making by Black, Latin American, Asian American, and Native American artists, *Asia/America* was literally received as a mixed blessing.[73] Critics made snap judgments about the exhibition as reductively bearing witness to an individual's marginalized experience of the world, and the artwork as static displays of testimony. As "an instructive example of the impoverished approaches and inadequate language to describe such works of art," Alice Yang cites Kay Larson's review in *New York* magazine, which at one point describes the artists in *Asia/America* as "migrants [who] tell of loneliness, sleeping on floors, working at dull jobs, learning that nobody cares. Sounds familiar, doesn't it? I could sympathize, and I do, but what did they expect?"[74] Not engaging the

works of art *as art* as well as misreading and erasing the historical differences underlying Asian American immigrant experiences of exclusion, alienation, and displacement, critics dismissed much of the work as victim art, missing opportunities to see the multivalent and enriching ways Machida and the artworks were reimagining art as a way to engage topics of multiculturalism and race within an exhibitionary space.

Crucially missing, however, from the gallery wall labels was the term "Orientalism" in relation to the history of Asian and Asian American exclusion and U.S.-Asia relations. Jack Tchen's essay in the catalog was key in anticipating and responding to critics such as Larson. In "Protestant, Anglo-American Orientalism," Tchen highlights the prejudices and predilections of perceiving Asia, and in turn Asian Americans, since the turn of the century as either "opposites of the west"—perpetually foreign, inassimilably alien—or "models of the west"—incredibly docile, model minorities. Incisively and persuasively emphasizing the role of Orientalism and its racializing and disempowering effects on Asian Americans, Tchen makes central how modernity and the Enlightenment needed to invent Asia as the Orient in order to make sense of itself and its imperial endeavors, constructing the "Orient" as primitive and fixed in time in order to constitute the West as technologically progressive, developmentally advanced, and highly cultured. Tchen's essay emphasized how Orientalist thinking not only informs the way the West perceives Asian Americans but also reinforces presumptions of race as only black and white. Positioning *Asia/America* as groundbreaking for the way each artwork "visualize[s] and make[s] tangible the often invisible and inchoate forces that have affected [Asian Americans'] identities and identifications," Tchen's essay was key in bringing up one of these "invisible" forces, Orientalism, and how it was constitutive of the category, the exhibition, and the works of art.[75]

Not merely an overturning of stereotypes or a reversing of the occidental gaze upon the Orient, Tseng Kwong Chi's *East Meets West* best exemplifies the intent of *Asia/America* to destabilize the binary structure of Orientalism and to reorient perceptions of both Asia and America (see figure 1.5). Playfully engaging the processes of Orientalism and the numerous ways Asian immigrants are constantly misrecognized, Tseng adopted and accepted, in 1979, his unofficial role as the Chinese "Ambiguous Ambassador" from the East, donning a thrift-store Mao-era suit

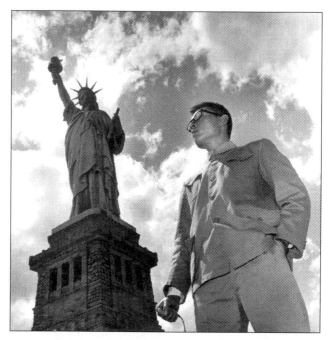

Figure 1.5. Tseng Kwong Chi, *New York, New York*, 1979. Gelatin silver, 36" x 36". From his series *East Meets West*, a.k.a. *The Expeditionary Self-Portrait Series*, 1979–1989. Collection of Muna Tseng Dance Projects, Inc., New York.

and a pair of dark sunglasses, after constantly being misrecognized as a foreign dignitary or Chinese communist.

Inspired by President Richard Nixon's historic trip to China in 1972 and the failure to create greater openness between the two nations, Tseng embarked on a goodwill tour of the United States until his death in 1990 of AIDS, creating a photographic mockumentary of his dignitary duties through a series of self-portraits posed next to famous and not-so-famous celebrities and iconic U.S. landmarks, including the Statue of Liberty, the Empire State Building, Disneyland, and Mount Rushmore. Anticipating the selfie but using a cabled shutter release, *East Meets West* is comprised of hundreds of mostly black-and-white self-portraits, parodying and challenging representations not only of China but also of the United States, "re-presenting the West as if seen through a possessive Occidental gaze."

Halfway between a tourist snapshot and a portrait, Tseng's *East Meets West* was not just a conceit, but a carefully composed series of photographs with a number of formal elements and variables at play. While some photos were tightly packed, with pictorial elements filling the space, others were expansive, as in *Lake Ninevah, Vermont* (1985) in his later *Expeditionary Series*. Blurring the boundaries between portraiture and landscape photography, Tseng humbly portrays himself from a distance, apart from but a part of the North American landscape, as in *Shrines of Democracy: Mount Rushmore, Black Hills, South Dakota* (1986). In Tseng's case, the back story that tracks his journey from Hong Kong to Vancouver to New York was relevant in the reading of select photographs from *East Meets West*, at the same time the emphasis on his individual journey eclipsed his multivalent identifications and relationships with cross-racial, queer, transnational, and cosmopolitan circles, as well as the broad range of formal influences he drew from, including Henri Cartier-Bresson and Ansel Adams. Tseng's artistic choices of tone, light, scale, and composition of photography, his play with the gaze, portraiture, camp, and performance are relevant and important aspects of his work that highlighted how he was not only a conceptual and performance artist but also aware of and committed to the performative power of photography.

Part of a growing multicultural bohemia in New York City's East Village, Club 57, located in the basement of the Holy Cross Polish National Church on St. Mark's Place, was a home away from home for Tseng. "Adopted" in the late 1970s by a surrogate family, described by Ann Magnuson as "suburban refugees who had run away from home . . . that liked . . . Devo, Duchamp, and William S. Burroughs," Tseng, alongside Magnuson, Keith Haring, Kenny Scharf, John Sex, Joey Arias, Wendy Wild, and many other artists, musicians, and fashion designers, engaged in punk mayhem and creative interdisciplinary experiments until the AIDS crisis and the club's paradoxical market success and closure in 1983. Referencing or even just mentioning the activities of this subculture and Tseng's collaborations with artists such as Keith Haring would have not only deepened the reading of Tseng's photographs beyond constructions of identity from ambassador to tourist to everyman but also highlighted Tseng's multiplicity of allegiances, opening up the parameters and possibilities of Asian American art as a "dynamic, unsettled,

64 | UNNAMABLE ENCOUNTERS

and inclusive" space analogous to the permeability of the virgule that *Asia/America* was trying to convey.[76]

In other words, the works of art in *Asia/America* were not "Asian American" because they contained some essential Asian characteristic or essence. Rather, the exhibition was a showcase of artworks as a consequence of a transitive relation—a hybrid amalgamation or fusion of transnational flows, Asian and Euro-American art-historical traditions, and local and global histories.

But when we look at the artworks together with Machida's essay and Vishakha N. Desai's foreword, contradictions abound, pointing to the need to consider the institutional pressures and parameters that Machida probably had to contend with when conceiving and curating *Asia/America*, an irony considering that the exhibition would not have become a real possibility without the 1990 appointment of Desai, who, as director of the Asia Society's museum, placed Asian American art as her top priority and investment.

It is not surprising that the first Asian American exhibition would debut at the Asia Society, "America's leading institution dedicated to educating Americans about Asia and fostering understanding between Americans and the peoples of Asia" since 1956.[77] Founded by John D. Rockefeller, whose interest and investment in Asia culturally, economically, and politically began during the Cold War, Asia Society has become a global pan-Asian organization that runs and supports programs in the arts, government, public policy, and education. It was not until 1990 and the hiring of Desai, when the Asia Society finally took "into account the complex relationships between [Asia and America]" and the accomplishments of "Americans of Asian descent," that an exhibition like *Asia/America* could ever be imagined. Bound to "the Society's traditional emphasis on Asia," Desai states, "we thought it logical to begin with a theme that would provide a link between Asia and the United States."[78]

Keeping within Asia Society's parameters, and the need to focus on the *link* between Asia and America in combination with the hype about engaging hot topics such as "identity," Machida, it seems, had little choice but to focus on particular artists who were born in Asia but whose artworks engaged in questions of bicultural identity.[79] Aware of the pitfalls inherent in identity politics and themes related to bicultural

identity, acknowledging that "all Asian American artists obviously do not deal with identity-related questions in their art," and asserting that "the selection of this topic for the [Asia Society] Galleries' first exhibition of Asian American art does not imply that this is the most significant concept," the exhibition, by virtue of being the first and only one of its kind in a major institution, became *the* definitive survey of Asian American art.

Relieving the pressure on other art institutions to include Asian American artists or mount an Asian American art exhibitions, *Asia/America* was viewed as a "'corrective inclusion,'" to borrow a term from Kobena Mercer's review of *The Other Story*, which shared similar curatorial approaches and received similar reviews.[80] Mercer writes how *The Other Story* was forced "to carry an impossible burden of representation in the sense that a single exhibition had to 'stand for' the totality of everything that could conceivably fall within the category of black art."[81] The same could be said for *Asia/America*: the pressure of the exhibition to be all things to all artists, curators, and critics was overwhelming. What should have been the first of many exhibitions—with subsequent exhibitions engaging more specific cross-racial and ethnic or art-historical concerns, expanding perceptions about Asian Americans and Asian American art—was almost the last until *One Way or Another*, which opened at Asia Society in 2005.

Asian/American/Modern Art: Shifting Currents, 1900–1970 (*Shifting Currents*)

By the end of *Asia/America*'s national run, racial fatigue had set in and a chilling effect had begun to take place, a backlash against identitarian and ethnic-specific exhibitions that provoked curators and artists to retreat from such exhibitions, which seemed to ghettoize art into a few governing themes and narratives. Yet already underway were plans to mount the most comprehensive survey to date on Asian American art. In 1989, over dinner around the dining room table of art historian Moira Roth, she and guests Mark Johnson, Carlos Villa, and Margo Machida began discussing the need to research, document, and curate forgotten Asian American artists up and down the West Coast. The first iteration of this idea was *With New Eyes: Toward an Asian American Art History*

66 | UNNAMABLE ENCOUNTERS

in the West (1995), which opened at San Francisco State University a year after *Asia/America*.[82] The exhibition was essentially a result of these conversations and a preview of what was to come fourteen years later: *Asian/American/Modern Art: Shifting Currents, 1900–1970 (Shifting Currents)* (2008), a landmark exhibition, at the de Young Museum.

Co-curated by Mark Johnson and Daniell Cornell, *Shifting Currents* presented a wide array of works, a visual cacophony of beautiful forms that situated Asian America historically at the nexus of multidirectional channels of exchange and influence among the United States, Asia, and Europe beginning in the nineteenth century. Many of the ninety-five artworks from different periods and styles—many never seen before in public—were spread out, in salon style, in five compact galleries. Works such as Alfonso Ossorio's *Beachcomber* (1953)—a large-scale oil painting with boldly colorful organic forms, interlocking and swirling counterclockwise toward the vortex of a small, white homunculus—and Chiura Obata's *Setting Sun: Sacramento Valley* (ca. 1925)—a nine-foot scroll painting in which Obata unleashes a brilliant fiery sunset of angular orange-red ripples, outlined in reflective metallic pigments, which overwhelm the deep midnight blue of the Sacramento Delta valley—were among many reasons this exhibition was a must-see. Early sculptural works in fiberglass by Masami Teraoka and nonfigurative works by Martin Wong, such as *Fairy Tale*, a prose poem on the Summer of Love rendered in uniformly dense calligraphic handwriting, were noteworthy, as such works linked Asian American artists to a wide array of cultural events and happenings, from the youth counterculture movement to the San Francisco theater scene, and from underground comics to the mural movement.

Unlike other exhibitions, including *Asia/America* and *One Way or Another*, the exhibition was accompanied not only by a catalog but also by the publication of *Asian American Art: A History, 1850–1970*, edited by Mark Johnson, Gordon H. Chang, and Paul J. Karlstrom, a rich and extended history of Asian American art that not only served as a scholarly tome introducing and offering productive contextualization of a number of artworks, in the exhibition and beyond, but also provided an in-depth analysis of the adverse conditions in which the artworks were produced, displayed, and interpreted due to legacies of systematic exclusion, legislative racism, racial violence, and stereotyping. With more than five

hundred pages of impressive breadth and depth on Asian American art, including detailed biographies of more than one hundred artists, four hundred reproductions, and thoughtful essays about the work from myriad perspectives by art historians of different generations, the book served not only as a comprehensive study but also as an important adjunct to the exhibition in multiple ways.

Opening the introduction to the catalog, Johnson and historian Gordon Chang wrote, "Forty years ago there were no Asian Americans." Pointing to how the term "Asian American" was not claimed until 1968—a signifier of a pan-ethnic collectivity reappropriated as a sign of resistance within the context of the Asian American movement—Johnson and Chang underline how many of the artists featured in *Shifting Currents* did not necessarily identify as "Asian American" nor did they categorize, describe, or mark their art with that label. But due to Orientalist presumptions about Asian art and Asian Americans, museums and curators were unable to easily place or identify the art neatly within any existing frameworks or categorizations, leading to the marginalization and in some cases almost disappearance of such artworks as Chen Chi-Kwan's experimental ink painting.[83]

At first glance, *Ball Game (V)* (1952/1980) appears as a form of modern Chinese calligraphy or a balletic representation of movement that recalls the drawings of artists Henri Michaux and Eadweard Muybridge. Ignored by Asian American scholars too until recently, as part of a lingering cultural nationalist agenda in which artworks that looked "Oriental" or were constitutive of an East-West alliance were considered complicit and dismissed as *not* Asian American, *Ball Game (V)* is nonetheless all "American." Divided subtly into "yards" of a football field, *Ball Game* is a study of the forward movement of a football rendered through thick and thin gestural lines of ink. The rediscovery of Chen's art among many works of art, some of which had never been displayed before, made *Shifting Currents* distinctive and significant, but the back story of its rediscovery, beyond a general theory of Orientalism, was missing from the narrative logic of the exhibition. For example, Japonisme, a Western fascination with things Japanese, paradoxically opened up and created professional liaisons and exhibiting opportunities for a number of Asian American artists at the turn of the century, but at the same time the aesthetic accomplishments of these artists were

68 | UNNAMABLE ENCOUNTERS

overlooked: the way they appropriated, for example, woodblock prints and ukiyo-e in distinctive ways. Japonisme also later racialized future works of art by Asian American artists whose art was a move away from that style.[84] The reasons the artworks were being displayed *now* as opposed to before, or how they had been forgotten due to misinterpretations, leading to their disappearance, deaccession, or deterioration, were unevenly contextualized in the space though cogently articulated in the accompanying texts and publicity materials. The term "race" was downplayed, almost suppressed, by the curatorial organization and the flow of the exhibition, a missed opportunity in which to highlight the need to display so many works at one time. In contrast, narratives of Asian American art's racial formation are interwoven throughout *Asian American Art: A History*, highlighting the role race plays in excluding and marginalizing Asian American art in one decade, and revealing how museums and the art world have historically recuperated otherness and dissent over the years by way of empty promises of inclusion as exotic others or model exceptions. Documenting an impressive exhibit record of artists (including some featured in *Shifting Currents*) in highly visible art venues such as the San Francisco Museum of Art, the de Young Museum, and the Museum of Modern Art, *Asian American Art* offers a multilayered but not yet comprehensive history of what happened to these artists and of a once very active, vital, and self-sustaining Asian American art scene between the 1940s and the present. Beginning with ethnic-specific and pan-ethnic arts organizations such as the East West Art Society (1921), Shaku-do-sha (1923)—literally translated as "Glowing Earth Society," "an association dedicated to the study and furtherance of all forms of modern art"—the Chinese Revolutionary Artists Club in San Francisco (1926), led by Yun Gee and his storefront gallery, the Modern Art Gallery, co-managed with his former teacher Otis Oldfield, and a number of galleries, photography salons, and clubs, including the Japanese Camera Club of San Francisco, the Japanese Camera Pictorialists of Los Angeles, and the Seattle Camera Club (1924), *Asian American Art* reveals a parallel art world in which Asian American artists came together to form loosely organized gatherings and more structured and established clubs to discuss and debate modernism and other art matters, and to share and display each other's artwork. While not all of these groups were diverse or inclusive, especially of women, many of them

opened their membership to anyone who shared an investment in art making. Such collaborative efforts and shared commitments to art— Genichiro Inokuma's acquaintance with Matisse and Picasso in the late 1930s and early 1940s, Alfonso Ossorio's friendship with Jean Dubuffet and Jackson Pollock, Isamu Noguchi's partnership with dancer and choreographer Martha Graham, Ruth Asawa's exchange with Imogen Cunningham, and Walasse Ting's involvement with CoBrA, an avant-garde painting movement, in the 1950s—reveal not only the overlapping of two art worlds but also a mode and dynamic of polyculturalism.[85]

In an exacting attempt to do too many things at once, it was in explicating this overlap of art worlds, and the inability to neatly show and not tell Asian American art in a straight chronology or linear narrative, that *Shifting Currents* lost sight of its main curatorial premise and historical inquiry. Organized chronologically, but also teleologically, the exhibition could be seen from one perspective as desiring to establish a canonical tradition of Asian American art parallel to that of canonical modern art. On the other hand, the strength of the artworks was precisely the breaks, discontinuities, and differences that pressed and cleaved received meanings of *Asian/America/Modern/Art*. Plagued by an underlying desire—as Karin Higa points out in her essay "The Search for Roots, or Finding a Precursor"—to search for origins, continuities, and commonalities, *Shifting Currents* wanted to be both art-historically relevant and legitimate *and* distinguished from this history, recognizing and incorporating the material differences of the conditions in which many made their art. It was the former desire to find a solid, legitimate foundation to present and preserve the artworks that derailed the potential aims of the exhibition and opened up a space that could present and decenter the history of race in America and American modernism in unique ways, and in contradistinction to previous Asian American art exhibitions.

In dialogue with Alexandra Munroe's *Third Mind: American Artists Contemplate Asia, 1860–1989* (2009)—an exhibition at the Guggenheim Museum in New York City that opened shortly after *Shifting Currents* closed, and included only a handful of Asian American artists as an afterthought to its exploration of the impact of Asian art, literature, philosophies, and thought on American creative culture and modern expression—*Shifting Currents* presented a number of works that were stylistically and art historically a part of modern art's trajectory, but also

apart from its legacy, including modernism's formal engagement with various styles of Asian art.[86] In a room off to the side of the main gallery where *Shifting Currents* was installed hung Kenzo Okada's *Quality* (1956), a calm landscape of flat, rectangular, Stonehenge-like shapes rendered in thick brushstrokes and earthy tones, next to Paul Horiuchi's painting of overlapping black and white squares informed by the weathered traces of posters on a community billboard in Seattle's Chinatown. Opposite these paintings was part of Tseng Yuho's 9.5-foot-tall panel mural *Western Frontier* (1964), a series of evenly spaced abstract tree trunks and branches made of brown acrylic paint, with applied patches of blue and red color and gold leaf, surrounded by honey-colored and yellow handmade paper. On the back wall, between these two sets of paintings, hung Ruth Asawa's enthrallingly beautiful tied-wire sculptures, which not only charged the room but at first glance seemed both figurative and otherworldly, recalling the sensuality of a Modigliani portrait.

In *Untitled (s.439, s.250, s.047)* (1955, 1968), hourglass-like shapes, nesting one within another, swell and contract. Made of dense, intricately crocheted loops of wire, the voluminous sculptures hang tall, translucent, and, in Asawa's words, transparent. Having spent several years at Black Mountain College studying with Josef Albers and Buckminster Fuller, Asawa says, "It was Albers' word. I liked the idea, and it turns out my sculpture is like that. You can see through it. The piece does not hide anything. You can show inside and outside, and inside and outside are connected. Everything is connected, continuous."[87] Inviting the viewer to attune his/her perceptions to form, light, and color through a fusion of stasis and mobility, the earthy tones of the discrete sculptures, made out of brass, iron, and copper, respectively, produced a shadow-play of undulating lines and pathways, opening and closing one onto another.

Citing nature and its biomorphic forms and patterns and various art-historical sources, rather than ethnic identity or ideas, as elements of inspiration for the U.S.-born Asawa, *Shifting Currents* had a unique opportunity to complicate the question of how liberalism and modernism designated the categorical boundaries of who is legitimately "human" and an "artist" during the course of Asawa's lifetime. In the book *Asian American Art*, but not in the catalog or the wall labels of the exhibition, Paul Karlstrom attempted to go beyond the works' modernist renderings

of light and form and situated Asawa's work within the context of "social modernism." Not necessarily going against Asawa's consistent statement about her works not being Japanese American, Karlstrom's intriguing thesis of alternative modernism, defined as "a branch or tributary of modernist expressions that extends outward rather than inward," had the potential to implode the demarcation of Asian American art's subsumed relationship with modern art, and shift the aims of the exhibition beyond asserting the work's legitimation into the canon. Instead, the opportunities to do so in relation to the different levels of transnational, cross-ethnic, and racial networks and flows outlined in *Asian American Art* were sidestepped. The room seemed separate from the rest of the exhibition and seen in isolation, apart, reinforcing ideas about modernism as a retreat towards form and/or an inward reality. Despite the number or function of the slashes in the title and the multiple nodes in which the works were seen as reflected in the accompanying essays—with modernism being the central focus of the exhibition, and the "shifting" part of the title metaphorically pointing to the "play of changing [social] conditions" in the making of Asian American art—this point of inquiry was overwhelmed by the six themes that loosely organized the exhibition: "Looking Both Ways," "War and Peace," "Urban Life and Community," "Philosophy and Religion," "Sexuality as Abstraction," and "Ink and Line." *Shifting Currents* was several exhibitions packed into one, or, as simply put by Asawa, "a display of art by many unacknowledged artists who happen to be Asian American."[88] Encumbered by the legacy of identity-specific exhibitions, and the pressure to pack in and display as many artworks by Asian Americans as possible in the allotted space and time, relying on the label "Asian American art" as the means to display these artworks, the curators navigated this terrain by underlining from the get-go that "[f]orty years ago there were no Asian Americans," pointing out that the artists selected for the exhibition were chosen on the basis of a constructed category of racial identity. But without the constant reminder throughout the gallery floors that Asian American art has a history, including the history of intense anti-Asian racism and exclusion laws—a backdrop against which to foreground the absence and presence of these works and the fortitude of these artists in staying committed to their art, highlighting in the words of Michele Wallace that "the identity of

the artist does matter to the extent that it disrupts the very idea of who is capable of producing art and who is visible culturally"[89]—the exhibition became both another outlier in the discussion of modern art and another victim of identity politics, confirming Martha Ward's reading of culturally specific exhibitions in the twentieth century as "not so much a post-modern creation as a modernist suppression."[90]

Summary of Four Case Studies

Consistent in all four exhibitions was a lack of will or an inability to substantively engage the artworks and the artistic choices made by Asian American artists. Registering in different ways the contradictions of what racial parity really means in the art world, the persistent presumption that many of the artworks were devoid of aesthetics and all about content rather than form is not a personal or incidental problem, but a structural one in the understanding of Asian American art. Unnamable and illegible were those encounters that aesthetically set up the conditions for a potential politics to occur, as in the examples of Kim and Leung. The encounters were hidden in plain sight. The catalog essays served as a much-needed guide to these encounters, offering incisive insights that mediated the kind of viewing experience that was otherwise sorely missed and needed.

Ideally, the ideas in essays by James Luna, Homi Bhabha, and Jack Tchen needed to be somehow filtered, translated, and integrated into the extratextual materials installed throughout the exhibitions. The need to methodically define terms such as race and to articulate how racism is more than a personal matter or attitude has become imperative, but accessing where and how to place these labels—when a scaling back of heavily laden texts is also necessary—is a perennial curatorial hazard and challenge in the making of ethnic-specific and multicultural exhibitions. That is, to suggest having more explication and theorization in such exhibitions, even through alternative audiovisual means such as cell-phone acoustic guides, threatens to transform these kinds of exhibitions into places of information gathering rather than spaces of discovery that engage the senses. Finding the right combination and balance of artworks and text is every curator's challenge, and yet, in the case of

curating racial and ethnically specific exhibitions, it has become an insurmountable task.

Exhibition making entails anticipating the way an observer creates imagined and real links with art, bringing his/her biases, tastes, and presumptions to the encounter. Many of the encounters and connections in these exhibitions were overdetermined or foreclosed as the diverse array of artworks was curated for a "universal" art-historically informed white subject. In the case of the Whitney, there was an ironic expectation that the biennial would draw into the museum new members, record numbers from communities of color, with the presumption that these groups of people would identify with the artworks simply because artists of color made the art. The failure to attract these crowds is one indication of the need to question the universal visitor to the museum, but also the need to find alternative and innovative ways to address a heterogeneous audience on multiple levels by challenging a hierarchy of perspectives on subject matter and presenting overlapping modalities of displaying art. Curators must face this challenge and resist institutional pressures to curate the same version of an exhibition that maintains standard regimes of viewing art as well as secures an organization's brand and reputation.

Germane to reconsider is the need to bring in crowds and revenue and the pivotal role not only of corporate money but also of support from the state in the form of the National Endowment for the Arts (NEA), which has had an unfortunate tendency to manage and present racial difference by granting museums and exhibitions funding based on outdated and problematic notions of diversity. More research needs to be done in analyzing the ways institutions and curators are expected to conform to certain measures and procedures in grant applications that reinforce the making of a certain kind of ethnic-specific exhibition.[91] In turn, how might the NEA's mandate for balanced programming give institutions incentives and excuses to avoid addressing the persistent negligence of works by artists of color, including Asian Americans, in their exhibitions and acquisitions?

Concluding Thoughts on Exhibiting Unnamable Encounters

In concluding the examination of these case studies, I want to end with two examples with which to begin regrouping and rethinking exhibition

making as a space of disagreement. Curating Asian American art needs to be more than remedying the marginalization of artists of color and creating an order of things—in this case art objects and meanings—in order to ward off misreadings of Asian American art. Re-reviewing how Leung and Kim set up their work as chance intersubjective encounters that transform the conditions of/for the next encounter, I want to reconsider relinquishing curating as less about controlling and mediating different relations between the work and the art than about setting up multiple and new perspectives beyond the usual modes of museum display. In need of pursuing alternative cultural methods and pushing the exhibition beyond an ideological apparatus, one does not need to look too far to see the different ways art collectives, in particular, have historically to the present opened up the boundless possibilities of exhibition making as an artistic and democratic activity.

Formed in 1979, the collective Group Material early on led the way for other groups, including REPOhistory and Political Art Documentation/ Distribution (PAD/D), in reviving attention to the need for "a communicative art that would press for social and political change."[92] I want to make note of how the group, curating initially in storefronts and alternative spaces and then in museums, deployed all kinds of curatorial strategies and exhibition designs in their attempt to construct the exhibition as truly a social dialectical space. Unabashed in using a variety of styles and genres to organize their exhibitions, such as *People's Choice (Arroz con Mango)* (1981), Group Material intermixed "high art" with "non-art" that included posters, design appliances, and other images and objects. Collaborating with the local residents of Thirteenth Street (244 W. Thirteenth Street is where the storefront gallery was located), the artists and the community came together as curators, framing and arranging the works in meaningful ways under various curatorial themes in ways that Alan Moore and Jim Cornwell state were surprisingly subtle "rather than overtly didactic," a means "to open a space in the viewer's mind for thought and argument instead of simply asserting a stance."[93] Installed salon-style, the exhibition was a layered montage that was not just about representing diversity but also engaged in the democratizing of art. Expanding notions of what art and exhibition can be, getting away from the dichotomy of art as a private experience vis-à-vis the exhibitionary space as a counterpublic sphere, *Arroz con Mango* offers an

inspiring example of thinking outside of the box, and reconsidering the exhibitionary space as not about reconciliation or assimilation into a canon (*Shifting Currents*), the nation-state (*Asia/America*), and the museum (1993 biennial). As a collaboration among artists, local residents, and museum staff, Group Material's exhibition-making efforts still stand apart from new social and relational art practices.

Combining Group Material's bold breaking of the rules of exhibition making to open up and activate the space, I want to end with a brief summary of Maya Lin's midcareer retrospective that occurred in conjunction with *Asian/American/Modern Art: Shifting Currents* at the de Young Museum in San Francisco. Adjacent to *Shifting Currents* in the museum, Lin's midcareer retrospective not only represents her art practice but serves as a catalyst to think about how her public artworks can be mobilized as another model to reformulate curating Asian American art. The juxtaposition of the two exhibitions also offers a rare occasion to make connections and speculations that press against the contours of Asian American art in terms not of who can be included in the conversation but of how to let go of standard ways of curating Asian American art.

In 1982, Lin made her debut with the *Vietnam Veterans Memorial*, a 493-foot wedge-shaped wall made of polished granite vertical panels set up at a 125-degree angle with 58,307 names on it. Abstract and absent of representational elements, the memorial was controversial at the time, perceived as a dark void or an abyss. Politicized in a competition that stated the winning design should not be a political statement about the war, Lin's wall has over time become not just a memorial for Vietnam veterans but a museum where people leave mementoes, a site of activism for various protests, and a dialectical space about disavowed losses that goes beyond the specific topic of lives lost in a war. The memorial works well because it refuses to narrate a single history, consistent with Lin's art practice, which has been to show, not tell, about the war and her sustained interest in the environment.

Maya Lin: Systematic Landscapes, curated by Richard Andrews, explored Lin's sustained and committed interest in the relationship between the built environment and nature, specifically "topographies and geologic phenomena."[94] The exhibition offered a unique glimpse into Lin's art making, a very intricate process in which the works evolve from a constellation of texts, detailed maps, satellite photography, sonar

images of the ocean floor, and spatial-modeling computer programs, among other materials. The overall curation and installation of *Systematic Landscapes* paralleled the minimalist look of most of Lin's works: clean lines, spare presentation, a distillation of a complex idea into an essential form to insert into or to integrate within a landscape. Neither mimetic nor representational, Lin's sculptured landscapes are meant to serve as "visual evidence of nature's complex processes," of its ongoing cycle of creation and destruction.[95] For example, in *Pin River–Tuolumne River, Hetch Hetchy* (2008), a site-specific piece modeled after the Tuolumne River and its complicated relationship to other bodies of water both natural and manmade, Lin pushes thousands of straight pins into a white wall. From afar, the piece looks like a flowing thread of shimmering silver. Close up, the pins clustered together create the distinctive trace of a winding river. As the observer walks back and forth, the shadows of the pins create a blurred double image, a kind of haunted mirroring of a river and a life that once were. Lin metaphorically alludes to the function of the Hetch Hetchy reservoir as a resource of water and electricity for the city of San Francisco and the means of creating it (the construction of the O'Shaughnessy Dam), which resulted in the alteration of natural waters and the flooding and destruction of wildlife in Hetch Hetchy Valley.

In both her gallery installations and her public art pieces, her art practice endeavors to solicit a sensory experience from the observer that does not overwhelm at first, but draws the viewer in slowly. In contrast to viewing her work in a museum, viewing her public works invites a sense of openness to experiencing her artwork as a durational event, a deferred encounter, that over time becomes expansive and multilayered, as in her impressive large-scale land art or sculptural landscapes, such as in *Wave Field* at Storm King Art Center.[96] Once an abandoned gravel pit measuring eleven acres, *Wave Field* is informed by aerial photography of the ocean's surface. Similar to (but much smaller in scale than) *Earthwork (11 Minute Line)* (2004), a sixteen-hundred-foot-long serpentine mound created for the Wanas Foundation in Sweden in which an observer walks up and down on seven undulating hills of different elevations (some as high as eighteen feet), whose surface continually changes depending on the season, weather, and other environmental

conditions, *Wave Field* is modest, understated, and unfinished. As we walk through the scratchy grass, in and out of the different waves, Lin invites us to shift our individual perceptions about sculpture itself and the interface between human and natural forces as well as the imbalance between the two. The immediacy of the natural surroundings dispels any subject-object relationship, shifting fixed ideas of the piece in contrast to the engagement with Lin's objects in the white-cube setting of *Systematic Landscapes*. While Lin successfully translates "the *idea* of landscape within the space of architecture" in her exhibition, nature also gets systematized: lost is the unpredictability of experience and a certain affective charge.[97]

In contrast, Lin's idealized landscapes are let loose in the grand outdoors; her architectural forms initially frame the landscape, and then over time the landscape frames her works of neo-earth art into something different and new. The process of transformation is akin to experiencing the *Vietnam Veterans Memorial*. When one first encounters the V-shaped path of the memorial, the names either overwhelm or mean nothing, depending on the observer. But over time, one walks along the pathway and touches the names inscribed on the reflective polished stone wall, a spark is created, connecting the viewer to an event and/ or place that is not so far away. For others such as *New Yorker* art critic Peter Schjeldahl, the *Vietnam Veterans Memorial* wall is "about death, which erases all differences."[98] Schjeldahl's comment reveals an instance of how art can communicate about war in a way that does not necessarily require explanations or commentaries on the war, U.S. imperialism and nationalism, or class and race dynamics in the United States. What Lin does include is a directory of names that lists all those Americans who died for the war alongside the text offered by the U.S. National Park Service. Highlighting how death and Schjeldahl's experience in relation to the memorial can be singular and universal does not completely erase or deny differences. Another visit, exhibition, or installation might offer an alternative viewing experience and another insight where imperialism, not death, will be seen as the universal stand-in that unsettles one's understanding of why wars are fought and determines whose lives are valued over others. This is all to say that one cannot predict the outcome of every encounter with a work of art and that while the writing about

Asian American art refuses to put differences under erasure, the curating of Asian American art entails making decisions on not only how but when to mention these differences, depending on the work of art and context. Returning to *Wave Field*, walking on the uneven grassy knolls at Storm King Art Center might not lead directly to an awareness of the contingent relationship between self and a failing ecosystem, the interface between human and natural forces as well as the imbalance between the two, but the effect of engaging the piece is unpredictably reworking the frame of our understanding of Lin's work and nature. Her merging of public and earth art practice offers a model to think about the exhibition as an open-ended encounter as well as an invitation to engage her work on multiple levels, including through an Asian American art context, a reading that I want to suggest does not close or contain her work, but extends it.

The relationship between the two exhibitions at the de Young and between Lin and the other artists in *Shifting Currents* was never articulated in the publicity materials given out by the museum, except that it was implied that the de Young was presenting two Asian American art exhibitions, a rare coincidence and phenomenon. Lin's work, like Yoko Ono's, has usually been discussed outside categorizations of Asian American art until recently, though at the start of her career, she was marked by her race such that her aesthetic style, including the minimalist look of the memorial, was understood to signify Asianness. Until recently, she attributed her interest in nature and organic forms to growing up in southeastern Ohio, influenced greatly by the serpent burial mounds of the Hopewell and Adena Indians. Interestingly, however, Lin has recently begun pointing to her ethnic identity as influencing her innate interest in Asian aesthetics. The shifting roles that ethnicity plays in Lin's art practice—placed on her and taken up by her—reveal the slippery terrain that Asian American artists navigate.

The exhibitions were seen as completely separate, but imagine inviting the curators of both exhibitions, or artists Maya Lin and Ruth Asawa, to compare their work and artistic sensibilities and discuss how they each engage nature and the legacies of modernism, as indicated by their fidelity to form, the perception of structures, and extension of possibilities inherent to a particular medium or media. Both Lin's taut and variable installation of *Pins* and the reticulation of wire in

one of Ruth Asawa's mesmerizing sculptures offer an experiential relationship to the natural environment, one that cannot be anticipated and can only be known partially. On another level, while the artworks offer a singular experience, what would it mean to impart the not-so-tangential history of Asawa's experience at Rohwer Relocation Center and Lin's relationship to the Vietnam War as a means to flesh out or challenge Karlstrom's concept of social modernism? Relying on an open-endedness in which every encounter is contingent, depending on the angle of the approach, the presence of other bodies, and the interplay of light, shadow, and reflection, the artworks also impart a different kind of knowledge: an outward engagement or awareness of the relational nature of experience and the domain of appearance. Lin's larger works of art like the *Vietnam Veterans Memorial* and *Wave Field* are effective in this way precisely because they invite the observer to engage without reciprocity; the awareness or the moral obligations to the environment or history are felt by the observer, not imposed by Lin or any curator.

Not at all trying to claim Lin as Asian American or imply that she should have been a part of *Shifting Currents*, I am trying to make the point that it is necessary to be constantly alert to juxtapositions and possibilities, to loose threads, as in the example below, where such discussions could occur that do not impede or interfere with the way these exhibitions were curated, but offer opportunities to enhance the viewing experience of approaching Asian American art, and open up alternative meanings for individual artworks.

Intriguingly, outside the physical space of *Shifting Currents*, placed in a different gallery but included in the exhibition, were Ono's *Sky TV* and Nam June Paik's *TV Clock*. The placement of the work was an instance of excess of an exhibition's curatorial premise and planning and used as a means of publicity to alert visitors to come and check out *Shifting Currents*, in another part of the museum. Ono's *Sky TV* (1966/2008) broadcasts a live feed from a camera on the roof of the museum, focused on the sky (figure 1.6). In the version of the piece for the de Young, she replaced the television with a video projection. In both scenarios, she creates an image-space both inside and outside the exhibition itself. As one approaches the wall-sized video projection, a shadow or silhouette forms on the screen. The piece recalls Lin's public artworks in the way

Figure 1.6. Yoko Ono, *Sky TV*, 1966/1998. From the exhibition *Have You Seen the Horizon Lately?* originated at Modern Art Oxford. Installation image from Israel Museum, Jerusalem, November 26, 1999–March 25, 2000. Photo credit: Oded Lobl © Yoko Ono.

it invites observers to be open to the unpredictability of San Francisco weather and engage in a different spatio-temporal and sentient experience. Together, both works enable a suspension through which the observer engages in different spatio-temporal experiences of duration. Ideally, this is what an Asian American art exhibition can offer too. Offsetting expectations of what one sees when approaching Asian American art, the following example of Ono, a review of Lin, and lessons learned

from the different ways Asian American art has been curated over the last several decades are all meant to serve as examples or case studies, maybe even models, to consider when proceeding to curate the next "Asian American art" exhibition.

The curatorial premise and frameworks of all four exhibitions discussed in this chapter had the potential to open up the works of art, but the wall labels and extratextual materials seemed to impede both direct and sentient engagement with the artworks to the point where the curators were doing the thinking and experiencing for the observer. Would last-minute adjustments in writing up the extratextual material and displaying them differently have clarified themes or shifted the tone of some of these exhibitions? It is impossible to speculate, but reviewing recent exhibitions makes it clear how curating these kinds of exhibitions has become formulaic and standardized. Considered a finished product rather than a work in progress, an exhibition is understood as not to be messed with or further revised except under extreme circumstances. In the case of exhibitions that are organized or conceived around race and ethnicity, this kind of thinking presumes that the exhibition is presenting the final word on race in the selection of works and representation of artists, rather than as a point of departure to discuss how race is contested and far from resolved. While programming events and impromptu talks open up multiple levels of engagement, how might we see extratextual materials as modular texts and components that can move and/or be replaced? That said, adding and crafting more wall labels and extratextual materials, or in the case of *One Way or Another*, mounting barely any labels at all, does not fully address the quandary curators of Asian American art face.

As a curatorial artifact, the multicultural and ethnic-specific exhibition continues to be an efficient way to present a large group of artists of color and Asian American artworks all at once, but despite all its good intentions, the structure remains immutable, insofar as it continues to fix or reinforce entrenched ways of approaching Asian American art. Rather than dismiss such exhibitions, I am grateful and inspired by the efforts of the curators and select artworks discussed here. Keeping in mind the spirited ways Group Material broke the rules, activating an egalitarian logic, I want to continue to explore how exhibitions can build

bridges to expand an artist's reach and offer another kind of viewing experience.

How can we curate an exhibition that offers a challenging viewing experience—a space of disagreement? Currently, there is a tendency to present art as recognizable, formally engaged with the canon in which the role of the curator is to construct a space of reconciliation and assimilation or add cultural commentary. How might we treat and curate these works other than as proper objects that fit within the set rubrics of art-historical categories or expected roles of what Asian American art is supposed to do politically?

Recalling how in the 1960s and 1970s, curators-artists took matters in their own hands to present and contextualize minimalist and conceptual artworks that best set up the pieces in contradistinction to previous modes of display and exhibition making, I seek a mode of curating in which Asian American artists, scholarship by those in Asian American Studies and art history, and curators symbiotically work together in approaching the exhibitionary space as a potential stage of disagreement, a process that does not happen with just one exhibition but develops over the *longue durée* and in many formative iterations.

Art depends on the curator to mediate, not only to select, frame, display, and circulate the art in a particular way to be seen but also, as Gilles Deleuze urges, to keep things moving, facilitating the flows of ideas, exchanges, looks, and voices, in order to engender new meanings, values, and relations.[99] Approaching exhibition making in this way entails a need to reconfigure Asian American art as a discursive experimental space, an analytic, and a negative dialectic—a move that entails a transversal mode of curating and writing about non–Asian American works of art alongside art by artists of Asian American descent.

To this end, the following chapters are curatorial proposals on paper, presenting further examples of artworks that engage aesthetics and politics but also spin, complicate, expand, and challenge central themes in Asian American Studies to the point of reconceiving not only the initial curatorial premise but also Asian American art. At this time, a work by an artist of Asian American descent is expected to do too many things at once. The artwork must engage legacies of modernist form, critique the establishment and the social, represent the community, resist classifications of otherness, engage issues of race, class, sexuality, gender, etc.,

and instruct the viewer how to approach the work and present a readily accessible and authentic experience (not at all an exhaustive list). The following chapter reasserts the political potential of what these works can offer, at the same time it implicitly throughout aims to challenge the idea of recruiting Asian American artists as agents of representation. While this chapter reviews and explores the potential and limits of Asian American art exhibitions, the next chapter explores the role of Asian American artists as cultural laborers.

2

Formal Actions

Reevaluating the "Cultural Work" of Tehching Hsieh, Byron Kim, and Simon Leung

Whatever we do, we are supposed to do [it for] the sake of
"making a living." . . . The only exception society is willing to
grant is the artist, who, strictly speaking, is the "only" worker
left in a laboring society.
—Hannah Arendt[1]

What do artists do? What is the value of their work? Tehching Hsieh, Simon Leung, and Byron Kim do a lot in various spheres and registers. This chapter explores how select works by Hsieh, Kim, and Leung unsettle dominant modes of thinking about labor, work, the political, and the artist's role as a cultural laborer and a cult figure of genius and alienation.

From one point of view, making art is wasting time, a means of consuming the surplus labor time of a society, and producing nothing of tangible use.[2] The globalization of the art market would suggest otherwise as it works overtime to mobilize desire for its products, converting an artist's surplus labor to surplus symbolic value. While art is an unproductive expenditure with marginal utility, it now has tangible value. Moreover, while it used to be that an object's cultural worth was determined by an artist's skill and craft, and the value of the materials, recently an artwork's value has also been determined by his/her ideas and ability to provide a service or offer an experience. Within the field of art history, the implications of this turn in relation to the enfolding of conceptual art into the market, correspondent with the rise of the derivative, have been amply discussed.

Within Asian American Studies, questions concerning the value of an artist's work and the role of the Asian American artist as cultural laborer

86 | FORMAL ACTIONS

have been engaged in part by Asian American authors and literary critics. David Mura, Shelley Wong, and Sau-ling Wong have written about the expectations of Asian American authors to "advanc[e] and engag[e] in practices of liberation and freedom," "unlock a historical memory... [and] provide a basis for unity or cultivate a shared literary grammar."[3] Offering a different perspective, literary critic Mark Chiang points to how Asian American writers and literary scholars have depended on the Asian American community, especially the immigrant laborer and his/her symbolic capital, as a means to attain and accumulate their own cultural capital.

Tehching Hsieh's *One Year Performances* and Simon Leung's *Squatting Project* at first may seem like similar projects, iconic representations of the undocumented Asian migrant and/or low-wage immigrant laborer or guest worker, paradigmatic figures within Asian American Studies who have come to represent the gendered and racialized contradictions among the idealistic principles of the state, the discourse of U.S. citizenship, and the demands of capitalism. In this chapter I want to focus on how these artists are engaged in another form of critical labor in which their artwork acquires a different value that is not tied to any authentic representation or documentation of an Asian immigrant's life. In this chapter, I want to play with the meaning of "occupy," focusing on the occupation of Hsieh, Leung, and Byron Kim as cultural workers, but also on the various ways they occupy space as a mode of resistance to neoliberalism's encroachment and abstraction of space and relations.

Much has been written about neoliberalism as market fundamentalism and its philosophy of unfettered capitalism—an endless growth of the economy vis-à-vis a free market. Foregrounding the need for austerity by limiting the role of state and public-sector activities, neoliberal policymakers have advocated for the need to dismantle social welfare programs and privatize public entities and institutions—a standard practice in an attempt to manage ongoing stagnation crises while simultaneously maximizing accumulation by removing any and all major obstructions and regulations that impede the free flow of capital and market exchange. In the 1970s, neoliberal policies guised as state reform were experimentally applied ad hoc in the Southern Cone of Latin America and New York City to deal with their bankruptcy crises, the same year Hsieh decided to embark on his "lifeworks." Since the 1980s,

the promotion and implementation of neoliberal policies have not only led to the intensified mobility of goods, services, people, and capital across borders and an upward flow of capital and power but have also resulted in the hegemonic establishment of global oligarchic rule and the restructuring of state governance and everyday life.[4]

Recognizing that neoliberalism is not at all the sole or totalizing determining force influencing and regulating the production and reception of these artworks, and aware of the uneven developments of forms of neoliberalism contingent on history and geography, among other factors, I seek here not to posit how these artists are intervening in discussions of and scholarship about neoliberalism.[5] Rather, I want to frame these works as aesthetic responses to neoliberalism. The ascendancy of neoliberalism serves as background against which these artworks emerged and/or took place during different stages of neoliberalism from the 1970s through the 1990s.[6] Aware of the working conditions of their art production, I want to extend this awareness by suggesting how they are inscribed/ embedded in the ideological workings of neoliberalism and globalization. Their art practice in combination with these specific works, I want to aver, serve as formal responses to this situation, in which their works resist, in multifarious ways, the regulation of social and spatial relations and the disciplinary effect of neoliberalism's reconfiguration of individual responsibility. More specifically, I want to consider how their work challenges a primitive individualism—the mandate to protect one's own interests in the marketplace—and the privileging of artificial transactions and negotiated contractual obligations between juridical individuals over human relations and alternative forms of sociality. Intrinsic in all the artwork is a gesture to acknowledge how the individual artist's autonomy and art making is contingent on others and their labor.

While these artists are not specifically focused on eluding systems of commodity exchange and the market, they have little to show in the aftermath of their art making. They produce no-thing of "value," leaving no permanent trace of their labor, nothing tangible, useful, or arguably exchangeable at all. That said, I want to argue that they are engaged in a kind of critical and disruptive labor, one that intersects with broader forces and shifts, including the protracted pursuits of social and racial justice. Rather than instrumentalizing their labor or elevating them as promoters of liberation, freedom, and autonomy, I want to highlight

FORMAL ACTIONS

what is already present in the work itself and hint at how their labor is setting up conditions of possibilities for a potential politics. I begin with an analysis of Hsieh's *Cage Piece* and *Time Piece*. Following this reading, I then look closely at Byron Kim's *Whitney Philip Morris: Wall Drawings*, and conclude with a reading of Simon Leung's *Squatting Project*.

Tehching Hsieh: The Labor of Art Making

Born and raised in Taiwan, Hsieh arrived in the United States in 1974 while "working as a seaman." As in an account of an immigrant myth, Hsieh "walked down the gangplank of an oil tanker docked in the Delaware River and slipped into the United States. Hailing a taxi, Hsieh paid the driver $150 to take him to Manhattan."[7] Four years after his arrival in New York City, in 1978, Hsieh announced the beginning of five year-long life performances, using as his calling card a wanted poster of himself. *Wanted by Immigration Service*, a cross between a passport and a police report, includes a photocopy of a 1974 photograph of Hsieh, his signature, and a list of statistics: his date of entry into the United States, birth date, weight, race, nationality, physical characteristics, and occupation. At the bottom of the poster, above a grid of his fingerprints and his phone number, Hsieh matter-of-factly states his violation—illegal entry, without visa.

Between September 1978 and July 1986, Hsieh produced and presented his One Year Performances, different year-long living situations each organized around and bound by a set of self-imposed rules involving endurance acts of spatial and temporal constraint. In his inaugural *One Year Performance, 1978–1979 (Cage Piece)*, Hsieh lived in a cage, measuring eleven feet six inches by nine feet, for an entire year in isolation. In that time, he spoke to no one nor did he read, write, listen to the radio, or watch TV (figure 2.1). He not only sequestered himself in solitary confinement; he also simulated prison conditions: the cell, built within his own apartment-studio, contained nothing but the barest necessities—sink, twin mattress, blanket, and light bulb—and he even wore the requisite prison uniform stitched with the semi-pseudonym "Sam Hsieh" and an "ID" number: 93078–92979.

During the period of time when the performance took place, the general public was invited to his studio on designated dates circled on the poster that publicized his piece. Now *Cage Piece* can be experienced only

through photographic documentation taken by his friend Cheng Wei Kuong. The photos depict Hsieh alone, undertaking the basic functions of everyday life—eating, excreting, and resting.[8] But we also see images where he appears frustrated, bored, and contemplative, though these are all projections from the observer's viewpoint, as no text or audio accompanies the images. We never hear Hsieh's voice, or his take on his experience of the performance.

Accompanying all his performances were statements written in pseudo-legalese, including a terse artist statement stipulating his intentions, which in the case of *Cage Piece* includes the promise, "I shall NOT converse, read, write, listen to the radio, or watch television" between September 30, 1978, and September 29, 1979, and a letter from his attorney, Robert Projansky, certifying that Hsieh "remained within said locked cell for a period of ONE YEAR."

A year later, Hsieh again hunkered down in his studio with a stated objective to think about art twenty-four/seven. Casting himself as a blue-collar factory or industrial worker, Hsieh punched a card in a time

Figure 2.1. Tehching Hsieh, *One Year Performance, 1978–1979* (*Cage Piece*). Life image. Photograph by Cheng Wei Kuong, © Tehching Hsieh. Courtesy of the artist and Sean Kelly Gallery, New York.

clock every hour on the hour for 365 days, in *One Year Performance, 1980–1981* (*Time Piece*). In 1982, he spent a year outdoors, wandering Manhattan, sleeping on the streets, and vowing never to enter a private space. Between 1983 and 1984, in a performance entitled *Art/Life*, he spent a year tied by an eight-foot rope to another performance artist, Linda Montano, without either touching the other. In his fifth performance in the series, Hsieh spent a year not making any kind of art or participating in any kind of art-related activities. He did not look at art, read about it, or talk about it. In 1986, Hsieh said that he would spend the next thirteen years producing art but not showing it. At the end of 1999, he announced to an audience gathered in Judson Memorial Church simply that he had kept himself alive. If the latter performances are about keeping to himself, making art, and staying alive, I want to suggest that the first two performances—*Cage Piece* and *Time Piece*—are in part about what it means to work, but also about the freedom and right to work and make art.

In his first lifework piece, Hsieh's main task in the studio was to make art: "[T]hinking was my major job." I want to suggest that he was also doing time, placing himself in detention because of his undocumented status—although Hsieh himself and other art curators and critics have denied this insofar as neither *Cage Piece* nor any of the other performances were intentionally meant to serve as mimetic representations of his undocumented status.[9] In an impressive catalog *raisonné* (in collaboration with Hsieh), Andrew Heathfield characterizes Hsieh's one-year activities as "lifework" performances, inviting readings of his art within the context of lived duration, the "gravitational pull into the density of time's passing." By inviting us to look at Hsieh's body of work across time, not as a series of events but as a single duration, Heathfield strategically brackets the moments and contexts as a way to step away from frameworks of seeing his work in relation to identity, performance, and body art.

Foregrounding his performances as explorations on the meaning of time for an artist—what an artist does, day in and day out or, in Hsieh's own words, "the process of thinking about art in my studio"—I want to extend this interpretation but focus on the underpinnings of this process in his first two "lifeworks."[10] Pursuing his task and right to "think," Hsieh's formal actions might be seen as not only about survival but also about elevating the human condition, an endeavor that requires him to

make himself "appear" legible as worker, citizen, artist, and human, a challenging task in light of his exclusion from the polis and the art world.

Hsieh's description of the task at hand corresponds with the first item in a list of activities Hannah Arendt proposes to uplift the "human condition"—"that is of thinking about something, *Nah-denken*."[11] The other activities that make up the tripartite of Arendt's human condition are labor and action. She related "labor" to causality, specifically activities involving the body's survival, maintenance, and subsistence. She also characterizes labor as an activity repeated continuously with no end result. In contrast to labor, which attends to life's needs, Arendt calls "action" the privileged apex of the human condition, a singular form of expression and a way-of-being-in-the-world that has no beginning or end. Action transforms facts, events, and patterns of thought into worldly things that then get "absorbed into a web of relations setting into motion and distributing a kind of chain reaction, in which its effects are felt widely across time and space with unexpected and random consequences."[12] Action, like art, is purposeless, political, and free. Denied the right to work for wages as an undocumented immigrant, Hsieh presents an intriguing limit situation: he is removed from the task of making a living and thus left paradoxically with time and a unique opportunity to live life without necessity, to experience freedom from want, and to attend to, in Arendt's words, "higher and more meaningful human activities," though at the same time his self-imposed "labor" always seems to get in the way.

Unable to work legally, Hsieh sets out to work for himself, organizing his day in the studio by assigning himself a set of tasks. In *Cage Piece*, he thinks about art nonstop, and in *Time Piece*, he does the same, but punches a time clock on the hour, every hour. Demanding sheer will power, endurance, discipline, and deprivation, his performances recall the work ethic and mindset of the persevering, hard-working immigrant, and from another perspective, his performative acts of deprivation and discipline were uncanny in their timeliness and correspondence with Reagan's embrace and revival of the Protestant work ethic and the financial austerity measures instituted in New York City at the time.

At the brink of bankruptcy in 1975, New York City became a pioneering test case for a number of neoliberal measures, policies, and tactics to purportedly fight stagflation and save the city from bankruptcy. Forcing the city's municipal government to use its tax revenues for bond

payments, the city's bondholders—Wall Street investment firms and bankers—pushed through a number of severe austerity measures in the guise of "fiscal discipline," to create and secure optimal business conditions. These measures included restructuring local government, freezing wages and making cutbacks in public employment and social provisions, imposing user fees to attend the public university system (which had to that point been tuition-free), and privatizing public institutions. Stripping the power of labor unions and local government, these measures also weakened the city's social and physical infrastructure, testing the endurance and grit of its inhabitants.

An outcome of Ronald Reagan's ingenious strategic merger with the Christian Right was the revival of the Protestant work ethic and a call to save and sacrifice, a mantra that would become a familiar refrain in the promotion of neoliberal austerity measures. No longer, however, a divine call that assigned an individual "a duty, a life task, a mission, or a field to which one is supposed to devote one's best energies," the secular manifestation of Reagan's Protestant work ethic focused instead on worldly deeds in the form of remuneration: an accumulation of money that despite its materiality becomes transcendent in the measurement of one's individual worth, seen primarily as economic value. Conjoining Christian virtues of discipline, diligence, self-sufficiency, frugality, punctuality, sobriety, and prudence with free enterprise, the Protestant work ethic also became an effective measure of individual success and a means to obscure structural inequities, conditions, and exclusions that placed one's failure to transcend one's condition on the individual. Effectively relinquishing state responsibility to protect and promote the economic and social well-being of its citizenry, Hsieh's second One Year Performance, *Time Piece*, seemed to be a timely response to this call to take action and responsibility.

Hsieh describes *Time Piece* as follows:

1) I shall have a witness sign each of the 365 time cards for the total one year performance . . .

2) With a 16mm movie camera, I shall document each time I punch the Time Clock by shooting one frame . . .

3) To help illustrate the time process, I shall begin the performance with my head shaved bald and allow my hair to grow back naturally.

FORMAL ACTIONS | 93

Written in overly formal pseudo-legalese, typed and signed, the document serves as both artist statement and contract. One of a number of documents that Hsieh fastidiously generated and maintained, including 365 punched time cards, approximately 8,760 mugshot-style self-portraits, and a six-minute film, the documentation serves now, as mentioned before, as the only means to see and experience his performance. On one level, Hsieh's documentation foreshadows the neoliberal predilection for contracts, data, and information. On another level, given Hsieh's purported unfamiliarity with other conceptually based art practices that dematerialized the object and performed everyday tasks within and outside the studio, his careful documentation needs to be approached both as a recording of the event as a way to preserve the work and disseminate it to a wider audience and as the only formal means to present and certify himself at the time.[13]

The 365 time cards, the carefully recorded self-evaluations, and the documents in which he lays out a set of outcomes and rules—I will not do this, I will do this—in addition to a moral code ("to avoid any suspicion of cheating") keep him not only occupied but also out of trouble. Generating his own rehabilitative contract with the state as compensation for working outside the law, executing and completing his self-given tasks, utilizing his body and labor power, and verifying that he actually performed the tasks not only demonstrate Hsieh's competence and industriousness but also attest to his potential to be a good worker, model citizen, and model minority. However, how might we, while remaining mindful of his artistic intentions, see Hsieh's performance not only as foreshadowing neoliberal demands of self-sufficiency, self-regulation, and investment in one's potential but also as revealing its cracks in the disciplinary effects on bodies and social relations? In contrast to the iconic image of factory workers in constant collective motion, as integral cogs in an industrial machine, we see Hsieh working alone, atomized and isolated. In contrast to the regimented Fordist schedule of shift work, we see Hsieh literally working around the clock. Over time, his simple task to think about art becomes increasingly difficult due to his inability to sleep for an extended stretch of time, throwing his circadian rhythm out of whack. Revealing not the end, but the residual spillover of Fordist work methods, which Max Horkheimer described in part as forcing the need to "dispense with memory and [a] straying imagination," Hsieh

must concentrate on the contractually binding task of clocking in and clocking out on the hour every hour, the consequences of which Hsieh highlights in his Super 8 film. The film opens with a clean-shaven Hsieh looking directly at the camera. The condensed montage of eight thousand photographs, however, quickly unfolds into six minutes of slapstick horror in which we see a head with a mass of hair gone wild atop a jittery body convulsing out of control. In contrast to the methodical documentation and photographing of his punching the clock, the film exposes how the mechanization of procedures dictated by neoliberalism takes on a life of its own or can take someone's life as we see Hsieh's spasmodic body move out of control and almost out of the picture frame.

His "stuplimated" condition at the end of the film reveals an intensification of Taylorist techniques to manage the body.[14] But instead of a foreman regulating his schedule and structuring his production, it is Hsieh who takes on the responsibility of his own production and destruction. Unregulated and free to structure his workday, Hsieh takes control of his own production, but to the point of utter exhaustion, failing to produce anything of value. That is, the only "product" of his labor that we see is the act of him punching the clock, an obsolete gesture during an era of major economic restructuring and deindustrialization. However, given his status as an undocumented Asian immigrant, it is not what he produces that is of value but his body.

Suggesting the impossibility of a racialized subject experiencing material and spiritual uplift by way of the Protestant work ethic, Rey Chow suggests that the only way someone like Hsieh can find redemption and recognition is through his body or by becoming a Protestant ethnic.[15] Appropriating Georg Lukács's tracking of the worker's awakening to his/her status and the requisite journey to class consciousness, Chow defines the Protestant ethnic as a racialized subject who becomes conscious of his/her own difference and subjection, and whose salvation is contingent on captivity.[16] Aware of his/her own subordinated position but without any other alternatives except to resist and protest, the Protestant ethnic has no choice but to embark on a journey demanding recognition of his/her own injury and injustice. Interpellated within a fixed narrative of "universal justice" and the globalization of capital, the Protestant ethnic, as Chow points out, is always already captive, subjected to engaging in racialized protests that are always already circumscribed, never

FORMAL ACTIONS | 95

demanding emancipation from capitalism, only access to "the benefits of worldwide visibility, currency, and circulation."[17]

While Hsieh's *Time Piece* could be seen as part of a long history of low-wage Asian immigrant labor, a representation of the current makeup of global capital's factory assembly lines, Hsieh's performances, including all the documentation, do not really offer us anything about this experience. Not at all a poster child protesting in favor of Asian immigrant working rights and producing neither capital nor an object of exchange for revenue, describing his own performances as passing time, which also could be read as consuming surplus time, Hsieh manages to elude or "escape from a series of categories upon which subjectivity depends."[18] Put another way, Hsieh wastes time by producing no-thing, a reckless and counterintuitive endeavor for an undocumented Asian immigrant and future model minority, but by doing so, he breaks free from the binds of captivity.

Hsieh does not re-create or represent his "real life" situation in his first two One Year Performances, but renders a semblance of it by setting up his own rules and parameters of confinement. Engaged in a simulation of alienation, Hsieh goes through a series of "prescriptive negations" or "near-systematic negation[s] of subjectivity, staking out a position along the intersecting limits of economic, juridical, and political orders" wherein he is able to slip between the call of the law and its articulation.[19] Free to make art, but in a way that is paradoxically binding, given his situation outside of the law and the art world, he produces on one level something else through his labor: the freedom to question freedom, his right/s, and the higher purpose of being an artist. Refusing the demands of the state, capital, and the art world (which I bracket and discuss in the last chapter), Hsieh creates his own version of defined contributions, pushing away the future promised to ethnic artists, and the art world's outdated principles of individual autonomy.

While Hsieh arguably produces no-thing of exchange value, on another level, his austere and minimalist formal actions render what it means to be counted as human, a condition contingent on the interdependency of interpersonal relations and intimacy. But *Time Piece* cannot be seen as an absolute refusal of the capitalist system. His expenditure and generation of "surplus labor"—labor in excess of what is necessary to produce the means of livelihood of the worker—paradoxically rests

on another stratum of surplus labor. Financially secure and stable as owner of his own living space and studio, his everyday needs taken care of with a monetary allowance given to him by his mother and the help of his friend Cheng Wei Kuong, Hsieh reveals an indebtedness to an unseen support network that offers him sustenance to make something like *Time Piece* even possible. In *Cage Piece*, Kuong documents Hsieh undertaking the basic necessities and functions of everyday life; in these photographs, his incarceration is made palpable. They also show how Hsieh's performance was made possible: Kuong was in charge of bringing Hsieh food every day, as well as taking care of his clothing and daily refuse, and his mother took care of his other expenses. Resisting neoliberal forms of socialization as well as challenging myths of individualism and self-reliance, Hsieh's performances form a display of filial piety, evidence to his mother that he is staying out of trouble, perhaps an unspoken condition attached to receiving his monthly allowance. On another level, it is these relations that enable Hsieh to thwart the ways capitalism maximizes profit by controlling time and profit and convert the experience of alienation into one of estrangement and imagination. In *Cage Piece*, Hsieh survived his days of isolation by using his imagination, dividing his cell between "inside" and "outside," organizing his time, setting up a routine, and drawing imaginary boundaries, wherein sitting on the bed represented being inside and standing or otherwise being off the bed meant being outside. Using resources of imagination, time, and space, Hsieh occupies the nation-state but produces in his own makeshift space, one parallel to that of the art world, a schema consisting of a separate set of criteria of what it means to make art. While alienated and exhausted after *Time Piece*, Hsieh remains free from the forces that bind and seek to bind him, maintaining the right to self-possession of his body, of time (a property of the mind), and, more importantly, of his art.

Byron Kim: Shades of Labor

While sharing with Hsieh a similar quest to explore and question the vocation of the artist, the artist's work process, and the myth of the alienated modern artist, Byron Kim, in contradistinction to Hsieh, has been active in the art world as a practitioner and professor, as well as part of a growing corps of cosmopolitan, border-crossing artists who are

awarded commissions and exhibitions all around the world. Well aware of the shift in contracting artists as service providers of experiences, I want to suggest how Kim and Simon Leung, whose work I will discuss shortly, short-circuit the idea of the racialized artist as embodiment of liberation, freedom, and autonomy. This aspect of Kim's work is not the central focus of his art practice, but I see it as such in his solo commission at the Whitney Museum at Philip Morris.

As discussed in chapter 1, Kim's "skin" monochromatic paintings were in part wry commentaries on race, but also on color, presenting his own oeuvre as a lofty quest to explore the question, "How much lore and beauty can a single color carry?"[20] Inspired by and in dialogue with artists such as Ad Reinhardt, Brice Marden, Allan McCollum, and Robert Irwin, his body of work could be approached as a series of conversations about painting and color. In the case of a 1999 solo commission at the Whitney Museum at Philip Morris, curator Eugenie Tsai commissioned Kim to produce a new work, a painterly response to a simple but complicated question: what is the color gray? Drawing on a longstanding personal and professional familiarity with the stakes of Kim's artwork (both were founding members of the Godzilla arts collective), Tsai formulated a question that was an ongoing query not only about color but also about abstract painting.

Kim responded to Tsai's question by creating three mural-scale wall drawings in different shades of gray, highlighting its range of hues and emotional effects while offering tribute to three canonical artists: Sol LeWitt, Mark Rothko, and Brice Marden. On the south wall of the gallery, Kim rendered a brick pattern, a playful tribute to LeWitt that combined that artist's breakthrough geometric wall drawings with "his use of brilliantly colored ink washes that were diluted and then layered in order to achieve secondary colors and shades of gray" (figure 2.2).[21] Adjacent to this drawing, Kim painted a series of muted gray panels or columns of varying widths, illuminating the vertical features and auratic surfaces of a Rothko painting (figure 2.3). And in the largest rendering of the three, Kim suffused the wall from floor to ceiling with a diaphanous, smoky haze of differentiated shades of gray and swirling calligraphic ribbons or swirling orbs (figure 2.4). Titled *How Big Is the Moon*, the drawing was clearly an ode to Marden, a frequent point of reference for Kim and the ideal interlocutor on the subject of the color

Figure 2.2. Byron Kim, *Whitney Philip Morris: Wall Drawings*, 1999. Installation at Whitney Museum of American Art at Philip Morris, New York. Photo by Dennis Crowley. Copyright the artist. Courtesy of James Cohan Gallery, New York/Shanghai.

Figure 2.3. Byron Kim, *Whitney Philip Morris: Wall Drawings*, 1999. Installation at Whitney Museum of American Art at Philip Morris, New York. Photo by Dennis Crowley. Copyright the artist. Courtesy of James Cohan Gallery, New York/Shanghai.

Figure 2.4. Byron Kim, *How Big Is the Moon*, part of *Whitney Philip Morris: Wall Drawings*, 1999. At Whitney Museum of American Art at Philip Morris, New York. Photo by Dennis Crowley. Copyright the artist. Courtesy of James Cohan Gallery, New York/Shanghai.

gray, a preoccupation Marden shared with Jasper Johns, who found both the color gray and the subject matter of identity vexing, life-long questions (figure 2.5).

Upon closer viewing, the modulations of gray that make up the looping lines around Marden's moon are splatters of sludge, strands of hair, lint, and grime. Interrupting this esoteric query on the sublime, Kim discloses under the title of the piece, *Whitney Philip Morris: Wall Drawings*, that the translucent gray wash applied on the walls is not made up of oil or even paint, but "material vacuumed from this building"—a mix of water and collected contents of daily vacuum bags from the office building that houses the gallery (figures 2.6 and 2.7). Looking at Kim's unconventional choice of materials and the space in which the work was installed—a nine-hundred-square-foot cube gallery located within the corporate offices of Philip Morris, one of the largest tobacco companies in the world and one of the major corporate sponsors of art in the United States during this time—I approach *Whitney Philip Morris: Wall Drawings* (henceforth, *Wall Drawings*) as a site-specific installation, an

Figure 2.5. Byron Kim, *Whitney Philip Morris: Wall Drawings*, 1999. Installation at Whitney Museum of American Art at Philip Morris, New York. Photo by Dennis Crowley. Copyright the artist. Courtesy of James Cohan Gallery, New York/Shanghai.

exceptional case study through which to approach and understand Kim's role as a painter's painter, a service provider, and a cultural laborer.

"[T]he fascinating thing about a good abstract painting is that, content-wise, it operates at two extremes. You look at it once, and it is merely a red rectangle. You look at it again, it is the universe in red. It is nothing and everything,"[22] wrote Byron Kim. "Love and an inner necessity, not ambition" motivate Kim's imperative to paint, as *Los Angeles*

Figure 2.6. Byron Kim, *Whitney Philip Morris: Wall Drawings*, 1999. Installation at Whitney Museum of American Art at Philip Morris, New York. Photo by Dennis Crowley. Copyright the artist. Courtesy of James Cohan Gallery, New York/Shanghai.

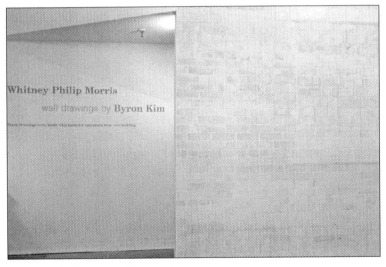

Figure 2.7. Byron Kim, *Whitney Philip Morris: Wall Drawings*, 1999. Installation at Whitney Museum of American Art at Philip Morris, New York. Photo by Dennis Crowley. Copyright the artist. Courtesy of James Cohan Gallery, New York/Shanghai.

Times critic Leah Ollman declares in one of the more comprehensive reviews of Kim's midcareer retrospective, *Threshold: Byron Kim, 1990–2004*. In "The Inquiring Mind of a Restless, Energetic Spirit," Ollman describes Kim's body of work as "a sustained engagement with a lifelong process of looking 'outward and inward.'"[23] She writes,

> Kim's work emerges from a range of inquiries, some straightforwardly empirical, many of them philosophical sparklers, referring specifically to Kim's series of *Sunday Paintings* (2001–2004)—a series of 14-inch by 14-inch painted panels of the sky and clouds created every Sunday for four years, each accompanied at the bottom by a handwritten note about an event or his thoughts during that day or week.[24]

Using Ollman's review as a point of departure, the following is a summary of Kim's art practice, a means to set up an alternative reading of his installation at Philip Morris.

* * *

"In the course of my art practice, I often find myself copying things," wrote Byron Kim.[25] Since his national debut at the *1993 Whitney Biennial*, Kim has been quite expressive about his thought and process, his methodical experimentation with materials, and the role and craft of painting, historically to the present. Aware that every utterance manifested in a work of art exists or emerges in response and relation to those who have come before and what has previously been visually articulated and experienced, Kim produces paintings that serve as both an homage to artists of the past and a contested space to examine what makes art "art." From his painting performance at the Metropolitan Museum of Art in New York—where he obtained a copyist's permit to capture Jacques-Louis David's rendering of the gossamer tulle of chemist Antoine-Laurent Lavoisier's wife's sumptuous pink dress and the satin toe of her slipper peeking out—to attempts to capture the "essence" of a Robert Irwin disc sculpture from a poor, misleading reproduction, Kim has over time simultaneously built and deconstructed an idiosyncratic and impressive repertoire of painterly techniques, as well as acquired a vast body of knowledge about the art and history of painting (figure 2.8). A close look at his body of work reveals that his paintings are not

just about contrasts in color but also studied comparisons of textured physicality, the application of paint, and the capture of hue and light.

The labor and time invested by Kim to learn how to capture the light in an Edward Hopper painting recall those of the Sunday or amateur painter. Conventionally, an amateur is someone who passionately admires and possesses an almost encyclopedic knowledge of a certain field—for example, the history of painting—and tries to achieve mastery

Figure 2.8. Kim with *Antoine-Laurent Lavoisier (1743–1794) and His Wife (Marie-Anne Pierrette Paulze, 1758–1836)* by Jacques-Louis David, at the Metropolitan Museum of Art, New York, 2003. Copyright the artist. Courtesy of James Cohan Gallery, New York/Shanghai.

through copying and repetition. On one hand, what makes an amateur distinct from a professional is his/her passion to paint out of love, not ambition. On the other hand, an amateur is usually viewed with derision, and his/her work is seen as derivative rather than inventive or innovative. These days we tend to distinguish amateur artists from professionals less through their skill or craft and more through their credentials and their approach to the act of creating.

It would be remiss to label Kim an amateur, given his Yale education and his enviable exhibition record and representation by several galleries around the world. His painterly experiments and reproductions of select works are less a means to gain technical proficiency than a way to highlight the gaps and contradictions in what it means today to make art. Norms about what is required to be considered an artist have shifted, and have less to do with skill, craftsmanship, or talent, and more with a notion of "creativity" that aligns it with ideas about originality and invention. Thierry de Duve, for instance, defines creativity "as an absolute and unformalized potential, a supply of energy prior to any division of labor. One has creativity, without qualification; one is creative, period."[26] In other words, not everyone has talent in the traditional sense, but everyone possesses "certain degrees of creativity," giving the illusion of a level playing field. Creativity's conversion into novelty or innovation as a measure of added value production underscores how in determining an object's worth, the focus is not on the quality of the craftsmanship or the materials, but rather on the artist's capacity to attract symbolic social capital to his/her work.[27]

Responding to this lack of symbolic capital or, in the words of art historian Darby English, to make "room in the discourse of painting for an investigation into the perceptual conditions and conventions of art that can accommodate a positioned, culturally specific subject," Kim and his long-time peer, friend, and occasional collaborator, Glenn Ligon, have challenged, together and separately, the framework and manner by which abstract painting has been approached and reinforced. In *The Triumph of American Painting*, Ligon and Kim paint on a boxer's punching bag Irving Sandler's reading of Mark Rothko.[28] Recontextualizing and inscribing Irving Sandler's abstract expressionist treatise on the punching bag—an object on which one can viscerally project aggressions and frustrations but also an object that tenaciously always remains intact

in shape and form—Kim and Ligon metaphorically build resistance in reading against a critic's pronouncements and power to make permissible what counts as painting and who can and who cannot paint by inaugurating a new generation of American painters.

In "An Attempt at Dogma" (1992), a play on Ad Reinhardt's manifesto of "art-as-art," Kim highlights how it matters who can be seen as creative, and ultimately who makes art, recounting the tepid response he received from art critics when he had, early on in his career, attempted "to make some large paintings exactly like Brice Marden's Grove Group."[29] Rather than engaging Kim's engagement with Marden's philosophy or art practice, the critic responded to his announcement by saying, "Why are you making abstract paintings?" The "you," Kim understood, was not Kim, the universal artist subject, but an "Asian-American, artist-of-color, artist-with-something to say"—an artist who was already predetermined never to be in the same league as Marden.[30] Having much to say through his painterly gestures, Kim's paintings are serious and poignant explorations of the role of color as a formal property and signifier, and the search for meaning in abstraction, but also conceptual inquiries concerning the delimits of such concepts as beauty and the sublime. In an interview with Phyllis Roshenweig, Kim stated, "I have developed a strong sense that beauty is a learned concept. I believe that one cannot walk in from the street uninitiated and see a Rothko painting as beautiful."

By highlighting the discourse of art history in framing a work of art as beautiful and sublime and/or divesting the exclusive connotations of abstraction and its purist grandiose intentions, Kim has consistently aimed to open a "a window toward opening up the game to others." Blurring the boundaries between abstraction and representation by indexing the quotidian and the personal—including his everyday surroundings, daily activities in the studio, and personal memories and observations—and rendering the distillation of it in profound and beautiful ways, Kim presses against art-historical notions of abstract painting as only pure and nonobjective. In addition, Kim has also tried to make art accessible through the use of interpretive and supportive materials that accompany all of his paintings—straightforward titles, clearly written artist statements, and occasional supplemental texts—all of which subtly suggest how his paintings may not be so elusive or esoteric as first perceived.[31]

Abstractions of a meaningful instance in time and space, Kim's paintings are also representations of people and places, as in the case of *Synecdoche*, presented at the 1993 *Whitney Biennial*, and of *Whorl (Ella and Emmett)* (1997). At first glance, Kim's *Whorl (Ella and Emmett)* (1997) appears to be a monochromatic study, a meditation in browns and blacks that swirl and float in different directions (figure 2.9). The gentle swirl of colors with delicate flecks that seem to form a mysterious orb of infinite depth and then transform into a cosmic underground constellation reveals upon prolonged viewing an intimate portrait, the tightly rendered images of two hair whorls from the heads of Kim's children, Ella and Emmett. Blurring the boundaries of both portraiture and abstraction, Kim presents at once in *Whorl* a cosmic world and the viewpoint of a parent looking down at the familiar and the extraordinary.

Boldly refusing both modern art history's and neoliberalism's insistence on abstracting the specificity of human relationships and relinquishing direct participation in everyday life, Kim's art practice challenges the idea of abstract painting as a pure space and a refuge from capitalism and the social. What makes him an intriguing artist, but for some frustrating, and for others confounding, is how his conceptual art practice is not only driven by the desire to challenge abstract art's rarefied stance but

Figure 2.9. Byron Kim, *Whorl (Ella and Emmett)*, 1997. Egg tempera on panel—left: 4.25" x 4"; right: 4.75" x 4.5". Copyright the artist. Courtesy of James Cohan Gallery, New York/Shanghai.

also motivated by aesthetic concerns such as finding the perfect shade of gray to express the multiple layers along a picture plane.

How might we approach *Wall Drawings*, as a set of paintings, a tribute, or a site-specific installation of something else? In *Wall Drawings* Kim overturns misperceptions about gray's noncolor status—its neutrality—while at the same time offering a wry commentary on the current idea of modern art as a refuge from capitalism, the creative economy, and on Philip Morris as a corporate entity. Converting the invisible and inert fallout of everyday office work into a painterly force—drips of gray grime—that can be used to re-create Sol LeWitt's modular sequence of rectangular shapes, Kim shares what came before, citing recognized artists who have pondered the color gray—LeWitt, Robert Mangold, Gerhard Richter, and Marden—but then adds his own spin on the color by incorporating the gray space of Philip Morris itself as both setting and target (figure 2.10).

While Hsieh's performances occurred during a time of severe austerity in New York, Kim's site-specific installation at Philip Morris took place at the height of market expansion and corporate America's

Figure 2.10. Detailed shot of Byron Kim, *Whitney Philip Morris: Wall Drawings*, 1999. Installation at Whitney Museum of American Art at Philip Morris, New York, 1999. Image courtesy of the artist and James Cohan Gallery, New York/Shanghai.

108 | FORMAL ACTIONS

profligate spending. By the late 1980s, with the rise of a financial sector that drove a great deal of public policy and shifted the climate of the city to make it more hospitable to big business, Wall Street began to reinvest in New York's cultural scene as an opportunity to boost the economy. In addition to turning a quick profit, buying art created cultural capital for a rising economic class and a means to raise one's personal and professional profile. First conceived as an initiative to save public funds and reallocate tax revenues to other collective needs, the privatization of art spaces and museums in the form of public-private partnerships with major art institutions (such as Philip Morris's relationship with the Whitney Museum) became a project that radically changed the way art was not only funded but also seen.

In 1983, Philip Morris debuted its twenty-six-story, 650,000-square-foot skyscraper in the center of midtown Manhattan—on Park Avenue and Forty-second Street, across the street from Grand Central Terminal. The first of its kind, the Whitney Museum of American Art at Philip Morris (Whitney Philip Morris, for short) was a satellite gallery of the Whitney Museum. Adjacent to a fifty-two-hundred-square-foot, glass-enclosed atrium or indoor piazza (dubbed as a "sculpture court"), the gallery, while open to the public, was also seen as an integral part of Philip Morris's promotion to offer a better workplace and environment that "productively" blurred the divide between work and leisure and public and private.

During its twenty-five years of existence, the Whitney Philip Morris exemplified the growing corporate influence on the art market, naturalizing the relationships between corporations and museums.[32] Its corporate sponsorship for the arts enabled the tobacco company to rebrand its image from that of purveyor of a deadly product to one of generous art patron, underlined in a slogan that accompanied the gallery's opening: "It takes art to make a company great."[33] Between 1983 and the museum's close in 2008, a range of artists from Carolee Schneeman to E. V. Day exhibited at the gallery. Many of these artists, such as Sowon Kwon, used their commissions to comment critically on the space itself, expanding the parameters of institutional critique.

Magnanimous in its role in promoting "critical" and cutting-edge art making, the gallery space diminished or depolicitized such efforts and was seen more often than not as a ground-level means to enter into a tranquil

and contemplative space, a distraction or respite from workday drudgery and the chaos outside. Rather than reducing working hours, Philip Morris offered another perk, art, not as a means to improve skills or acquire knowledge that would then allow workers to move up in the company, but as an indirect way to "enrich" the self, presumably improve job satisfaction, and inspire and increase productivity. Kim's *Wall Drawings* highlight this paradoxical conceit embodied by the Philip Morris site. Merging the spirit of capitalism with the spirit of Ad Reinhardt, Kim takes on the invitation to occupy and animate the space of Philip Morris, offering both visual pleasure as well as insight in which the longer an observer spent time with his wall drawings, the more they revealed. Like the work of almost all the employees of New York City's Philip Morris office—administrators, executives, and artists commissioned to produce work for the gallery—Kim's immaterial labor had nothing to do with the actual making of a cigarette. But in contrast to the collective act of pushing smoking, paper, and people, Kim's muted gray drawings complement the surrounding urban architecture and, may I suggest, offer a portrait of this working world of unseen manual, temporary, and contractual workers.

While the temporary duration and site specificity of *Wall Drawings* would seem to dodge commodification, I concede how Kim's art making is nonetheless complicit with and constituted by the art market. Without the commission and support of Philip Morris, there would have been no *Wall Drawings*. Aware of the situation and the conditions that make his production possible, Kim reveals this tacit awareness and these relations not only by including the institutional and corporate name in his title, *Whitney Philip Morris: Wall Drawings*, and listing his materials—the vast bags of dust and detritus, produced courtesy of Philip Morris's corporate offices—but also through the work itself. Documenting his process during the installation of *Wall Drawings*, Kim dispels the romantic myth of the solitary artist passionately at work by humorously highlighting the mundaneness of making art. Snapshots located at the front desk of the gallery (rather than within the installation) picture Kim laboriously using a dish sponge and sheepskin to draw and inscribe his gestural abstractions and rectangular shapes onto the high walls of the gallery (figure 2.11). In contrast to Sol LeWitt, whose drawings require a team of assistants, Kim works alone. But he is not entirely alone; he enlists the custodial staff of Philip Morris to help him collect the materials

Figure 2.11. Byron Kim preparing installation of *Whitney Philip Morris: Wall Drawings*, 1999. Installation at Whitney Museum of American Art at Philip Morris, New York. Image courtesy of the artist and James Cohan Gallery, New York/Shanghai.

he applies on the walls of the gallery. The collective labor of Philip Morris not only comprises Kim's materials but also in turn becomes reinscribed and embedded in the walls of Kim's installation.

Much of Kim's gray matter is dust, itself a product of time and transformation, made up of the excess of human waste and skin gathered in corners and other fugitive spaces. In *Wall Drawings*, we see Kim's transformed raw materials as suspending rather than facilitating the production of capital, as his dips and swipes of a cloth sketch a sort of group portrait, an indexical trace of the rank-and-file laboring bodies that make up Philip Morris. We can also contrast Kim's piece to a now-celebrated work by Marcel Duchamp, *Elévage de poussière* (*Dust Breeding*), a collaboration with Man Ray that consists of a photograph of Duchamp's work *The Bride Stripped Bare by Her Bachelors, Even* (*The Large Glass*; 1915–1923) covered in dust. Kim's drawings are simply washed away with a water hose after the closing of his exhibition, his contract with Philip Morris expired, his job "done." Yet in a spirit similar to Duchamp's, Kim reveals the potential to see two different worlds within a single space, the

exalted and the hidden, and how the humblest commonplace materials can serve as a potential disruptive agent of change.[34]

Simon Leung: Unhomely Positions

Recruited by a number of art institutions in different cities—Vienna (1998), Chicago (1997), New York (1995), and, most recently, Guangzhou, China (2008)—as a representative agent of change and a service contractor, Simon Leung has been commissioned to reproduce *Squatting Project*, iterations of which he has taken advantage of by placing his work in situ, shifting the meaning of the piece over time.[35] I will focus in this section on the initial iteration of *Squatting Project* that took place on the streets of Berlin. Commissioned by nGbK (New Society for Visual Arts) in 1994, *Squatting Project/Berlin* was a site-specific response to the repatriation of approximately sixty thousand Vietnamese in 1992, many of them guest workers recruited from North Vietnam beginning in the 1950s, and the second part of a trilogy Leung produced between 1992 and 1998 to explore "the residual effects of the violence of the U.S. war [in Vietnam]" (figure 2.12).[36]

Squatting Project/Berlin consisted of two posters, mirroring the verticality of the city, placed alongside advertisements and announcements on mundane structures around the city: on brick walls, the sides of buildings and bus shelters, and utility boxes (figure 2.13). On one poster, Leung posed a set of propositions in German and English, asking viewers—Berlin's citizens and visitors—to do the following;

> Proposal:
> 1. Imagine a city of squatters, an entire city in which everyone created their own chairs with their own bodies.
> 2. When you are tired, or when you need to wait, participate in this position.
> 3. Observe the city again from this squatting position.

The other poster pictured, centered against a white background, a male figure squatting, wearing a grey hooded jacket, black pants, and black shoes (figures 2.13 and 2.14). Turned at a three-quarter angle, the partial profile reveals an Asian man, the artist himself.

Figure 2.12. Preparatory drawing of Simon Leung's *Squatting Project/Berlin*, 1994. Image courtesy of the artist.

Squatting Project/Berlin was inspired and conceived by an unsettling memory of his younger brother's, which Leung recounts in an article that he wrote about the piece in 1995:

> He was probably twelve or thirteen, waiting for the bus in San Jose, California, the suburban city where we grew up, with a few other people whom he took to be Vietnamese immigrants. What struck him about this otherwise innocuous moment, and perhaps what located the foreignness [sic] of these strangers for him, was the position of their bodies while they were waiting—they were squatting. . . . Although they were not squatting to call attention to themselves, that was exactly the effect as they rested their un(der)assimilated Asian bodies in a habitual position of waiting, incongruous with the sun-bathed sidewalks of a California suburb.[37]

Figure 2.13. Simon Leung, *Squatting Project/Berlin*, 1994. Image courtesy of the artist.

Figure 2.14. Simon Leung, *Squatting Project/Berlin*, 1994. Image courtesy of the artist.

Recalling this image, what struck Leung was his brother's calling out of the men's foreignness juxtaposed with their casual ease, the way in which their bodies were both unhomely and also so at home. The question of home has been a vexing one for the Vietnamese diaspora. Beginning in 1975, thousands of Vietnamese, Cambodians, Laotians, and Hmong were forced to flee their homes in the catastrophic aftermath of the Vietnam War. Faced with a growing refugee crisis due to a number of factors, including the miscalculation of displaced refugees and a rushed and ill-conceived resettlement plan, the United States called on the world for humanitarian aid and to serve as host countries; East Germany agreed to receive nineteen thousand refugees. The influx of these refugees made the Vietnamese population the largest ethnic community in the country at that time.

Already beginning in the 1950s, Vietnamese guest workers had begun migrating to East Germany, and thus were already a familiar presence, in contrast to their arrival in the United States. To help rebuild from the devastation of World War II and make up for the country's labor shortage, the East German government, under an agreement with the North Vietnamese government, began to contract large numbers of Vietnamese. Despite the understanding that their stay would be only temporary—initially only for five years—many Vietnamese decided to remain illegal or become legal by marrying German nationals. For some, Germany was "home," and for others returning was just not a viable option due in part to the instability of their home country, where the war for independence had become a massive effort not just against France but by 1955 against the United States as well.

Soon after the fall of the Berlin Wall in 1989 and the reunification of Germany, the Maastricht Agreement of 1991 was adopted, with a series of neoliberal reforms that included the privatization of a number of German state companies, resulting in soaring unemployment rates. Economic unrest and a resurgence of nationalism led to scapegoating and an increase in xenophobic violence against the Vietnamese community, sending a message that the guest workers had overstayed their welcome.[38] As a stopgap measure against spreading economic and civil unrest, the German government negotiated a controversial multilateral agreement with the Hanoi government to repatriate thousands of guest workers to Vietnam by offering them a free flight back "home" along with two thousand dollars in compensation.[39]

While approximately fifty thousand Vietnamese returned from Germany to Vietnam between 1992 and 1993, the German government engaged in a revolving door policy, in which thousands of Vietnamese expatriates from other Eastern European countries were allowed to enter Germany on a two-year visa as long as they already had jobs and possessed no criminal record. But, in a dramatic turnaround in 1994, the German government revoked the residence permits of all former Vietnamese contract workers, designating the entire group illegal immigrants. Released from their jobs, the Vietnamese guest workers who had made Berlin their home over decades, along with those who arrived in 1975 after the Vietnam War and the thousands of Vietnamese asylum seekers from other Eastern European nations, were forced to wait months in an occupational and residential limbo to learn about their individual status and their collective fate.

Recalling these foreign bodies who were invited to rebuild the nation-state and then quietly expelled without ceremony, Leung's *Squatting Project* posters served on one level as reminders, remnants of a daily practice in which the man in Leung's poster is neither protesting nor resisting but "merely waiting, hovering in a position between sitting and standing."[40] Underlining how squatting is a "position between pause and motion, sitting and something else" but also a signifier, coded as both language and an aesthetics of corporeality, Leung invites the observer to consider the multiple meanings and contexts of squatting: to read the squatting body as a text framed by another text, in this case, the city of Berlin.[41] On one level, squatting is a form of sitting that entails anchoring one's feet to the floor, bending one's knees, and lowering the hips and lower back to a crouching position almost to the ground. Utilizing the body's own use-value by transforming it into a chair and creating a place of rest, squatting is efficient, practical, and economical. In contrast to the way squatting is humorously perceived as cool and "Asian" in Daniel Hsia's mockumentary *How to Do the Asian Squat* (2002) (figure 2.15), the sight of the Vietnamese guest worker was seen as an eyesore in the 1990s and a source of anxiety due to shifting demographics, globalization, and the multi-billion-dollar restructuring of the city of Berlin, much of it spent on remembering the Holocaust and obliterating all traces of the post–World War II East German labor force and culture.[42] The hostility during this time against the Vietnamese transformed squatting from a "meaning without a code into an encoding of violence"[43] (see figures 2.14 and 2.16). Given the way Vietnamese residents

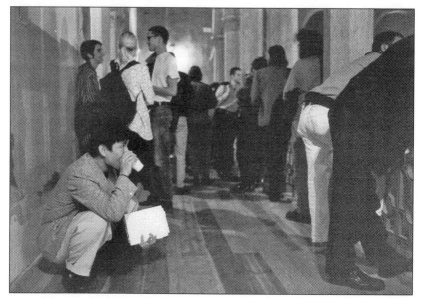

Figure 2.15. Snapshot of Simon Leung squatting. Image courtesy of the artist.

were forcibly removed from the streets either through repatriation or dispossession of home and livelihood, Leung's posters, which seemed to appear out of nowhere on the sides of buildings, utility boxes, and bus shelters, could be seen on one level as a return of the repressed, and subjected to a violence of interpretation[44] (figure 2.17).

In his essay "Squatting through Violence," Marcel Mauss mobilizes squatting as a means to organize the world between those who sit and those who squat. He characterizes squatting as a "technique" in which the body can learn to be at rest. It is a technique that Mauss notes "we" in the "west" no longer know. Describing the inability to squat as reflective of "an absurdity and an inferiority of our races, civilizations, and society," Mauss highlights that like sitting, squatting is something learned and trained, but also culturally relative.[45] Taking note of and inspiration from Mauss's call to squat, Leung conceives his propositions as a set of instructions analogous to Yoko Ono's *Instruction Pieces* but also as a readymade.

Challenging notions of taste, authorship, and the meaning of art itself, Marcel Duchamp conceived the readymade as nothing but the conditions "born out of indifference and chance encounter between an author

Figure 2.16. Simon Leung, *Squatting Project/Berlin*, 1994. Image courtesy of the artist.

Figure 2.17. Simon Leung, *Squatting Project/Berlin*, 1994. Image courtesy of the artist.

and object."[46] A readymade is an object that is recoded into a work of art through a process of inscription, of choosing and naming, transforming an ordinary manufactured object, such as a bicycle wheel or a urinal, and isolating it from its functional context. But more than a fabricated or found object turned art object, the readymade as conceived by Duchamp is always in "perpetual oscillation between its status as a thing and as a sign,"[47] destabilizing the relation between the object and its contextual frame. It is not only the object that is altered but also its context. Integral to this process, what Duchamp characterizes as a "creative act," is the role of the observer to inscribe and name the readymade as art.[48] He writes how "art is a product of two poles; there's the pole of the one who makes the work and the pole of the one who looks at it. I give the latter as much importance as the one who makes it."

The observer's task is to be on time for this rendezvous, but Duchamp structures the rendezvous with a number of delays—"planning for a moment to come (on such a day, such a date, such a minute), 'to inscribe a readymade'—the readymade can later be looked for . . . it is a moment to come (on such a day, such a date, such a minute)."[49] The readymade's rendezvous, as Leung underlines, always involves some lag time. As mentioned in the previous chapter, Duchamp has been and continues to be a major influence on Leung's art practice. Appropriating and merging Duchamp's readymade with Jacques Derrida's conceptualization of the arrival of the other in a time and place that differs from and defers the present, Leung figures the poster not only as a readymade but also as an invitation for a future rendezvous, a deferred encounter. That is, rather than assigning the responsibility to the observer to inscribe the readymade as "art" and determine the "weight of the work on the aesthetic scale," Leung refigures the hailing actions of the readymade as a call to an ethical relationship and the rendezvous as a metaphysics of waiting.

While current debates are often hesitant about the ethical turn in contemporary art that threatens the space of the aesthetic as a site of dissensus, I posit Leung's ethical proposition as a call to awareness and disjunction that presses against the limits of contemporary German law, its adoption of neoliberalism's version of "shock therapy" and rewriting of history, redrawing the boundaries and dividing the world into those who squat and those who do not. Underlining how squatting not only is

culturally relative but also operates as a signifier, coded as both language and an aesthetics of corporeality—a "position between pause and motion, sitting and something else"—Leung invites the observer to consider its multiple meanings.[50] Approaching the body as a text situated within another text, Leung invites us to read the squatting figure in the form of a sentence.[51] While in some places in the world, a squatting figure is a commonplace occurrence, in multicultural San Jose, California, the ritual made strange its suburban streets. With each backdrop change in each of Leung's *Squatting Projects*, the meaning of squatting shifts. For example, in *Squatting Project/Wien*, Leung is pictured squatting in front of a number of buildings all over Vienna, disclosing the real estate holdings and capital flow of the Generali Foundation, the arts organization that commissioned the work, and its financial sponsor, the Generali Group, one of the largest insurance companies in the world. In *Squatting Project/Berlin*, Leung squats in front of mundane places where his squatting creates a kind of counter-architecture, transforming sites in places where normally one would not be sitting and/or destabilizing the boundaries between public and private.

Leung's poster of the squatting figure raises the question of what it means to wait for some compared to others, connoting a second reading of his propositions as a metaphysics of waiting. What does it means to wait and take the place of the other? His invitation is not to occupy the space of the squatting figure—an impossible endeavor because to do so would mean to take the place of the other—but to occupy the text and consider one's responsibility to the other as well as the historical and political processes that designate a once-familiar sight—the squatting Vietnamese figure—as a stranger (figure 2.18). Creating an estranged space, then and now, the weathered posters, after they are gone, remain, cutting into the urban landscape, in a way that recalls graffiti's extralegal deployment, inviting us to see Berlin anew from a fresh perspective and read against the grain of the reigning nomos or law in order to envisage a world of squatting self-sufficient bodies along the city's streets (figure 2.19).[52]

Squatting also means to "surreptitiously occupy an abandoned space or building illegally or without permission."[53] How might we see Leung's propositions as revealing an ongoing occupation that reveals and reminds us of not only our rights but others' rights to be at home, and the shared condition of being human? As a site of defiance and assertion,

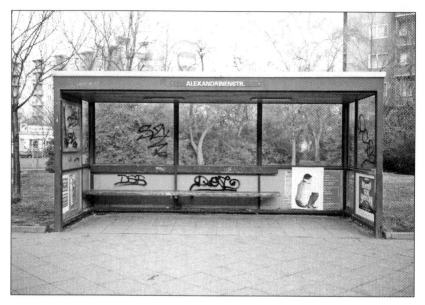

Figure 2.18. Simon Leung, *Squatting Project/Berlin*, 1994. Image courtesy of the artist.

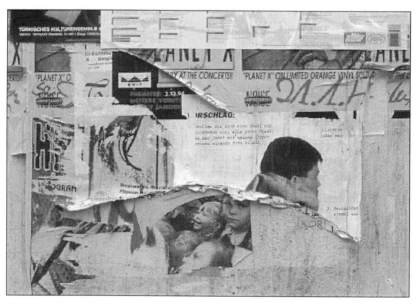

Figure 2.19. Simon Leung, *Squatting Project/Berlin*, 1994. Image courtesy of the artist.

squatting is not only a technique but also a tactical practice and a speech act, improperly occupying and claiming a space that is not one's own.

Occupying a commissioned space as a guest artist and "cosmopolitan border-crossing artist intellectual," Leung's *Squatting Project* also reverses the guest/host dynamic, complicating notions of hospitality. Hospitality is about making oneself at home, how one relates to oneself and the other's dislocation. The figure of the squatting worker sets up house, makes himself at home on the streets of Berlin, and exposes the contradictions of a world that is divided between those who squat and those who sit, and between those who squat and those who host.

While the fall of the Berlin Wall symbolized the spread of democracy and of economic and political freedom, neoliberalism's promise of access to flexible labor opportunities and flex-time arrangements has bypassed many, effectively expelling some into perpetual exile. Despite actively recruiting the Vietnamese in the 1950s to participate in training programs and rebuild the country, the German government was a poor host, contracting and assigning them to low-wage menial labor, segregating them in separate housing settlements, discouraging friendships between Vietnamese trainees and German coworkers, and allegedly preventing the settlement and formations of family.[54] After 1989, with Germany turning into an extractivist economy, the labor of the Vietnamese had not yet been full extracted. But instead of being expendable, the workers were surplus and denied both jobs and asylum. Authorities increasingly figured these model guest workers as increasingly idle, illicit, and lawless. Cigarette, flower, and food vendors were presumed to be fronts for organized crime, or part of an expanding and dangerous black market.[55] With few options to choose from—counter to neoliberalism's promise and promotion of labor flexibility and fluid mobility—the Vietnamese expatriate, unable to sell his/her labor power, becomes situated as a squatter, with a status that is neither guest nor host.[56]

In "Definitive Article in View of Perpetual Peace" (1795), Immanuel Kant describes how natural law endows all human creatures with the right to share "common possession of the surface of the earth. . . . [W]e cannot be infinitely scattered, and must in the end reconcile ourselves to existence side by side. . . . No one can in principle, therefore, legitimately appropriate for himself the aforementioned surface and withhold access to another man."[57] As long as the foreigner or stranger is neither treated

as an enemy nor sent to his/her death, he/she may be told to go his/her way. Despite outlining cosmopolitan law in such a way as to encompass universal hospitality without limit, Kant's conceptualization of hospitality, as Jacques Derrida underlines, is conditional; its ties to the nation-state, economic incentives, and laws of asylum and residency limit the conditions of the right of refuge for all immigrants and newcomers.

How does a conditional hospitality preclude and rewrite the roles of guest and host? Historically and into the present, Germany's guest worker program has been an example of "conditional" hospitality. Bound to a set of rules, obligations, and laws, the guest worker program is a temporary arrangement that is supposed to be mutually beneficial. Complicating the guest/host relationship, *Squatting Project* raises the question of how the guest worker turned refugee can be denied hospitality when the guest worker is forced to live in exile in his/her own body? Describing hospitality without conditions as signifying a reckoning with the dislocation of belonging, Derrida points to how a host is also fundamentally a guest.[58] Without a guest, the host cannot take on the role of being a host, of being at home: "[T]he host is fundamentally a guest in that his or her at-home-ness in the world is always in some way derivative and dependent."[59] Outside the juridical scope of the law, an unconditional hospitality creates a potentially violent situation, a requirement that the host relinquish his/her sovereignty, transforming the host not only into a guest but almost into a hostage, as, in Derrida's words, the subject "surrenders self-identity to and for the sake of others."[60]

The mechanics of the readymade are such that once someone sees Leung's poster, the encounter is always already conceived to be a missed rendezvous. But rather than seeing the poster as a missed opportunity, Leung leaves open the space of the encounter, approaching the rendezvous as a signifying deferral, a future possibility. In contrast to his brother, who saw squatting as a marker of difference and displacement, Leung draws from squatting's many meanings, and posits it here as a demarcation of belonging, being at home. That is, in correspondence with the Vietnamese guest workers whose squatting signified a sense of being-at-home-ness despite their exilic condition, Leung—a guest worker too, but in his privileged status as international nomadic artist—complicates in *Squatting Project* the precarious relationship between guest and host. By inviting the citizens of Berlin to squat beside him

as his guest, the poster, with its site-specific propositions, sets up the figure in the poster as both a host and a hostage. Pushing against the limits of representation and pure hospitality, Leung imposes a certain conditionality, and at the same time leaves it up to the viewer how to proceed and interpret this form of representation and precarious situation (figure 2.18).

Not idle at all, the selected artworks by Hsieh, Lum, Kim, and Leung are doing a lot, refusing the roles of long-suffering, alienated artist, model minority, service provider of experiences, and proxy and protestor of Asian immigrant exploitation, and in their own way resisting neoliberal attempts to stratify relations and intensify regulations of time, bodies, and events. Occupied in their respective art making, the artists are aesthetically engaged, pressing quietly against our common sensibilities of what counts as work and politics, who can work, and who can make art.

3

Gleaning the Art Practices of Simon Leung
and Mary Lum

In dialogue with the artworks in the previous chapter on the effects of neoliberalism, Mary Lum, in collaboration with Mary Beth Tauke, created *Remnant/Referent* and *Occupational Information* (1989–1999), a mixed-media installation at Hallwalls that focused on the city of Buffalo, New York.[1] Buffalo, once a thriving manufacturing metropolitan center with a busy rail terminal, became known in the 1970s and 1980s as a dramatic casualty of deindustrialization and part of the Rust Belt.[2] In October 1979, Paul Volcker, chairman of the U.S. Federal Reserve under President Carter, raised interest rates and instituted a number of austerity measures as a means to tackle high inflation and reverse the slowing down of the U.S. and global economy, an economy that was already vulnerable due to the OPEC oil crisis, the introduction of Japanese-made fuel-efficient cars, and the outsourcing of jobs with the transfer of industrial activity from the northeastern United States to the U.S. South, and then to Mexico and Southeast Asia. The Volcker shock reverberated throughout the United States as a corrosive force resulting in the total collapse of the steel industry and the closing of hundreds of factories. The city's abandonment by the state and federal government led not only to the breakup of organized labor—one of the primary targets of neoliberal reform—but also the mass exodus of Buffalo's urban inhabitants.

Covering the floor with hundreds of files comprising a sort of false floor, Tauke's installation served as a pathway to Lum's piece in the adjacent room. The second room was a mausoleum made of paper, filled with hundreds of obituary headlines from the *New York Times* glued together into fifty swaying strips, eleven feet long, that hung like garlands from the ceiling and walls, sixteen inches apart and connected to the studs of the building's architectural foundation (figures 3.1 and 3.2). While Tauke's pile of file folders frenetically scattered on the floor

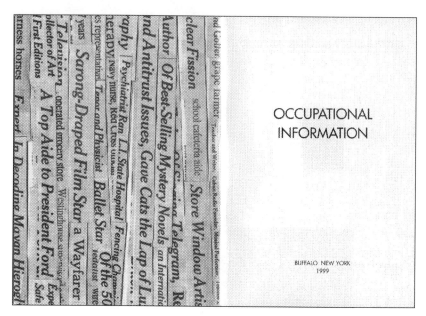

Figure 3.1. Mary Lum, *Occupational Information*, 1998–1999. Artist's book.

Figure 3.2. Mary Lum, *Occupational Information*, 1998–1999. Artist's book.

metaphorically referred to a lifetime of work or a Kafkaesque nightmare of bureaucracy and record keeping, Lum's room synecdochally represented the summation of a person's worth that comes at death.

The installation rendered an alternate world schema that took stock of the uncounted lives affected by neoliberalism and rendered the decline, abandonment, and death of an era, an industry, and a city.[3] On another level, the exhibition highlighted how framing a person's life, a building, a city can change the way something is seen and remembered, as in Lum's installation of cut headlines that reveal how an individual's life is remembered less by his/her human relations and individual idiosyncrasies than by his/her occupational title or profession. Concurrently with the making of this installation, Lum was also working on a series of drawings entitled *Historical Present*, re-presentations of front-page newspaper images. Using the *New York Times* as her source material, Lum collected and cut its front-page images between 1980 and 1991, categorizing them under general subject headings such as "fires," "terrorism," "natural disaster," "political figures," "the environment," "racial hate crimes," or "domestic abuse."[4] Stripping away the text and context of each image, but retaining the AP caption that accompanied the image as the title for each drawing of *Historical Present*, Lum reproduced the news event, rendering it in a familiar canonical style. Highlighting the beauty and the banality of these images, but also abstracting just beyond comprehension, Lum resignified the meaning of the image beyond its denoted "original" meaning.

For example, in *300,000 Join in the Largest Demonstration in South Korean History after Mourning the Death of a Student* (1987), Lum reproduces an AP photograph taken during the Kwangju Uprising in 1980—depicting protestors smashing the windows of a bus, with other demonstrators pumping their fists in the air—in overlapping diagonal planes and precise intersecting lines reminiscent of the cubist work of Georges Braque (figures 3.3 and 3.4). In the far right background, behind the bus, riot police can be discerned by a cluster of short vertical and horizontal lines. Using the wide diagonal of the roof of the bus to ground a viewer's point of perspective, Lum places positive and negative straight edges alongside composite sections of shaded triangles and block-like human forms to create an image that looks both familiar and strange.

Figure 3.3. Associated Press photograph, "300,000 Join Demonstration in Seoul after Mourning the Death of a Student," *International Herald-Tribune* (Paris edition), 1987. Image courtesy of Mary Lum.

The showing and telling of history, as alluded to in Lum's *Historical Present*, produces, in the words of Simon Leung, "a social space where the meaning and unity of the social (events, relationship, legacies, memory) are at once constituted": a seamless and banal presentation of society that, Leung warns, needs to be constantly "questioned."[5] In 1990, the twenty-four/seven coverage of the U.S.-led UN military intervention in Iraq and the invasion of Kuwait signaled a new mediatization and era of watching news about war and politics. Lum and Leung noticed in particular how the presentation of the Gulf War as spectacle changed our relationship to an event and a place in ways that seemed to fulfill a desire

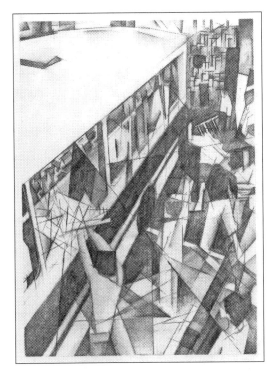

Figure 3.4. Mary Lum, *300,000 Join Demonstration in Seoul after Mourning the Death of a Student*, 1987. Graphite on paper, 7 3/8" x 5 1/8".

for proximity to what was going on "over there" in the Middle East, yet also dispassionately created distance from it, engendering an isolated and disconnected experience.

Leung, in particular, observed how the Vietnam War was not only discursively mobilized as a distant past and bygone event but also used to establish the terms under which the current war could be understood in terms of why the United States *had* to be there. While the United States was not the victor, but the loser of the Vietnam War, the re-presentation of the war in the United States enabled and legitimized its imperial forces to invade and occupy Kuwait, at the same time effectively foreclosing alternative perspectives and histories about the United States' role in the Vietnam War. Reminded of how the experience of an event is always mediated and recontextualized by images, and how the meaning of an image

is never wholly congealed, but always constructed by and contingent on its positioning, its captions, and its surrounding text, Leung began to explore "the residual effects of the violence of the U.S. war in Vietnam" by embarking on *The Vietnam Trilogy*. The first part of the trilogy was *Warren Piece (in the 70s)*, which took place at P.S.1. The second project was *Squatting Project*, which I discussed in the previous chapter, and the third and final part was *Surf Vietnam*, which I will focus on here.

For Lum, the 1991 Gulf War resulted in *Operation Desert Storm*, the last in her series *Historical Present*. Resisting the consensus of the media's presentation of the war as true, complete, and comprehensive and implicitly aware of the impossible project of seeing the present and of representing what is no longer present, Lum's body of work after *Historical Present* is less a search for truth than an ongoing aesthetic challenge to work with and through what Fredric Jameson has characterized as the "waning of affect," the dissipation of emotional states such as anxiety and alienation due to distraction—and "cultural schizophrenia."[6] Lum's drawings that hover between abstraction and representation are not cognitive mappings—a means to make her world intelligible and locate or position herself; rather, they are active responses to an increased sense of alienation and displacement that is contingent on being adrift and distracted, but also sharply attuned and alert.

While the artworks of Mary Lum and Simon Leung differ from each other in subject matter, form, and style, they share elements that allow us to bring them together in revealing ways. I have chosen to juxtapose these two artists in order to highlight how their aesthetic engagement and conceptual process entail gleaning representations, including the stray detail or excess remains of a narrative, and then resignifying them in ways that shift and disrupt the relationship between texts and their meanings, images and words from a given relation among signs, bodies, and places. To glean is to collect is to read is to interpret. The Latin and Greek etymological root for "reading"—"*legere*"—means "to pick, collect, or gather together." In this case it is a question of found images and texts, material that the artists manipulate and reconfigure anew, offering alternative interpretations, or setting up the construction for new representational possibilities. Their art practice could be best ascribed to *New York Times* critic Holland Cotter, who describes the art practice of Rirkrit Tiravanija in the same vein as "staying alert . . . extracting things

from the world, gently, and then putting them back, but with new meaning, like manipulated ready-mades." My reason for focusing on Lum and Leung, and not all three artists, or a different pairing or coupling of other contemporary artists, has to do with a shared investment also in the unconscious, specifically, for Leung, the psychic border between fiction and history, and for Lum, the "Unbuilt" and proper places.

Reclaiming history and memory are key concerns for Asian American Studies. Within the field, the "concept of history," as Christopher Lee notes, "remains primarily concerned with historical knowledge and social critique."[7] Gordon Chang underlines that one of the main aims of Asian American Studies is "to reclaim a minority voice, to uncover the 'buried past, to recover collective, lived experience.' "[8] Lisa Lowe describes Asian American culture in part as an articulation or refracted *mise-en-abyme* of "images, memories, and narratives—submerged, fragmented, and sedimented in a historical 'unconscious.' "[9] The two artists deviate from both these tasks insofar as their artworks do not uncover buried histories or bear witness. Neither does their art making concern itself with the assembly and interpretation of historical fragments to limn and recover a subjugated Asian American history or tableaux of loss and grievances.

Relying on the contingency of language, the mobility of signs, and the chance encounter and incidental detail, their recursive art practice of drifting and surfing, combining and recombining shifting layers and folds of images, unsettles sedimented readings and perceptions about a place or past by turning our attention to the residues of representations and human experience as points of entry to the unconscious and the "remains of what cannot come under the present."[10] Their artworks not only press against the senses in terms of how we think about certain events and places but also direct us towards a practice and technique that invite becoming more attuned to the imperceptible and uncounted in order to see anew space, place, and the world.

Where they part ways is their approach to the frame and their engagement with the content or meaning of these representations. Specifically for Leung, his focus on the rhetoric of the image aims to shift the frame of representation, revealing a yet unseen point of view, and in turn, opening up the space of conversation to others about how we approach the Vietnam War. In contrast, Lum strips the frame and extracts

the content, akin to the way a short story leaves out detailed accounts of an event or place. Contrary to a writer who does so to keep a story moving forward, Lum does so in order to confound a viewer's assumptions and projections and, at the same time, break wide open a space to reimagine and discover.

The first half of this chapter focuses on an analysis of select artworks by Mary Lum, beginning with an introduction to some of her earlier works in order to set up readings of her later and more recent abstract drawings and paintings, followed by a concluding discussion that approaches many of her drawings of places in terms of the "Unbuilt," a term borrowed from Homi Bhabha. The second half of the chapter centers attention on Leung's *Surf Vietnam*, a multilayered installation whose interrelated and overlapping components, configurations, and discourses engender a residual space in which to remember the Vietnam War. I conclude the chapter with some thoughts on how *Surf Vietnam* also offers a model of responding to the call of the other or, put another way, building one's capacity, cultivating an ability to respond to the other.

<p style="text-align:center">* * *</p>

I begin the first half of this section with a reading of Lum's *Final Results of Psychoanalytic Treatment* (1991), a mixed-media text filled with collaged and cut-out found words and phrases, as a means to introduce and establish her conceptual and working process. The text was part of a larger installation, *The Reading Room* (1992), that took place at INNOVA. Inspired by Aleksandr Rodchenko's Workers' Club, *The Reading Room* consisted of sixteen differently styled chairs surrounding a twenty-two-foot-long black enamel table in a red-and-black-painted room, dimly lit by four evenly spaced green library-style lamps that hung low from the ceiling; at each place setting, Lum placed a copy of *Final Results*.[11]

In *Historical Present*, Lum excises and abstracts content and context, representing the image in order to unsettle it, raising the question of what and how we know about an event. In *Final Results*, she reformulates this challenge by abstracting the meaning in this case not of an image and its representation of an event but of a text and its ideas, specifically, a 1925 Modern Library edition of Freud's *Outline of Psychoanalysis*. In *Introductory Lectures on Psychoanalysis*, Freud writes about the difficulty of translating one's dream thoughts into visual images, a task he analogizes with an

illustrator's challenging assignment to substitute a "series of illustrations" for a political article in a newspaper. Instead of offering a series of illustrations or presenting a one-to-one correspondence between her thoughts and what she reads on the page, Lum visually renders the difficulty of reading the text, of being constantly distracted. While aware of how distraction can be mobilized as a point of escape, denial, or fantasy, driven by desire and trauma, Lum cleverly turns this distraction to rework the terms of psychoanalysis by way of cutting out words, letters, and phrases of the source text, then spatially reconfiguring and collaging it in combination with different font sizes and styles. In the end, Lum offers in *Final Results* a viscerally textured rereading of Freud and his psychoanalytical terms, an experience akin to "dialing around on the radio [which] . . . abruptly shifts from one tune and mood to the next" (see figure 3.5).

The Final Results of Psychoanalytic Treatment also offers an exemplary model of Lum's conceptualization and deployment of slippage, a playful appropriation of Freud's concept of parapraxis, as a means to enter into

Figure 3.5 Mary Lum, *The Final Results of Psychoanalytic Treatment*, 1991, pp. 108–09.

the unconscious. In *Psychopathology of Everyday Life* (1901), Freud defines parapraxis as slips of the tongue, failures of memory, or hiccups in decorum. Generally seen as an error of speech, saying the wrong thing involuntarily, or divulging something repressed, parapraxis exposes the layers of meaning beyond the initial enunciation. Analogous to the psychoanalytic session, where a patient may jump from topic to topic, *Final Results* evokes a reading experience that is constantly going off track and topic, leading not only to the generation of slips of the tongue, jokes, and dreams due to the subject's lack of full control of his/her speech but also to a loosening from the subjugation and regulation of the official discourse of psychoanalysis with its oppressive narratives of the oedipal complex and female sexuality.

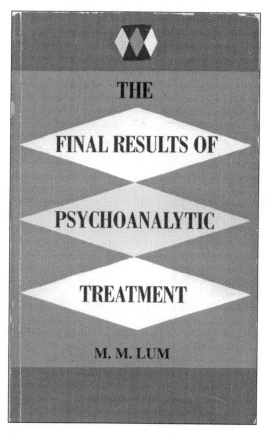

Figure 3.6. Mary Lum, Cover of *The Final Results of Psychoanalytic Treatment*, 1991.

Excising and restructuring the book's 128 pages, Lum keeps intact the retro red spine and the off-white margins that had framed the original text, replacing the cover with that of the 1953 Signet edition of J. D. Salinger's *Nine Stories*, a colorful harlequin-like diamond pattern of white, yellow, red, and gray (figures 3.6 and 3.7). Its text reformatted to look like a play, *Final Results* opens with a table of contents written in various typefaces and fonts—(*Parte II*); TROISIEME PARTIE; ACT IV; SCENE FIVE; VII; 8; nine—and with a set of stage directions in the epigraph of chapter 1, titled "The Elements":

A few chairs, a little table.
discarded Sunday papers **It has rained**
all day. *The sun has just set. A concertina*
plays in the street,

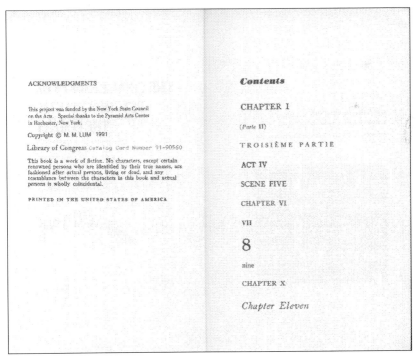

Figure 3.7. Mary Lum, Table of Contents of *The Final Results of Psychoanalytic Treatment*, 1991.

The opening line, "Every psychoanalyst finds that it is very difficult for his patient to reconcile himself to the very discovery of his hidden instinctive cravings," is followed by what begins as a series of lectures on psychoanalysis. But after a couple of pages, the text unravels into psychobabble: a mélange of words, fragmented sentences, and sections of phrases culled from a variety of sources, including romance novels, comic books, plays, foreign-language textbooks, and a Chinese newspaper printed in Mandarin.

Like the workings of free association and the vagaries of the unconscious, non sequiturs, changing typefaces, and different languages interrupt every other word and sentence in *Final Results*. The following example begins with an address about truth and appearance, which is then disrupted by a description of the speaker taking a snapshot, which then leads to an opaque allegory about truth and fantasy.

> Ladies and Gentlemen: It is not easy to tell the truth, especially when one must be brief, and so today I must correct an incorrect artistic effort I made in my last lecture. *(Takes a snapshot)* . . .
>
> The whole problem of freedom *appears at the window*. From the moment he learns to recognize that in his inner-love, nor acquired full connection with it. If imagination takes possession of it, *comme il faut*. easily become the world in which it truly lives. It is by no means unusual that a child is not even able to separate fantasy from *sitting down to* entire sincerity . . .

Throughout *Final Results*, Lum disrupts the syntactic and semantic structure of each chapter, creating contextual confusion while at the same time interrupting the "recommended" psychoanalytical treatment. Responding to the psychoanalyst, who is himself constantly distracted, failing "to hear the things of most importance," Lum resists his direction by creating a structure of delay and distraction, forcing the reader to slow down by diverting his/her attention from the narrative to the arrangement and sequence of words on the page.

Analogously to *Historical Present*, in which she abstracted an image of a news story vis-à-vis formally recognizable means, Lum visually renders the symptoms in each of the chapters of *Final Results*—including

"Lightning Calculations," "The Effect of Distraction," "Forgetting during Sleeping and Waking," "Blue Period," "Idiot Savants," "Concealing Memories," "Night Blindness," "The Elopement," "Indirect Discourse," and "Backgrounds"—through a series of fonts, layouts, and other visual elements. For example, in "Backgrounds," the words on the page seem to take on a life of their own; slippery thoughts appear out of nowhere in the form of a circular cutout of words. Commanding a significantly larger font and pushing aside or obscuring the rest of the original text on the page, the words seem to take on a life of their own (figure 3.8). Here the circular substitution of words interrupts a discussion on prejudice that loosely and briefly coheres. Compulsive thoughts literally seem to press and push through the surface of the text. In all the chapters, the form and arrangement of the text distract from the content, including, in "Idiot Savants," a mutiny of displaced words presented in a collage

Figure 3.8. Mary Lum, *The Final Results of Psychoanalytic Treatment*, 1991, pp. 112, 113.

combining French, Russian, Greek, and Chinese characters, and in "Indirect Discourse," the literal splitting of sentences resulting in an absurd, almost impossible reading.

In the appropriately titled "Chapter 11," Lum exposes the bankruptcy of psychoanalysis, or at least of the casual treatment model of analysis and interpretation, along with the problematic power dynamics between analyst and subject.

> . . . we may console ourselves with the obvious fact that our good results are *de facto* far-reaching and much more effective than they appear on the surface to be. For many patients who leave us apparently uncured, do, after a short period of **generosity**, effect a self-cure, or are healed by **a passionate desire**, sometimes even by some quack.
>
> This is the final result which the psychoanalyst must from the beginning bear in mind. He who has learned this secret holds the key to the greatest possibilities of successful treatment.

Neither abandoning psychoanalysis nor directly challenging the authority of the analyst, Lum takes matters into her own hands in the last two paragraphs of *Final Results*. There she proposes to the reader the need to be aware of the multiple desires and drives that underlie all perceptions, and in turn how they are reinscribed or reproduced, and reflected onto the social. The emphasis on the word "final" in the title, as well as some of the content in the back matter of the book, in which Lum inserts found and fabricated advertisements for get-rich-quick schemes as a comment on the rise and development of self-help literature, hints at the ways in which *Final Results* is both a critique of psychoanalysis as an overarching theory and an acknowledgment of how it can open up a multiplicity of ideas, experiences, and connections and help us make "sense" of our meanderings and wanderings.

Tracing the City

> When walking or driving in the city it is sometimes possible to detect the poetic subconscious of the place, the thing we cannot see but can only occasionally access through feeling. The sharp attention required for

THE ART PRACTICES OF SIMON LEUNG AND MARY LUM | 139

this experience comes from extensive looking (for nothing in particular),
walking without distraction but implicitly always distracted.
—Mary Lum

Whenever Lum took a walk, she noticed how she was "always thinking
of other things, no matter how subliminal or transparent," comparable
to her experience of reading Freud. Since 2000, Lum has been commit-
ted to walking and reading the city as text, a practice she calls "tracing
the city." Paying special attention to mundane places, urban elements,
and architectural details that we pass by every day, Lum's walking is a
constant detection of the poetic subconscious of place, "thing[s] we can-
not see but can only occasionally access through feeling."

As discussed in the previous chapter, Lum, like Byron Kim and Simon
Leung, is part of a growing network and circulation of artists who are
able to create work *elsewhere*. Taking advantage of her proximity to Bos-
ton and New York City and participating in residencies in Paris and
London, Lum has been privileged and able to aimlessly wander the
streets of these major metropolises, collecting the ephemera of urban
life and its poetic undercurrents and minute visual details that usually
pass unnoticed or are taken for granted: the different colors on the side
of a nondescript building, the patterns of a set of windows, a reflection
of the street in a storefront.

Art historian Steven Nelson characterizes Lum's ambulatory practice
of collecting scenes and images as flânerie. Dating back to the nineteenth
century, flânerie has been historically understood until recently to be en-
acted by a flâneur, a privileged bourgeois male, who had the means and
time to stroll in the cities of Paris, London, and Berlin and the deftness
to translate the signs, sounds, and images of everyday life into a narrative
or visual presentation—a painting, drawing, or photograph—in addition
to being, in the words of Anke Gleber, a "reflective critic of [the] city, a
close analyst of its architecture . . . a collector of scenes and images."[12]
Experiencing the thrill of getting lost in the crowd, while simultaneously
feeling a sense of profound loss, the flâneur became an iconic figure: a
consequence and a casualty of European modernity. The flâneur being
aware and capable of reading beneath the teeming streets and making
legible the changes effected by modernity—the accelerated exchange of

bodies and commerce and capitalism's reorganization of space—his actions were mythologized as slowing down the flotsam of distraction, but not enough to prevent his alienation, and eventually his own demise.[13]

Lum's drifting, scavenging, and recycling also recall one of the flâneur's contemporaries, the rag picker, who picks up the refuse, the unwanted, the overlooked, and the forgotten, and then gives it life in another form or use. Anonymous and marginalized, the rag picker "subsist[ed] largely on his status as a public witness."[14] Lum bears witness to the ordinariness of things, but also that which cannot be seen, covered over, or forgotten by the ongoing destruction and construction of buildings driven by a purported need to sustain economic growth and improve the city's capacity and efficiency to further the well-being of its citizens.

Formally, her art practice of scavenging draws from a number of art-historical traditions that include one of her major influences, Allen Ruppersberg. Scanning and gleaning from the streets amid an onslaught of stimuli and debris, Lum also shoots pictures while she wanders, taking advantage not only of the way the camera expands her range of visual perception but also the way a photograph can become a text and an imprint of the world, laden with memories and details that are present yet hidden, evident yet not always what they seem. Sharing with Ruppersberg not only a proclivity to take postcard-like photos of mundane façades, an abandoned set of chairs, or a run-down motel lobby, she also shares with the artist an investment in being attuned to the everyday and mundane—its capacious open-endedness and anything-can-happen signification. Many of her initial sketches and snapshots, taken from different angles, heights, and perspectives, depict overlooked elements embedded in the architecture, on the streets, and along the thresholds of doors, windows, stairs, and hallways she passes or enters. Her archive of images of major world and domestic events has been replaced by hundreds of shots of urban and architectural details taken during her meanderings: the corner of a building, a reflection in a café window, a worn staircase. Back in her studio, Lum develops her negatives, reviewing the drawings and photographs she creates of her peripatetic experience. She then processes them by formally and instinctively curating this source material into mini-exhibitions within photo albums, in a manner akin to Ruppersberg's

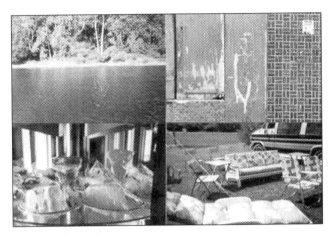

Figure 3.9. Mary Lum, Photo Album.

arrangement of everyday pictures of interior and exterior landscapes in his *Drawings* and photo books produced in the late 1960s and early 1970s (figure 3.9).[15]

Lum does not stop there, however. After "noticing things," she "acts" on them, "making manifest the transitional possibilities of every mark, object, and idea." Her elaborate process entails an intuitive stripping and distilling of context, similar to the process she employed in *Historical Present* and *Final Results*. Stacking segments from each drawing or photograph into sets of two or three, Lum proceeds to arrange these cutouts onto a page, demarcated into "positive and negative volumes, shapes," and then transposes these outlines into pencil drawings, where they become living lines. These living lines of remnants and referents recall Moyra Davey's befitting description of her photographs as an "accident with possibilities." They also become signifiers that Lum arranges and superimposes to construct spatial imaginaries and multilayered abstract structures.[16]

Intimate in scale—eight by ten inches—*Slip 35* is an array of intersecting vertical lines and planes arranged flush against a white wall. The combination of intricate layers creates a sense of texture and depth. On the left of this ghostly schematic cityscape (figure 3.10) is a large rectangular structure, which includes a slight curvilinear shape that appears to be made of glass windows and a large entrance hallway or area.

Figure 3.10. Mary Lum, *Slip #35*. 1999. Collection of David Deitcher.

Overlapping both structures is a tall skyscraper with a yellow-green strip running through the middle of it. On the far right is the diagonal profile of a building, and off to the left side appears some scaffolding or perhaps the side view of a covered patio. On top of the overhang, tilted toward the left, are two structures with open passageways that offer a glimpse of the large glass building in the background. On the bottom left is a cluster of vertical rectangles that look like books on a shelf, or perhaps a different overall perspective on the building above. In contrast to the assumed solidity of a built environment, however, the outlines of buildings in black gouache seem to be leaning, threatening to collapse onto the curved portion of a grid-like play structure.

Slip #35 (figure 3.10) is one of several drawings in the series that hint at a familiar landscape and elicit a kind of déjà vu, provoking the desire to draw from one's memories of the familiar and insert a narrative, or to read the lines connotatively to make sense of the interrelations between the intersecting and overlapping structures. While Lum's reticulate drawings are localized mappings of a certain city, they do not guide us to any one point or place. Nor are they mappings or recordings of her

walks in the city, but rather of sentient experiences and the vicissitudes of everyday life, or what curator and writer David Deitcher describes as the "inner life of an urban dweller's multiply-divided consciousness . . . an interface between perception and consciousness."[17]

In this way, the drawings are a kind of psychogeography not unlike the one that the Situationists formulated as a mapping of ambiances and alienating effects of the urban environment, one of several exercises that promoted new forms of experimental play that would inspire an individual's creative capabilities in his/her daily interactions with the city. Founded in 1957 and active until around the early 1970s, the Situationist International emerged as a response to postwar consumer culture and the homogenization of the urban landscape brought on by the encroachment of transnational capital and the functionalism of urban development. This revolutionary cultural collective, made up of different radical groups all around Europe, shared a vision aiming to dissolve the compartmentalization of art and life, public and private, work and leisure. In contrast to the Surrealists, their aim was not to aestheticize life or turn inward but to create situations that would lead to collective agitation, and ultimately revolution.

In spirit and practice, Lum's art making complements the Situationists' conceptualization of *dérive*, which Guy Debord describes as embarking "on a passional journey out of the ordinary, to wander the streets randomly with abandon."[18] She rises to the challenge of not only getting lost and letting go of the "usual motives for movement and action," but through her art making she invites the viewer to do so as well.[19] By removing the frame of a cityscape, neighborhood, park, and corner, thus creating a negative contour, and collaging her living lines and remnants intuitively and aesthetically, Lum creates an ambient situation—a space for psychic possibilities to emerge and erupt.

At first glance, *Superslip* looks like the scaffolding of a cluster of buildings or the schematic blueprint of a town or city (figure 3.11). Yet upon closer inspection, the line of storefront-like shapes and the gray outline of two smaller building structures in the far background are not unstable and disorienting but swerve in a way that requires the observer to move back and forth between background and foreground. Overlaid against this intricate scene is a cutout in muted green tones of what appears to be a larger roof-like structure. To the left, we see a set of stairs

Figure 3.11. Mary Lum, *Superslip*, 2004. Gouache on cut paper.

or possibly a dais. Placed diagonally over this bleacher-like structure is a house or structure slightly tilted in diagonal opposition to the direction of the stairs. By fastidiously abstracting a place, stripping, and then positioning a building on its side, Lum reconstructs the urban environment to become something new. Setting up multiple formal entry points into her work, Lum invites the observer to resist the impulse to name and know what a particular shape represents. As with the reading of *Final Treatment*, in which letters, words, and phrases are made strange and are almost impossible to read and apprehend in the conventional sense, in *Superslip* Lum invites viewers to drift and at the same time focus in their engagement with the work, to go ahead and follow a set of lines that dead end, or to take a step back and then be drawn in again by the different colors and shapes, lines and forms.

In comparison to the flâneur, who has been widely discussed as being able to critically see the effects and symptoms of modernity and capitalism, and the Situationist International, with its romantic undertaking for total revolution and the reclamation of space through playful experimentation and spontaneous revolt, Lum's constructed situations are more modest but, I want to suggest, just as resonant and resistant. Compared to the spare and schematic structures of her earlier *Slip* drawings, meticulously cut components on paper, that appear ghostly, seemingly about to slide through a wall and disappear, Lum's other bodies of work—*Multiple*, *Fold*, *Situation*, and *Condition* and more recent

paintings—are chaotic and condensed, saturated with color and replete with drama and texture.

Against a flat banana-yellow plane, composed of old comic books found in old Paris flea markets and *bouquinistes*—in which Lum pares down the narrative elements by removing the frame of the comic panel or using the edge of it—reassembled with strips of cut-out photographs of building façades and interior spaces, *Condition 1* is on one level a vertical assembly of motley scenes composed of debris and clutter that are about to collapse, explode, or spill off the page, an architect's worst nightmare. Working in contradistinction to the urban planner and the architect, who seek to create a fixed space that conditions and abstracts the interior lives of the city's inhabitants, Lum is constantly throwing a viewer off balance, formally thwarting his/her ability to embrace a scopic possession or perspective of a particular place or abstracting space. Critical of recent standard practices in urban planning and development of replacing one building for another, Lum's spatial and formal art practice of stripping and recycling the content of her living lines is not about producing something new but about challenging a given perceptual apparatus (figure 3.12). Her drawings offer a pleasurable but critical exercise of extended looking that at the same time, I want to suggest, gives us a set of tactics to destabilize our complacent knowledge and experience of given spaces and representations, and to see not just a building with a familiar name on it, but the overlooked details of the building and its surroundings. She invites us not to see a space but almost to see through it, to sense the frozen unrest of living lines as an indiscernible force.

In other works, Lum takes advantage of the way a graphic artist uses color and line in a comic strip to suggest action or a heightened sense of emotion. Turning architectural elements on their side, Lum transforms a window frame, a receding passageway, a doorway, and a stairwell, former transitional spaces, into something else, mobilizing them to serve as points of entry or "slips" into another dimension and space (figure 3.13). Take, for example, Lum's arrangement of multiple assemblages in *Group 3* (2009), a kind of mashup of several works: two photographs and two collages (including *Thirteenth Fold* and *Fourteenth Fold*), placed horizontally, off-kilter, above a photograph of two building structures—one brown, lined with rusting copper, and the other a black-tiled, wooden structure connected by terra cotta water or gas pipes (figure 3.14).

Figure 3.12. Mary Lum, *Condition 1*. Acrylic on birch plywood. 30" x 40". Collection of Brooke Gladstone and Fred Kaplan.

Selecting, paring, and recombining multiple folds of an image, Lum places in the center—next to the collage *Fourteenth Fold*, which depicts part of a bright green trash bin next to a colorful café or restaurant—a photograph of a window reflecting an indiscernible street scene. Inverting the divide between inside and outside and making strange the conventional thresholds of a building—entrances, exits, windows, doors, and staircases—that control the flow of movement, the perpendicular and diverging geometric planes and maze-like lines in *Fourteenth Fold* converge and then go off in disorienting ways, leading to a staircase or a platform amid a red void, into a green labyrinth or between two doors to an expansive background of sky blue. Drawing the viewer's gaze to rest and making it possible to recognize familiar elements such as a trash can and a store window, Lum immediately distracts us by encouraging our eye to wander elsewhere, so that the scene is resignified to mean

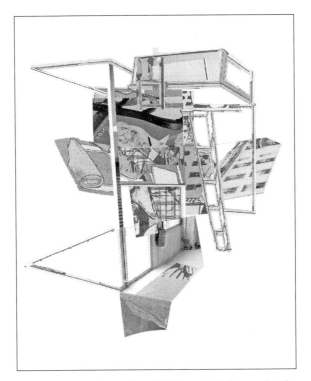

Figure 3.13. Mary Lum, *Second Fold*, 2008. Collage, 10" x 8".

Figure 3.14. Mary Lum, *Group 3*, 2009. Acrylic, photo, paper. Variable dimensions.

Figure 3.15. Mary Lum, *Eighth Fold*, 2009. Acrylic, photo, paper. 10.95" x 8.49".

something else, transporting us to another place and spatial order that we cannot yet see, a residual space of a past that is not yet past. By doing so, Lum opens and sets up the possibility for a whole new range of psychic and material relations.

Surfing Vietnam

Sharing with Lum the practice of gleaning and manipulating existing representations and undoing the "representative relation between text and image," Leung sets out in *Surf Vietnam* to unsettle the signifier of Vietnam. Troubled by the way the United States was mobilizing and incorporating Vietnam as part of its logic to invade Iraq, repressing other narrations about the Vietnam War, but also by the way one could almost be there, in close proximity to it, on the television screen, apprehending the violence, and being able to withdraw from it, Leung presents *Surf Vietnam* as a residual space of the Vietnam War. Drawing from essays by Kelly Dennis, David Joselit, Marita Sturken, and the artist

himself, the following is a descriptive commentary on *Surf Vietnam* with a focus on Leung's and his collaborators' aesthetic intention to shift the narrative about Vietnam by creating "new vocabularies of form."[20] On another level, the chapter continues the discussion from the previous chapter regarding Leung's art as an invitation to a rendezvous, a future encounter. Extending Leung's rearticulation of Duchamp's conceptualization of the readymade as a rendezvous, which he reconfigures as an ethical encounter, I want to consider how this set-up can be a means to cultivate an ability to respond to one another and art in general, an "initial" means towards understanding our responsibility for the other.

Commissioned by the Huntington Beach Art Center, *Surf Vietnam* was a seven-week-long multimedia installation and collaboration initially inspired by what one critic described as "a strange stew of cultural beliefs innocently revealed in a newspaper article."[21] The article was "Surf's Up at China Beach," published in the *New York Times* Style section on September 13, 1992. Chronicling the participation of a delegation of young American surfers attending an international surfing tournament in Vietnam (figure 3.16), the story centered on a place known as "China Beach," which was "the R. & R. center in Danang, the place to go to after you were shot down . . . the place to kick back with a beer . . . a little bit of Honolulu . . . only with barbed wire," as recounted by Dave Ferrier, a U.S. Army helicopter gunner during the Vietnam War.[22] Accompanying the *New York Times* story was a grainy image from Francis Ford Coppola's film *Apocalypse Now* (1979) depicting a U.S. soldier

Figure 3.16. "Surf's Up at China Beach," *New York Times*. Image courtesy of Simon Leung.

surfing against a background of warplanes destroying a Viet Cong village with firebombs and napalm. The caption reads, "China Beach, where *Apocalypse Now*, above, was filmed."

At the time the story appeared, Leung noted the misleading caption and the disjunction between the image and the article's text, the mixed or unintended messages the article was conveying, and its contemporary reality, given the United States' then punitive economic sanctions against Vietnam. Between the fall of Saigon in 1975 and the normalization of relations in 1994 during the Clinton administration, the United States responded to its defeat in Vietnam by placing a devastating trade embargo on a newly formed nation whose land and economic infrastructure had been ravaged by sorties of U.S. bombs and chemical warfare over a twenty-five-year period. The embargo included an injunction against any and all business ventures. This forced Francis Coppola to film his surreal meditation on the Vietnam War in the Philippines, far from the shores of China Beach, where the newspaper photo caption erroneously placed the shoot. The *New York Times* feature omitted any mention of the U.S. embargo and how repositioning China Beach as a welcome destination for surfers was paradoxically considered a positive turn of events by a Communist country desperate to rebrand itself and promote a fledgling tourist economy. The evocative image of young men waiting for a perfect wave in an endless summer not only reinforced Vietnam War redemption narratives but positioned the United States' patriarchal return to Vietnam as naturalized and necessary, a revised image in which the young American men were over there this time to teach "Charlie" how to surf. These contradictions, which become the article's ambivalent subtext, along with the slippage between fact and fiction inflected in the caption and image, and the casual lifestyle or light human interest story—what Leung characterizes as "media debris"—set the stage for *Surf Vietnam*.

Using the article and its remains as source material and centerpiece, *Surf Vietnam* was comprised of six discrete overlapping and sequential installations that changed weekly over a seven-week period. Each installation in *Surf Vietnam* revolved around the interpretation and visual articulation of the *Times* article vis-à-vis the arrangement of nineteen surfboards in different configurations in the main gallery. On one side of the gallery, Leung also placed an ongoing video triptych made up

of three videos—"China Beach," "Throwness," and "Surf's Up." Shot in three different locations—San Francisco, Vietnam, and the Huntington Beach Pier—Leung's videos highlight the way "China Beach" has been referred to as a simulacrum but also as a place of return, as alluded to in the misidentified location where *Apocalypse Now* was shot. In addition, he points out China Beach's multiple significations and identities. Now known by Bay Area residents as a local beach destination, China Beach was formerly named Phelan Beach, after James D. Phelan, former mayor of San Francisco between 1897 and 1902. Historically, the area was also locally known to be the cove where Chinese fishermen anchored their junks and camped until they were expelled and excluded from the beach, the fishing industry, and California in the 1880s with the passing of the Chinese Exclusion Act. After many years of advocacy seeking to claim and recognize the history and presence of Chinese Americans in the California landscape, the beach's name was officially changed to China Beach in 1983. Starting in 1965, during the Vietnam War, China Beach, however, had already been used as a code word, designating one of the largest U.S. military bases in the country, a frequent first stop for newly arrived American troops. In the 1980s, China Beach was the fictional setting and title for the popular television series *China Beach*. And in 1997, a couple of miles from the military base that once bore the name, the $35-million luxury resort China Beach opened along the coast of Danang, which has become a prime tourist destination.[23]

Analogously to the way he approached the signifier China Beach, Leung drew out the multiple meanings of "surfing" and its relation to Vietnam, specifically its signification as a place to surf. Raising the question of what it means for these surfers to return to Vietnam and placing this question front and center, Leung imprinted and inscribed the *New York Times* article on the center of nineteen surfboards, literally blowing it up to cover the seven-foot-long glossy surfboards sanded out of rectangular foam banks.[24] The number of surfboards in the set—nineteen—was meant to correlate both with the length in years of the U.S. embargo against Vietnam and with the average age of the American soldier who fought in the conflict.

Taking place at the Huntington Beach Art Center, *Surf Vietnam* (1998) opened with the first of three installations created by Leung,

who parsed and parceled out select keywords and quotations he culled from the *New York Times* article "Apocalypse Now": "The Vietnamese are waiting for us to come"; "The kids really enjoyed getting up on the board." With each interpretation, informing the form of the installation, Leung's first installation commented on Hollywood's role in reinforcing the United States' re-presentation of the war and its frequent use of a plot device that is now known as the "return to Vietnam." Producing films that project and place the United States at the center as both victim and hero, offering redemption and a different denouement to the Vietnam War, is symptomatic of what Rick Berg and Kelly Dennis point out is the need for the United States to represent the war on the basis of a double loss: losing both the war and the right to represent it. Unable to acknowledge this double loss, as doing so would mean accepting accountability for all the wrongs perpetrated before, during, and after the war, such movies continue to proliferate. Hollywood films are one form of this disavowal and denial, producing an excess of representations of the Vietnam War at the psychic border of fiction and history.[25] The film image of *Apocalypse Now*, together with the inaccurate *New York Times* caption, is another example of this excess of representation, which Leung recombines to re-create his own version of *Apocalypse Now*. But unlike this emblematic scene, in which a sortie of U.S. Army helicopters led by Lieutenant Colonel Bill Kilgore swoops down to bomb a seaside village with Richard Wagner's "Ride of the Valkyries" blasting out from helicopter-mounted speakers, Leung's installation is silent and foreboding (figure 3.17). Hung from the ceiling in a tight V formation, nineteen surfboards cast shadows on the gallery floor, foreshadowing the impending arrival of the United States, of bloodshed, of death. From another perspective, the V shape could be seen as symbolizing the peace sign or the letter V for victory or Vietnam. In the second installation, Leung leaned all nineteen surfboards against a wall, projecting and eliciting responses to the quotation, "The Vietnamese are waiting for us to come" (figure 3.18). In "The kids really enjoyed getting up on the board," Leung arranged the surfboards so that they overlapped one another in the form of a wave (figure 3.19). The neat arrangement of surfboards on the floor could be read in multiple ways, including as a fallen stack of dominos, referencing the "domino theory," the hysterical basis for the position that U.S. military intervention was needed all over the world.[26]

Figure 3.17. Simon Leung, *Surf Vietnam*, 1998. Multimedia installation. Dimensions variable. Image courtesy of the artist.

Figure 3.18. Simon Leung, *Surf Vietnam*, 1998. Multimedia installation. Dimensions variable. Image courtesy of the artist.

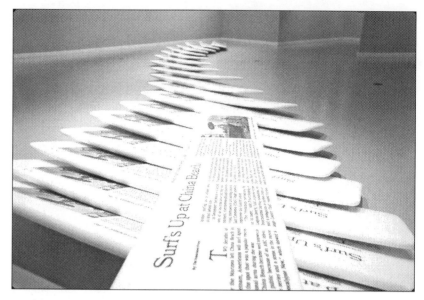

Figure 3.19. Simon Leung, *Surf Vietnam*, 1998. Multimedia installation. Dimensions variable. Image courtesy of the artist.

The next three installations were commissioned by Leung and completed by local community members in and around Huntington Beach. The members were arranged in three groups, their "identities forged through violence, and the subsequent movements of people—veterans, deserters, refugees, and immigrants." As we know from documentation provided in other contexts, Leung's initial proposal to the Huntington Beach Art Center was taken to reflect Leung's own identity and experience. The misrecognition of Leung as Vietnamese (he is Chinese) led to a spurious attribution of authenticity, followed by institutional support, and an exhibition, opening up an unexpected opportunity to enter into the regulated discourse about the Vietnam War, and to extend the opportunity to others.[27] Experiencing literally how identity politics—or in his preferred term, a "politics of difference"—operates, specifically how one's "identity is conveyed through the body . . . how each identity, once we name it as such, already gives us a narrative in the collective imagination," and well aware of how bodies accrue meaning historically and discursively, Leung answered the call, a strategic response as a way in to negotiate "between identities," "a kind of speech act," and a

"procedure."[28] Engaging a politics of difference as less a preemptive bind and more a point of entry and opportunity, Leung approached the categories as temporary ciphers that, if they wanted, the participants could slip out of and in their own way choose not to represent something (for example, his experience connected to the war, of which he had none) but *do* something: create another re-presentation about the war.

Taking advantage of the location of the Huntington Beach Art Center—home both to the Surfers' Hall of Fame and to the annual U.S. Open of Surfing—and, to its west, the cities of Westminster and Garden Grove, an area known as Little Saigon, home to the largest Vietnamese population in the United States, Leung gathered these "veterans, refugees, and immigrants" to "surf Vietnam."[29] That is, Leung invited them to create their own installation and arrange the surfboards based on their interpretation of the article as they wished, providing them with loose directions and facilitating a parallel open-endedness in how the groups organized themselves.

Aware of how not only the assigned category but the article itself was also a kind of interpellation that required each "member" of the group to actively engage the text and interact with each other, Leung stressed in a brochure handout that "although individual participants will work in one of the three groups, they need not 'belong' to any of the three groups, or may identify with more than one group" and that the groups "may be re-configured or rejected due to the process of discussion and collaboration; shifts in identification on the part of those who have multiple relationships to the prescribed categories; or a critique of the prescribed categories." What unfolded from this process was an interesting disconnect and possible disruption. Parallel to the disjunction between the *New York Times* caption text and the image, between Leung and the Huntington Beach Center, with each installation, beginning with the surfers from Huntington Beach High, Leung noted that the relation between text and image increasingly slipped out of alignment, opening a gap to reveal another story about the Vietnam War.[30]

The first of three collaborations and the fourth installation overall of *Surf Vietnam* involved a cadre of surfers from the Huntington Beach High School surfing team. Too young to remember the war, as many were born after 1975, the younger generation of surfers laid out the surfboards on their backs on the floor in a large circle like a radiating sun,

Figure 3.20. Simon Leung, *Surf Vietnam*, 1998. Multimedia installation. Dimensions variable. Image courtesy of the artist.

or a flower (figure 3.20). According to Leung, the circle represented a daisy—a symbol of friendship and camaraderie. Linking the article to the arrangement of the surfboards, the daisy circle for Leung evoked peace and the flower children of the 1960s who had opposed the war. In the second collaboration, he worked with the Monday Evening Veterans Group at the Anaheim Vet Center. In contrast to the tight configuration of the surfers' installation, in which one surfboard overlapped the other, the veterans' group installed ten surfboards standing upright, spaced like tombstones (figure 3.21). The other nine surfboards were covered in black cloth, and laid on the floor at different angles, in and around the cluster of standing surfboards. Above, camouflaged netting hung from the ceiling, hovering over the upright surfboards like a black cloud, creating a somber, almost funereal aura.

Neither involved in the war nor personally connected to Vietnam, Leung was initially seen with suspicion and even hostility by the third group, the Vietnamese American community in Huntington Beach, who questioned his involvement and intervention in a war that was not his. In the end, Leung convened an intimate group of local Vietnamese

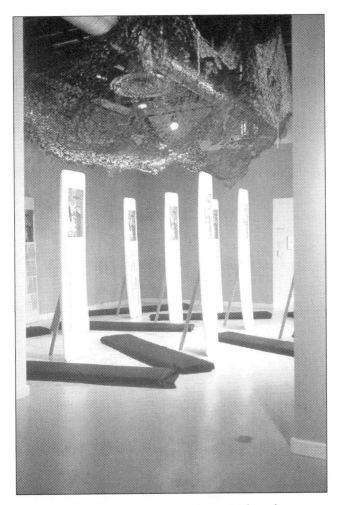

Figure 3.21. Simon Leung, *Surf Vietnam*, 1998. Multimedia installation. Dimensions variable. Image courtesy of the artist.

immigrants who upon their entrance to the United States were all processed and housed at Camp Pendleton Marine Base before settling in the communities of Huntington Beach, Westminster, and Garden Grove. In the sixth and final installation of *Surf Vietnam*, one member of the group, Le Kim Dinh, who in 1974 was a correspondent for the *New York Times*, provided the text for a twentieth surfboard. Inscribed on it was an article written by Dinh in April 2, 1975. Published

on the front page of the *Times*, the banner headline reads, "SOUTH VIETNAMESE YIELD QUI NHON AND REPORTEDLY QUIT NHA TRANG; COMMUNISTS PUSH NEARER SAIGON." The title of the lead story chillingly reads, "For Those Who Fell, Life Is 'Hell on Earth'" (figure 3.22). Placed against the wall, on top of a pile of nineteen surfboards arranged as if washed ashore and scattered like a pile of rocks (figure 3.23), the twentieth surfboard emphatically presents the article's text, which enumerates the harrowing experiences of people trying to flee from the beach village of Cam Ranh. Dinh's article opens with a chaotic scene, a foreshadowing of what was to come with the fall of Saigon twenty-three days later on April 25, 1975.

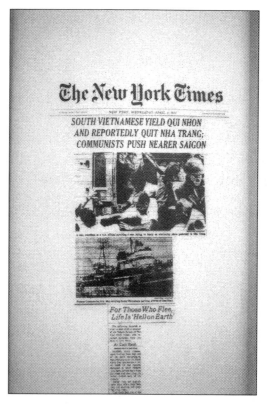

Figure 3.22. Simon Leung, *Surf Vietnam*, 1998. Multimedia installation. Dimensions variable. Image courtesy of the artist.

Figure 3.23. Simon Leung, *Surf Vietnam*, 1998. Multimedia installation. Dimensions variable. Image courtesy of the artist.

Figure 3.24. Simon Leung, *Surf Vietnam*, 1998. Multimedia installation. Dimensions variable. Image courtesy of the artist.

In the aftermath of the Vietnam War, more than eight hundred thousand Vietnamese refugees fled to the United States, and approximately fifty-eight thousand U.S. soldiers were killed. The total number of Vietnamese deaths throughout the war is estimated to be between two and four million. The twentieth surfboard in the last installation metaphorically brought the icon of the surfboard full circle. Linking China Beach with Cam Ranh Bay, which was also a destination for surfers, the last installation underlined the question of what it means to return to Vietnam.

Highlighting "the violence inherent in our fantasy of returning to Vietnam," *Surf Vietnam* shifts our perceptions of Vietnam as a site of reconciliation and recreation. Each installation's spin interpreted the article in ways that destabilized the signifier of Vietnam and introduced into the space of the exhibition an array of emergent voices, challenging proscriptions about who could speak about the war.[31] The intertextuality of the interpretations also led to a reconfiguration of relations, a kind of representational drift proving Leung right in this case about how the group members saw their categorizations as temporary or provisionary attachments. That is, while the participants stayed within their assigned groups, their variable readings of the article forged unexpected connections between them. Death linked the three groups and became a recurring theme in all the interpretations that transformed the gallery into a site of mourning and melancholia through a process of substitution, renewal, and proposition. Over the week-long duration of their installation, the surfers decided to remove some of the surfboards at random intervals. The initial flower shape of the surfboards gestured toward the bond that initially brought them together. But the changes over the course of the installation pointed to a different kind of belonging together or being-with. In the process of making *Surf Vietnam*, one member of the surfing team died unexpectedly. The removal of the individual boards not only acknowledged the "disappearance" of a friend and peer but also—akin to the installations of the other groups—conveyed a sense of being haunted by the future that bears one's own death. The young surfers having been invited to Vietnam, their encounter with the country was different from their fathers'. But by accepting Leung's invitation to "surf" Vietnam, they discovered an awareness of lives abstracted as well as an apprehension of a war that was neither in the past nor geographically far away that comes when one is in proximity with death.

THE ART PRACTICES OF SIMON LEUNG AND MARY LUM | 161

Experiencing precariousness and bearing witness to the many deaths incurred by war, the group of veterans and immigrants also found common ground in the hostile experiences they had upon their arrival in the United States in the aftermath of the war. On their return home, American Vietnam veterans were greeted with ambivalence and protests that marked them both as a symbol of repressed national trauma and the living memory of a failed endeavor. Southeast Asians were treated in similar ways, but also seen as a foreign presence, an enemy. Viet Nguyen, a veteran of the South Vietnamese army and participant in the last installation, described his experience coming to the United States as engaging in a "new war, a war of language and adjustment."[32] Behind the scenes and beyond the collaborations in the construction of *Surf Vietnam*, other connections and cross-references were made among some of the participants: one of the surfers' fathers was a Vietnam vet; three of the surfboard fabricators were also Vietnam veterans; and Leung's assistant on the project, artist Lan Thao Lam, arrived in the United States as a Vietnamese refugee in 1975.

The exhibition opened up the conversation to those, including Leung, who had no place in the preexisting network of cognitive categories of subjects who could legitimately engage in discussions about the war. By inviting onto the stage marginalized voices and visions to interpret a light human-interest story in exchange for another set of stories with meaning, the exhibition also itself became a form of representation about the war, a residual space, inaugurating a new field of signifying possibilities around the terms "Vietnam" and "War."

Conclusion: Response-Ability and Unbuilt

Challenging impoverished and entrenched ways of seeing the world, I approach the art making by Lum and Leung as modes of resistance in the differentiated ways they invite the viewer to be active in his/her engagement with their respective artworks. Brian Holmes describes resistance as manifesting itself in many stages and forms and underlines how the process includes "acquiring tools, capacities and ideas."[33] In this last section, I want to suggest how their art practice invites an opportunity to cultivate a responsibility to the other, which I would like to reconfigure as an ability to respond and hear the call of the other, or response-ability.

My thoughts on this stem from spending time scrutinizing Lum's drawings in all its iterations with the result that it has become almost impossible, at least for me, to walk in the city and respond to it without thinking about the way she engages the urban environment. While not oppositional in the discernible way that Leung exposes and disrupts ideological underpinnings and divisions in discussions about the Vietnam War, Lum's art practice offers techniques to challenge ennui and passive ways of seeing that we have already developed with our ability to multitask, such as looking at multiple images simultaneously in various spatial planes (primarily electronic device screens). Lum's multitasking removes these constraints imposed on us by the threshold of the visible that deter us from seeing everyday places we pass by and the spaces we traverse but also the interstices between the past, present, and future of these places.

In the aftermath of 9/11, the empty New York City skyline was seen as an affront and a historical reminder of U.S. vulnerability and the threat of terror. In an initial response to *Artforum*'s call to scholars, critics, artists, and writers for "insight" or "plain solace" about the days following the terrorist attacks of September 11, 2001, in New York City, Homi Bhabha questioned the rush to replace the twin towers with something similar, an architectural form of vertical progress constitutive of U.S. imperialism. Underlining how skyscrapers and monuments do not memorialize but cover over a haunted space of fire workers and others who lost their lives to save others, Bhabha redefines progress as a "lateral or adjacent move toward the stranger as toward the neighbor."[34] Calling for the need to "[resist] the eye's craving for a restored image" and rearticulate what we mean by "making progress," Bhabha suggests that in place of World Trade Towers, what the city and public need is a "vision of the Unbuilt." In what looks like an extension of this initial response, in "Democracy De-Realized," Bhabha defines the Unbuilt as a means to envision the foundation both of what already exists and of other "buildings, foundations, and worlds" that can only be seen *through* the already built environment.

In contrast to Leung's and Kim's work in the previous chapter, Lum's art practice and output are not self-critical commentaries about the ease, mobility, and privilege through which she is able to wander the streets. Rather, taking advantage of her situation, she constructs a situation in

THE ART PRACTICES OF SIMON LEUNG AND MARY LUM | 163

which to expand her worldview. Her drawings and paintings challenge a given perceptual apparatus to see through the different folds and conditions that she traverses in her daily walks and distractions. In *Eighth Fold* (2009), Lum renders a myriad of conflicting and contiguous perspectives and vectors, including painted diagonals parallel to the plane of a photograph cutout of a storefront window, placed on its side (see figure 3.15). Cutting across the panel, a red diagonal meets another diagonal perpendicular to it, painted in overlapping squares of red, pink, yellow, and orange. In the photographic fragment, a small yellow-and-white rectangular painting lying on what looks like a pink plane parallels the painted shapes of the multicolored panel, and a brick wall and sidewalk in the upper left corner, next to the storefront window framed in blue, seems to extend beyond the edge of the painting and be in the process of transforming into a series of painted vertical rectangles of orange-brown, vivid blue, and blue-gray. While some find this abtracted layering frustrating insofar as Lum's drawings refuse to offer a legible narrative or provide any immediate context or referent, her art challenges the programmatic way we read images and places, offering an exercise and example in what it means to engage in a parallax way of looking.

Lum's drawings offer various versions of the Unbuilt. While all of her drawings are absent of bodies, the built architectural forms hinted at in her drawings are living structures embodied and imbued with human activity and histories, poetic and psychic spaces that we cannot see but can sense through her formal engagement with color, line, and form. On another level, her art practice provides a "perspicuous view of the foundations of possible buildings" in the way she dislodges taken-for-granted elements—doors, windows, and stairs—to open new spaces and find new relations.[35] While Lum invites us to enter into spatial imaginaries and future structures that expand visuality, Leung's offsite components of *Surf Vietnam* invite the viewer to a future rendezvous that, if we ever encounter it, it is on us to follow through with.

Surf Vietnam was only open for a seven-week run. Due to the likelihood that few would be able to experience all six interpretations successively in person, Leung added several components to the installation, extending its significations both temporally and spatially. On the gallery wall, adjacent to the introductory wall text and trilogy of videos,

Leung hung a series of snapshots, documenting the different stages and installations of *Surf Vietnam*, revealing the processes through which the disparate groups came up with their variable readings.

At each stage of *Surf Vietnam*, Leung and his collaborators recoded the surfboard as both thing and sign by emptying out certain values and structures and playing with both the object's instrumental use and its exchange value as an art object. As a readymade, the surfboard slipped back and forth between the roles of frame, found object, flower, coffin, rock, and then back to a surfboard again. For example, the surfboard as a functional object can be seen in one of the videos that shows high school surfers attempting to surf on the text-inscribed prototypes along the shores of Huntington Beach (figure 3.24). As demonstrated here, beginning with the inscription of the *Times*, Leung sets up the surfboard as a readymade. And in this last manifestation of the surfboard, Leung highlights how the transformation of a surfboard into a readymade does not convert an ordinary object into a "useless" or "priceless" one; rather, it suspends its instrumental value, transforming it into what Duchamp referred to as a reciprocal readymade.[36]

As discussed in the preceding chapter, Duchamp describes the readymade as a rendezvous between an artist and an object, a deferred encounter that will take place in an unknown or underdetermined location in time and space. Just as Leung placed posters all over the streets of Berlin in *Squatting Project*, he placed additional surfboards, inscribed with the *Times* article, in offsite venues in Huntington Beach, Garden Grove, and other locales wherever Vietnamese immigrants, surfers, and veterans congregate as a "community." Placing the surfboard against a wall without pretext or wall text, Leung extended the invitation to a broader community to read and interpret, recode and recontextualize the article. Serving as oversized publicity "flyers" for the exhibition, the offsite surfboards also served as a residue of the exhibition, but also an invitation to a rendezvous. Not meant to create closure or elicit empathy with the traumatic plight of those who experienced the war, *Surf Vietnam* invites the viewer to occupy the text, to "surf" Vietnam.[37]

In an interview with Marita Sturken and in Kelly Dennis's insightful analysis of *Surf Vietnam*, Leung offers some thoughts about the video of the young men surfing and his ideas on surfing in general not only as a physical sport or passion but also as an act of projection and a locus

of an ethical encounter. Taking the ocean as a large force in which the surfer must learn how to surrender and conform to the crest of the wave, Leung observes that much of surfing is spent waiting for the perfect wave. Here waiting does not represent paralysis or inaction but rather a future rendezvous in which one will be thrown into an unknown situation. Leung highlights the exhilarating and dangerous act of surfing in the wide turbulent ocean as a constant "brush against death . . . of literally being thrown in the world."[38] Alluding to Martin Heidegger's metacommentary on the concept of being-in-the-world as being thrown into existence, Leung metaphorically situates a surfer's encounter with a wave as a metaphysics of waiting. In *Surf Vietnam*, Leung invites the viewer not only to occupy the text but to enter into an existential state of waiting, leaving oneself vulnerable, upon learning about the histories of the Vietnam War—an experience that entails "a throwing forward, . . . displacement, dislocation, transfer."[39] In other words, analogous to how the surfer waits to encounter an oncoming wave, encountering Leung's surfboard is to interpret it without at the same time being interpreted within it, throwing the viewer into an untimely situation—an instance less of empathy than one of vulnerability and exposure.

Returning to that moment of Leung's troubled awareness during the Gulf War of being able to be in close proximity to the war and violence on the screen, and then ably withdrawing from it, engaging *Surf Vietnam* jolts us away from this passive response, to be able and ready to respond to other calls for alternative histories. It offers an example of how an artwork can engage on multiple levels and extends the question of what it means to return to Vietnam beyond the readership of the *New York Times*, marking and making us aware of how the war resides in all of us.

4

The Vanishing Acts of Nikki S. Lee and Tehching Hsieh

In this chapter, we return to the exhibitionary space as a gathering place and a site of community, a description that is often used in museum mission statements and books on exhibition making. In general, communities are formed through shared experiences and/or by sharing something in common. How a given community gets formed depends on a number of factors that are ultimately contingent on a precondition of absence and lack, and a process of inclusion and exclusion. What binds a community? What is the "in common" of the art world and Asian America as a community? What does it mean to belong to a particular community, at what cost and to what end?

At first glance, the personal backgrounds, artwork, and art practices of Nikki S. Lee and Tehching Hsieh do not seem to share much in common, except that both artists emigrated from Asia, and both entered into the art world as outsiders. Shortly after his illegal arrival in the United States from Taiwan, Hsieh began enacting his One Year or "lifework" performances, which he staged between 1978 and 1999: *Cage Piece* (1978–1979), *Time Clock Piece* (1980–1981), *Outdoor Piece* (1981–1982), *Art/Life* (1983–1984), *No Art Piece* (1985–1986), and, lastly, *Earth* (1986–1999). In the case of *Art/Life*, Hsieh collaborated with Linda Montano—for an entire year they were tied to each other with a length of rope, never to be left alone, always to be together (figure 4.1). Next, between 1985 and 1986, Hsieh did not make or look at art for one year. And in his last "lifework" performance, entitled *Thirteen Year Plan* or *Earth*, Hsieh withdrew from the public and made art privately for thirteen years. Though he has always been recognized for his distinctive performances based on endurance and constraint, it is only recently that his influence has been widely recognized both in various publications, including his own gorgeous monograph coauthored with Andrew Heathfield, and by the inclusion of his work in major museums such as MoMA and the Guggenheim Museum.

Figure 4.1. Tehching Hsieh and Linda Montano, *Art/Life*, aka One Year Performance, 1983–1984 (*Rope Piece*). Life image. © Tehching Hsieh, Linda Montano. Courtesy of the artists and Sean Kelly Gallery, New York.

In contrast to Hsieh's belated recognition by the art world, Nikki Lee received immediate critical attention and visibility shortly after her arrival from South Korea in 1994. Initially conceptualized at NYU while Lee was a graduate student, each "project" in her series—generically titled: *Hispanic, Punk, Tourists, Exotic Dancers, Lesbian, Swingers, Skateboarders*—comprises a number of color photographs with Lee posing and passing as a member of a particular subculture. Collaborating and bonding with the members of a specific group over a three-to-four-month period, Lee proceeds to reinvent herself, adopting a subculture's

look, posture, behaviors, and gestures. Snapshots portraying Lee in an impressive array of chameleon-like transformations—East Village punk rocker, Hispanic mama, white trash, Asian tourist, yuppie, hip hop groupie, swing dancer, skateboarder, stripper, senior citizen, and butch lesbian—quickly caught the attention of *New York Times* critic Holland Cotter, who described her series as imbued with a sense of "humor, satire (including self-satire), a keen eye for social detail, a Method school histrionic flair, and a self-assured faith in the endless possibilities for self-alteration," one of many reviews that swiftly propelled her to the status of art world darling.[1]

But if we look more closely at their art practice, we see that Lee and Hsieh in fact do have much in common. Both participate in a kind of masquerade: this is obvious in Lee's artwork and less legible in Hsieh's, but his works all involve his taking on a certain role or prototype: prisoner, industrial laborer, homeless drifter, artist, recluse, and survivor. Both of their works emerged in the context of a growing interest in the relationship between identity and art, with Hsieh's "performances" taking place during a time when performance art was seen through a framework of the self and Lee's body of work correlating to the moment of identity politics. Both artists also engage in disidentificatory practices, anticipating misrecognition of their art and their racialized bodies as figures of transformative alterities. Both take advantage of photography's truth effect: Hsieh's snapshots in combination with his set of documents serve to document and legitimate his performances—to prove that they happened according to his given task or assignment—while Lee uses the genre of the snapshot, with its date stamp in the right-hand corner, to highlight the authenticity and spontaneity of her otherwise staged performances. Both artists are elusive—coy or skittish—when it comes to discussing their art and art practice; at the same time, they share the need—even the compulsion—to underline that they are thinking about art all the time.

In numerous interviews as well as in her film, Lee appears loquacious, ostensibly candid, yet she remains guarded. In either case, she does not divulge very much. With the exception of Adrian Heathfield's monograph and a small handful of insightful interviews over the years, Hsieh has been famously reticent, even overtly contrarian. In fact, much of what both these artists have said about their art and art practice is

recycled and recirculated: clichés or koan-like reflections that seem to contradict and almost undermine the work itself. Each artist anticipates the fetishization of his/her artwork as a site of bodily identification primarily within ethnocentric contexts. In this context, how might we read these rehearsed sound bites not as information but rather as tactics: a kind of compensatory mechanism, a mode of disidentification, or, per Doris Sommer's analysis, as part of a strategic practice of withholding?[2]

Considering Hsieh and Lee as outsiders within, I want to explore in this chapter how their encounters with the art world reveal processes of inclusion and exclusion, incorporation and differentiation, that constitute the boundaries of their art making and the art world. Pamela Lee offers a succinct and multilayered definition of the art world as both real and imagined: on one level, a "society of individuals and institutions . . . a social, cultural, and economic world organized around museums, galleries, and the art press . . . [that includes] legions of artists, critics, collectors, curators, and audiences," and on another level, a discursive space that engages an art object through theory and knowledge by way of a tight network of individuals who believe in and are committed to the distinctiveness and autonomy of art.[3] Since the 1980s, the globalization of the art world has expanded the definition of art and its once bounded and exclusive space to the point where this art world has ceased to exist.[4] Globalization, a phenomenon fueled by capitalism and developments in technology, is a process that creates connections, systems, and interdependence across national borders, spatially reorganizing the world and relations. No longer separate or above realities such as globalization and cosmopolitanism, the art world, according to Pamela Lee, is no longer exclusive and has become a major player in constructing those realities from which it used to be critically apart.

Concurrent with the globalization of the art world was the emergence of a radical form of multiculturalism with demands for reallocation of resources and capital, which, as I discussed in the first chapter, was quickly co-opted and recoded in terms of a recognition of diversity. Pamela Lee insightfully notes that while globalization may have internationalized and even democratized art to a point, expanding the art world's traditional borders, it has done so only to the point of being seen as "accommodating," as the criteria through which art is judged and defined remain the same.[5]

In 2006, Lee premiered *A.k.a. Nikki S. Lee*, a biopic or, in Lee's words, a "conceptual" documentary, written, directed, and performed by the artist herself. The film served as a meta-commentary on her multiple selves and a quasi-response to the question of *who* might the *real* Nikki Lee be—a "character" whom she purports to create, according to people's expectations and projections. Praised and criticized by scholars and critics for playing the roles of both ethnographer and native, Lee's Projects was perceived to be an ethnography of different subcultures. I want to suggest how the film seems to be another one of her Projects—in this case the "Artist Project."[6] In 2001, Lee disclosed to curator Russell Ferguson that this project was already in the making: "[T]here aren't any pictures of it but it does exist."[7] In contrast to her other Projects, however, in this imaginary or speculative version of one of her projects, Lee is already presumed to be an insider in this particular subculture, and as the film unfolds, it reveals the underside of Lee's charmed existence in the art world as an outsider-within.

In 1983, Hsieh was outside the boundaries of the art world. Less a renegade artist than a fugitive one, he was given the opportunity to be embraced and legitimated as an artist through his extraordinary collaboration with Linda Montano. While their work was not at all intended to be an ethnography, the artists, I want to suggest, were nonetheless interpellated by critics and scholars as native informants and objects of an ethnography of a world of their own making, delineated and bounded by a rope and with each other.

Revealing the ways racial difference is abstracted and fetishized, managed within an art world that distinguishes itself as cosmopolitan and open to difference, Hsieh and Lee reveal the art world as an elaborate system of classification, where artists, objects, and desires are categorized and hierarchized. These artists are engaged not only in disidentificatory practices but also in what I want to call vanishing acts, and I see their presence and interaction within this world as acting as a limit that reveals the contours of this so-called cosmopolitan setting. In the last section I want to describe Lee's film and Hsieh's last performance as vanishing acts in which Hsieh disappears into an unnamable void and Lee into the background of global capital. I begin the chapter with a description and reading of Lee's Projects and *A.k.a. Nikki S. Lee*. Following my discussion of her film, I extend the reading of Hsieh's work that I began

in chapter 2 by turning to an analysis of Hsieh's *Art/Life* and his last two lifework performances. After looking at these two artists and their select works, I conclude with one last set of propositions: to reconsider what is "in" common in Asian American art and to let go and imagine the possibilities of being unbound to set ways of thinking about the relationship between art and politics, art and Asian American art.

Where's Nikki?

In *The Hispanic Project (1)* (1998), Lee poses with a group of girls in a snapshot taken during New York City's annual Puerto Rican Day parade with the date "98 6 14" imprinted in a refracted rainbow strip at the bottom of the image (figure 4.2). Dressed in a sexy, tight-fitting shirt and hoop earrings, her hair curly and highlighted and lips outlined with heavy, dark liner, Lee seems like part of a group of girlfriends as they come together to document this moment of good times, the photo taken by one of Lee's friends or another friend of the group. A male onlooker in a green shirt on the right side stares at the girls with bemusement.

Projects is fun, accessible, and easy on the eye as Lee draws the viewer in and dares us to play a game of "Where's Waldo?" wherein she is almost always pictured at the center of the image. At first glance, Projects conveys the idea that identity is something to slip into and shed, a matter of choice. Upon her arrival in the United States as Seung-Hee, Lee adopted the name Nikki after the model Niki Taylor, and she appears to assimilate easily into almost any subculture, becoming a member of a wide range of "communities." Embraced by many in the art world as a poster child for performing difference, Lee was also perceived to possess, in the words of critic Barry Schwabsky, "an immigrant's sharp eye for the daily rituals of social identification."[8] Her ability to don identities as a matter of choice plays on myths of self-determination, requires her performances to be seen as effectively covering over structural equivalences and contradictions of equal opportunity and differentiated treatment among racialized immigrant bodies. With its timely debut in 1998, Lee's Projects was received as a positive postscript in the aftermath of the *1993 Whitney Biennial* and an inauguration of a new kind of flexible citizenship—a neoliberal idealization of individualism and self-determination,

Figure 4.2. Nikki S. Lee, *The Hispanic Project (1)*, 1998.

one that, it could be argued, strikingly converges with the premises of President Clinton's Illegal Immigration Reform and Immigrant Responsibility Act of 1996.

Lee represented what was problematically wrong with the art world's embrace of her Projects series and her engagement with difference. In contrast to Cindy Sherman's *Untitled Film Stills*, a series of photographs that deconstruct the female image and body in Hollywood films, and challenge our preconceptions about feminine identity and heteronormativity, Lee's images have been reviewed and analyzed as complicit in flattening, fetishizing, consuming, and erasing historical differences. These critiques are numerous, and I would like to briefly summarize some of them here. Lee has been accused of ethnic self-fashioning, taking advantage of her ethnic and racialized position, and perpetuating stereotypes and mainstream cultural fantasies of certain groups. Positioning herself as an intermediary between herself and a particular subculture, brazenly and breezily tapping into our knowledge of existing cultural representations of certain groups, as described by Mark Godfrey—"lesbian life is

all short hair and body-building, Hispanic leisure is shouting matches on the pavement"—Lee's photographs were "believed" to represent the real world. One case in point is Lee's *Hip Hop Project*.[9] Rather than challenge the way the mainstream reads racialized signs of black bodies or presents hip hop culture as the global phenomenon it now is—a complex intersection of transnational, national, and local influences—Lee presents the community as a site of consumption, stylized and dressed in bling and in black face. In *The Hip Hop Project (25)* (2001), Lee strikes a provocative pose in a slinky, low-cut V-neck dress, leaning against an SUV, arching her back, and wearing a white do-rag over sun-bleached hair and darkened skin, with large designer sunglasses. Surrounded by a group of young black urbanites—a man to her right wraps his arm gingerly around her silver-chain-belted waist and the tall youth to the left playfully places his hand on her back—Lee looks the part as object of desire or rising star, in an image that brings to mind any number of hip hop music videos.

Although Lee denies that her work deals with race—"I'm not Korean-American, which means I don't have issues about race!"—because she frames her work as performing identity and characterizes the snapshots as "evidence" of the many personas that reside in her, Lee's process has raised deep skepticism and the need for scrutiny about her ethnic self-fashioning.[10] Because her snapshots are absent of any captions or supplementary material, except for statements of her inherent ability to identify with the other—"I identify myself easily. . . . It's kind of weird, but I knew this naturally—how to act like a punk, how to have that attitude"—art historians such as Miwon Kwon have reproached Lee, equating her art practice with an ethnographic project. Extending Hal Foster's criticism of contemporary art's appropriation of anthropological methods in the 1990s, which he dubbed "the ethnographic turn,"[11] Kwon questions Lee's role as both ethnographer and native, and in particular her narcissistic "self-reflexivity," in lieu of some much-needed self-criticality. Leaving unnamed the other members of the subcultures she enters into, presenting those subcultures as lifestyles and little more, and persistently reticent about her working methods and context—for example, of how she makes first contact with a particular subculture—Lee consistently responds by denying her practice as such.

In an interview with curator René de Guzman, she states, "[T]here is a person you present to a schoolteacher or to your parents or to a new

boyfriend. Each is affected by the context and each shows a gap between inside and outside. Each is a personal performance."[12] Although it is true that her encounters fluidly change the constitution of her identity, what we see in the photographs are nonetheless choreographed performances that are already overdetermined and fixed in place within familiar codes and conventions. Not above exploiting her own Asian identity, aside from playing the stereotypical Asian tourist, and using it as an excuse— for example pointing to her Korean immigrant status as the reason for her unfamiliarity with the long history of blackface and the complexities of race relations in the United States and stating that "I came to the U.S. in 1994 . . . [I]t's strange: I can put myself into all these different cultures here and fold them into myself. Maybe it's a very special ability"—Lee has on numerous occasions in interviews deployed Orientalist stereo-types to authenticate and legitimize her art practice with offhand clichés about where she is from ("in Western culture, identity is always 'me' . . . [I]n Eastern culture, the identity is 'we.' Identity is awareness of others") and her encounters with the other as "spiritual, almost Buddhistic."[13]

Notwithstanding Lee's reinforcement and perpetuation of stereotypes, and her complicity in commodifying difference in her Projects series, I want to challenge or at the very least complicate assertions of Lee as an ethnic entrepreneur for hire by turning to her film *A.k.a. Nikki S. Lee*. Described by the artist as a "conceptual" documentary, *A.k.a. Nikki S. Lee* lures us in with the premise that the film will probe the question of *who* the real Nikki Lee might be. Lee analogizes the camera to a mirror in her description of the film as "me watching me mapping myself," and the film promises as well to reveal behind-the-scenes footage of her process. In this light, I want to suggest how her film opens up an alternative read-ing of Projects that does not dismiss or refute its criticisms, but rather might bring to light some of the remarks underlying her oftentimes con-tradictory and convoluted responses.

Shot between 2004 and 2005 on digital video in the manner of a real-ity TV show, the hour-long film documents in a series of short scenes Lee's quick rise in the art world and incorporation into a robust and inflated contemporary art market. Throughout the film, we see her jet-setting to different art fairs and openings, hobnobbing at a reception at the Peggy Guggenheim Collection in Venice with actor Jeremy Irons and other Hollywood producers, being surrounded by admirers at the

opening of the Museo Universitario de Ciencias y Arte in Mexico City, and participating in a fashion shoot for the *New York Times Magazine*, wearing over-the-top haute couture from the houses of Chanel and Valentino. The film's tracking of Lee's "glamorous" life as an artist seems to reinforce Mark Godfrey's intriguing reading of Projects in his review for *Frieze* magazine, in which he figures her as not only an operator but an insider, a member of the art establishment. Framing Projects as a "comedy of stereotypes" addressed to an art audience, Godfrey describes the photographs less as a collaboration between members of the subcultural group and Lee than as a collaboration between the artist and viewer, who together reproduce familiar stereotypes based on a "shared and secret understanding . . . that we are not like the people with whom she appears and we can recognize the subtlety of the joke."[14] Taking Lee to task from a different direction than Kwon, Godfrey notes that the artist's catering to the viewer threatens to "[lull] the viewer into a kind of snobbery"; at the same time, he writes, "[I]f the work exposes the assumptions of the artists, then perhaps it is the audience who are the butt of the last laugh."[15]

Using Godfrey's intriguing review as a point of departure, I suggest the film is another "project," but also an address to the art world, a subculture that Lee has come to know over more than a decade—a fast-growing, globalized art economy and community within which she is presumably seen as an insider.[16] Shot in Venice, Long Island City, Manhattan, Brooklyn, South Korea, Mexico City, and Santa Fe, the film underscores that the art scene is no longer confined to New York City but is dispersed, as Lee takes us to an exclusive world filled with private art openings, dinners, and parties at collectors' homes, unabashedly presenting her charmed life and the ease with which she is able to connect to collectors, including Heather and Tony Podesta, and gallerist Leslie Tonkonow.

In one scene, we accompany Lee to Ellen Schweber's palatial Long Island home, where we witness her entering in media res an intimate gathering that looks like a mothers' group, kissing babies, making small talk, and attempting to fit in (figure 4.3). The camera scans Schweber's home, which is filled with art hanging on the walls and stacked along the floor. At one point, Schweber's young son indicates the works he does not like by randomly affixing green Post-it notes to them. In response,

Lee jokingly removes one of the green Post-its and sticks it on another work of art to see if he will even notice. We learn eventually that Lee is there for a purpose, to borrow one of Schweber's dresses to wear in her series *The Wedding*, one of the components of her work *Parts*.[17]

In contrast to her photographic series Projects and Parts, where Lee offers little insight into her process, the film presents a glimpse of her working methods, one that overturns the casualness underpinning her "snapshots." For example, in a behind-the-scenes glimpse of the making of *The Wedding*, we see Lee firmly in control of her situation: her snapshot-like photographs are far from serendipitous but instead are carefully choreographed and composed constructions.

Lee shoots Parts in an outdoor café, in the bedroom, in a car, at the pool, at the airport, at a wedding. As in Projects, albeit even more so, the images center on Lee, always attached or linked to the arm, hand, or wrist of a man, whose body, however, is cropped out of the picture (figure 4.4). *The Wedding (2)* (2005) presents a wedding ceremony in

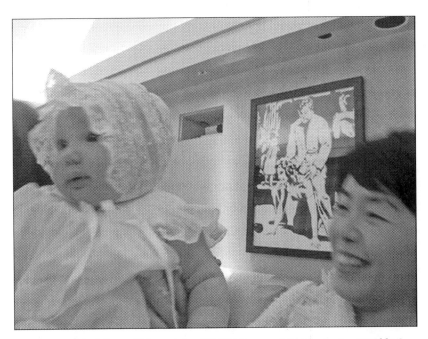

Figure 4.3. Nikki S. Lee, still from *A.k.a. Nikki S. Lee*, 2006. Sixty minutes. © Nikki S. Lee. Image courtesy of Sikkema Jenkins & Co. Gallery, New York.

Figure 4.4. Nikki S. Lee, *Part (14)*, 2002. C-print mounted on aluminum. Image courtesy of Sikkema Jenkins & Co. Gallery, New York.

progress with Lee, the bride, wearing something borrowed (one of the wedding dresses from Schweber's vast collection) in the middle between a rabbi and the groom, who is only partially seen—part of his arm and hand signing the *ketubah*. In the image, Lee looks passively and lovingly at her betrothed while he signs the "contract" that will seal their marriage (figure 4.5). In contrast, however, to the male presence in her still images, who always remains active vis-à-vis Lee's docile and compliant body, the film shows Lee in full control. Far from being a casual shot, the scene we see is carefully composed and choreographed by Lee, who is assertively calling and directing *all* the shots (figure 4.6). Throughout, the film reveals her hands-on art practice, which entails close attention to every detail in the various stages of the making, developing, framing, and hanging of all of her images (figure 4.7).

Broadly defined, ethnography occurs when one enters a community as a participant-observer in order to document and study it. Historically, an ethnographic study of other cultures was underpinned by the

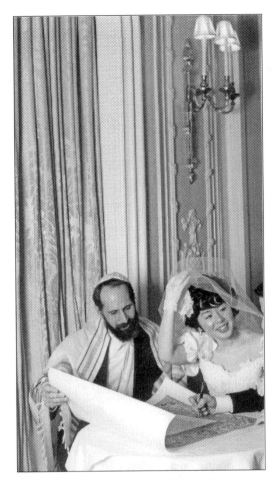

Figure 4.5. Nikki S. Lee, *The Wedding (2)*, from the Parts series, 2005. C-print mounted on aluminum, 30" x 34". Image courtesy of Sikkema Jenkins & Co. Gallery, New York.

need to construct "encompassing patterns, symmetry, and logical social order" to make the other culture knowable and transparent, a form of discipline and part of the colonial project. On one level, describing Lee's art as sociological, anthropological, or ethnographic implicitly figures her work as non-art, a consignment that shifts the criteria for evaluating her work from aesthetics to authenticity—an assignment that conflicts with her entire conceit, based in this case on her need to be seen as an

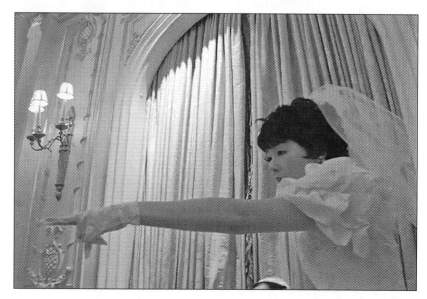

Figure 4.6. Nikki S. Lee, in a bridal dress directing a scene. Still from *A.k.a. Nikki S. Lee*, 2006. Sixty minutes. © Nikki S. Lee. Image courtesy of Sikkema Jenkins & Co. Gallery, New York.

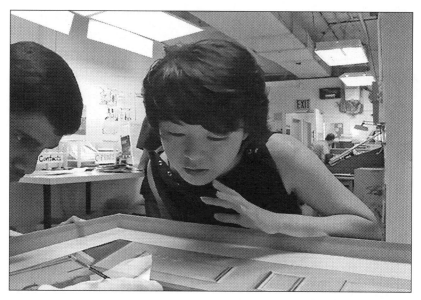

Figure 4.7. Nikki S. Lee, checking out a photograph. Still from *A.k.a. Nikki S. Lee*, 2006. Sixty minutes. © Nikki S. Lee. Image courtesy of Sikkema Jenkins & Co. Gallery, New York.

artist. On another level, I want to suggest how we might see the film as an appropriation or deformation of autoethnography, defined conventionally as a research methodology that seeks to reveal something compelling about one's own community or, as Mary Louise Pratt defines it, a "specific genre by which colonized subjects undertake to represent themselves in ways that engage with the colonizer's own terms."[18] Lee's film is less a study than an exposé of the art world, a taking part in, and a taking apart of the art world as a critical response to her being positioned as other and a duped agent of "subversion for hire." On another level, I see the film as a plea not to see her as belonging to this world but to allow her to find a way in on her own terms.

Within this framework and shifted aim, her film recalls *The Yuppie Project*. Playing on the term "yuppie," which emerged in the 1980s to signify young professionals' desire for status and upward mobility through conspicuous consumption and social climbing, Lee's *Yuppie Project* pictures her, in one image, seated cross-legged, looking conservatively professional, eating lunch in a New York City park with white-collar Wall Street colleagues. In another photo, Lee leans down to pose with a friend in front of a department store, two days before Christmas as indicated by the digital date stamp recorded in red at the bottom right-hand corner of the photograph. Dressed in a sleek black outfit with her accoutrements in hand—a blue-green Tiffany bag and the leash to a cute little beige, poodle-like dog—Lee seems both in and out of place (figure 4.8). As in each of the Projects, Lee's transformation is made through makeup and hair, consumption and clichés, but what makes *The Yuppie Project* distinctive, according to Maurice Berger, is how she exposes the construction and invisibility of whiteness as a racial category and standard, capturing "the dress, the gestures, the eating, work, and leisure-time habits of people who do not have to think about their skin color or the power it affords them."

Lee's "outing" of whiteness as a racial category raises questions about what other categories and presumptions are covered over in her photographs or, in turn, are revealed aside from the generalized group rubrics under which the images are organized. From another perspective, *The Yuppie Project* evokes another racial category, that of the model minority, where Lee once again is notably exceptional, the only Asian American pictured, except for one image of her lunching with a glum Asian

Figure 4.8. Nikki S. Lee, *The Yuppie Project (2)*, 1998. Chromogenic print, 23 1/2" x 15 3/4". © Nikki S. Lee. Image courtesy of Sikkema Jenkins & Co. Gallery, New York.

male companion who looks at neither the camera nor Lee. In almost all of her Projects, with the exception of *Young Japanese (East Village)* and *The Schoolgirls Project*, Lee is the only one or one of the few Asians/Asian Americans pictured.[19] What is both disturbing and apropos of her representation as a model minority, and what makes it so distinctive, is the ease with which in all her projects Lee "goes native," fully assimilating into whatever milieu she enters to the point where she recedes or blends into the background, maintaining the status quo.

In a similar vein, initially Lee seems both in and out of place in her film, occupying a role—that of an artist professional, an identity that seems to precede her. While we see Lee traipsing around the globe, the art world, like her other backdrops in Projects and Parts, remains bounded—a cosmopolitan world that in this case not only requires a well-stamped passport in order to traverse it but also recognition by others. Intercut throughout the film, we see her, in contrast to her other Projects, out of place, isolated, displaced, creating a disjunction between her role as an insider within and her role as an interloper. For example,

in the days leading up to the installation and opening of her debut in Germany—at an exhibition in Frankfurt—Lee discovers upon her arrival at Galerie Anita Beckers that her photographs have been cropped: the framer has taken the initiative to "tidy up" and remove the white borders that frame the images in her Parts, denying and removing one aspect of Lee's "photographic hand" or unique vision. She becomes understandably and visibly upset, declaring that the ready-to-hang art "is not my work." Although the opening is just days away, Lee refuses to present the cropped images, calling her main gallerist, Leslie Tonkonow in New York City, to demand that the photographs be redeveloped, reframed, and re-sent. The delay means that in place of the photographs, a slide show of her works is projected against a wall in an awkward opening night for her first exhibition in Germany.

In another instance, in a series of shallow encounters, including one with actor Jeremy Irons and another at Yvonne Force Villareal's loft party, where she meets a sycophantic fan only to be abandoned, left abruptly and awkwardly alone, Lee reveals the limits of her artifice and control. In these unsettling instances it is clear she does not quite belong—in contrast to her Projects and Parts photos, where she is seemingly never excluded, but always accepted by the group or as part of a group, subculture, or coupledom. That is, with a few exceptions—for example, one shot in *The Hispanic Project*—there are almost no images of conflict with Lee or befuddlement at her presence among the members of the group. In fact, Lee seems to fit harmoniously into her surroundings. But in the film, we never see her with any other artists, friends, or family, only other collectors and gallerists. The film presents Lee as a lonely figure, a portrayal reinforced by the multiple images of her wandering and shopping in the streets of Frankfurt, hanging out solo in her hotel room, and eating dinner alone.

While the film seems to offer an insider's view of not only Lee but an exclusive art world, Lee does not play the native informant or traditional Malinche role, nor does she really tell us very much about the art world, in contrast to ethnography's protocol of disclosure and description. Rather what she shows is her inability to take shape except as an outsider within. Figured as an outsider within, Lee hints at the lack of depth or shallowness of the bonds she has with other members, and the tenuous borders of an art world that is supposed to be open and accepting

of difference. In other words, by highlighting herself in a room filled almost entirely with white people, Lee underlines not only how she is marked by difference but how her acceptance in the art world is based on difference. And in correspondence with the *Yuppie Project*, she also discloses the unmarked category of whiteness and privilege.

In between interludes of solitude, Lee intersperses throughout the film "one-on-one" candid interviews that take place in a hotel during her travels and "at home": a spacious and light-filled studio in Williamsburg. Against the white background with multicolored spines of hundreds of books lined up against the wall in modular bookshelves, the film presents the "other" Nikki Lee, literally a close-up on the purportedly *real* Nikki Lee—a shy, bookish, thoughtful, and clean-cut artist who once fantasized about being an actress.[20] In contrast to her glamorous alter ego—the social-butterfly fashionista—Lee wears a simple Oxford shirt with a pixie haircut and no makeup. The "real Nikki" discloses her preference to read books rather than go out to explore the sights or mingle with fellow artists or friends.[21] However, at one point in the film, Lee accuses her hired cinematographer of indirectly asking her to perform her real life. Responding in exasperated despair that she "cannot be totally natural and be myself," Lee proceeds to concede that she might be pretending to be lonely and bored in the film, but it might also be precisely what she feels; it is impossible to tell anymore, as Lee and her artist persona have merged seamlessly to the point of no return.

Disclosing her feigned loneliness and boredom (in a related *New York Times* feature, she notes that the artist's studio is a "fake set"), the film, I suggest, is more than another constructed layering and parody of Nikki S. Lee, consistent with her "artistic manifesto," written in 1999, meant "to mock documentary and to document life as simulation."[22] Exposing her own complicity but also the art world's, in which she is figured as a Zelig character subject to people's expectations and projections, Lee assumes the image of "Nikki Lee" the artist, only to reveal that her fictional persona and the real have become utterly continuous—the distinction between the two has increasingly become a challenge to maintain. Revealing or making hypervisible the artifice in the presentation of identity as an illusion retroactively created by her performances, the end of the film seems to raise the question, to what end? In an attempt to try to be self-critical, falling short in showing her awareness of her relationship

to other bodies that she puts under erasure or makes hypervisible in her Project series, the film succeeds in placing a mirror towards the art world that reveals how her body and her art reflect projections of displaced desire for racial difference.

In the second-to-last scene of the film, we follow Lee in a long tracking shot, walking through a row of endless booths at New York's Armory Show, consistently one of the more lucrative international fairs of contemporary art. In 2004, near the height of another art market bubble—the year in which authorities had to start turning people away from the fair for fear the pier on which it was staged might collapse—we see a nondescript Lee, walking anonymously and determinedly through the Armory past hundreds of booths selling art. She drops off a package at her gallerist's booth and exits the art world. There is no voiceover or dialogue. In contrast to her Projects photographs, we lose her as she disappears into the crowd out the blue doors of the Armory, neither looking at the camera nor with any onlookers watching her. Parallel to the art world's predicament, Lee seems to vanish. She becomes subsumed into capital, as I will discuss at the end of the chapter, a spectral figure who slips from view for different ends.

Proximate Relations—Tehching Hsieh and the Art World

By 1983, Tehching Hsieh had made a name for himself, especially after his *One Year Performance 1981–1982* (*Outdoor Piece*), during which he lived outside for almost an entire year (part of which was the coldest winter ever in New York City), and was very publicly arrested for carrying a dangerous weapon (nunchucks). His compelling posters and the arrest caught the attention of both curators and artists. Yet in contrast to Lee, whose entry into the art world seemed fast and easy, Hsieh's collaboration with Montano provided an invitation to an exclusive world that only a few years before had been impossible and inaccessible due to his racialized illegal status. Prior to *Rope Piece*, with Hsieh located outside of the law and the gallery and museum system, the set of documents attached to each performance—the artist statements, supplementary certification documents, and photographs of his performances—were key not only as evidence of Hsieh's potential to be a law-abiding citizen (see chapter 2) but also as a means to authenticate, legitimize, and safeguard his artwork.

Figure 4.9. Tehching Hsieh, Poster for *Art/Life*, aka *One Year Performance, 1983–1984 (Rope Piece)*. © Teching Hsieh. Courtesy of the artist and Sean Kelly Gallery, New York.

In earlier performances, Hsieh masqueraded under the pseudonym Sam Hsieh: as a prisoner in *Cage Piece*, a factory worker in *Time Piece*, and a homeless person in *Outdoor Piece*. I want to approach *Art/Life* as another opportunity to spend or, in Hsieh's chosen term, to "waste" time thinking about art. In this piece, Hsieh, used his real name, Tehching Hsieh, instead of his alias, Sam. Playing himself, a struggling artist, Hsieh embarks on a journey with Montano to think and engage deeply with his ideas on art (figure 4.9).[23] Whereas just a few years before he was completely outside of it, it was through Montano's established

reputation and relationships in the New York art world, as well as the publicity their collaboration garnered, that Hsieh was invited to be a part of this world, an acceptance with profound consequences.

Following the completion of *Outdoor Piece*, in an interview with Andrew Heathfield, Hsieh revealed that the initial impetus for *Art/Life* was a desire to explore his bond with others and, on a more abstract level, the contingency of human struggle. On paper, Montano seemed to be the perfect partner for such a collaboration. Encountering one of Hsieh's posters while living and meditating in a Zen center in upstate New York, Montano purportedly heard a voice in her head that said, "Do a one-year piece with him." Known at the time for her provocative work with conceptual artist Tom Marioni (in which they were once handcuffed together for three days) and her performances that took place for five days within a sealed room in a gallery, Montano, who at one point in her life aspired to be a nun and practiced daily meditation, seemed well prepared for her "one-year meditation retreat," a description she used in conversation with a friend to describe her collaboration with Hsieh. Barely acquaintances, Montano and Hsieh embarked on *Art/Life* on July 4, 1983, for a performance in which they vowed to "stay together for one year" tied at the waist with an eight-foot rope held by a metal clasp, but with the stipulation never to touch (figure 4.10). As in Hsieh's previous performances, a descriptive document was written up and signed by the artists and two witnesses—Pauline Oliveros and Paul Grassfield—that stated simply that the artists were tied together by a rope that was to remain "still complete, intact, and unbroken."

Tethered together, never alone, the two artists were always "in the same room at the same time." As in his previous pieces, the need to survive became central. In *Cage Piece*, Hsieh lets his mind wander and imagine other things in order to avoid losing his mind; in *Time Piece*, the task to clock in every hour for 365 days leads to sleep deprivation, clouding his thinking; in *Outdoor Piece*, his time is spent on the basic needs of life—finding a place to eat, to keep warm, and to sleep, and staying safe at all times. In *Rope Piece*, Hsieh, who had embarked on his previous One Year Performances in solitude, used all of his energy to focus his attention on getting along not only with Montano but also with her dog, Betty, and her social circle.[24] In an interview with Jill Johnston, Montano describes a "typical" day:

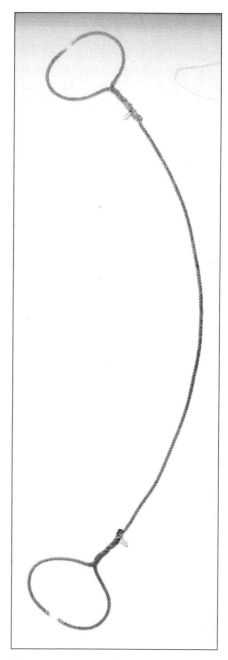

Figure 4.10. Rope used in *Art/Life*.

We have this pattern. We go to bed around midnight, Tehching sleeps in the morning. I get up earlier, meditate, exercise, watch TV. Then he gets up. Sometimes we run. Three times a day we walk Betty, my dog. We take one picture every day and turn on the tape recorder whenever one of us is talking. . . . If we aren't doing carpentry, teaching, or part-time gallery work, then we go to our desks and sit back-to-back for about five hours.[25]

Parallel to Hsieh's previous performances, mundane habits and rituals took on new meaning: simple things—every desire and act from brushing teeth to reading the newspaper, wanting a glass of water, going to the bathroom, riding a bike, walking on the Brooklyn Bridge—became not something to be taken for granted but a matter of difficult negotiations and relinquishments of control. Like Hsieh's previous One Year Performances, the project was supplemented by hundreds of photographs, in this case, at least one photograph per day, documenting the minutiae of their everyday lives (figure 4.11). Other photographs served more like snapshots to commemorate events, picturing the two at a wedding, lying

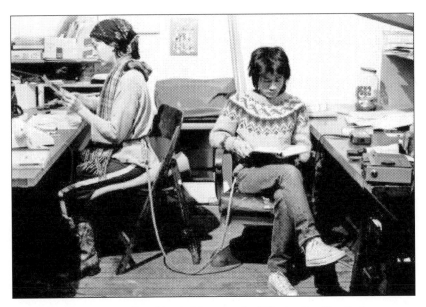

Figure 4.11. Tehching Hsieh and Linda Montano, *Art/Life*, aka *One Year Performance*, 1983–1984 (*Rope Piece*).

out in the sun, sitting with a group of friends on a couch in Hsieh's studio, and attending art openings.

Interspersed among these moments of togetherness are images of strife and tension, where snapshots of the artists were replaced by the word "FIGHT" written in capital letters either on large pieces of crumpled paper or on Post-it notes. Hsieh and Montano communicated both verbally and nonverbally. According to Montano, at the beginning of the performance, she and Hsieh had long conversations about art and life that soon, however, devolved into gestures and grunts.[26] As they lost patience with each other, their relationship became hostile, to the point where they were barely on speaking terms. Never privy, however, to the details of the argument, we are only allowed to see images of tense bodies, turned away from each other.

While seemingly in sync regarding their approach to the relationship between art and life, they were conceptually at odds in terms of their objectives, as reflected in the different titles by which the work is known, *Art/Life* and *One Year Performance, 1983–1984 (Rope Piece)*. For Montano, the title *Art/Life* was apposite, as the performance was consistent with her understanding that every moment was perceived to be a work of art itself, from "washing dishes, making love, holding children [to] . . . fighting, eating, sleeping." The title was also appropriate in Montano's figuration of the performance as a therapeutic means "to live better through lifelike art works"; her year with Hsieh brought to the surface a lot of "suppressed rage" but also an awareness of her need to meditate and "purify" in order to reach transcendence.

Correlating with the interest at the time on event-centered performance art, particularly pieces that relived and shared a traumatic event or engaged the suffering body as broken object, features and reviews of the collaboration primarily focused on the power dynamics between the two, specifically Montano's positionality, which led to questions for Hsieh that were informed more by her work than by his own intentions and experience. For example, responding to a question about whether his performance centered on training his awareness to better himself— one of Montano's aims—Hsieh remarked that such concerns were secondary. Less interested in emoting and experiencing the process and aftermath of this year together, Hsieh saw the performance within a "continuum of instants" and a flow of duration: the phenomenal totality

of the lived body and one's own subjective experience. Pointing to the mechanics underpinning the performance, he described his experience with Montano as a "mirror," exposing his "weaknesses, limitations . . . potentials" while at the same time training his will. Stripped down, Hsieh's performances were attempts to sense "life['s] quality" and build a will to be free, an endeavor that necessitated intense concentration in the form of deprivation (of sleep, space, privacy, passion), and endurance, or constraints and techniques.

As with his other performances, Hsieh attempted to compartmentalize and confine his body to serve as a vehicle to carry out his work (in this case, the daily interactions with Montano), while his mind remained "detached from . . . confinement" and thus "free to think and to advance." Rather than approach *Rope Piece* as a "clash and struggle" of wills between Montano and himself, Hsieh saw the piece as exposing the tension between being a good human being and being a good artist, and between wanting a relationship and craving independence. The rope, either slack or taut, served as a constant reminder of each other's presence, which for Hsieh became more than a mind/body conflict, addressed by his previous performances.[27]

The artists became objects of art, living sculptures, to be "held and studied." Taking on the role of ethnographer, the press and critics sought not only knowledge but also testimony about "the *experience* of the work, the interstices between documentation and public ritual, the liminality of the event," which went against Hsieh's conceit for the piece.[28] Like Nikki S. Lee in her Projects, Hsieh offers little exposition about his work and practice, or any other kind of supplementary material that conveys to the viewer the experiential dimensions of his performances. Unlike Lee, and in contrast with Montano's ease in speaking about the performance in relation to her personal experience, Johnston notes, Hsieh was "unwilling to discuss such things—things he has learned about himself and human nature . . . [H]is objective is really art, and the images he creates so far as he's concerned are symbolic, not biographical or personal."[29] Negotiating media attention—a novel situation for Hsieh—soon became an encumbrance.

The press's privileged framing of *Rope Piece* from Montano's perspective, one based in Catholicism, Zen, and various traditions of redemptive suffering, left Hsieh little room to respond from outside these

contexts, except to deny that his work was a reflection of personal experience or about "political imprisonment or . . . the self-cultivation of Zen retreats." Although his dedication to making art paralleled the intensity of a spiritual imperative, his motivations and aims were neither spiritual nor self-reflexive. For lack of better phrasing or terms to describe his position and motivations, Hsieh unwittingly fell into using ethnographic terminology in which he was forced to serve as cultural translator of his own performance. In other words, seen as inscrutable and reticent, with an inadequate vocabulary to describe what he was trying to do through his performances, Hsieh unwittingly characterized his art practice as an "Oriental kind of technique" and his performance an "Oriental kind of experience." Analogously to Lee, Hsieh found himself in a quandary, reliant on his being fetishized as a particular kind of subject-object to secure his place in the art world, revealing the limits of his incorporation into this world.

In *Rope Piece*, through his proximity to Montano, Hsieh was given the opportunity to have the ultimate art experience: to be immersed in art twenty-four/seven on one level, and, on another level, to take part in Montano's world and social circle. While one can reference art world luminaries in some of the images, the project overall—absent of captions, supplementary texts, and transcripts of the conversations between Hsieh and Montano—does not offer much insight into the art world or the collaboration. While the different components that make up *Rope Piece*—the documents, photographs, tape, and time—leave us with a residue of an experience, the recording of time passing, it leaves us with little else. Much of the documentation of *Rope Piece* is made up of "moments filled with nothing of consequence." The mutual decision by Hsieh and Montano to seal the hundreds of tapes of dialogue recorded during their one year together upholds the singularity of their experience and an awareness of the limits of representation. Keeping in mind Hsieh's limited English, how might we see his economical use of language, reticence, and generalizations about his Asianness not as a mode of inscrutability but as a strategy of withholding, in anticipation of an encroaching art world, and in response to a growing gap between his approach and art world expectations?

The last three of Hsieh's lifework performances are not ethnographies of the art world but radical responses to and distancing from it: a prescient and perspicacious awareness and ambivalence toward the

art world, if not a rejection of it. In other words, despite being in close proximity with the art world, Hsieh's subsequent performances highlight how he becomes not only estranged but a stranger in the aftermath of his collaboration with Linda Montano.

Returning to Nikki Lee as a point of comparison and a counterpoint, is her film a rejection of the art world or a renegotiation and reassessment of her position within it? The film concludes with her at home, which at the time was in New York City. Wishing to extend this feel, the film, if seen in this way, is less an exposé of the art world than a plea to be counted and to be allowed to seek a place where it is possible to belong in the art world on her own terms—a reinvigoration of her resolve not to play a part, but to be a part of a world that, in the words of Pamela Lee, however, no longer exists. Aware about the art world's transformation or collapse into one globalized world where everything has become fungible and interchangeable in an intensified economy driven by commodification and alienation, Lee and Hsieh share not only an art practice that anticipates the subjugation of their marked bodies within narrow constraints of referential and symbolic meaning but also an imperative to negotiate their predicament in order to continue to do what they want to do, which is simply to make art.

Vanishing Acts

This concluding section begins with a reading of Lee's evacuation of her "authentic self," a refusal to serve (in Gayatri Spivak's formulation) as an "agent instrument of global capital who not only provides information but acts as a source and an object of knowledge too . . . leav[ing] an ethical relation impossible," followed by a reading of Hsieh's departure from the art world.[30] The reading is followed by some discussion of Hsieh's last lifework performances. I want to posit in the conclusion of the chapter and the book how both Lee's and Hsieh's experiences with the art world serve as a cautionary tale of which, I want to suggest, those invested in Asian American art should take note. I want to suggest how their art practice offers alternative paradigms and propositions that reconceive not only the end of Asian American art but its ends.

Counterintuitive as it may seem to posit Nikki S. Lee's art practice as a model for reconceiving community, given the criticisms outlined at

the beginning of the chapter and a reading of the film as all about her, I want to look at two readings about her art practice that bring to light the limits of conventional notions of community building and an idea of a cosmopolitan community. In his essay "Let's Be Nikki," curator Russell Ferguson highlights how her photographs serve as "evidence of Lee's uncanny ability to become an integral part of an extraordinarily diverse set of social situations."[31] What I find intriguing about Ferguson's reading is the rearticulation of this "uncanny ability" as not a conceit or something essentially, inherently "Asian" within Lee. Rather, her "uncanny ability" is her ability to live with difference as indicated by all her interactions with the many subcultures that one does not see directly in her Projects but that are hinted at in the film. In his essay, Ferguson points out that implicit in all the images that make up Projects is Lee's face-to-face encounter with a community that is open to her, yet this encounter does not involve the revelation of the other's truth, but rather a projected form of community in which difference might be lived.

In his reading of Lee, Kaplan analyzes her work in a similar vein, but in relation to Jean-Luc Nancy's reconception of community. Giving Ferguson and Kaplan credence in their readings of Lee, how might we see the photographs of her encounters—not what we see in the images, but what we do not see—as an index or trace of her relationship with these subcultures? While her photographs serve as a kind of spectacle in which social relationships between people are mediated by the concatenation of her images, the films hints at other meaningful relations. Negative readings of her Projects series point to how Lee's proximity to the different members of a selected subculture becomes strange and distant in the photographs that fix representations of the milieu and divert accountability or create an easy way out for the viewer to interrogate his/her own stereotypical perceptions. In the images that make up her Projects series, we see how she is superficially constituted and transformed through such encounters, but never the other way around. In contrast to critiques of how Lee treats and projects the other members in her subcultures, the readings by Ferguson and Kaplan remind us of how the encounters that take place between Lee and her various subcultures are never a one-way street, but a process of sharing something in common and then a parting of ways.

In *The Inoperative Community*, Jean-Luc Nancy questions the "in" of being-in-common that comprises a community. He reconceives community as "unworking"—or "inoperative"—a constant and evolving process engendering multiple affiliations and relations to one another, a projection of a formal schema of community to come.[32] Writing partly in response to the history of Nazi Germany and World War II, in which "the goal of achieving a community of beings by way of producing in essence their own essence" led to devastating consequences, Nancy reviews and rethinks traditional notions of community driven by ideas of Christianity, immanent absolutism, power, and a desire to fix origins, the idea of community as consisting of preconstituted "individuals" who come together as discrete building blocks or units that can be aggregated or even transcended in totality. In an economy that rends social bonds, the desire to restore this kind of organic sense of community and return to traditional values has only intensified. The only primal bond that binds an organic community in immanence is death. For Nancy, however, death is the "being-in-common" that we all share, but in a paradoxical fashion; for if experience of finitude is what we share absolutely, it is also what divides us absolutely. By reconceiving the bonds and ends of community as a being-with—a sharing and splitting of "singular beings in contrast to the indivisibility of the self-contained and indivisible individual"—Nancy characterizes community essentially as sharing the absence of a common bond. Kaplan reads Lee's photographs as performing the contours of community formation, which is contingent on an opening up only in and through a co-opening with others—a being-with relation.

I perceive this process of being-with as occurring literally in one particular scene in the film, toward the end, where we follow and watch Lee dancing with different partners in a park in Mexico City: a couple, an old man, and a larger group of other dancers. At first, the montage seems extraneous, another showcase of Lee being cosmopolitan, while at the same time the scene is refreshingly unpretentious. In contrast to the dance scene in *The Wedding*, we see a casual, not a directed, representation of the coming together of older men and couples of different races dancing and then, soon after, seamlessly and spontaneously dancing with Lee also here—a singular convergence of bodies

bonding—being-with—and parting ways. The unassuming moment recalls Paul de Man's lyrical image of a group of dancing figures, where a spectator from above

> observes an infinite variety of crisscrossing motions which keep decisively but arbitrarily changing directions without ever colliding with each other. Everything has been arranged in such a manner that each dancer has already vacated his position by the time the other arrives. Everything fits so skillfully, yet so spontaneously, that everyone seems to be following his own lead, without ever getting in anyone's way. Such a dance is the perfect symbol of one's own individually asserted freedom as well as of one's respect for the freedom of the other.[33]

A projection of Nancy's community and of the art world's notion of multiculturalism, the scene, as Lee implies throughout the film, is a fictive construction. While wanting to believe in the meaningful relationships that take place in the film and in Lee's Projects photographs, I read *A.k.a. Nikki Lee* as a negation of the art world (and of her own negation) or, put another way, as a commentary on her object of desire, her desired community, as inoperative. Trying on the role of punk rocker, Lee burst onto the art scene not as an ingenue but as part of the edge of society. Perceived as promoting individual freedom from the margins of different subcultures, Lee was already from the get-go far from being anti-establishment. Timely in her entree into the art world, Lee became emblematic of neoliberal multiculturalism. Seamlessly trying on different identities, Lee was invited into the art world not so much as a multicultural ambassador but as a stranger fetish. While the art world appeared to offer Lee the chance to enter and assimilate into its fold, it is clear from looking at the reviews in combination with the film how she was invited not as an artist in her own right but as a figure of the unassimilable. The film discloses her realization of and the cost of being unable to assimilate, of a membership contingent on being constantly objectified and fixed into being Nikki and her many personas. Looking the part of defiance—with her studded leather jacket over a see-through black blouse and red bra, ripped net stockings over striped tights, as seen in *The Punk Project (6)*, from her first Projects—Lee comes full circle in the making of her Projects series. Engaged in a different kind

of rebellion against the status quo in an attempt to resist being pinned down by a community that she paradoxically wants to be a part of—but fails to become part of—Lee exposes the art world. At one point in his analysis of Lee as an exposer of community, Kaplan describes her photographic practice as "a route into an ethics of being-with that exposes us to our sharing and separation at the limit."[34] In contrast to the other subcultures that she enters and leaves on her own terms, maintaining what she calls her need for "borders," in the film, she attempts to claim this space, the art world, by showing, not telling, how "we are all artists" or, put another way, "I am an artist too." While almost all of Lee's body of work explores her relation to others or, in her own words, how "other people make me a certain kind of person,"[35] in the film, she questions the terms in which she is seen as an idealized native or ethnic entrepreneur. Alluding to an awareness of her art making as symptomatic of the time period, and the art world's neoliberal global turn, the film questions not who Nikki S. Lee is but who the art world is, and the "in" common of this once-exclusive art world that is contingent on consuming and fetishizing difference.

Needing to part ways from the art world in which it is now almost impossible to differentiate the form of art from the commodity form, Lee elects not to assimilate but instead in her film reveals a split desire to belong or to preserve herself and survive. Lee has no option but to recede and become once again part of the background of her milieu, this time the heterogeneous background space of late capital. *A.k.a. Nikki S. Lee* conveys a tale of desire for recognition and legitimacy that must be perpetually frustrated in order to avoid being fixed into a narrow grid of interpretation—a condition and situation that involve a never-ending and exhausting process of substitutions and disidentification. This constant shuffle and hustle of eluding identity continues in *Layers*, a series of portraits of Lee rendered by street artists whom she encounters all over the world, a chance opportunity afforded by her travels as an artist in demand, and another symptom of globalization's impact on the art world. In the series, she overlaps these drawings, lit from behind, to make a photographic composite of charcoal on vellum, resulting in blurred and ghostly heads—a translucent layering of an indifferent and marred image, a semblance of Lee, muted (for now), and unable to break free from her already assigned formation.

Cutting an untimely figure in relation to capital, in the aftermath of *Rope Piece*, Hsieh seems initially to withdraw from the art world as he willfully vanishes from it for a year by abstaining from making, seeing, and reading about art in *No Art Piece*. In contrast to his other pieces, the only documentation in *No Art Piece* is his artist statement, which declares that he will neither make nor see nor talk nor read about "ART," but "just go in life." And in his penultimate performance, *Earth*, Hsieh makes art for thirteen years between 1986 and 1999, but refrains from displaying it. Hsieh's last performance could be seen as a homecoming. On December 31, 1999, New Year's Eve, Hsieh returns "home," like a prodigal son and a stranger, declaring to the art world, his friends, peers, and admirers who had congregated at Judson Memorial Church, to say that he had survived: "I kept myself alive." Accompanying this statement is a poster in which Hsieh cuts and pastes colorful letters from a magazine, ransom note style, spelling the same statement, "I KEPT MYSELF ALIVE. I PASSED DEC 31, 1999" in all capitals, (figure 4.12).

Hsieh's last two performances could be seen as another instance of deprivation—not of movement, sleep, comfort, or solitude, but of art: the very *thing* that seemed to compel him to extreme and extraordinary acts. To make art entails the need to survive, a means enabling him to pursue his more lofty project, but as noted in the second chapter and here, survival becomes another distraction—as in *Cage Piece*, where he had to let his thoughts wander, and in *Art/Life*, where he had to focus his attention on getting along with another human being. Thrown into a situation with Montano, which in turn threw Hsieh's engagement off in his aim to create art, Hsieh nonetheless found that his experience with Montano and its aftermath enabled him to continue to make art. That is, while Hsieh's disappearing act in the aftermath of *Rope Piece* and his last two performances could be seen as giving up and abandoning the making of art, his last performance reveals a contrary reading.

According to numerous accounts, *Earth* began with a cross-country trek across the United States. Unable to reach his final objective, Alaska, Hsieh ended up in Seattle, working odd jobs, trying to make ends meet, once again distracted from any kind of "art making." Ending his self-exile after only six months, he returned to New York City. In 1988, he claimed asylum and got a green card, legally transforming himself from an illegal migrant laborer who worked as a contractor on other people's

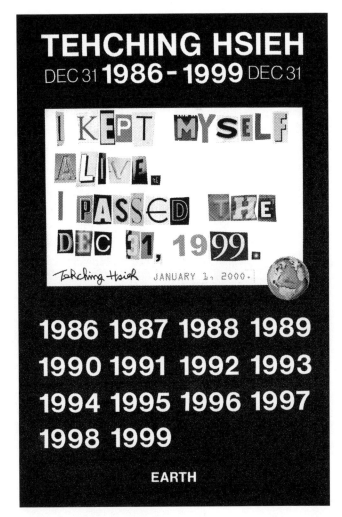

Figure 4.12. Tehching Hsieh, *Earth*, 1986–1999.

properties to a law-abiding U.S. citizen. In 1999, Hsieh invited the art world to a face-to-face encounter with him and declared, "I Kept Myself Alive" at an event that materialized the art of his thinking, a gift, to the art world.[36] From one point of view, Hsieh gives nothing, but nothing is something (as underlined in reference to *Time Piece* in the second chapter). The gift I want to suggest Hsieh offers to the art world is freedom. In light of his poster composed as a kind of hostage note, I want to

consider how Hsieh's last performance is an imperative and declaration of his release from captivity within the art world, an ongoing negotiation of his placement within art spaces, economies, and discourses.

For Hsieh, freedom, like the concept of art, seems to have multiple significations depending on the context. For example, freedom in *Cage Piece* seems to signify thinking about art twenty-four/seven; in *Time Piece*, it means freedom from work; and in *Rope Piece*, it means the desire for freedom to be with and then apart from another human being. But as Hsieh notes in the few passing comments about his collaboration with Montano, in order to survive we need to be bound together: "I feel that to survive we're all tied up. We cannot go in life alone, without people. . . . [W]e're together. So we become each other's cage. We struggle because everybody wants freedom."[37] Recently in interviews with various newspapers and magazines where Hsieh has become less media shy, he states that he has freedom from the art world. His performances do not illustrate or represent freedom but are, on one level, a demonstration against the neoliberal presuppositions of freedom and, on another level, a form of freedom, of being thrown into the world, into an unconditional existence, that knows no end.

In 1999, at the Judson Memorial Church, Hsieh's last performance was not only a release of Hsieh from the art world but also a call and response to the art world and beyond. In his oft-cited "Ideology and Ideological State Apparatuses (Notes towards an Investigation)," Louis Althusser conceptualizes interpellation and presumes that one has no choice but to answer the call of ideology. But as Žižek, Chow, and others have noted, there is a gap between the call and the response—the latter being the moment in which one internalizes the interpellation and becomes the thing one is hailed as, an entry point into subjectivity. In contrast to seeing this gap as a moment of disidentification—a moment of resistance in the form of disidentification or rejection against the call—Žižek, Chow, and others conceive it not so much as an alternative than as a nonchoice.[38] That is, "only by answering such a call, only by more or less allowing one's self to be articulated in advance by this other, symbolic real, can one avoid and postpone the (ontological) terror of a radically open field of signatory possibilities . . . the terror of complete freedom rather than the ideological, institutional process of being interpellated."[39] In other words, by responding to the call, one trades

freedom for the postponement of terror, but also for the reassurance and insurance of the self, visibility, and a sense of belonging. In the case of racialized subjects, however, as Lee and Hsieh remind us, identification does not necessarily lead to stability and belonging, but instead to displacement and disorientation, in which case nonidentity can become an attractive alternative, a suspension of subjection. As underlined in the second chapter and here again, Hsieh refuses to respond to the call, in this case one hailing from the art world. This negation of subjectivity allows him to escape (not in perpetuity but for the time being) being assigned a proper place, suspending (for now) the naming and categorizing of his performances, and enabling his artworks to enter into free fall, into an unknown that has allowed someone like me to conjure and contemplate the unnamable ends of his performances. Contrary to the idea of the artist as object, as defined recently by Marina Abramovic, Hsieh frames his austere performances as "art time" and the afterlife of these performances as "life time." His performances do not simply end after a year, but continue to evolve and unfold. Resisting the tyranny of art time, Hsieh leaves behind not the art world but the art world as a global market enterprise. Since 1994, he has been known informally to have supported a number of artists by letting them live rent-free in his Brooklyn studio. Since 1999, Hsieh has remained "at the edges of public visibility," and his decision to stop making artwork in the conventional sense has in fact made his work more visible, as indicated by his recent representation by the blue chip Sean Kelly gallery and his upcoming presentation at the Venice Biennale.

For some, the archival maintenance of the tapes and the re-presentation of some of his performances seem self-serving; the making of a DVD documenting his performances, the enlarging and silk-screening of select photographs from his One Year Performances, and the publishing of his catalogue raisoneé with Heathfield are seen as undermining his "uncompromisingly unconventional work . . . prettify[ing] what Hsieh has spent so much time and energy drawing out."[40] I would argue on the contrary that Hsieh does what is necessary, not only exercising his "rights to regulate the social and economic conditions of an artist's activity" but clearing the way to pursue art as a "way to live, an energy or power that gives you a way to be."[41] Yet it is his refusal to respond to the call—to participate in the usual channels of art

production and exchange, the syntagmatic chain that extends from the creations of the artist's studio to the marketplace of private galleries—that, I want to argue, is pivotal in his discharge and liberation from a certain functionality and relationship to time and community.[42]

I posit Lee's and Hsieh's art practices—the constant need to retreat and supplement their work with elusive and contradictory comments to thwart having their intentions and artworks misread—as survival tactics that those invested in Asian American art need to resort to in its current formation in order to keep art relevant not for the market, but for a futurity that cannot yet be claimed or named. The pressure to name what ties Asian American art together as a genre and a category and to name its parameters and boundaries, criteria and chronology raises the inevitable question, what is the "in" of being "in" common of Asian American art?

Much has been written within Asian American Studies about how community building has been central in creating solidarity and building coalitions. I want to suggest that the artworks gathered here open up alternative social and spatial relations that recontour not only the way we see the world but also our understanding of Asian American art beyond a set of objects and a community of art professionals, scholars, and collectors invested in Asian American art. Following through with these propositions to rethink the role of the curator, artist, viewer, and exhibitionary space and to leave unnamable the incredible "work" that these artists are already engaged in does not mean abandoning pursuits that are already underway in terms of creating archives of Asian American art or commissioning artists to build community. That is, I am not proposing getting rid of the term "Asian American art" or dissolving it as a category altogether, but rather reconceiving it as a concept and discursive formation that does not rest on categories of identity, but rather relies on new orders of being in the world, alternative forms of temporality, and other modes of community engagement.

Throughout the book, I have tried to point out the different ways in which the artworks are engaged in pressing against the sensible, setting up the stage for a politics to come. Asian American art has the capacity and the potential to be a galvanizing force for thought and action, as attested by the artists featured here, not because the artists are Asian American but by way of looking at their work vis-à-vis an analytic of Asian American art. While social equity and the end of racism and

exclusion of course remain priorities, the idea I want to put out there is that Asian American art has no end or, put another way, its ends are unknowable and unnamable. Aesthetically setting up open-ended encounters for a viewer to cultivate ways to ably respond, situating the work within a larger social geo-political formation, and displaying works of art that offer experiences that are "coterminously plural" while opening opportunities for other subjects to emerge are incommensurate with or in excess of current understandings and evaluations of art and, at the same time, expand our ideas of what art can do.[43]

ACKNOWLEDGMENTS

This book has taken a lot of time to conceptualize and complete. I want to thank so many people who have supported me over the years in not only writing this book but also giving me the time and space to do so. With gratitude comes guilt and the knowledge that these acknowledgments are really inadequate. I only hope that, someday, I can reciprocate somehow, some way.

This book would not be possible without the generosity and inspiration of Byron Kim, Tehching Hsieh, Mary Lum, Simon Leung, Nikki S. Lee, Yong Soon Min, Maya Lin, and Yoko Ono, and all those artists, scholars, and curators whose passionate efforts and commitments have made Asian American art a visible and viable field of study. The NEH Re-envisioning Asian American Art History Institute at NYU was the culmination of such efforts, laying the foundation and fostering an environment of stimulating conversations on Asian American art that helped me to crystallize my thinking about this book. One person who was a consistent force in driving this project forward was Karin Higa. I so miss her sharp and forthright insights and understated wit.

The book has gone through many iterations from its earliest stages beginning at Brown University, where I was a graduate student. There, Robert Lee, Leslie Bow, Daniel Kim, and Deborah Bright at RISD were especially instrumental in giving me the freedom and support to pursue my research interests. The UC President's Postdoctoral Fellowship Program and the Mellon Postdoctoral Foundation offered generous support in helping me finish my research and reconceptualize the book project. Gary Okihiro, Elaine Kim, Sau-ling Wong, David Yoo, and Rena Fraden provided me with the opportunity to reshape my ideas about art and Asian American Studies. While I was at the Drawing Center, Luis Camnitzer was a model of integrity and independence of mind and spirit in his approach to art, politics, and exhibition making. Over the years, I have been in several writing groups made up of incredible scholars

206 | ACKNOWLEDGMENTS

who with their brilliance, generosity, good humor, and love for food and drink provided me with profound wisdom and much-needed sustenance. Special thanks to Cynthia Tolentino, Sanda Lwin, Shirley Lim, Mary Lui, and the Surplussers—Grace Wang, Robin Hayes, Nadia Ellis, Leigh Raiford, Michael Cohen, and Tori Langland.

I thank the department of Asian American Studies at the University of California–Davis, which has continually supported my work in numerous ways. I am exceptionally thankful to Richard Kim, Bill Hing, Wendy Ho, Nolan Zane, and Sunaina Maria, who have taken great care of me and enthusiastically promoted my work. I thank the dean's office for its financial and institutional support for the publication of this book. I thank Omnia El Shakry, Gayatri Gopinath, James Housefield, Karen Shimakawa, Simon Sadler, Renny Pritikin, Grace Wang, and Jaimey Fisher for being excellent colleagues and dear friends.

I am deeply grateful to Carolina Gonzalez, Michelle Alumkal, and especially Loren Noveck for their meticulous reading and editorial guidance. Thanks to Ritu Birla, Deborah Cheung, Anna Chu, David Eng, Jason Francisco, Anna Pegler Gordon, Margaret Honda, Carole Kim, Sunhee Kim, Chisun Lee, Rachel Lee, Sharon Mizota, Gautam Premnanth, Kasturi Ray, Eric Reyes, Moira Roth, Teemu Ruskola, and Leti Volpp for your constant source of warm support, love, wisdom, and encouragement to persevere. I am also so appreciative of Theo's friends and their parents, who have helped out in so many ways.

At NYU Press, I am infinitely grateful to Eric Zinner for his vision, patience, and support for this project. Thank you to the two anonymous readers and to Emily Wright, Alicia Nadkarni, and Ciara McLaughlin, for their exemplary attention to and management of all the details of production. Special thanks are due to the artists Karla Merrifield, Jon Hendricks, Scott Briscoe, Sue Grinois, Wade Aaron, and all the wonderful gallerists, archivists, and assistants who mediated and facilitated in helping me attain permissions and images.

I dedicate this book to Seong Ha and Gilcha Min, the Min and Sung family, and Jeff and Theodora Fort. Jeff has been the perfect partner in this long, too often torturous and sometimes even destructive endeavor. His loving impatience, steadfast belief in me and in this book, and daily

prodding to clarify and think through my ideas remind me, as I write this, how tremendously lucky I am to have him in my life. Theo brings love and joyful distraction to my daily life and in her own way has in unnamable and profound ways shaped this book. In the midst of discovering the wonders of what art has to offer, I hope she will soon find this other world too.

NOTES

INTRODUCTION

1 Much of Asian American art is seen as a form of autobiography: bearing witness to an individual experience of the world. For example, Margo Machida's *Unsettled Visions* focuses primarily on how "artists of Asian heritage, whether foreign or U.S. born, conceptualize the world and position themselves as cultural and historical subjects through the symbolic languages and media of visual art." Looking at work by Allan deSouza, Yong Soon Min, et al., Machida's study presents Asian American art as a "visual articulation of cross-cultural subjectivities who have been marginalized." Machida underscores the importance of lived experience throughout the book and presents it as integral to these artists' artistic vision and practice. My book does not intend to refute these projects and their aims, as all of these projects and efforts have made visible overlooked artists and have expanded the resources and opportunities for Asian American artists. Rather, this study complements this formidable body of research by serving, on one hand, as a reflective counterpoint and, at the same time, exploring new lines of inquiry. Margo Machida, *Unsettled Visions: Contemporary Asian American Artists and the Social Imaginary* (Durham, NC: Duke University Press, 2008).

2 As Holland Cotter bluntly lays out, "The deal was, you could get inside the gates, but your movement was restricted." Holland Cotter, "Beyond Multiculturalism, Freedom," *New York Times*, July 29, 2005, www.nytimes.com.

3 Christopher Newfield and Avery Gordon, "Introduction," in Avery Gordon, ed., *Mapping Multiculturalism* (Minneapolis: University of Minnesota Press, 2008).

4 Rita Gonzalez, Howard Fox, and Chon Noriega, *Phantom Sightings: Art after the Chicano Movement* (Berkeley: University of California Press, 2008).

5 See Trinh Minh-ha, *When the Moon Waxes Red: Representation, Gender, and Cultural Politics* (New York: Routledge, 1991), 20.

6 Thelma Golden, *Freestyle: The Studio Museum in Harlem* (New York: Studio Museum in Harlem, 2001), 14. *Frequency* (2005), with a different set of artists, opened with similar fanfare. And in 2008, *Flow* opened, introducing a diverse array of works by artists located within a shifting and expanding notion of the Black African diaspora.

7 Golden, *Freestyle*, 12.

8 Ibid., 14.

9 Jeff Yang, "Art Breakers," *SF Gate*, October 16, 2006, www.sfgate.com.

210 | NOTES

10 Roberta Smith, "A Mélange of Asian Roots and Shifting Identities," *New York Times*, September 8, 2006, www.nytimes.com.

11 Often described as constructed "girlishness," Mari Eastman's use of glitter, pastel washes, and airbrushing accentuates both the beautiful and the banal. Eastman draws much of her imagery from magazine photos, newspapers, calendars, and Time-Life books, and the sumptuous images and subject matter of her paintings frequently recall familiar and even mundane subjects—in the case of *Bird on Flowering Spray: Porcelain Cup*, the Chinese motifs and iconography inscribed on mass-produced china and paintings that continue to circulate and reinforce signs of Chineseness.

12 Embalming appropriated images from old *Life* magazines on leaves through photosynthesis, Danh's *One Week's Dead #1*, from the *LIFE: One Week's Dead Series* (2006) curls over time in a process of natural decay. In Dahn's unmonumental memorial for the approximately fifty-eight thousand American soldiers who died during the Vietnam War between 1960 and 1975, ephemeral images invite reflection on war and the precariousness of life. Initially conceived after Hurricane Katrina's cycle of destruction and the U.S. government's colossal mishandling of the catastrophe in 2005, Arcega's *Eternal Salivation* (2006) is an absurdist commentary that links the past with the present, myth with reality, sovereignty with bare life, through craftsmanship, clever puns, and playful conceptualism. *Eternal Salivation* is a large-scale construction of a wooden ark, a blown-up version of a boat constructed from a child's craft kit, anchored in the middle of the gallery. Inside the ark, in place of a pair of animals, hang strips of rare and exotic beef jerky—dried and cured meats collected from various stores in New York City's Chinatown. In contrast to Danh's somber *One Week's Dead*, Arcega's *Eternal Salivation* is a humorous take on who decides and what it means to reach salvation.

13 Identity serves as the entry point not for the artists but for Smith to engage the exhibition, in which race and identity become interchangeable and the art becomes legible and universalized through the way in which its main objective, to look for selfhood, "becomes an everywoman's desire." In Smith's review of *Frequency*, she writes how

> issues of identity have become part of a larger mixture of concerns for black artists while reminding us that these preoccupations should be inherent in all art making. Any art of lasting interest is a form of identity that emanates from, and expresses the core of the artist's personal and social being. The ability to get at this core is a necessity for art and a result of being free.

Roberta Smith, "Where Issues of Black Identity Meet the Concerns of Every Artist," *New York Times*, November 18, 2005, www.nytimes.com.

14 Rita Gonzalez, Howard Fox, Chon Noriega, *Phantom Sightings: Art after the Chicano Movement* (Berkeley: University of California Press, 2008), 3. Shifting attention away from outmoded ways of seeing Chicano art as only about protest murals and posters, the curators offered an alternative trajectory befitting their curatorial premise by beginning with the 1970s collective Asco, whose conceptual

performances and antics informed a younger generation of Chicano artists. For an excellent summary and review of the show, see Nizan Shaked, "Phantom Sightings: Art after the Chicano Movement," *American Quarterly* 60.4 (2008): 1057–72.

15 Ibid.

16 Ken Johnson, "They're Chicanos and Artists, but Is Their Art Chicano?" *New York Times*, April 9, 2010, www.nytimes.com.

17 Wall label for *Phantom Sightings*.

18 Johnson, "They're Chicanos and Artists."

19 Ibid.

20 Lisa Leong, "One of These Things Is Not like the Other," *Asia Pacific Arts*, December 14, 2007, http://asiapacificarts.usc.edu.

21 Kelly Klaasmeyer, "One Way or Another: Asian American Art Now," *Houston Press*, March 15, 2007.

22 Žižek, "Multiculturalism; or, the Cultural Logic of Multinational Capitalism," *New Left Review*, September–October 1997.

23 Hayes's definition of unspectacular racism borrows and expands upon John Jackson's concept of racial sincerity, which she describes as "acts that negotiate intersecting ethnic, class, and sexual identities through specific scripts for choices in relationships, aesthetics, and politics." *Unicorns and Black Presidents* tracks and documents the experiences of Black youth in elite universities who are seen as exceptions and are conscripted to legitimize institutions as "not racist" through their presence and visibility. Robin J. Hayes, "Introduction: The Course," in "Unicorns and Black Presidents: An American Generation's Struggle against Unspectacular Racism" (unpublished manuscript, 2010), 27.

24 Colleen Lye, "Introduction: In Dialogue with Asian American Studies," *Representations* 99.1 (2007): 1–12; Colleen Lye, "Racial Form," *Representations* 104.1 (2008): 92–101.

25 Melissa Chiu, "A Conversation on Today's Asian America," in Melissa Chiu, Karin Higa, and Susette S. Min, eds., *One Way or Another: Asian American Art Now* (New Haven, CT: Asia Society with Yale University Press, 2006), 27.

26 Jeff Yang, "Art Breakers," *SF Gate*, October 16, 2006, www.sfgate.com. He writes in the same review,

> One might say that the end of the "multicultural era" didn't represent the death of race but, to some extent, it's [sic] triumph, we live in A.I., Anno Identitate, an era in which race has become a permanent and intrinsic part of our social and perceptual makeup. Kids born in the '70s and later have grown up with the concept of race as a fixed part of the social landscape. It's a check box on every form, a standard item in every cultural inventory. Whether or not they choose to emphasize it, they recognize it as a valid and instrumental part of their reality.

27 David Harvey's seminal *A Brief History of Neoliberalism* (2007) traces the hegemonic formation and implementation of neoliberalism and its draconian policies of deregulation, promotion of private ownership, and austerity that cover up an

unprecedented decadence through accumulation by dispossession. Historically, the racialization of the Asian laborer, U.S. imperialism, restrictions on immigration, and legal disenfranchisement, and more recently the emergence of multicultural capitalism have been indispensable in the development of global capitalism and empire, what Cedric Robinson has termed "racial capitalism." He writes that "the development, organization, and expansion of capitalist society pursued essentially racial directions, and so too did social ideology. As a material force, then, it could be expected that racialism would inevitably permeate the social structures emergent from capitalism." Cedric Robinson, *Black Marxism: The Making of the Black Radical Tradition* (Chapel Hill: University of North Carolina Press, 2000), 2. From another perspective, Jodi Melamed, Robert Lee, and others have traced the formation of U.S. liberalism as the "ideological core" of U.S. governance, which in the 1960s was a means to respond to challenges by multiple postcolonial movements and Soviet accusations against domestic racism. In her recent *Represent and Destroy*, Melamed argues persuasively how American liberalism and neoliberalism share the need to efface the historicity and deep-rootedness of racism in its collusion with capitalism. Jodi Melamed, *Represent and Destroy: Rationalizing Violence in the New Racial Capitalism* (Minneapolis: University of Minnesota Press, 2011).

28 Susette S. Min, "The Last Asian American Exhibition in the Whole Entire World," in Chiu, Higa, and Min, *One Way or Another*, 36.

29 Peggy Phelan, *Unmarked: The Politics of Performance* (New York: Routledge, 1993), 26.

30 Darby English, *How to See a Work of Art in Total Darkness* (Cambridge, MA: MIT Press, 2007), 6, 44.

31 Glenn Omatsu's "The 'Four Prisons' and the Movements of Liberation: Asian American Activism from the 1960s to the 1990s" is one of the few essays that clearly delineate the priorities of an extant movement that relies on the nostalgic and mythic role of the artist in guiding the community, as well as envisioning collective liberation through the imagination. It is also one of the few essays that relate the Asian American writer/artist as a cultural worker to Walter Benjamin's call for the author to intervene in the means of production in solidarity with labor. In the essay, Omatsu implies that artists were not only part of a cultural revolution, but they too were creating a new revolution that validated or participated in the logic of the Asian American movement as a revolution. At issue for Omatsu is the changing definition of activism within the Asian American movement, in particular the location of action, which in the past involved the working class, and today takes place primarily in middle/upper-class, professional contexts in which "action" entails "advancement for a few." This is most evident in the contrast between the keywords used by activists back in the 1960s—"consciousness," "theory," "ideology," "participatory democracy," and "liberation"—and the vocabulary used by activists in the 1990s—"advocacy," "access," "legitimacy," "empowerment," and "assertiveness." See Glenn Omatsu, "The 'Four Prisons' and the Movements of

NOTES | 213

Liberation: Asian American Activism from the 1960s to the 1990s," in Karin Aguilar San Juan, ed., *The State of Asian America: Activism and Resistance in the 1990s* (Boston: South End Press, 1994), 19–69.

32 In one of the few texts about Asian American art in relation to the Asian American movement, William Wei matter-of-factly (albeit sweepingly and unfairly) reassesses Asian American art:

> During the middle 1970s, Asian American artists began to move away from the political and toward the aesthetic approach, a trend reinforced by the 1980s' obsessive preoccupation with ego and materialism. . . . [T]hey were tired of producing so-called politically correct or "socially realist" art, which sought to propagate certain ideas in order to mobilize the masses behind a specific cause. The aesthetic approach is consciously individualistic, emphasizing the development of personal style and technique. . . . [A]lthough aesthetic Asian American artists share the same themes (identity, cultural conflict, alienation, etc.) as political ones, they are less concerned with the political content of their work than with whether it fulfills their artistic vision and standards. They are also often more interested in exploring the universal rather than particularistic aspects of these concerns and seek to make them recognizable to as wide an audience as possible, including non–Asian Americans. In recent years, being able to "cross-over" to a general audience is a mark of artistic maturity as well as a means towards commercial success.

Wei's lament is part of a growing collective suspicion that Asian American artists are only concerned with themselves, tending to "to organize collectively against threats to the autonomy of their creative work or the functioning of their field (censorship)" rather than for the endless pursuit of justice. William Wei, *The Asian American Movement* (Philadelphia: Temple University Press, 1993), 67.

33 Ibid.

34 *Cut Piece* was first performed in 1964 in Kyoto, Japan; a year later, on March 21, 1965, at Carnegie Hall in New York City; and for a third time in 1966 at the Destruction in Art Symposium at the Institute of Contemporary Arts in London.

35 *The Stone by Anthony Cox, Sound Forms by Michael Mason, Eye Bags by Yoko Ono, Film Message by Jeff Perkins* (exhibition catalog), March 10–27, 1966, Judson Gallery, New York.

36 Ono's *Cut Piece* intersects in interesting ways with Judith Butler's discussion of the inherent use of violence as a response to loss: "The body implies mortality, vulnerability, agency: the skin and the flesh expose us to the gaze of others, but also to touch, and to violence, and bodies put us at risk of becoming the agency and instrument of all these as well." Judith Butler, "Violence, Mourning, Politics," in *Precarious Life: The Powers of Mourning and Violence* (London: Verso, 2004), 26.

37 This was the case during the Lois Ann Yamanaka controversy in 1988. Her novel *Blu's Hanging* was named the best literary text by the Association of Asian

American Studies, an award that was then rescinded due to a repressed discussion in the mainstream press about the politics of representation both within the association and within the specific locale of Hawaii. In his incisive commentary on the 1998 fiction award controversy over Lois-Ann Yamanaka's *Blu's Hanging*'s "racist" depiction of Filipino Americans in a small town in Hawaii, Mark Chiang tracks the competing roles the aesthetic has played within Asian American literary studies. Chiang is one of a number of literary scholars who have attempted to resurrect the critical power of the aesthetic as more than a mere judgment of choices in form, genres, traditions, and conventions. Informed by Pierre Bourdieu, who makes central the role of taste in his conceptualization of aesthetics, Chiang conceives of the aesthetic as a value and social form informed by a structure of perception in which those of a certain class determine the common round of judgment of what is beautiful and valuable. Drawing from Bourdieu's "field of production," Chiang foregrounds the need to see Asian American literature as a set of social positions including the author, critic, academy, publishers, and markets and how on one level, each of these entities negotiates and subscribes to place a certain kind of value on a work of literature. He argues that Asian American Studies by necessity preserves the aesthetic as a conservative, autonomous, disinterested domain in order to make possible coded and indirect political arguments.

My engagement with aesthetics is part of a recent trend within Asian American literary and cultural criticism that on one hand extends the role of the aesthetic offer "as a rich critical variable . . . and framework," and on the other hand departs from positioning it as a site of tension between materialist and formalist concerns. See Mark Chiang's essay "Autonomy and Representation: Aesthetics and the Crisis of Asian American Cultural Politics in the Controversy over *Blu's Hanging*" and "Introduction: The Aesthetic in Asian American Literary Discourse," in Rocio G. Davis and Sue-Im Lee, eds., *Literary Gestures: The Aesthetic in Asian American Writing* (Philadelphia: Temple University Press, 2005).

38 George Ubu, "Versions of Identity in Post-Activist Poetry," in Shirley Geok-Lin Lim and Amy Ling, eds., *Literary Gestures* (Philadelphia: Temple University Press, 1992), 34–37.

39 Rancière's writings are grounded and engaged in an ongoing dialogue with Immanuel Kant's theories on the forms of sensibility—the capacity to access objects, experiences, and manifest structural organization as a counterpoint to reason—and Friedrich Schiller's aesthetics of education, which "holds the promise of both a new world of art and a new life for individuals and community." Jacques Rancière, "The Aesthetic Revolution and Its Outcomes," *New Left Review* 14 (March–April 2002): 133.

40 Jacques Rancière, *Disagreement: Politics and Philosophy* (Minneapolis: University of Minnesota Press, 2004), x.

41 Underpinning Rancière's conceptualization of politics is that politics exists because no social order is natural. *Disagreement*, 16.

42 In the late 1960s and early 1970s, when the term and concept "Asian American" had not yet entered into consciousness even for Asian Americans, the Asian American movement's call to claim America was not only a demand to be recognized as equal citizens but also a means to recast Asian Americans historically as being at the horizon of American democracy. At the time, cultural nationalism and other essentialist tactics were strategically tactical—a means to form a site of identification and to create a united front by building solidarities around shared experiences of discrimination, injustice, and disenfranchisement. The writings by Frank Chin problematically prioritized a series of demands that suppressed difference and promoted a homophobic masculinist identity but were also at the same time crucial in deconstructing the power of ideology, foregrounding the power of language, and articulating the affective experience of injustice, disenfranchisement, and marginalization. Since the mid-1970s, Asian American scholars have challenged the precepts of cultural nationalism, foregrounding Asian America as a heterogeneous pan-ethnic coalition. Informed by a wide range of influences, from Raymond Williams's and Stuart Hall's writings on culture to recent forays in queer theory and queer diaspora, scholars of Asian American Studies have been at the forefront of recognizing and understanding the neocolonial imperial role of the United States and the failure of U.S. citizenship, identity politics, and multiculturalism.

43 Ralph Rugoff, "You Talking to Me? On Curating Group Shows That Give You a Chance to Join the Group," in Paula Marincola, ed., *What Makes a Great Exhibition?* (Chicago: University of Chicago Press, 2007), 44–51.

44 Michael Kimmelman, *The Accidental Masterpiece: On the Art of Life and Vice Versa* (New York: Penguin, 2006).

45 Paul O'Neill, *The Culture of Curating and the Curating of Culture(s)* (Cambridge, MA: MIT Press, 2012), 6.

46 Raymond Williams, *Culture and Society: 1780–1950* (New York: Columbia University Press, 1983), 122.

47 José Esteban Muñoz, *Cruising Utopia: The Then and There of Queer Futurity* (New York: NYU Press, 2009), 9.

48 Strategic essentialism is a strategy and organizing concept that enabled diverse Asian American groups to come together under one pan-ethnic formation in order to build solidarity, mobilize, and engage on the U.S. political stage. Gayatri Spivak, *The Post-Colonial Critic: Interviews, Strategies, Dialogues*, ed. Sarah Hasayan (London: Routledge, 1990), 1–16.

49 Rachel Haidu, "On Being Significant during War" (response to question, "In what ways have artists, academics, and cultural institutions responded to the U.S.-led invasion and occupation of Iraq?"), *October* 123 (Winter 2008): 84.

50 Mick Wilson, "Autonomy, Agonism, and Activist Art," *Artforum* 66.3 (Fall 2007): 108.

51 Simon Leung, "On Being Significant during War" (response to question, "In what ways have artists, academics, and cultural institutions responded to the U.S.-led invasion and occupation of Iraq?"), *October* 123 (Winter 2008): 103.

216 | NOTES

52 Susan Koshy, "The Fiction of Asian American Literature," *Yale Journal of Criticism* (1996): 342.

CHAPTER 1. UNNAMABLE ENCOUNTERS

1 These kinds of discussions on the fate of the museum include "Dark Matter into Light: A Round-Table Discussion with Chris Gilbert, Carlos Basualdo, Gregory Sholette, and T. J. Demos," *Art Journal* 64.3 (Fall 2005), and Chon A. Noriega, "On Museum Row: Aesthetics and the Politics of Exhibition," *Daedalus* 128.3 (Summer 1999): 57–81.

2 Other projects and exhibitions that took place during this time include Jane Farver and Seoro Cultural Network's curatorial collaboration *Across the Pacific: Contemporary Korean and Korean American Art* (1993); Karin Higa's *View from Within* (1992) and her curatorial endeavors at the Japanese American National Museum; Ken Chu's *Dismantling Invisibility: Asian and Pacific Islander Artists Respond to the AIDS Crisis* (1991) at Art in General; Godzilla's *Curio Shop* (1993); *With New Eyes: Toward an Asian American Art History in the West* (1995) at San Francisco State University; and retrospectives of Theresa Hak Kyung Cha, Michael Joo, Martin Wong, Tomie Arai, and Bruce and Norman Yonemoto.

3 Jacques Derrida and Derrick Attridge, *Acts of Literature* (New York: Routledge, 1991), 74.

4 Curating is what Julie Ault describes as a "political process of inclusion and exclusion" or, according to Charles Wright, a practice "in which specific choices are made—determined by ideological interests, whether these be institutional or individual." Julie Ault, ed., *Alternative Art New York, 1965–1985* (Minneapolis: University of Minnesota Press and the Drawing Center, 2002), 6; Charles A. Wright Jr., "The Mythology of Difference: Vulgar Identity Politics at the Whitney," in Grant Kester, ed., *Art, Activism, and Oppositionality: Essays from Afterimage* (Durham, NC: Duke University Press, 1998), 77.

5 Mary Kelly, "Re-Viewing Modernist Criticism," *Screen* 22.3 (1981): 45.

6 Mieke Bal, "Guest Column: Exhibition Practices," *PMLA* 125.1 (January 2010): 14.

7 The backstage scenes and countless number of political matters curators need to contend with are rarely discussed even in the recent spate of books on curatorial practice or exhibition making. Due to the changes in the role of the museum and exhibition and, more recently, budgetary reasons, curators' responsibilities have become more about fundraising than anything else.

8 Alice Yang, *Why Asia? Essays on Contemporary Asian and Asian American Art* (New York: NYU Press, 1998), 95.

9 Gayatri Spivak, "Subaltern Studies: Deconstructing Historiography," in Ranajit Guhu and Gayatri Chakravorty Spivak, eds., *In Other Words: Essays in Cultural Politics* (Oxford: Oxford University Press), 208.

10 "Global Assemblages, Anthropological Problems," in *Global Assemblages: Technology, Politics, and Ethics as Anthropological Problems*, ed. Aiwha Ong and Stephen Collier (Malden, MA: Blackwell, 2005).

NOTES | 217

11 Ault, *Alternative Art New York*, 4. Minor Injury, led by artist Mo Bahc, opened in the Brooklyn neighborhood of Greenpoint in 1985 as an artist-run alternative space for "the creative voices of those operating outside of the mainstream."

12 Formed in 1986, PESTS was modeled after Guerilla Girls, with a similar agenda to be the "conscience of the art world," but later reconfigured its mission to "bug the art world" and address the art establishment's relationship with race. In a flyer passed out to various art institutions, the anonymous artists' organization stated, "Our immediate goals are to publicize the serious omission and de facto censorship practiced by galleries, museums, and art publications. As a person of conscience, you must have reflected on these issues and wished you had been presented with a broader and more accurate view." Other fliers presented data to show evidence of racism while posters and newsletters sought to raise genuine interest in artists of color. Ault, *Alternative Art New York*, 74.

13 "Directors' Introduction: A Conversation with Nilda Peraza, Marcia Tucker, Kinshasha Holman Conwill," in *The Decade Show: Frameworks of Identity in the 1980s* (New York: New Museum of Contemporary Art, 1990), 10–11.

14 Preceding *The Decade Show*, for example, was Kathy Halbreich's *Culture and Commentary: An Eighties Perspective* (1989) at the Hirshhorn Museum and Sculpture Garden. The exhibitions shared similar agendas in "locat[ing] a particular set of intellectual concerns that informed the cultural dramas of the past ten years." Yet in contrast to *The Decade Show*, the selection of artists in *Culture and Commentary* was glaringly not diverse. (Yasumasa Morimura was included, but no other Asian American artists.) Thematically, Maurice Berger notes, racism in the United States and even apartheid in South Africa were barely noted not only in Halbreich's exhibition but in almost all exhibitions that occurred during this period.

15 F.D.V., "The Decade Show," *Artnews*, November 1990.

16 Elizabeth Hess, "*The Decade Show*: Breaking and Entering," *Village Voice*, June 5, 1990, 87–88.

17 Though the works were generalized as sharing some kind of relationship to "oppression," the absence of any contextualization concealed deep-seated differences. Entirely absent from the wall texts was Whitman's engagement with homelessness, one of the themes of the exhibition. His engagement with homelessness—as not a recent phenomenon nor a transcendental condition—specifically references the material consequences of U.S. manifest destiny and the forced relocation of Indians to urban settings, away from reservations, where their presence is made more invisible because they appear "less Indian." Describing these men as survivors both literally and spiritually, Whitman's portraits document a "subaltern" community that is cohesive despite its members' migration from different tribes and variety of birth languages.

18 Roberta Smith, "3 Museums Collaborate to Sum Up a Decade," *New York Times*, May 25, 1990, http://www.nytimes.com.

19 In the same review, Baker also cites some artistically complex and visually compelling works of art, including Ben Sakoguchi's paintings, which he described

218 | NOTES

as subversively humorous. Sakoguchi's *Art Sucks (Orange Crate Label Series)* (1979–1982) consists of small-scale painterly commentaries combining multiple institutional critiques against the art world, the California agriculture industry, and governmental legislation. Sakoguchi paints, in bold primary colors, major and overlooked histories, art events, and modern life in general. Appropriating and reproducing the colorful retro labels that were once placed on the side of orange fruit crates—promoting the abundance and sunshine of California— Sakoguchi renders a glass of juice next to a picture of oranges; diagonally across from it, against a vivid blue background, he paints in bold block red the phrase "Art Sucks." Kenneth Baker, "10 Years of Socially Relevant Art: N.Y. 'Decade' Show Offers Works with Political Messages," *San Francisco Chronicle*, July 19, 1990, E3.

20 Jimmie Durham, "A Central Margin," in *The Decade Show*, 175; Guillermo Gómez-Peña, "Border Culture: The Multicultural Paradigm," in *The Decade Show*, 131.

21 In his catalog essay "Taking Control: Art and Activism," Deitcher compares the terms "cultural activism" and "cultural criticism" in order to track and juxtapose the historical and theoretical preconditions of cultural activism from the 1960s to the present with examples of cultural criticism today. Citing the works of Cindy Sherman and Barbara Kruger as prime examples of cultural criticism, which deconstructs "dominant forms of mass and high cultural representations," he makes the case that cultural criticism currently operates as a form of cultural activism. Highlighting the ways "museums and galleries, the institutional and the phenomenological circumstances of display, determine much of the status and meaning of works of art," he points to the threat of the "museum effect" and the need for curators and critics alike to denote how cultural work exists in and as particular social relations. This task was abandoned or overlooked by the curators, despite their good intentions. David Deitcher, "Taking Control: Art and Activism," in *The Decade Show*, 180–97.

22 Laura Trippi and Gary Sangster, "From Trivial Pursuit to the Art of the Deal: Art Making in the Eighties," in *The Decade Show*, 70.

23 Smith, "3 Museums Collaborate."

24 Distinguishing the United States as "the first permanent colony to establish itself *against* and through the denial of local inhabitants," Durham goes on to underscore the violence underlying U.S. manifest destiny and imperialism: "the genocide (and invasion) of other nations." However, pointing out the paradox of the situation—that is, if the United States were to admit that the other lies within the nation-state—Durham argues, "would call into question the validity of a state that must continually propound its validity." See Jimmie Durham, "A Central Margin," in *The Decade Show*, 163.

25 Before the emergence of Godzilla, there were a number of prominent Asian American cultural organizations across the country, many based in universities. Such organizations that focused on literature and art include the Asian American Basement Workshop (New York City), Asian American Women Artists Association (Bay Area), and Asian American Arts Centre. See Alexandra Chang,

Envisioning Diaspora: Asian American Visual Arts Collectives from Godzilla, Godzookie, to the Barnstormers (Shanghai: Timezone 8 Editions, 2008); Machida, *Unsettled Visions*. In July 1990, Ken Chu, Bing Lee, and Margo Machida met and came up with the idea to form some kind of alliance to address the state of contemporary Asian American visual artists. Other artists and curators who became part of Godzilla include Karin Higa, Paul Pfeiffer, Yong Soon Min, and Eugenie Tsai. See Karin Higa, "Origin Myths: A Short and Incomplete History of Godzilla," in Chiu, Higa, and Min, *One Way or Another*, 21–25. Godzilla's archive is housed at New York University's Fales Library, www.nyu.edu.

26 Godzilla's *New World Order III: A Curio Shop* took place at Artists Space. The exhibition included the forty-eight artists who dealt with the image of Chinatown as an emporium of racial, cultural, and sexual stereotypes.

27 Inspired by John Yau's incisive critique against the Whitney Museum—in which he wrote, "If you are white and upper middle class and have been following the art world for the last few years, this year's Biennial probably had something for you. However, if you are Black, Asian, Hispanic, Native American, or recently arrived from another culture, then you probably left the museum alienated, dissatisfied, and perhaps even angry"—Godzilla's letter served as a kind of following up or extension of his critique. John Yau, "Official Policy: Toward the 1990s with the Whitney Biennial," *Arts* 64.1 (September 1989): 143–44. In 1991, the curators—Richard Armstrong, John G. Hanhardt, Richard Marshall, and Lisa Phillips—invited politically active collectives such as Group Material, including Tim Rollins and K.O.S., and a fair number of women artists (thirty-three out of ninety-four) to that year's biennial. Especially notable was the curators' concerted effort to address the AIDS crisis. In making that effort, they invited a number of artists who were either affected by the HIV/AIDS epidemic or part of the campaign to raise public and government awareness of it, including Felix Gonzales-Torres, David Wojnarowicz, Nayland Blake, Keith Haring, and Glenn Ligon, to participate in the biennial. Filmmaker Rea Tajeri was also invited, joining the rarified "club" of Asian American artists that included Nam June Paik and Yasuo Kuniyoshi, both of whom were invited to the exclusive biennial in other years.

28 The full letter and a summary of the events can be found in *Godzilla* 1.2 (Winter 1991): 1–2.

29 Higa, "Origin Myths," 22.

30 Since 1968, the Whitney biennial's focus has been less on presenting the best of contemporary art than on what John I. H. Bauer described in a director's statement as "new directions which seem to be generating the most creative excitement." Over the years, the biennial has become an "informative, if hardly infallible, barometer of contemporary art." David Ross, "Preface: Know Thy Self (Know Your Place)," in *1993 Biennial Exhibition* (New York: Whitney Museum of American Art with Harry N. Abrams, 1993), 8–10.

31 Ibid., 9–10.

220 | NOTES

32 In "No Man's Land," Lisa Phillips defines pathetic aesthetic as works of art that are "handmade, deliberately crude, tawdry, casual, diminutive in sanctity and scale and made out of humble salvageable material." Artworks by Mike Kelly, Cady Noland, Karen Kilminik, Raymond Pettibon, and Sue Williams were identified by Phillips as timely, symptomatic of and resistant to the excess of the Reagan era. Rejecting the art of the 1980s and the canonical investment in originality, integrity of materials, and the coherence of form, "loser art" was seen as symptomatic of the time, a reflection of the disaffection and anger of the socially marginalized. Lisa Phillips, "No Man's Land: At the Threshold of Millennium," *1993 Biennial Exhibition* (New York: Whitney Museum of American Art with Harry N. Abrams, 1993), 54.

33 Paul O'Neill, ed., *Curating Subjects* (London: Open Editions, 2007), 62.

34 Eleanor Heartney, "Report from New York: Identity Politics at the Whitney," *Art in America* 81.5 (May 1993): 43–47.

35 Elizabeth Sussman, "Coming Together in Part: Positive Power in the Nineties," in *1993 Biennial Exhibition*, 13.

36 Ibid.

37 David Deitcher, "Polarity Rules: Looking at Whitney Annuals and Biennials, 1968–2000," in Ault, *Alternative Art New York*, 235.

38 Claire Bishop defines "installation art" as "a term that loosely refers to the type of art into which the viewer physically enters, and which is often described as theatrical, immersive or experiential." See *Installation Art* (London: Tate Museum, 2010), 6. Installation art seemed to be in the 1990s the medium of choice for many Asian American artists for a number of reasons, including having a sense of control of one's environment and the frame. However, due to its interdisciplinary, immersive, and theatrical nature, installation art has also been denigrated by both art historians and critics such as Adam Gopnik, whose scathing review of MoMA's *Dislocations*, which focused on installation art and included more female than male artists (a rare phenomenon at the museum), calls installation art "less worldly than almost any art movement that has come before—more opaque to the uninstructed viewer, and more distant from the rhythms of lived experience. . . . [T]hese works may claim the world, but most of them certainly don't feel like the world. Instead, they have a self-satisfied peppiness and slickness." Adam Gopnik, "Empty Frames," *New Yorker*, November 25, 1991, 110.

39 Rather than a privileging of video over painting, the presence of film and video in the biennial reflected the strengths and interests of the museum's director, David Ross, who prior to coming to the Whitney was known precisely for his promotion of new media and young, emerging artists. But rather than being seen as edgy and timely, much of the work, with the exception of Simpson's, was perceived as an exposé of raw rage.

40 John G. Hanhardt, "Media Art Worlds: New Expressions in Film and Video, 1990–1993," in *1993 Biennial Exhibition*, 46. Holliday purportedly was using his

camcorder for the first time, creating a videotape that brought into the living rooms of America the issue of racism.

41 Ibid., 37. The Rodney King beating and the Los Angeles Uprising were also addressed, for example, in Lorna Simpson's installation *Hypothetical?* (1992). Almost all the reviews cited her incisive piece as exemplary, one of the most notable works to be seen at the biennial. Conceptually spare, *Hypothetical?* consists of one wall with a grid of brass instrument mouthpieces. On the opposite wall of the room, Simpson places a photograph of a pair of lips. The sound of modulating breathing fills the room. On the connecting wall—small but significant—is a part of a newspaper article from the *Los Angeles Times* sandwiched between Plexiglas. Printed on the upper part of the Plexiglas in a large font is the word "hypothetical?" The cut-out section of the article is Mayor Tom Bradley's response to a reporter who asked, "If [you] were not mayor would [you] be afraid to be a black man at that moment?" Bradley's response: "[I] would not be afraid, [I] would be angry."

42 Exposing the role of the docent as a mouthpiece for the curator, Fraser's acoustic guide not only introduced the curatorial premise but also presented an insider view of the exhibition. Schaffner notes that labels also stand in for the curator, speaking to the viewer and to the art simultaneously, "transmitting insights, inspiring interest, pointing to the fact that choices have been made, referring subtly to how the image engages the theme or premise of the exhibition." See Ingrid Schaffner, "Wall Text," in Paula Marincola, ed., *What Makes a Great Exhibition?* (Chicago: University of Chicago Press), 154–67.

43 Robert Hughes, "The Whitney Biennial: A Fiesta of Whining," *Time*, March 22, 1993; Roberta Smith, "At the Whitney, a Biennial with a Social Conscience," *New York Times*, March 5, 1993. The exception, arguably, was Coco Fusco's and Guillermo Gómez-Peña's *Couple in a Cage*, which hilariously and ingeniously provoked a disturbing carnivalesque atmosphere that exposed hierarchies and divisions of the dominant social order, but the citations of this piece, at least as documented in reviews, were few and far between.

44 Hilton Kramer, "The Biennialized Whitney: Closed for Deconstruction," *New York Observer*, March 29, 1993, 1, 19.

45 Mary Louise Pratt, *Imperial Eyes: Travel Writing and Transculturation* (New York: Routledge, 2007), 4.

46 In 2005, writing retrospectively about the *Whitney Biennial 1993*, Sussman conceded that both curatorially and discursively there was an "inability of language or the inadequacy of terms to describe the anxiety underpinning the consensus of works, the works' engagement beyond the walls of the self-contained museum." Elizabeth Sussman, "Then and Now: Whitney Biennial 1993," *Art Journal* 64.1 (Spring 2005): 74–79.

47 Phillips, "No Man's Land," 53.

48 Rey Chow, *The Protestant Ethnic and the Spirit of Capitalism* (New York: Columbia University Press, 2002), 15.

222 | NOTES

49 Cornel West, "The New Cultural Politics of Difference," in Russell Ferguson, Martha Gever, Trinh T. Minh-ha, and Cornel West, eds., *Out There: Marginalization and Contemporary Cultures* (New York: New Museum and MIT Press, 1990), 27.

50 Kay Larson's description of Kim's "witty 'color-field' paintings based on actual people's skin colors" misses the point of his absurd attempt to search for the "perfect" skin color as well as his anticipated attempt to document race. In both the Whitney Museum catalog and reviews of Kim's works, there was little to no mention of his experimental use of materials vis-à-vis someone like Brice Marden, whose own paints made from beeswax, damar varnish, and linseed oil serve as a model for Kim, who switched from latex paint to encaustic around this time.

51 Next to *Synecdoche* was *Belly Paintings,* six swollen sacs of various solid colors made of encaustic and melted crayons that resembled pregnant bellies ready to pop. These pieces and Kiki Smith's sculpture of glass tears and her mixed-media collaboration with David Wojnarowicz, *Untitled* (1980–1982), which consisted of a series of photographs in light boxes picturing parts of their bodies coated in vibrant blood red with a tangle of black electric cords strewn along the wall and floor, suggestive of "veins or lymphatic systems," were seen as being at odds with each other, strange bedfellows as described by *Village Voice* art critic Elizabeth Hess. Counter to this general observation, I want to suggest how Kim's paintings actually shared much in common with Smith's corporeal artwork.

52 Giorgio Agamben, *The Coming Community,* trans. Michael Hardt (Minneapolis: University of Minnesota Press, 1993).

53 Constance Lewallen, "Generosity: A Conversation with Byron Kim, Janine Antoni, and Glenn Ligon," in Eugenie Tsai, ed., *Threshold: Byron Kim, 1990–2004* (Berkeley: University of California, Berkeley Art Museum and Pacific Film Archive, 2004), 55.

54 Sussman, "Coming Together in Part: Positive Power in the Nineties," 19.

55 W. J. T. Mitchell, "Showing Seeing: A Critique of Visual Culture," *Journal of Visual Culture* 1.2 (2000): 167.

56 Hal Foster, "The Artist as Ethnographer," in *The Return of the Real: Art and Theory at the End of the Century* (Cambridge, MA: MIT Press, 1996).

57 Shu Lea Cheang's ambitious multimedia installation *Those Fluttering Objects of Desire* was both a confrontation and a conversation among and between a collective of women artists, a multicultural microcosm of the 1993 biennial. The first part, *1-900-Desires,* invited observers to place a coin into a bright red telephone, to engage in phone intimacy, and the second part, *Channels of Desire,* required observers to part with a coin to come very close to a screen and so be privy to barely audible, charged dialogues on sexuality and gender. In addition, the installation was a commentary on intimacy and desire—the importance of positionality and different degrees of "touch" in the various media used to "connect" or "clash" with someone. In a large room fabricated to look like a pornography booth, with seven nineteen-inch video monitors hanging from the ceiling and bright red telephones with coin slots sitting atop white pedestals, Cheang invited the viewer to

call 1-900-DESIRES, where he/she would find on the other end audio recordings of stories by a dozen women artists and writers, including Laurie Carlos, Jessica Hagedorn, bell hooks, and Marguerite Duras. Presented on each of the monitors was a degraded video image of a single artist offering a layered narrative—with anecdotes, commentaries, personal testimony, and fiction—about her interracial sexual experiences. Cheang's juxtaposition of taboo sexual imagery and stark narratives of desire, power, and racism related through video and phone recordings situated the viewer at once as voyeur and witness, consumer and art patron, but also as constitutive of an evolving community of remarkable artists and writers. Highlighting the destabilization of identities and overlapping subjectivities, Cheang's installation, as well as her participation in Paper Tiger TV, a collective of media activists and artists founded in 1981 and dedicated to the critique of mass media, highlighted formations of an assemblage of communities/crossing boundaries in order to transgress forbidden territories and taboos.

58 Rosalind Krauss at one point questions the complexity of racial difference, inquiring, "Is the idea of black rage more difficult than what I have described as my experience—not having read any statement but simply looking at the work? Which is more theoretical?" Rosalind Krauss, "The Politics of the Signifier: A Conversation on the Whitney Biennial," *October* 66 (Fall 1993): 3–27.

59 The critics' vehement response could be perceived as pushback for the usurpation of their role by curators and artists that began in the late 1970s. In the case of *The Decade Show* and the 1993 *Whitney Biennial*, both curators and artists were not only setting up an agenda, bringing "into the arena arguments, positions, speculations, that criticism had largely ignored" but also implicitly exposing the ideological function and makeup of the art critic.

60 Homi Bhabha, introduction to *The Location of Culture* (New York: Routledge, 1994), vi.

61 Phillips, "No Man's Land," 58.

62 In another exhibition statement on *Marine Lovers*, Leung states,

First of all, there is the metaphor of the puncture. This is what we have inherited in the business of interpretation; piercings (pricks). Piercing the depths, always on the side of violence, echoes of the master hand . . . [T]here are several moments here: a ship that comes, its rostrum clearing the surface of the ocean, coming, coming, the rocks on which the waves break in an endless encore; a sudden sighting of LAND, after being out in nothing but sea, looking for land . . . need I say that in any return all soils are foreign. *Marine Lovers* meets in the pores of vision, seeing themselves only through the belated answer to the call of the sea. This is the beginning of postcolonial eyes—blind is born from nautical ruptures through the centuries, always beside themselves, always answering the call of the colonizer who has come to invade, to rule, to say, I was born in a colony. In *The Penal Colony*, Kafka noted that there is no point in telling the prisoner the sentence which has been passed on him for he'll learn it on his body. Indeed, porous, blind

224 | NOTES

and marked, we desire in the field of the Other's violence. Some tattoos are without pigment.

63 Recalling Ronell's rethinking of an ethico-politics—accepting the condition that one will never understand fully the other—Leung's *Marine Lovers* is one of a number of works that underscore this same belief. Leung's art practice merges Marcel Duchamp's conceptualization of the readymade with Ronell's philosophical thoughts about writing. The found object is waiting to be found, summoned as art in the form of the readymade. Intermixed with desire, the object chooses you, and you, the artist, must assume responsibility for the work and acknowledge the debt to the Other and to others or, in Ronell's words, "respond responsibly as a signator but without presuming credit."

64 William Grimes, "3 Specialists Check the Vital Signs of the Art Museum," *New York Times*, February 15, 1994. One could argue that Ross had to go to extremes or make the Whitney "flashy" and "trendy" in order to distinguish it from MoMA and the Guggenheim—because museums today are about numbers: of visitors, revenue, and overhead costs. Driven by corporate sponsorship and an inflated market, the operating costs to run a museum and install exhibitions have become exorbitant. More so than ever, museums are forced to compete and cater to a fickle yet at the same time conservative public. And in the case of the Whitney, it seemed that one of the major problems Ross had was not any kind of ulterior motive underlying his intentions for the museum to act as or like an alternative space, but rather conflicts with the institution's Board of Trustees. Charles A. Wright Jr., "The Mythology of Difference: Vulgar Identity Politics at the Whitney," in Grant Kester, ed., *Art, Activism, and Oppositionality: Essays from Afterimage* (Durham, NC: Duke University Press, 1998), 79. In an interview with Charlie Rose in 1998, Ross cited the *1993 Whitney Biennial* as his one regret during his tenure as director of the museum between 1991 and 1997.

Ross's opening director's statement in the Whitney catalog, "Know Thy Self, Know Your Place," could be read in two ways: as a commentary on identity politics or, retrospectively, in the aftermath of the biennial, as a warning. That is, by breaching the sanctity of the museum as a site separated from the exigencies of the world, the artists in the biennial entered as interlopers, temporary sojourners who needed to have their say and be on their way so that the Whitney could return to business.

65 Klauss Kertess, "Postcards from Babel," in *1995 Biennial Catalog* (New York: Whitney Museum of American Art with Harry N. Abrams, 1995).

66 Margo Machida, *Asia/America: Identities in Contemporary Asian American Art* (New York: Asia Society Galleries and New Press, 1994). Until recently, Desai was the sixth president and CEO of the Asia Society. Invested and committed to expanding the mission of the Asia Society and keeping up with the "unprecedented growth of the Asian American population," Desai wrote that it was time for the organization to recognize this "new reality" in which East and West

are not separate, but rather fluid and hybrid. Despite my criticisms of the Asia Society, it remains an incredibly important institution for Asian American art and Asian American Studies in general. Desai in particular must be commended for expediting the visibility of Asian American art on the national scene as well as supporting it via promoting and supporting exhibitions and commissions, expanding the Asia Society's permanent collection, and hiring the first curator of Asian and Asian American art, Melissa Chiu.

After opening at the Asia Society in New York City, *Asia/America* traveled to the Tacoma Art Museum in Tacoma, Washington; the Walker Art Center in Minneapolis; the Honolulu Academy of Arts; the Center for the Arts at Yerba Buena Gardens in San Francisco; MIT's List Art Center; and the Blaffer Gallery at the University of Houston.

67 Parallel to the curatorial premise of *Asia/America*, Machida's recent *Unsettled Visions* focuses primarily on how "artists of Asian heritage, whether foreign or U.S. born, conceptualize the world and position themselves as cultural and historical subjects through the symbolic languages and media of visual art." She describes the art of Allan deSouza, Yong Soon Min, Ming Fay, and Zarina Hashimi as a "visual articulation of cross-cultural subjectivities who have been marginalized."

68 Lisa Lowe, "Heterogeneity, Hybridity, Multiplicity: Asian American Differences," in *Immigrant Acts: On Asian American Cultural Politics* (Durham, NC: Duke University Press, 1991), 67.

69 Margo Machida, "Out of Asia: Negotiating Asian Identities in America," in *Asia/America*, 69.

70 Margo Machida, "Seeing 'Yellow': Asians and the American Mirror," in *The Decade Show: Frameworks of Identity in the 1980s* (New York: New Museum of Contemporary Art, 1990), 110, 126.

71 Jenifer P. Borum, "Asia/America" (review), *Artforum*, September 1994, 108.

72 Machida, "Out of Asia," 69.

73 I reference here Lucy Lippard's brave and groundbreaking book, *Mixed Blessings*, a broad overview of art and ideas associated with the movement toward multiculturalism and the conception of identity politics. Advocating for an aesthetics of pluralism, Lippard challenged the notions of quality art and good taste.

> Time and again, artists of color and women determined to revise the notion of Quality into something more open, with more integrity, have been fended off from the mainstream. . . . Time and again I have been asked, after lecturing about this material, "But you can't really think this is Quality?" Such sheeplike fidelity to a single criterion for good art—and such ignorant resistance to the fact that criteria can differ hugely among classes, cultures, even genders—remains firmly embedded in the educational and artistic circles, producing audiences who are afraid to think for themselves.

Lucy Lippard, *Mixed Blessings: New Art in a Multicultural America* (New York: New Press, 1990).

74 Kay Larson, "Asia Minor," *New York*, March 7, 1994, 80. Alice Yang, *Why Asia? Essays on Contemporary Asian and Asian American Art* (New York: NYU Press, 1998).

75 John Kuowei Tchen, "Believing Is Seeing: Transforming Orientalism and the Occidental Gaze," in *Asia/America*, 40. Tchen's arguments on Orientalism is an extension of Edward Said's concept of Orientalism from his seminal book of the same name. Tracing the term from the Enlightenment and tracking its genealogy, Said argues how "Orientalism" provided a way of seeing and constructing the Arab world—the Orient—as exotic, uncivilized, and backwards compared to Europe and the United States. Edward Said, *Orientalism* (New York: Vintage Books, 1979).

76 In his book *Asian/America*, David Palumbo-Liu describes his decision to use the virgule between "Asian" and "American" in order to highlight "an element of undecidability, that at once implies both exclusion and inclusion; . . . a distinction installed between 'Asian' and 'American,' and a dynamic, unsettled, and inclusive movement." David Palumbo-Liu, *Asian/American: Historical Crossing of a Racial Frontier* (Palo Alto, CA: Stanford University Press, 1999), 1.

77 From the institution's website at www.asiasociety.org.

78 Vishakha N. Desai, "Foreword," in *Asia/America*, 8.

79 In curating *One Way or Another*, we were instructed by Melissa Chiu to select artists who had a "strong association with being American."

80 Desai, "Foreword," 8. This approach was not exceptional, as underscored in Mercer's analysis of Rasheed Araeen's *The Other Story: Afro-Asian Artists in Post-War Britain* (1989), the first-of-its-kind exhibition that explored the aesthetic practices of British visual artists of African, Caribbean, and Asian ancestry in relation to British modernism. Both *The Other Story* and *Asia/America* were approached and read in similar ways: perceived as "corrective inclusions" and forced "to carry an impossible burden of representation in the sense that a single exhibition had to 'stand for' the totality of everything that could conceivably fall within the category of black art" or, in the case of *Asia/America*, Asian American. Kobena Mercer, "Black Art and the Burden of Representation," in *Welcome to the Jungle: New Positions in Black Cultural Studies* (London: Routledge, 1994), 234.

81 Ibid.

82 *With New Eyes: Toward an Asian American Art History*, co-curated by Mark Johnson, Irene Andersen, Diane Tani, and Dawn Nakanis. Opened in 1995 at the Fine Arts Gallery at San Francisco State, the exhibition was the first historical survey of Asian Americans who were active on the West Coast between 1865 and 1965.

83 We see this at work in Eugene Neuhaus's statement in the catalog for the 1915 Panama-Pacific International Exposition, where he proclaimed in exasperation, "Why the modern Japanese artists want to divorce themselves from the traditions of their forefathers seems incomprehensible. . . . I think the sooner these wayward sons are brought back into the fold of their truly oriental colleagues, the better it will be for the national art of Japan, the most profound art the world has ever

seen." Eugene Neuhaus, *The Galleries of the Exposition: A Critical Review of the Paintings, Statuary, and Graphic Arts in the Palace of Fine Arts at the Panama-Pacific International Exposition*, quoted by Mark Dean Johnson, "Uncovering Asian American Art in San Francisco, 1850–1940," in Gordon Chang, Mark Dean Johnson, Paul Karlstrom, and Sharon Spain, eds., *Asian American Art: A History, 1850–1970* (Stanford, CA: Stanford University Press, 2008), 24.

84 Karin Higa describes *nihonga* as a painting style in the late nineteenth century "that self-consciously adapted traditions of Japanese painting—from material to method—and was conceived as a direct response to the promulgation of Western-style oil painting in the decades after the Meiji restoration" (4). See her essay "Hidden in Plain Sight: Little Tokyo between the Wars," in Chang, Johnson, Karlstrom, and Spain, eds., *Asian American Art*.

85 Vijay Prashad defines "polyculturalism" as an *active* engagement with multiple cultures to produce an ongoing and always changing entity that engages and does not erase difference and its contradictions, a process analogous to "the idea of polyrhythms—many different rhythms operating together to produce a whole song, rather than different drummers doing their thing" (66). See *Everybody Was Kung Fu Fighting: Afro-Asian Connections and the Myth of Cultural Purity* (Boston: Beacon Press, 2002).

86 *The Third Mind: American Artists Contemplate Asia, 1860–1989* at the Guggenheim Museum, curated by Alexandra Munroe, a large and ambitious project, included more than one hundred artists born before 1960, and over 250 works. Organized chronologically around seven themes—"Aestheticism and Japan: The Cult of the Orient," "Landscapes of the Mind: New Conceptions of Nature," "Ezra Pound, Modern Poetry, Dance Theater: Transliterations," "The Asian Dimensions of Postwar Abstract Art: Calligraphy and Metaphysics," "Buddhism and the Neo-Avant-Garde: Cage Zen, Beat Zen, and Zen"; "Art of Perceptual Experience: Pure Abstraction and Ecstatic Minimalism"; and "Performance Art and the Experiential Present: Irregular Ways of Being"—the exhibition stated its premise as illuminating "the transformative impact of Asian art and thought on American creative culture and modern expression . . . how the art, literature, and philosophical systems of 'the East' have inspired experiential, contemplative, and process-oriented art and literature, defining seminal ideas that have given rise to abstract, Conceptual, Minimalist, and neo-avant-garde art movements in America" (10). The encounter with Asian thought seemed to be the central focus of the exhibition, especially Asian philosophies ranging from I Ching to Zen, Hinduism to Neo-Vedanta, though also explored were stylistic Asian influences—flatness of the picture surface, the use of negative space, and the art of calligraphy—as in the examples of James Whistler's and Arthur Dove's nineteenth-century landscapes and Mark Tobey's, Jackson Pollock's, and Brice Marden's gestural abstractions.

Yoko Ono's *Instructions for Paintings* and Nam June Paik's *Zen for Film* (1964) were clearly seen in conversation with John Cage and the Fluxus Movement, yet the inclusion of painters Yun Gee, Yasuo Kuniyoshi, and Paul Horiuchi

228 | NOTES

seemed random, with the exception of a brief mention of their influence at the end of Kathleen Pyne's and D. Scott Atkinson's essay, "Landscapes of the Mind: New Conceptions of Nature." Theresa Hak Kyung Cha's elusive documentation of a performance, *Pause Still* (1979), and video, *Videoeme* (1976), and an amazing, rarely seen installation of Tehching Hsieh's *One Year Performance, 1980–1981* (*Time Clock Piece*) were really a treat to see. But without contextualization in comparison to other parts of the exhibition, his installation seemed out of place, as Hsieh's piece is not about religion but, as I suggest in chapters 2 and 4, about human relationships, displacement, and alienation. Alexandra Munroe, *The Third Mind: American Artists Contemplate Asia, 1860–1989* (New York: Guggenheim Museum, 2009).

87 Jacqueline Hoefer, "Ruth Asawa: A Working Life," in *The Sculpture of Ruth Asawa: Contours in the Air* (Berkeley: University of California Press, 2006), 16.

88 Daniell Cornell, "Journeys into Abstraction: Asia, America, Europe, and the Art of Yun Gee, Alfonso Ossorio, and Isamu Noguchi," in Daniel Cornell and Mark Dean Johnson, eds., *Asian/American/Modern Art: Shifting Currents, 1900-1970* (Berkeley: University of California Press, 2008), 31.

89 Michele Wallace, "Why Are There No Great Black Artists? The Problem of Visuality in African American Culture," in *Dark Designs and Visual Culture* (Durham, NC: Duke University Press, 2004), 184–94.

90 Martha Ward, "History of Modern Art Exhibitions," in Reesa Greenberg, Bruce W. Ferguson, and Sandy Nairne, eds., *Thinking about Exhibitions* (New York: Routledge, 1996), 458.

91 The NEA and the National Endowment for the Humanities (NEH) were established in 1965 to ensure "a healthy cultural life . . . vital to a democratic polity." Committed to creating a creative climate that encouraged freedom of thought, imagination, and inquiry, federal art agencies since the late 1960s and early 1970s have helped to promote diversity along both class and racial lines. They have funded collective organizations such as Cityarts Workshop, which opened in 1968 and was once led by artist and former Godzilla member Tomie Arai. Cityarts transferred the gallery into the streets, opening up membership to the larger community to engage in collective organizing around the urgent issues of the day, but also to collaborate in ambitious and beautiful communal wall paintings in which everyone could visually articulate the local history of the neighborhood and its interconnections with a larger constituency.

Despite the increased reliance on corporate support and the diminishing governmental role in supporting the arts, the NEA remains a force in promoting diversity and providing funding to institutions that offer public outreach and diverse and altruistic programming, establishing for example the Expansion Arts Program, an initiative to encourage art awareness and production among inner-city youth. The motivations that drive federal arts funding and these initiatives have not always been magnanimous. George Yúdice, Brian Wallis, and Grant Kester have persuasively suggested that the U.S. government

has consistently used the NEA as a tool for crisis management—as a means to deal with the deterioration of social control, subsidizing cultural activism in order to channel and curtail the expression of growing minority and governmental opposition by "qualifying the types of art being made and shown, conceiving of art as instrumental, refiguring the role of artists as professional workers." Brian Wallis, "Public Funding and Alternative Spaces," in Julie Ault, ed., *Alternative Art New York, 1965–1985* (Minneapolis: University of Minnesota Press, 2002), 164.

Beginning in 1989 with the attacks against select NEA-sponsored performance pieces and the Robert Mapplethorpe retrospective, the NEA's priorities began to shift. Arguing that work by Mapplethorpe and others was socially deviant and morally reprehensible and that an artist's autonomy was not above the laws of decency, Jesse Helms and other conservatives called to ban public funding for obscene and indecent cultural works. In addition to his demands to cut all NEA funding, Jesse Helms also threatened to intervene in the NEA panels of art experts—mediators and protectors of the arts—who, according to Helms, should be accountable to the moral good of the U.S. public. Yúdice reveals how the NEA's response to these threats and demands was devastating; in 1994, numerous reports pointed to a shift in the way state arts funding was being diverted from individual artists to community-based projects that were educational but apolitical. Just when minority voices were finally being heard and challenging the universalist presumptions of quality art, the NEA narrowed its standards, figuring "race," for example, as extra-artistic, a private matter, irrelevant to the public sphere. Welcoming such a move were NEA panelists and arbiters such as painter Helen Frankenthaler, who in 1991 complained in an article for the *New York Times* that the NEA's quest to promote cultural diversity and social consciousness was interfering with or subverting criteria for excellence. See George Yúdice, "The Privatization of Culture," *Social Text* 59 (Summer 1999): 17–34, 19.

See also George Yúdice, *The Expediency of Culture: Uses of Culture in the Global Era* (Durham, NC: Duke University Press, 2004); Jonathan Rabinovitz, "In L.A., Political Activism Beats Out Political Art," *New York Times*, March 1994; Steven Benedict, ed., *Public Money and the Muse: Essays on Government Funding for the Arts* (New York: Norton, 1991).

92 Deitcher, "Polarity Rules," 187.

93 Alan Moore with Jim Cornwell, "Local History: The Art of Battle for Bohemia in New York," in Ault, ed., *Alternative Art New York*, 334.

94 *Systematic Landscapes* originated at the Henry Art Gallery, University of Washington, in 2006.

95 Richard Andrews, "Outside In: Maya Lin's Systematic Landscapes," in *Maya Lin: Systematic Landscapes* (New Haven, CT: Yale University Press, 2006), 62.

96 Erik Olsen and Carol Kino, "Maya Lin's 'Wave Field'" [video], *New York Times*, November 17, 2008, www.nytimes.com.

230 | NOTES

97 Ibid., 61.

98 Peter Schjeldahl, "Bare Minimal, Views from New York and Los Angeles," *New Yorker*, May 3, 2004, www.newyorker.com.

99 Gilles Deleuze, "Mediators," in *Negotiations, 1972–1990* (New York: Columbia University Press, 1990).

CHAPTER 2. FORMAL ACTIONS

1 Hannah Arendt, "Labor," in *The Human Condition* (Chicago: University of Chicago Press, 1988 [1958]), 127.

2 "[A] writer is a productive laborer not in so far as he produces ideas, but in so far as he enriches the publisher who publishes his works." Karl Marx, *Theories of Surplus Value* (Amherst, NY: Prometheus Books, 2000).

3 Shelley Wong, "Sizing Up Asian American Poetry," in Sau-ling Cynthia Wong and Stephen H. Sumida, eds., *A Resource Guide to Asian American Literature* (New York: Modern Language Association of America, 2001), 299.

4 See David Harvey, *A Brief History of Neoliberalism* (Oxford: Oxford University Press, 2005) and Lisa Duggan, *The Twilight of Equality: Neoliberalism, Cultural Politics, and the Attack on Democracy* (New York: NYU Press, 2004).

5 David Harvey's *Brief History of Neoliberalism* (Oxford: Oxford University Press, 2005) informs my understanding of the complex and uneven development of neoliberalism, which has changed in shape and intensity depending on specific transregional and local political forces, histories, existing infrastructures, and institutions.

6 Neoliberalism's declaration of class warfare is a draconian response to the gains made by the New Deal and the anticolonial, civil rights, and new social movements.

7 Adrian Heathfield and Tehching Hsieh, *Out of Now: The Lifeworks of Tehching Hsieh* (London: Live Art Development Agency and MIT Press, 2009). Despite being disenfranchised in regards to U.S. law, Hsieh presents a peculiar and unique case of whether he is indeed a nonperson due to the fact that he has access to capital, allowing him a certain agency that distinguishes him from other undocumented immigrants who are trafficked into the United States.

8 Kuong was in charge of bringing food to Hsieh as well as taking care of his clothing and refuse. I discuss their relationship in more detail later in the chapter.

9 Adrian Heathfield, "I Just Go in Life: An Exchange with Tehching Hsieh," in Heathfield and Hsieh, *Out of Now*, 327.

10 Heathfield, "I Just Go in Life," 369, 319.

11 Turning to Greek philosophy and how Greek civilization and culture offered space for an active life, in *The Human Condition* Arendt traces the division between productive and unproductive labor, manual and intellectual labor, and creative and immaterial labor and rearticulates different types of human activity: labor, work, and action. Those who engage in menial labor and work leave no meaningful, permanent trace or value. Those who engage in "action" perform

spontaneous acts (a gesture or speech act) that express one's uniqueness or create an individuality that expresses one's status in the world. Despite the assessment that any occupation must serve the needs involved in the maintenance of life, those who engage in "action" seem freed from necessity, a status that is contingent on the physical labor of others.

12 Arendt, "Labor," 90.

13 Contemporary peers of Hsieh at the time, including Bruce Nauman, Vito Acconci, Charles Ray, Joseph Beuys, Eleanor Antin, Valerie Export, and Bruce Connor, used their own bodies as sites of experimentation and documentation in order to study their environments or question their artistic vocation.

Hsieh spent his formative years in Taiwan during an era of martial law and censorship. In an interview with Heathfield, Hsieh describes his situation: "The whole environment in Taiwan [in the 1970s] was very oppressive; there was little chance to catch exciting avant-garde art from the Western world. I did hear of something called Happenings and Conceptual Art. Only the names, that's all. I didn't know any more than that" (Heathfield, "I Just Go in Life," 322). Whereas much of the spotlight has been on China as the site of Communist oppression and Taiwan as a thriving site of Asian capitalism, martial law in Taiwan, instituted in 1949, was not lifted until 1987. Trained as a painter, Hsieh held his first performance in 1972 when he jumped from the third floor of a building in Taipei. Yet with no record at all of his citing Yves Klein, for instance, in any interviews or discussions about this particular performance, it is not clear whether Hsieh may have been informed by the nascent conceptual art movement that developed in Taiwan in the 1960s—what Gao Minglu calls "*guannian yishu*" (concept art), a movement that "played a similar role to that of Dada, that is, as a vehicle for upsetting conventions—aesthetic, social, and political." Heathfield, "I Just Go in Life," 265.

14 Taylorism was part of a growing study of scientific management and economic organizational models. Developed by Frederick Winslow Taylor, Taylorism deskilled the tasks of production, creating equivalence among workers and, more importantly, increasing workers' efficiency. See Anson Rabinbach, *The Human Motor: Energy, Fatigue, and the Origins of Modernity* (Berkeley: University of California Press, 1992).

Ngai conceives stuplimity as a condition of boredom that emerges alongside feelings of shock and surprise and brings "together . . . what 'dulls' and what 'irritates' or agitates; . . . sharp, sudden excitation and prolonged desensitization, exhaustion, or fatigue." Sianne Ngai, *Ugly Feelings* (Cambridge, MA: Harvard University Press, 2005), 271.

15 Chow, *The Protestant Ethnic*, 32.

16 Chow refigures Lukács's tale of class consciousness as a captivity narrative. She writes, "[C]aptivity serv[es] as the indispensable underside to the emancipatory meaning of modern civilization itself." The ethnic laborer is always already in captivity; a resistant captive, engaged in the "narrative of protest and the preoccupation with universal justice." Chow, *The Protestant Ethnic*, 39.

232 | NOTES

17 Chow correlates the Protestant ethnic's journey with Lukács's conceptualization of class consciousness for the proletariat—a teleological progression from exploitation to subjection to awareness of his/her condition as a commodity. The notion that one has no choice but to unconsciously go through and transcend these different transformative stages presumes modernity as a narrative of emancipation.

18 Frazer Ward, "Alien Duration: Tehching Hsieh, 1978–99," *Art Journal* 65.3 (Fall 2009): 18.

19 Tim Etchells, "Letters: Time Served," in Heathfield and Hsieh, *Out of Now*, 357.

20 In "The Local Color of Shadow," Kim retrospectively meditates on his "whole project as an artist" through a constellation of isolated memories, including memories of anxiously mixing the right colors to match artist Vija Celmins's skin color and finding sustenance/comfort in the dog-eared, rust-red cover of J. D. Salinger's *Catcher in the Rye*. Byron Kim, "The Local Color of Shadow," in Eugenie Tsai, ed., *Threshold: Byron Kim, 1990–2004* (Berkeley: University of California, Berkeley Art Museum, and Pacific Film Archive, 2004).

21 Press release for *Sol LeWitt: Forms Derived from a Cube*, September 8, 2009—October 17, 2009, at PaceWildenstein Gallery, New York City.

22 Byron Kim, "An Attempt at Dogma," *Godzilla* 21.8 (Summer 1992).

23 Leah Ollman, "The Inquiring Mind of a Restless, Energetic Spirit: Works from 1990–2004 Suggest Byron Kim Asks Good Questions, though Answers May Not Stick," *Los Angeles Times*, June 21, 2005, www.latimes.com.

24 Ibid.

25 Kim, "The Local Color of Shadow," 42.

26 Thierry de Duve, "When Form Has Become Attitude—and Beyond," in Zoya Kocur and Simon Leung, eds., *Theory in Contemporary Art since 1985* (Malden, MA: Blackwell, 2005), 22.

27 From a different vantage point, Howard Singerman's take on the value of the MFA is important to keep in mind. In *Art Subjects: Making Artists in the University* (Berkeley: University of California Press, 1999), Singerman highlights how universities act as gatekeepers, separating the professional artist from the amateur Sunday painter. To get an MFA (from Yale, for example) does not require manual skill, an expertise in craft, or a tortured soul, but rather demands that the artist acquire and produce a legitimated body of knowledge visually and rhetorically articulated through a distinct, pedigree-sanctioned language.

28 *The Triumph of American Painting* (1993), a collaboration between Glenn Ligon and Byron Kim, was composed of sections (written in Ligon's medium of choice, the oil stick) from Irving Sandler's 1970 survey of abstract expressionism in the United States as exemplified by a painting by Mark Rothko. The text creates a tension between attempting to make the painting by Rothko appear absolutely pure and the efforts of the text to cover over the desire with which the critic approaches and experiences a work of art. Darby English offers an insightful and poignant reading of this work by Kim and Ligon as "an image of beholding." See English, *How to See a Work of Art*, 225–35.

NOTES | 233

29 Ad Reinhardt and Barbara Rose, *Art-as-Art: The Selected Writings of Ad Reinhardt* (Berkeley: University of California Press, 1991). For Reinhardt, art was ineffective in enacting social change due to the institutionalization of the art world. Separating and compartmentalizing his art from his radical leftist activism, Reinhardt approached his art making by partly turning to Buddhist philosophy—its focus on presentness and the need to remove all worldly concerns in order to reach pure contemplation. His series of *Black Paintings*—shades of black with underlying grids—were the "ultimate" embodiment of this philosophy. These paintings were the culmination of a complex philosophy of karma and cosmic law that, far from cultivating passivity, calls for awareness of change, an embrace of impermanence and chance, and the contingency of one's intervention in the flux and flow of everyday life. On one level, his paintings are incredibly fragile and delicate; the mere touch of a finger or the accidental brush of an elbow can inadvertently leave a permanent imprint on their matte, suede-like surfaces. On another level, in their most pristine state, the *Black Paintings* invite constant changes in perception, as lucidly described by Holland Cotter: "[B]lacks change shades, reds and blues appear and fade. One minute you think you are looking at a grid or a cruciform; the next at a cloudy sky or a Monet landscape . . . [Y]our vision is changing things; you are changing. The paintings are not. But they are, perhaps, leaving their trace on your psyche and memory." Holland Cotter, "Tall, Dark, and Fragile," *New York Times*, Art and Design, August 1, 2008.
30 Kim, "An Attempt at Dogma."
31 Ibid.
32 Julian Strassbass, *Art Incorporated: The Story of Contemporary Art* (London: Oxford University Press, 2004).
33 In 2003, Philip Morris Companies officially changed its corporate name to the Altria Group, Inc., as part of a major campaign to restore and rejuvenate its corporate image.
34 At first glance, *Dust Breeding* looks like a science-fiction desert landscape seen from the air. Beneath the photograph a poetic text reads, "Voici le domaine de Rrose Sélavy / Comme il est aride— / Comme il est fertile— / Comme il est joyeux— / Comme il est triste!" (Behold the domain of Rrose Sélavy / How arid it is— / How fertile it is— / How joyous it is / How sad it is!). Beneath both photograph and text is the credit "Vue prise en aeroplane / Par Man Ray 1921" (View taken from an airplane by Man Ray 1921). In reality, Man Ray's photograph documents not an arid landscape but a thick accumulation of dust Duchamp had intentionally allowed to collect on the surface of *The Bride Stripped Bare by Her Bachelors, Even.*
35 While all the installations of *Squatting Project* picture a figure or set of figures squatting, each version is distinguished by the context in which the figures are seen and commissioned. For example, in *Squatting Project/Wien*, similar to Kim's commission by the Whitney Museum, Leung engaged in a kind of institutional

critique, in which he squatted in front of all the properties owned by the Generali Foundation, whose main business is insurance.

36 Simon Leung and Marita Sturken, "Displaced Bodies in Residual Spaces," *Public Culture* 17.1 (Winter 2005): 129. The first project, *Warren Piece (in the 70s)*, took place at P.S.1 in New York in 1993. In her interview with Leung, Sturken concisely describes *Warren Piece* as "simultaneously a portrait of Warren Niesluchowski, then assistant to the director of P.S.1, and a meditation on the history of P.S.1, which opened in 1976 with *Rooms*," an exhibition on site-specificity and 1970s art. Leung's piece draws "a parallel between Niesluchowski's biography—as a deserter from the U.S. Army during the Vietnam War who lived in exile in France from 1968 to 1975—and the aesthetics of the late 1960s/early 1970s postminimalist art practices such as site-specificity, the aesthetic terrain of which *Rooms* was a part" (ibid.). The third project of the trilogy is *Surf Vietnam*, which I discuss in detail in the following chapter. And Leung describes his recent installation *War after War*, though it is not part of the trilogy, as an accompaniment to *Warren Piece*, perhaps an epilogue to the project as a whole, in which he explores what it means to be a perpetual guest, a cosmopolitan nomad. Tracking Warren's life as he hops from one house to another in Europe and the United States as a "professional guest," Leung wonders about his status as a guest and refugee. Returning to the question of how "war resides in us," Leung's recent installation, as he describes it, "returns to many motifs, but the tone has changed . . . provoked by the precarious nature of a life being spent in need of being welcomed" (ibid.).

37 Simon Leung, "Squatting through Violence," *Documents* 6 (Spring/Summer 1995): 92–101, 92.

38 In July 1991, near the city of Berlin, a petrol bomb was thrown into the residence of a Vietnamese family, injuring an occupant of the house and creating fifteen thousand Deutsche marks worth of damage. Panikos Panayi, "Racial Violence in the New Germany, 1990–93," *Contemporary European History* 3.3 (November 1994): 265–87.

39 Much of this section is culled from Minority Rights Group International, "World Directory of Minorities and Indigenous Peoples—Germany: Vietnamese" (2008), *UNHCR/Refworld*, www.refworld.org.

40 Steven Lam, Introduction to Simon Leung, "Can the Squatter Speak?" *Printed Project: "Farewell to Post-Colonialism"; Querying the Guangzhou Triennial* 11 (2008): 44.

41 Ibid.

42 Daniel Hsia, dir., *How to Do the Asian Squat* (2002), *Asian American Film,* www.asianamericanfilm.com.

43 In an interview with Marita Sturken, Leung says that the project was an attempt to address "the xenophobic violence manifesting in the newly unified Germany, in the Balkan states upon the collapse of the former Yugoslavia, and elsewhere in Europe." Leung and Sturken, "Displaced Bodies in Residual Spaces," 132.

NOTES | 235

44 Soyoung Yoon describes *Squatting Project* as a "deliberate performance of displacement" in which "the ground is always already a figuration. . . . [T]hese displaced bodies are part and parcel of a specific structure of internal exclusion."

45 Marcel Mauss, "Principles of the Classification of Bodily Techniques," in *Sociology and Psychology: Essays by Marcel Mauss*, trans. Ben Brewster (Boston: Routledge & Kegan Paul, 1979), 107.

46 These thoughts on the readymade are from his *Green Box* (1934), a publication made up of facsimiles of unbound notes written between 1911 and 1915.

47 David Joselit, "No Exit: Video and the Readymade," *October* 119 (Winter 2007): 38.

48 Thierry de Duve, "Echoes of the Readymade: Critique of Pure Modernism," in Martha Buskirk and Mignon Nixon, eds., *The Duchamp Effect* (Cambridge, MA: MIT Press, 1996), 93–130.

49 Thierry De Duve, "Echoes of the Readymade: Critique of Pure Modernism," trans. Rosalind Krauss, *October* 70 (Fall 1994): 103.

50 Ibid.

51 The posters were placed in neighborhoods, including Kreuzberg and Charlottenburg, and near the Tiergarten, the Brandenburg Gate, and the former Berlin Wall.

52 During his residency, Leung documented a number of "responses" to his posters, including ones in which the squatting body is beheaded and the opposite, where the profile of the head remains but the bottom half of the poster is torn off. In one instance, across the street from a Turkish restaurant, the poster was left intact, but proposition 2 was spray-painted over.

53 "Squat" (American English), Oxford English Dictionary, www.oxforddictionaries.com.

54 Circulating on the internet are several unconfirmed reports of Vietnamese women being forced to have abortions between the 1950s and the 1980s.

55 Since the mass exodus of Vietnamese guest workers, the remaining Vietnamese are now seen as a growing body of "ethnic criminals." Vietnamese gang violence against those in their own community has intensified, especially in such tough neighborhoods as Marzahn. See Stephen Kinzer, "Berlin Journal: In Germany, Vietnamese Terrorize Vietnamese," *New York Times*, May 23, 1996, www.nytimes.com; John Brady, "Dangerous Foreigners: The Discourse of Threat and the Contours of Inclusion and Exclusion in Berlin's Public Sphere," *New German Critique* 92 (Spring/Summer 2004): 194–224; Roger Karapin, "Antiminority Riots in Unified Germany: Cultural Conflicts and Mischanneled Political Participation," *Comparative Politics* 34.2 (January 2002): 147–67.

56 Georg Simmel, *The Sociology of Georg Simmel*, trans. Kurt Wolff (New York: Free Press, 1950), 402–8.

57 Leung directly engages Kant on his recent installation at the CUE Art Foundation in New York, titled *War after War*, an accompaniment to *Warren Piece*. In "Definitive Article in View of Perpetual Peace," Kant conceptualizes hospitality as "the right of a stranger not to be treated as an enemy when he arrives in the land of another. One may refuse to receive him when this can be done without causing

his destruction; but, so long as he peacefully occupies his place, one may not treat him with hostility." Here, he approaches cosmopolitan law as less about the interaction between states than about the status of individuals as human beings. While I am aware of Kant's problematic writings on race, his thoughts on cosmopolitanism and the innate human right to freedom—an "innate equality, that is the independence from being bound by others to more than one can in turn bind them . . . that is not acquired but belongs to every human being by birth alone"— are intriguing and should not be easily dismissed. See *Metaphysics of Morals* 6: 237–38 and Leslie Arthur Mulholland, *Kant's System of Rights* (New York: Columbia University Press, 1993). His writings also seem timely due to recent changes in the status of individuals under international law. Derrida's extension of Kant's writing on cosmopolitanism and hospitality sets the discussion apart from the discourse on human rights that does not critically destabilize the foundational assumptions of citizenship. Immanuel Kant, *Kant: The Metaphysics of Morals*, ed. Mary J. Gregor (London: Cambridge University Press, 1996).

58 In French, "*hôte*" can mean either "guest" or "host."

59 Jacques Derrida and Anne Dufourmantelle, *Of Hospitality* (Palo Alto, CA: Stanford University Press, 2000), 51.

60 Theodore W. Jennings, "Hospitality, Ethics, and Politics," in *Reading Derrida/ Thinking Paul: On Justice* (Stanford, CA: Stanford University Press, 2006), 112.

CHAPTER 3. GLEANING THE ART PRACTICES OF SIMON LEUNG AND MARY LUM

1 A former icehouse, Hallwalls was founded in 1974 by a group of artists including Cindy Sherman, Charles Clough, and Robert Longo. It was the first multidisciplinary artist-run space in Buffalo. See "History," www.hallwalls.org; Carol Kino, "Buffalo Avant-Garde Art Scene," *New York Times*, May 2, 2012, www.nytimes. com.

2 In the 1950s, Buffalo had a population of more than a half-million people. By the late 1970s, its population had declined by 50 percent. With new investments beginning in 2000, Buffalo's downtown has recently shown strong signs of rehabilitation.

3 Accompanying the installation was an artist's book, *Occupational Information*. The title as well as its layout was appropriated from a 1930s manual for employees. The opening page was an image of overlapping headlines cut from obituary sections of the *New York Times* and the *Buffalo News*. With the exception of the opening page and two pages in the middle, each page in the book was laid out with three lines of continuous text at the top, presented in a kind of ticker-tape format. The first line of text lists the best and worst jobs from *Jobs Rated Almanac*. The second line displays, as on the opening page, headlines cut from the *New York Times* and *Buffalo News* obituary sections. The third line of text details the shipping orders, activities, exchanges, and interactions from the daily work log of a Buffalo-based business. At the bottom of the page is a standard evaluation

metric that assesses a worker's productivity: a score of ten signifies exceptional productivity; five signifies efficiency equivalent to that of a machine; three signifies average or sufficient; two alerts the supervisor that an employee is slow or frequently absent; and one warns the supervisor of an employee's violation of contract due to unruly or surly behavior or a bad work ethic. The mundane documentation hints at some kind of conflict due to reassigned tasks and a coworker's absence. In between these two sections of text, in the middle of each page spread, are two stamp-sized photographs, one on each side: on the left, a photograph of a tall building, and on the right, an interior shot of the same building. The same image is reproduced on consecutive pages, becoming noticeably fainter with each turn of the page. The tall building in the image is the Buffalo Central Terminal, a seventeen-story Art Deco railroad station no longer in use. Standing tall at the urban center of Buffalo, the building still has a clock in working order, which can be seen from miles away. Opposite is an image of the same building's derelict interior, completely destroyed, a ruin. Shut down in 1979, the terminal symbolizes the decline, abandonment, and death of an era, an industry, a city. The two-page spread in the middle of the booklet features two large-scale photographs, one of the back of an obsolete billboard, a metal structure resembling a roller coaster on top of the historical Vernor Building, and the other a billboard bearing the same photograph as on the left. Juxtaposing the rubble of devastation, waste, and nonproductivity with the daily routines of once-familiar places, Lum and Tauke render an alternate world schema that takes stock of the uncounted lives affected by neoliberalism—individuals remembered less by their life accomplishments, human relations, and individual idiosyncrasies than by their occupational title or peer evaluations and performance metrics.

4 The format and drawings of *Historical Present* recall the work of Sarah Charlesworth, in particular her series *Modern History* (1977–1979), which explored the ways front-page newspaper images tell a particular story, such as the kidnapping of Italy's prime minister by the Red Brigades in her piece *April 21, 1978*.

5 Leung and Sturken, "Displaced Bodies in Residual Spaces," 102.

6 Jameson describes how the pathologies of the ego such as anxiety and alienation, hysteria and paranoia have lost their relevance in the postmodern world. The waning of affect or loss of "historicity . . . and more particularly our resistance to globalizing or totalizing concepts like that of the mode of production itself, is a function of precisely th[e] universalization of capitalism." Frederic Jameson, *The Cultural Turn: Selected Writings on the Postmodern, 1983–1998* (New York: Verso, 1998), 43, 15, 21, 54. Concerning the increased importance of the visual in our daily intake of information, Douglas Crimp writes, "To an ever greater extent, our experience is governed by pictures, pictures in newspapers and magazines, on television and in the cinema. Next to these pictures, firsthand experience begins to retreat, to seem more and more trivial. While it once had seemed that pictures had the function of interpreting reality, it now seems that they have usurped it." He critiques the notion of the original by highlighting the aura of the copy,

238 | NOTES

the mesmerizing power of media images, the circulation of stereotypes, and the patriarchal desire of the gaze. Douglas Crimp, "Pictures," *October* 8 (Spring 1979): 75–88, 75.

7 Christopher Lee, *The Semblance of Identity: Aesthetic Mediation in Asian American Literature* (Stanford, CA: Stanford University Press, 2012).

8 Gordon Chang, "Emerging from the Shadows: The Visual Arts and Asian American History," in Chang, Johnson, Karlstrom, and Spain, *Asian American Art: A History*, xi.

9 Lisa Lowe, *Immigrant Acts: On Asian American Cultural Politics* (Durham, NC: Duke University Press, 1991), 12.

10 Simon Leung, *Surf Vietnam: A Project by Simon Leung* (Huntington Beach, CA: Huntington Beach Art Center, 1998), 10.

11 Lum's Reading Room connects with Remnant/Referent through her engagement with work and labor. Rodchenko's Workers' Club served as a way to reconceive leisure as active and collective rather than passive and solitary. The priorities of the room seemed aimed at educating the workers on matters such as information technologies through books and lectures, but it was also a place to relax. The formal construction of the room was just as important; although I do not discuss it here, it aligns with Lum's art practice and aesthetic.

12 Anke Gleber, *The Art of Taking a Walk: Flânerie, Literature, and Film in Weimar Germany* (Princeton, NJ: Princeton University Press, 1999), 130.

13 Flânerie was the central focus of many exhibitions of contemporary art during the 1990s, and in the last ten years has been a rich and lively topic of scholarship. Contributing to the ongoing debates on the practice of flânerie, writings by Elisabeth Wilson, Anke Gleber, and Deborah Parsons have not only opened up debates on the existence of the flâneuse but have also extended discussions of the flâneur.

14 Anke Gleber, *The Art of Taking a Walk*, 130.

15 Similarly to Lum's rearrangement of photos in an album in preparation for her collages and drawings, Ruppersberg's *Drawings* placed three found postcards together in a simple horizontal row and framed them, highlighting the fact that any sequence of events or images may be projected as a story with a logic all its own, no matter the sequence, thus underscoring the power of the banal.

16 Moyra Davey, *Long Life Cool White: Photographs and Essays by Moyra Davey* (Cambridge, MA: Harvard Art Museum, 2008), 92.

17 Lum's drawings are not cognitive mappings as defined by Frederic Jameson—a response to an increased sense of alienation and displacement, a means to make her world intelligible through a situational understanding of her position. Rather, they embody David Deitcher's insightful observations of Lum's *Slip* drawings that were presented at the Drawing Center in 2000. See David Deitcher, *Selections Fall 2000,* Drawing Papers 11 (New York City: Drawing Center, 2000), 8.

18 Guy Debord, "Theory of the Dérive" (1958), in Ken Knabb, ed. and trans., *Situationist International Anthology* (Berkeley, CA: Bureau of Public Services, 1981).

NOTES | 239

"*Dérive*," which has been translated into English as "roaming" and "drifting" but is not exactly rhetorically interchangeable with either, is described by Guy Debord as a "technique of transient passage through varied ambiences." He argues that chance became less and less of a determinant in such movement due to a city's "constant currents, fixed points and vortexes which strongly discourage entry into or exit from certain zones" (50). See Peter Wollen, "From Breton to Situationism," *New Left Review* 174 (March/April 1989): 67–95, 77; Iwona Blazwick, ed., *An Endless Adventure . . . an Endless Passion . . . an Endless Banquet: A Situationist Scrapbook* (London: ICA/Verso, 1989); Knabb, ed. and trans., *Situationist International Anthology*, 181.

19 As defined by Debord, psychogeography is "the study of the precise laws and the exact effects of the geographic environment, built or unbuilt, in terms of its direct influence on the affective behavior of individuals." Informed in part by Henri Lefebvre's *Critique of Everyday Life*, various approaches to making strange the city and conceiving it as a playground were central to the Situationist International project of unitary urbanism: "a spatial and conceptual investigation of the city through playful and experimental means to reveal the urban effects on one's psychogeography." For more, see Ken Knabb, ed., *Situationist International Anthology* (Berkeley, CA: Bureau of Public Secrets, 2006).

20 David Joselit, "Of War and Remembrance (Simon Leung's *Surf Vietnam*)," *Art in America* 87.5 (May 1999): 142–45.

21 Cathy Curtis, "Making Waves over Vietnam: A Huntington Beach Installation Fuses Thoughts on the War, Emigrés, Veterans, and the Mythos of Surf Culture," *Los Angeles Times*, July 1, 1998, http://articles.latimes.com.

22 "Surf's Up at China Beach," *New York Times*, September 13, 1992, www.nytimes.com.

23 *China Beach* was an ABC television drama that aired between 1988 and 1991. Taking place mostly in the United States and in an evacuation hospital in a place known as China Beach during the Vietnam War, the highly acclaimed series focused on the lives of civilian and military women.

24 The nineteen surfboards made out of fiberglass and covered with foam were eighty-four inches by twenty inches by three inches.

25 Only recently has the tenor of this effort changed, due to globalization and a geopolitical construct in which the United States now sees itself solely as the hero. Yến Lê Espiritu makes a pointed and disturbing argument regarding the shift in opinion about U.S. actions during the Vietnam War. Rather than an imperial venture, a Cold War mistake, the Vietnam War has been recently recast as ultimately necessary, just, and successful, no matter the cost in lives and money. Not only did the United States "do good" by rescuing Vietnamese refugees from the Communists and uplifting their lives, but more recently, the opening of Vietnam's markets and its reliance on American tourism underline how, at the end of the day, the United States, or rather "capitalism," comes out a winner. The surf competition and the China Beach resort make clear that the visibility and legibility of Vietnam

as a viable nation-state, no matter its ideological underpinnings, are tied to and contingent on being recognized by the United States and taking an active part in the globalization of capital. Yến Lê Espiritu, "The 'We-Win-Even-When-We-Lose' Syndrome: U.S. Press Coverage of the Twenty-Fifth Anniversary of the 'Fall of Saigon.'" *American Quarterly* 58.2 (June 2006): 329–52.

26 The domino theory, which emerged in the 1950s during the Eisenhower era, presumed that if one country, no matter its size, came under the influence of communism, then other nations would follow in a domino effect.

27 Previous prototypes of *Surf Vietnam* in the form of a proposal were exhibited at Pat Hearn Gallery (1995), Refusalson (1997), and the Los Angeles Municipal Art Gallery (1989).

28 Leung states how identity politics are strategic. He writes, "I wanted *Surf Vietnam* to play out how an identity speaks an individual, how identities become sites of rhetorical selves and others, psychological placeholders of emotional lives and historical violence, and yet, ultimately, how they are forms of enunciation that one must take up." Leung and Sturken, "Displaced Bodies in Residual Spaces," 139.

29 Between the 1950s and the 1970s, while the Vietnam War was happening, Southern California flourished, enjoying unprecedented fiscal growth, a population boom, and infrastructural development, due to massive defense contracts and the expansion and merger of the aircraft industry with an ambitious and well-funded aerospace program.

30 Leung and Sturken, "Displaced Bodies in Residual Spaces."

31 Leung and Sturken, "Displaced Bodies in Residual Spaces"; Holland Cotter, "Work Whose Medium Is Indeed Its Message," *New York Times*, March 18, 2005, www.nytimes.com.

32 Curtis, "Making Waves over Vietnam."

33 Brian Holmes, "Do-It-Yourself Geopolitics: Cartographies of Art in the World," in Blake Stimson and Gregory Sholette, eds., *Collectivism after Modernism: The Art of Social Imagination after 1945* (Minneapolis: University of Minnesota Press, 2007), 284.

34 Homi Bhabha, "Culture and Value: When Words Don't Fail," *Artforum*, November 2001.

35 Homi Bhabha, "Democracy De-Realized," in Getri Fietzek et al., eds., *Democracy Unrealized*, Documenta 11, Platform I (Berlin: Hatje Cantz Verlag, 2002), 347–64.

36 Douglas Crimp succinctly defines Duchamp's readymade as based on the proposition that artists invent nothing. Rather, artists use, manipulate, displace, reformulate, and reposition what history has (already) provided. See Douglas Crimp, "The Museum's Old, the Library's New Subject," in *On the Museum's Ruins* (Cambridge, MA: MIT Press, 1993), 71. Also see the more detailed discussion of Simon Leung's engagement with Duchamp in chapter 2 herein.

37 Appropriating and merging Duchamp's conceptualization of the readymade with the philosophies of Levinas and Derrida, Leung sets the rendezvous in the future tense, recalling Derrida's idea of "democracy to come," in which both democracy

and justice are always deferred onto the otherness of the future. Crystal Parikh offers some intriguing insights in her reading of Derrida's premise, writing that the

> "to come" or futurity of democracy does not authorize a deferral of democratic politics; rather, Derrida contends, the injunction of democracy carries with it an urgency that cannot be postponed . . . the possibility of democracy as the power of the people or the rule of the majority. The critical advance toward the horizon of the idea of democracy, where the truth of the Other cannot be assimilated to the One, provides us with an opportunity to know better what "democracy" will have been able to signify, what it ought, in truth, to have meant.

Crystal Parikh, *An Ethics of Betrayal: The Politics of Otherness in Emergent U.S. Literatures and Culture* (New York: Fordham University Press, 2009), 9.

38 Leung and Sturken, "Displaced Bodies in Residual Spaces."

39 Liz Kotz, "Video Projection: The Space between Screens," in Tanya Leighton, ed., *Art and the Moving Image: A Critical Reader* (London: Afterall, 2008).

CHAPTER 4. THE VANISHING ACTS OF NIKKI S. LEE AND TEHCHING HSIEH

1 Holland Cotter, "Art in Review: Nikki S. Lee," *New York Times*, September 10, 1999, www.nytimes.com.

2 Doris Sommer, *Proceed with Caution, When Engaged by Minority Writing in the Americas* (Cambridge, MA: Harvard University Press, 1999), chap. 5.

3 Pamela Lee, "Boundary Issues: The Art World under the Sign of Globalism," *Artforum*, November 2003, 164–67.

4 Beginning in the late 1970s, the idea of art as a financially sound investment began to take hold as a safe response to high inflation for the "newly prosperous baby boom generation." In early 2000, art indexes emerged—standards of measure that "compare the price appreciation of artwork with the performance of stocks and bonds"—solidifying art as a legitimate asset that complemented the diversification of an investor's portfolio. It was also during this time that the commercialization and corporatization of the art world made an impact in all areas of art production, ranging from the acquisition of works to the writing about them to the creation of art itself. Suzanne McGee, "Cool Art, Hot Prices: Young Buyers Are Plunging into the Market," *Barron's*, May 10, 2004, 21–23; Lee Caplin, *The Business of Art* (Englewood Cliffs, NJ: Prentice Hall, 1989); "Finance and Economics: Betting on Genius; Art as Investment," *Economist*, August 23, 2003, 60; Eric Uhlfielder, "Performing Art," *Institutional Investor*, August 2004, 71–72.

5 Turning to Arthur Danto's 1964 essay "The Artworld," she quotes his definition of the art object as existing in an "atmosphere of interpretation" with other artworks, requiring "something the eye cannot decry—an atmosphere of artistic theory, a knowledge of history of art: an artworld." She writes that, at its core, the "artworld" in this sense remains the same, inadequately shifting its "theoretical

242 | NOTES

paradigm . . . to accommodate new languages and ideas." See Lee, "Boundary Issues," 164.

6 In 2001, Lee disclosed to curator Russell Ferguson that this project was already in the making: "[T]here aren't any pictures of it but it does exist." Russell Ferguson, "Let's Be Nikki," in Russell Ferguson and Lesley A. Martin, eds., *Nikki S. Lee: Projects* (Berlin: Hatje Cantz Verlag, 2001), 19.

7 Russell Ferguson, "Let's Be Nikki," 196.

8 Barry Schwabsky, "Nikki S. Lee," *Artforum*, September 1999, 158.

9 Mark Godfrey, "Nikki S. Lee," *Frieze* 52 (May 2000), https://frieze.com.

10 In an artist statement, Lee writes, "I want to make evidence, as John Berger calls it. I always feel like I have a lot of different characters inside and I was curious to understand these things. I wanted to see some sort of evidence. That I could be all of those different things."

11 Hal Foster, "The Artist as Ethnographer," in *The Return of the Real: Art and Theory at the End of the Century* (Cambridge, MA: MIT Press, 1996).

12 René de Guzman, "Nikki Lee: *The Skateboarders Project* and Other Works," in *Try This On!* (San Francisco: Yerba Buena Center for the Arts, 2001), 4.

13 Louis Kaplan, "Performing Community: Nikki S. Lee's Photographic Rites of Passing," in *American Exposures: Photography and Community in the Twentieth Century* (Minneapolis: University of Minnesota Press, 2005), 30.

14 Godfrey, "Nikki S. Lee."

15 Ibid.

16 In an interview, Lee explains, "Nikki One is supposed to be real Nikki, and Nikki Two is supposed to be fake Nikki. But they are both fake Nikki." Carol Kino, "Now in Moving Pictures: The Multitudes of Nikki S. Lee," *New York Times*, October 1, 2006, www.nytimes.com.

17 In a rather drawn-out portion of the film, we get a chance to see less of Schweber's art collection than of her impressive wedding dress collection, which Lee models for us, posing in a different dress each time in front of a spacious mirrored dressing room, or on a staircase landing in front of a large sunlit window.

18 Mary Louise Pratt, *Imperial Eyes: Studies in Travel Writing and Transculturation* (New York: Routledge, 1992).

19 It is clear in *A.k.a. Nikki S. Lee* how aware she is of race as an insistent and instrumental part of her reality and art making. At the same time, her comments on her relationship to race recall Jeff Yang's writings on millenials' take on race: "embraced—in a way that's more immersive, more natural, more instinctive . . . [and in which] traces of racial awareness wash back and forth, rather than cresting and crashing. Sometimes ethnicity serves as figure, sometimes as ground. This generation's self-perception is assembled on-the-go based on whim, environment and the demands of the occasion. It's identity as iPod playlist." Jeff Yang, "Asian POP/Art Breakers," *SFGate*, October 16, 2006, www.sfgate.com.

20 She did get her chance to act in a small-scale Korean film appropriately titled *The Girl Who Has a Lot of Selves*, with one scene shot along the Pusan River. Her

bit part in the film, however, was edited out, according to Carol Kino. See Kino, "Now in Moving Pictures."

21 In her interview with Kino, Lee mentions that she not only reads a lot of post-modernist critique in Korean translation—Jean Baudrillard's *Simulacra and Simulation*, anything by Roland Barthes, a philosophy book by Kojin Karatani—but she also watches a lot of movies.

22 Louis Kaplan, "Performing Community: Nikki S. Lee's Photographic Rites of Passing," in *American Exposures: Photography and Community in the Twentieth Century* (Minneapolis: University of Minnesota Press, 2005), 179.

23 In the poster for *Art/Life*, what is immediately noticeable is Hsieh's signature, in his given name, Tehching Hsieh. After his arrest during *Outdoor Piece*, when he was charged with possessing an illegal weapon but not incarcerated for being an illegal immigrant, Hsieh began to use his own name. Despite the anti-immigration turn during the Reagan administration, according to legal scholar Leti Volpp, there was not close coordination between criminal prosecution and immigration enforcement. In other words, Hsieh could be convicted of a crime and not be reported to Immigration and Customs Enforcement (ICE).

24 Hsieh describes his tying the knot with Montano as "letting many people into your home." He reports that a photographer wanted to get involved as well as an astrologer, but neither was invited to participate.

25 Jill Johnston, "Hardship Art: A One-Year Performance," *Art in America* 72.9 (September 1984): 176–79. During their performance, Hsieh and Montano managed to maintain their "day" jobs, which for Hsieh consisted mainly of freelance carpentry and for Montano was administrative work at various galleries. The money that each of them earned was enough to support their living arrangement and experimental one-year situation.

26 Montano elaborates:

> We developed four ways of communicating. In the first phase we were verbal, talking about six hours a day. Phase two—we started pulling on each other, yanking on the rope. We had talked ourselves out, but yanking led to anger. In phase three we were less physical with each other and used gestures, so we would point when we wanted to go to the bathroom or point to the kitchen when we wanted to eat. Phase four—we grunted, and made audible, moaning sounds when we needed to go somewhere . . . that was a signal for the other to get up and follow the initiator. Communication went from verbal to nonverbal. It regressed beautifully.

27 At a low point, Hsieh and Montano communicated by shouting and yanking on the rope very hard.

28 Johnston, "Hardship Art," 178.

29 Ibid.

30 Gayatri Spivak, *A Critique of Postcolonial Reason* (Cambridge, MA: Harvard University Press, 1999), 223.

31 Russell Ferguson, "Let's Be Nikki," 17–19.

244 | NOTES

32 Louis Kaplan, "Performing Community: Nikki S. Lee's Photographic Rites of Passing," in *American Exposures: Photography and Community in the Twentieth Century* (Minneapolis: University of Minnesota Press, 2005), 173–94.

33 Paul de Man, "Aesthetic Formalization: Kleist's Über das Marionettentheater," in *The Rhetoric of Romanticism* (New York: Columbia University Press, 1984), 263.

34 Kaplan, "Performing Community," 190.

35 Gilbert Vicario, "Conversation with Nikki S. Lee," in Ferguson and Martin, eds., *Nikki S. Lee: Projects*, 100.

36 Hsieh's note recalls On Kawara's earlier works, wherein he sent, for example, nine hundred telegrams to people he knew informing them that he was still alive.

37 Heathfield, "I Just Go in Life: An Exchange with Tehching Hsieh," 40.

38 Chow, *The Protestant Ethnic*, 109–11.

39 Kevin Bell, 2. Kevin Bell, *Ashes Taken for Fire* (Minneapolis: University of Minnesota Press, 2007).

40 Kirby Gookin, "Review: Tehching Hsieh," *Artforum* 140 (April 2001).

41 First quotation, ibid.; second quotation, Adrian Heathfield and Tehching Hsieh, *Out of Now: The Lifeworks of Tehching Hsieh* (London: Live Art Development Agency and MIT Press, 2009), 328.

42 Hsieh's situation is unique, while at the same time not exceptional. Supported by his family, Hsieh early on acquired property that in time increased exponentially in value, enabling him to focus on his artwork instead of worry about paying rent. In 1994, Hsieh received a windfall when his paintings that were produced in Taiwan, prior to his *One Year Performances*, were sold at auction for five hundred thousand dollars.

43 Jose Munoz, *Cruising Utopia: The Then and There of Queer Futurity* (New York: NYU Press, 2009), 10.

INDEX

Note: Page numbers in *italics* refer to illustrations.

Abad, Pacita, 58, 59
Abramovic, Marina, 201
aesthetics in Asian American art, 20–21, 214n37
Agamben, Giorgio, 28, 51
A.k.a. Nikki S. Lee (Lee): and alternative reading of Projects, 175; and artistic control of Lee, 177, 178, *180*; and art world, 175–76, 181, 183–84, 185, 193, 196; assimilation and the unassimilable in, 196; the authentic Lee in, 184; desire for recognition/legitimacy in, 197; ethnographical aspects of, 178–79, 181; insider/interloper disjunction in, 182–83; interviews in, 184; loneliness portrayed in, 183, 184; premiere of, 171; and race awareness, 242n19; reviews of, 176; scene in Schweber's home, 176–77, *177*; shooting of, 175; as vanishing act, 171, 185; and working methods of Lee, 177, 178, *180*, 183
Alternative Museum, 37
Althusser, Louis, 200
Andrews, Richard, 75
Antoni, Janine, 51
Apocalypse Now (1979), 149–50, 151, 152
Arai, Tomie, 39
Arcega, Mike, 8, 210n12
Arendt, Hannah, 91, 230n11
Aristotle, 20
art collectors, 37, 241n4
Artforum, 2, 162

Art in General, 37
"Artist Project" (Lee), 171
Artists Space, 37
Art/Life (Hsieh and Montano), 190. See also *Rope Piece*
Art Miami Basel, 14
art world: assimilation and the unassimilable in, 196; classification system of, 171; emergence of global art scene, 3; and freedom, 199–200; and Hsieh, 167, 171, 193, 198, 199–200; and Lee, 167, 171, 175–76, 181, 183–84, 185, 193, 196–97; and multiculturalism, 196; and neoliberalism, 12–13; and social change, 233n29
Asawa, Ruth, 69, 70–71, 78–79
Asia/America: Identities in Contemporary Asian American Art (1994), 26–27, 36, 57–65; and *Arroz con Mango*, 75; artists of, 57–58; and Asia Society, 57, 64; and bicultural identity, 58, 64–65; curator of, 58 (*see also* Machida, Margo); galleries hosting, 225n66; installation of pieces, 59–60; and "Orientalism," 61; and *OWOA*, 7, 35; reviews of, 60–61; and *Shifting Currents* (2008), 35; themes of, 59; and Tseng's *East Meets West*, 61–63, 62; and *Whitney Biennial, 1993,* 35
"Asian American" (term), 16, 67, 215n42
"Asian American art" (term), 202
Asian American Art: A History, 1850–1970 (Johnson, Chang, and Karlstrom, eds.), 66–68, 70–71

246 | INDEX

Asian American Arts Center, 14

Asian/American/Modern Art: Shifting Currents (2008), 26–27, 65–72; and *Arroz con Mango*, 75; artists represented in, 67, 71; and *Asia/American* (1994), 35; catalog of, 66, 67; and concurrent exhibits, 79; curators of, 66; and Lin's retrospective, 75, 78; and modernism, 69–72; precursor of, 65–66; publication associated with, 66–68, 70–71; themes of, 71

Asian American Studies, 17, 24, 31, 85–86, 131

Asian American Women Artists Association, 14

Asia Society, 6, 57, 64, 224n66

assimilation and the unassimilable, 196

"An Attempt at Dogma" (Kim), 105

Ault, Julie, 216n4

authenticity, 52

autobiography in Asian American art, 209n1

autonomy, pursuit of, 13

Baker, Kenneth, 41, 217n19

Ball Game (V) (Chen), 67

Bascara, Victor, 22

Beachcomber (Ossorio), 66

Beckers, Galerie Anita, 183

Benjamin, Walter, 212n31

Berg, Rick, 152

Berger, Maurice, 181, 217n14

Berlin, Germany, 111–15, *112, 113, 117*, 118–23, *120*

Bhabha, Homi K., 46, 53–54, 72, 132, 162

Bishop, Claire, 220n38

black artists, 6, 15–16, 210n13

Black Audio Film, 48

Black Emergency Cultural Coalition, 14

Black Male: Representations of Masculinity in Contemporary American Art (Golden), 6

Black Paintings (Reinhardt), 233n29

Blanqui, Auguste, 28

Blu's Hanging (Yamanaka), 213n37

Bogawa, Roddy, 45

Borum, Jenifer P., 60

Bourdieu, Pierre, 214n37

Bradley, Loris, 46

Brancusi, Constantin, 1

A Brief History of Neoliberalism (Harvey), 211n27, 230n5

Buffalo, New York, 125, 236nn2–3

Butler, Judith, 213n36

Cage, John, 1

Cage Piece (Hsieh), 89; artist statement for, 89; and freedom, 90, 200; and labor, 91; performance of, 88–89, 167; photographs of, 89; and pseudonym of Hsieh, 186; and support system, 96; and survival, 96, 187, 198; and undocumented status of Hsieh, 90

capitalism, 212n27

categorization of Asian American artists, 20

"A Central Margin" (Durham), 43

Cha, Theresa Hak Kyung, 228n86

Chan, Paul, 11

Chang, Christine, 45

Chang, Gordon H., 66, 67, 131

Cheang, Shu Lea, 39, 45, 222n57

Chen Chi-Kwan, 67

Chiang, Mark, 86, 214n37

Chicano art, 8–9, 210n14

Chin, Frank, 215n42

Chinese Revolutionary Artists Club in San Francisco, 68

Chiu, Melissa, 6, 11

Choi, Sung Ho, 58, 59

Chong, Albert, 39

Chow, Rey, 94–95, 200, 231n16

Chu, Ken, 39, 44, 58

Chuh, Kandice, 22, 23

Chung, Y. David, 39, 58, 59

citizenship, 23, 172, 215n42, 236n57

Clinton, Bill, 173
collectives, 37–38
colonialism, 52
"Coming Together in Parts: Positive Power in the Art of the Nineties" (opening essay for *1993 Whitney Biennial*), 47
community, 24; alternative forms of, 39; of art world, 25, 197; building, 202; curation by, 74; and ethnography/autoethnography, 178, 181; exhibitionary space as site of, 167; exhibitions as related to, 26; and Group Material, 74; and Hsieh, 25, 27; and Kim's *Synecdoche*, 51; and leadership role of artist, 212n31; and Lee's *A.k.a. Nikki S. Lee*, 25; and Lee's work, 174, 193–95, 196, 197; and Leung's work, 54, 164; Nancy on, 195, 196; and Osorio's installations, 47; and Ranciere on art/politics relationship, 22; Sussman's concept of, 51; and *Whitney Biennial, 1993*, 46, 50, 51, 52
Condition (Lum), 144–45, *146*
Conwill, Kinshasha, 38
Cornell, Daniell, 66
Cornwell, Jim, 74
corporate funding sources, 108–9, 224n64
Cotter, Holland, 130–31, 169, 209n2
creativity, 104
Crimp, Douglas, 237n6, 240n36
Cruising Utopia: The Then and There of Queer Futurity (Munoz), 28
cultural nationalism, 215n42
cultural organizations, Asian American, 218n25
The Culture of Curating and the Curating of Culture(s) (O'Neill), 26
curators and curating: behind-the-scenes issues in, 216n7; and burdens of representation, 13; and creating spaces of disagreement, 73–74; and Deitcher on cultural work, 218n21; dialogue between, 35; engagement

with art impeded by, 81; and extra-textual materials, 81; as gatekeepers, 6; mediation role of, 82; as process of inclusion/exclusion, 216n4; standardized/formulaic practices of, 81; stand ins for, 221n42; and text/artwork balance, 72–73
Cut Piece (Ono), 18–20, *19*, 213n34, 213n36

Danh, Binh, 8, 210n12
Davey, Moyra, 141
Day, E. V., 108
Day, Ikyo, 29
death, 77, 160–61
Debord, Guy, 143
The Decade Show (1990), 26–27, 37–44; and Abad, 58, *59*; artists represented in, 38–40; and *Asia/American* (1994), 58; catalog of, 39; conception and framework of, 38; curators of, 38; influence on other exhibitions, 35; installation shot of, *41*; multiple locations of, 38, 40; opening of, 38; reviews of, 39, 40–41, 223n59; themes and categories of, 38, 39, 40–42
Deitcher, David, 39, 42, 47, 143, 218n21, 238n17
Deleuze, Gilles, 82
De Man, Paul, 196
democratizing of art, 74
Dennis, Kelly, 148, 152, 164
dérive concept, 143
Derrida, Jacques, 118, 122, 236n57, 240n37
Desai, Vishakha N., 64, 224n66
deSouza, Allan, 209n1
de Young Museum, 66, 68, 75, 78, 79
diaspora, Asian, 17–18
Diebenkorn, Richard, 1
Dinh, Le Kim, 157–58
Disagreement: Politics and Philosophy (Rancière), 21
dissensus, art as form of, 22
diversity management, 2, 56–57

248 | INDEX

Duchamp, Marcel: *Elévage de poussière (Dust Breeding)*, 110, 233n34; and Kim's *Wall Drawings*, 110; and Leung, 54, 55, 118, 149, 224n63; and readymades, 30, 116, 118, 164, 224n63, 240nn36–37
Durham, Jimmie, 39, 41, 43, 218n24

Earth (aka *Thirteen Year Plan*) (Hsieh), 167, 198–99
Earthwork (11 Minute Line) (Lin), 76
Eastman, Mari, 7, 8
East Meets West (Tseng), 61–63, 62
East West Art Society, 68
educational programming of museums, 2
Eighth Fold (Lum), 148, 163
Elévage de poussière (Dust Breeding) (Duchamp), 110, 233n34
Eng, David, 23
English, Darby, 15, 17, 104, 232n28
Epoxy Art Group, 39
Eternal Salivation (Arcega), 8, 210n12
exhibitions: absence of diversity in, 217n14; as assemblages, 37; catalogs of, 35–36, 72; and extratextual materials, 81; extratextual materials in, 81; funding sources for, 73; group, 36; innovative approaches to, 81–82; as interstitial space, 26; and marginalized artists, 2; multicultural or gender/race-specific, 2, 3; power of, 33; problematic structure of, 81; reactions to inclusion in, 11–12; reception of, 33–34; as site of community, 167; as spaces of disagreement, 73–74, 82; as statements on race, 81; text/artwork balance in, 72–73; thematic group exhibitions, 25–26. See also *Asia/America: Identities in Contemporary Asian American Art*; *Asian/American/Modern Art: Shifting Currents*; curators and curating; *The Decade Show*; *Whitney Biennial, 1993*
eXile, 37
Exotic Dancers (Lee), 168

expectations for Asian American artists, 82
Expeditionary Series (Tseng), 63
extratextual materials, 81

Fairy Tale (Wong), 66
Family Romance (Ray), 54
Fantastic Coalition of Women in the Arts, 38
Ferguson, Russell, 171, 194
Final Results of Psychoanalytic Treatment (Lum), 132–38, 133–35, 137
flânerie, 139–40, 144, 238n13
Fold (Lum), 144–45
Foster, Hal, 174
"The 'Four Prisons' and the Movements of Liberation" (Omatsu), 212n31
Fourteenth Fold (Lum), 145
Fox, Howard, 9
Fraser, Andrea, 48, 221n42
freedom, 199–201
Freestyle (2001), 3, 4, 6, 15
Frequency (2005), 8, 210n13
Freud, Sigmund, 132–34, 139
Fuentes, Marlon, 58
Fulbeck, Kip, 45
funding sources, 37, 73, 108, 224n64
Fusco, Coco, 46, 47

gatekeepers, 6, 11
Gee, Yun, 68, 227n86
Germany, 111–15, 112, 113, 117, 118–23, 120
A Gesture Life (Lee), 23
Gleber, Anke, 139
globalization, 3, 170
Gober, Robert, 52
Godfrey, Mark, 173–74, 176
Godzilla, 14, 44, 57, 58, 219n25, 219n27
Golden, Thelma, 6, 15, 46, 50
Gómez-Peña, Guillermo, 41–42, 47, 48–49
Gonzales, Rita, 9
Gopinath, Gayatri, 22
Gopnik, Adam, 220n38

Gordon, Avery, 2
Graft (2006), 7
Gran Fury, 37
Group 3 (Lum), 145–46, *147*
Group Material, 74–75, 81–82, 219n27
Guerilla Girls, 14, 37
Gulf War, 128–29, 130, 165
Guzman, René de, 174–75

Hamada, Sachiko, 39
Hanhardt, John, 46, 48
Haring, Keith, 63
Harvey, David, 211n27, 230n5
Hayes, Robin, 11, 211n23
Heartney, Eleanor, 46
Heathfield, Andrew, 90, 167, 187, 201
Heidegger, Martin, 165
Hertzberg, Julie, 38
Hess, Elizabeth, 40
"Heterogeneity, Hybridity, Multiplicity:
 Asian America Differences" (Lowe), 59
Higa, Karin, 6, 14, 44, 69, 227n84
Hip Hop Project (Lee), 174
Hirst, Damien, 1
The Hispanic Project (Lee), 168, 172, *173*,
 183
Historical Present (Lum), 127, 128, 130, 132,
 136, 237n4
history, showing and telling of, 127–31,
 128, 129
Holliday, George, 48
Holmes, Brian, 161
Horiuchi, Paul, 70, 227n86
Horkheimer, Max, 93
hospitality, 121, 122, 235n57
How Big Is the Moon (Kim), 97, *99*
How Mali Lost Her Accent (Abad), 59
*How to See a Work of Art in Total Dark-
 ness* (English), 15
Hsieh, Tehching, 27, 88–96, 185–93;
 archival maintenance by, 201; arrest
 of, 185; *Art/Life* project (see *Rope
 Piece*); and art time/life time, 201; and

art world, 167, 171, 193, 198, 199–200;
 background of, 231n13; as cultural
 worker, 86; and *The Decade Show*, 39;
 documentation maintained by,
 185–86; financial status of, 244n42;
 and freedom, 199–200; immigrant
 myth of, 88, 167; "lifework" perfor-
 mances of, 90, 167, 192; and media
 attention, 191–92, 200; objectives of,
 191; as outsider, 167, 171; political reso-
 nance of works by, 18; pseudonym
 of, 186, 243n23; reticence of, 169, 191,
 192; roles/prototypes of, 169; survival
 tactics of, 202; at *Third Mind* exhibit,
 228n86; undocumented status of, 90,
 91, 94, 185, 198–99, 230n7; wanted
 poster of, 88; WORKS: *Earth* (aka
 Thirteen Year Plan), 167, 198–99; *No
 Art Piece*, 167, 198; *Outdoor Piece*, 167,
 185, 186, 187; *Time Piece*, 89–94,
 95–96, 167, 186, 187, 200, 228n86;
 Wanted by Immigration Service, 88.
 See also *Cage Piece*; *Rope Piece*
Huang, Vivian, 29
Hughes, Robert, 49
Huntington Beach Art Center, 149, 151–52,
 154, 155
Hypothetical? (Simpson), 221n41

"Ideology and Ideological State Appara-
 tuses" (Althusser), 200
Illegal Immigration Reform and Immi-
 grant Responsibility Act (1996), 173
Inokuma, Genichiro, 69
The Inoperative Community (Nancy), 195
"The Inquiring Mind of a Restless, Ener-
 getic Spirit" (Ollman), 102
installation art, 47, 220n38
Instruction Pieces (Ono), 116
INTAR, 37
Irwin, Robert, 97
I Want to Be the One to Walk in the Sun
 (Nakadate), 12

250 | INDEX

Jackson, John, 211n23
Jacob, Mary Jane, 46
Jamaica Art Center, 37
Jameson, Fredric, 130, 237n6, 238n17
Japanese American National Museum, 14
Japanese Camera Club of San Francisco, 68
Japanese Camera Pictorialists of Los Angeles, 68
Japonisme, 67–68
Johns, Jasper, 99
Johnson, Ken, 8–9, 10, 15
Johnson, Mark, 14, 65, 66, 67
Johnston, Jill, 187, 191
Joselit, David, 148
Julien, Isaac, 16

Kaino, Glenn, 7
Kant, Immanuel, 121–22, 214n39, 235n57
Kaplan, Louis, 194, 195, 197
Karlstrom, Paul J., 66, 70–71, 79
Kearny Street Workship, 14
Kelly, Mary, 34
Kenkeleba house, 37
Kertess, Klauss, 56–57
Kester, Grant, 30
Kim, Byron, 72, 74, 96–111; on beauty, 105; copying practice of, 102–5, *103*; and critics, 105; as cultural worker, 86; midcareer retrospective of, 102; political resonance of works by, 18; reviews of, 102; and *Whitney Biennial, 1993*, 45, 50–52, 54; WORKS: "An Attempt at Dogma," 105; *How Big Is the Moon*, 97, *99*; "The Local Color of Shadow," 232n20; *Sunday Paintings*, 102; *Synecdoche*, 50–52, *53*, 54, 97, 106, 222n50, 232n20; *Threshold: Byron Kim, 1990–2004*, 102; *Whorl (Ella and Emmett)*, *106*, 106
Kim, Jin Soo, 58
Kimmelman, Michael, 25–26
King, Rodney, 48

Klaasmeyer, Kelly, 10
Knight, Christopher, 2, 10
Kramer, Hilton, 49
Krauss, Rosalind, 223n58
Kruger, Barbara, 218n21
Kuniyoshi, Yasuo, 227n86
Kwon, Miwon, 174
Kwon, Sowon, 108
Kwong, Dan, 39

Lake Ninevah, Vermont (Tseng), 63
Langer, Cassandra L., 39
Larson, Kay, 49, 60, 222n50
Lau, Pok Chi, 39
Layers (Lee), 197
Lee, Bing, 44
Lee, Chang-rae, 23
Lee, Christopher, 23, 131
Lee, Nikki S.: artistic control of, 177, *178*, *180*, 183; artistic manifesto of, 184; and art world, 167, 171, 175–76, 181, 183–84, 185, 193, 196–97; authentic self of, 184, 193; and community, 193–94, 195–97; critical attention of, 168; critiques of, 173–74, 176; ethnographical methods of, 174, 178–79, 181; on evidence, 242n10; guardedness of, 169; identities assumed by, 169, 172; immigrant status of, 175; and living with difference, 194; model minority representation of, 182; and neoliberal multiculturalism, 196; as outsider, 167, 171; political resonance of works by, 18; and stereotypes, 173–74, 175, 176; survival tactics of, 202; WORKS: "Artist Project," 171; *Exotic Dancers*, 168; *The Hip Hop Project*, 174; *The Hispanic Project*, 168, 172, *173*, 183; *Layers*, 197; *Lesbian*, 168; *Part (14)*, *178*; *Project* series, 25, 172–76, 181–83, 194; *The Punk Project*, 168, 196; *The Schoolgirls Project*, 182; *Skateboarders*, 168; *Swingers*, 168; *Tourists*, 168; *The Wedding*, 177, *179–80*;

Young Japanese (East Village), 182; *The Yuppie Project*, 181, *182*, 184. See also *A.k.a. Nikki S. Lee*
Lee, Pamela, 46, 170, 193
Lee, Robert, 212n27
Lesbian (Lee), 168
"Let's Be Nikki" (Ferguson), 194
Leung, Simon, 30, 72, 74, 86, 97, 111–23; as cultural worker, 86; Duchamp's influence on, 54, 55, 118, 149, 224n63; and fiction/history border, 131; and frame of representation, 131; and Gulf War, 128–29, 148; political resonance of works by, 18; and politics of difference, 154–55; on showing/telling of history, 128; and Vietnam War, 129–30, 234n36; and waiting imagery, 111–12, 115, 118, 119, 165; and *Whitney Biennial, 1993*, 45, 54–56, *55*; WORKS: *Marine Lovers*, 54–56, *55*, 223n62, 224n63; *The Vietnam Trilogy*, 130; *Warren Piece (in the 70s)*, 130, 234n36. See also *Squatting Project*; *Surf Vietnam*
Leval, Susana Torruella, 39
LeWitt, Sol, 97, 107, 109
liberalism, 212n27
Ligon, Glenn, 15, 51, 104–5, 232n28
Lin, Maya, 18, 23, 37, 75–80
Lippard, Lucy, 60, 225n73
Lipton, Eunice, 38, 39
literature, Asian American, 23, 29, 213n37
Liu, Hung, 58
"The Local Color of Shadow" (Kim), 232n20
Los Angeles Times, 100, 102
Los Angeles Uprising, 46, 47–48, 221n41
Lowe, Lisa, 22, 23, 24, 27, 59, 131
Lukács, Georg, 94, 231n16, 232n17
Lum, Mary: and frame of representation, 131–32; and Gulf War, 128, 130; political resonance of works by, 18; showing/telling of history, 128, *128*–29, *129*, 130; "tracing the city" practice of, 138–48,

141, 162–63; and "Unbuilt," 131, 132, 163; WORKS: *Condition*, 144–45, *146*; *Eighth Fold*, 148, 163; *Final Results of Psychoanalytic Treatment*, 132–38, *133–35*, *137*; *Fold*, 144–45; *Fourteenth Fold*, 145; *Group 3*, 145–46, *147*; *Historical Present*, 127, 128, 130, 132, 136, 237n4; *Multiple*, 144–45; *Occupational Information*, *125*, *126*, 127, 236n1; *The Reading Room*, 132; *Remnant/Referent*, 125, 238n11; *Second Fold*, *147*; *Situation*, 144–45; *Slip 35*, 141–43, *142*; *Superslip*, 143–44, *144*; *Thirteenth Fold*, 145; *300,000 Join in the Largest Demonstration in South Korean History after Mourning the Death of a Student*, 127, 128, 129
Luna, James, 72

Machida, Margo: as advocate for overlooked artists, 14, 57, 65; and autobiography in Asian American art, 209n1; and bicultural identities of artists, 64–65; and critics, 61; curatorial approach of, 58, 60; and *The Decade Show*, 39, 58; and Godzilla, 44, 59; and installation of pieces, 60; and institutional pressures, 64; and *With New Eyes*, 65. See also *Asia/America: Identities in Contemporary Asian American Art*
Magiciennes de la Terre (1989), 38
Magnuson, Ann, 63
Make Me (Min), 42–43, *43*
Makranthi, Baki, 29
Mangold, Robert, 107
Marden, Brice, 51, 97, 99, 105, 107, 222n50
Marine Lovers (Leung), 54–56, *55*, 223n62, 224n63
Marioni, Tom, 187
Martin, Agnes, 51
Martin, Jean-Hubert, 38
Martinez, Daniel, 47, 49
Mauss, Marcel, 116

Maya Lin: Systematic Landscapes (exhibition), 75–77
McCollum, Allan, 97
McGee, Micki, 39
media, impact of, 48
Mega Morning Calm (Chung), 59
Melamed, Jodi, 212n27
"A Mélange of Asian Roots and Shifting Identities" (Smith), 8
Mercer, Kobena, 65, 226n80
Min, Yong Soon, 39, 42–43, *43*, 58, 209n1
Minh-Ha, Trinh T., 6, 45
Minor Injury, 37
misrepresentations, 12, 17–18
Mixed Blessings (Lippard), 60, 225n73
Modern Art Gallery, 68
Montano, Linda, *168*; and communication with Hsieh, 190, 243nn26–27; and Hsieh's access to world of, 185, 186–87, 192; and title of piece, 190; on typical day, 187, *189*, 189–90. See also *Rope Piece*
Moore, Alan, 74
multiculturalism: and art world, 196; and "Asian American art" term, 16; and calls for inclusion, 13; and *The Decade Show*, 44; emergence of, 170; and exhibitions in the 1990s, 2; and inclusion, 13; and Lee, 196; museums' responses to, 2; neoliberal, 13, 28, 196; and *One Way or Another*, 10; and race as permanent aspect of society, 211n26; and racial/ethnic-specific exhibitions, 3; and unnamable art, 28; and *Whitney Biennial, 1993*, 35, 56–57
Multiple (Lum), 144–45
Munoz, Jose, 28
Munroe, Alexandra, 69, 227n86
Mura, David, 86
"museum effect," 42, 218n21
Museum of Contemporary Hispanic Art (MoCHA), 38, *41*
Museum of Modern Art (MoMA), 1, 68

museums: and audience, 73; demonstrations in front of, 37–38; educational programming of, 2; identity politics mobilized by, 36; and inclusivity pressures, 36; multicultural exhibitions of, 2; numbers emphasis of, 224n64; privatization of, 108

Nagai, Takako, 58
Nakadate, Laurel, 7, 11, 12
Nakashima, Tom, 39
Nancy, Jean-Luc, 51, 56, 194, 195
National Endowment for the Arts (NEA), 73, 228n91
National Endowment for the Humanities (NEH), 228n91
Nation Erupts: Parts 1 and 2 (Not Channel Zero), 48
Nelson, Steven, 139
neoliberalism: *A Brief History of Neoliberalism* (Harvey), 211n27, 230n5; and class warfare, 230n6; as context for approaching art world, 12–13; demands of, 93; development of, 24, 230n5; in Germany, 114, 118; and Hsieh's "life-work" pieces, 93, 96, 200; and Kim's works, 106; and labor opportunities, 121; and Lee, 196; and Leung's squatting project, 118–19; and Lum/Tauke's installation, 127; mechanization of procedures, 94; neoliberal multiculturalism, 13, 28, 196; and New York City's financial crisis, 86, 91–92; and occupation of space as resistance to, 86; policies of, 86–87; and racial capitalism, 212n27; and unnamable art, 28
Neuhaus, Eugene, 226n83
New Art Examiner, 14
Newfield, Christopher, 2
New Museum of Contemporary Art (New Museum), 38
A New World Order III: A Curio Shop (Godzilla), 44–45

New York City, 14, 34, 86, 91–92, 162
New Yorker, 77
New York magazine, 49, 60
New York Times: and Lum's *Historical Present*, 127; and Lum's *Occupational Information*, 125; and *One Way or Another* review, 7; and *Phantom Sightings* review, 8–9; and "South Vietnamese Yield" article, 158, *158*; and "Surf's Up" article, *149*, 149–50, 151, 152, 164
Nguyen, Long, 58, 59
No Art Piece (Hsieh), 167, 198
Noguchi, Isamu, 69
Noriega, Chon, 9, 46
Number 9: Expatriate Consciousness (Pham), 59
Nuyorican Poets Cafe, 39
NYC 1993: Experimental Jet Set, Trash and No Star (2013), 34

Obata, Chiura, 66
Ocampo, Manuel, 58
Occupational Information (Lum and Tauke), 125, *126*, 127, 236n1
occupying/occupation: of artist as laborer, 25; and Leung's squatting project, 119, 121; and Leung's *Surf Vietnam*, 164, 165; and Lum's *Occupational Information*, 127; of space as resistance, 86
Okada, Kenzo, 70
Ollman, Leah, 102
Omatsu, Glenn, 212n31
O'Neill, Paul, 26, 30, 46
One Way or Another: Asian American Art Now (OWOA; 2006): aftermath of, 16, 24; and *Asia/American* (1994), 35; and Asian American history, 17; and burdens of representation, 13; and emergence of racial/ethnic-specific exhibitions, 3; and extratextual materials, 81; influence of other exhibitions on, 35; initial conception of, 6–7; Klaasmeyer's review of, 10; and multicultur-

alism, 10; poster for, *5*; Smith's review of, 8, 9
One Week's Dead #1 (Danh), 210n12
One Year Performances (Hsieh), 86. See also *Cage Piece*; *Rope Piece*; *Time Piece*
Ono, Yoko, 18–20, 79–80, *80*, 116, 213n34, 213n36, 227n86
"Orientalism," 61, 67, 175, 226n75
Oshiro, Kaz, 7
Osorio, Pepon, 47
Ossorio, Alfonso, 66, 69
The Other Story (Araeen), 65, 226n80
Outdoor Piece (Hsieh), 167, 185, 186, 187

Paik, Nam June, 79, 227n86
Palumbo-Liu, David, 226n76
parapraxis, 133–34
Part (14) (Lee), *178*
Parts series of Lee, 177–78, *178*, 183
pathetic aesthetic, 46, 220n32
Patton, Sharon, 38
People's Choice (Arroz con Mango) (1981, Group Material), 74–75
perceptions of Asian American art, 1
Pereza, Nilda, 38
PESTS, 14, 37, 217n12
Pham, Hanh Thi, 58, 59
Phantom Sightings: Art after the Chicano Movement (2008–2010), 3, 5, 8–9, 15, 210n14
Philip Morris, 97–100, *98–101*, *107*, 107–10, *110*
Phillips, Lisa, 46, 49–50, 54, 220n32
Pindell, Howardena, 14
Piñero, Miguel, 39
Pin River–Tuolumne River, Hetch Hetchy (Lin), 76, 78
Plato, 20
pluralism, 2, 225n73
police brutality, 48
Political Art Documentation/Distribution (PAD/D), 74
political correctness, 49

politics: and aesthetics, 20–21; and artists' part in cultural revolution, 16; and challenges faced by political art, 29; as dissensus, 21–22, 202; and gatekeepers, 6; and "museum effect," 13, 35, 42; and neoliberalism, 12–13; and Rancière, 21–22, 214n41; and visual representation as political goal, 9, 14–15, 18, 28, 214n37, 226n80

polyculturalism, 69, 227n85

Pope.L, William , 15

post-black concept of Golden, 15

postracial era, 3

Pratt, Mary Louise, 49, 181

Project series of Lee, 25, 172–76, 181–83, 194

Protestant ethnic, 94–95, 232n17

Protestant work ethic, 91–92

protests organized by collectives, 37–38

psychoanalysis, 132–38

The Punk Project (Lee), 168, 196

Quality (Okada), 70

queer identity, 54, 55, 56

race: constructed categories of, 50; disappearance of, 3; and gatekeeping, 11; and multiculturalism, 211n26; and racial etiquette, 11; and racial sincerity, 211n23; racism in exhibitions, 217n14; role of, in art, 10–11, 68; role of art in racial justice, 18; statements vs. discussion points on, 81; and unconscious bias, 11; and *Whitney Biennial, 1993,* 49–50

Rancière, Jacques, 21–22, 23–24, 28, 214n39

Ray, Charles, 46, 47, 52, 54

Ray, Man, 110, 233n34

The Reading Room (Lum), 132

readymades: of Duchamp, 30, 116, 118, 164, 224n63, 240nn36–37; and Leung's squatting project, 122; and Leung's *Surf Vietnam,* 164; of Ono, 116

Reagan, Ronald, 37, 91–92

Reinhardt, Ad, 51, 97, 105, 109, 233n29

Remnant/Referent (Lum and Tauke), 125, 238n11

REPOhistory, 37, 74

resistance, art making as modes of, 161

Rich, B. Ruby, 46

Richter, Gerhard, 107

Rinder, Larry, 46

Robinson, Cedric, 212n27

Ronell, Avital, 46, 224n63

Rope Piece (Hsieh and Montano), 167, *168*, 185–93; and art world, 192, 193, 198; collaboration with Montano in, 187; communication in, 190, 243nn26–27; documentation of, 187, 189–90, 192; and employment, 243n25; and ethnographical language, 171, 191, 192; and freedom, 200; impetus for, 187; and media attention, 191–92; mind/body conflict in, 191; objectives of, 191; performance of, 90; posters for, *186*, 187; rope used in, *188*; and survival, 187, 198, 200; titles for, 190; typical day in, 187, *189*, 189–90; as vanishing act, 171, 198. *See also* Montano, Linda

Roshenweig, Phyllis, 105

Ross, David, 45, 46, 56, 220n39, 224n64

Roth, Moira, 65

Rothko, Mark, 97, 232n28

Rugoff, Ralph, 25–26

Ruppersberg, Allen, 140–41, 238n15

Said, Edward, 226n75

Sakoguchi, Ben, 39, 217n19

San Francisco Museum of Art, 68

Sangster, Gary, 38, 42, 46

Scene of the Crime (Whose Crime?), 47

Schaffner, Ingrid, 221n42

Schjeldahl, Peter, 77

Schlund-Vials, Cathy J., 23

Schneeman, Carolee, 108

The Schoolgirls Project (Lee), 182

Schwabsky, Barry, 172
Schweber, Ellen, 176–77, 242n17
"The Search for Roots, or Finding a Precursor" (Higa), 69
Seattle Camera Club, 68
Second Fold (Lum), *147*
See, Sarita, 29
The Semblance of Identity; Aesthetic Meditation in Asian American Literature (Lee), 23
September 11, 2001, terrorist attacks, 162
Setting Sun: Sacramento Valley (Obata), 66
Sew Hoy, Anna, 7
Shaku-do-sha, 68
Sherman, Cindy, 40, *41*, 173, 218n21
Shifting Currents. See *Asian/American/Modern Art: Shifting Currents*
Shimakawa, Karen, 22
Shimomura, Roger, 39
Shrines of Democracy: Mount Rushmore, Black Hills, South Dakota (Tseng), 63
Simpson, Lorna, 47–48, 221n41
Sims, Lowery Stokes, 39
Situation (Lum), 144–45
Situationist International, 143, 144
Skateboarders (Lee), 168
Sky TV (Ono), 79–80, *80*
Slip 35 (Lum), 141–43, *142*
Smith, Roberta, 7–8, 9, 13, 42, 49, 210n13
social justice, 18
Sommer, Doris, 170
Spivak, Gayatri, 36, 193
Squatting Project (Leung), 111–23; commissioning of, 111; as component of trilogy, 130; and encoding of squatting, 115, 119; and Hsieh's *One Year Performances*, 86; inspiration for, 112, 114; meaning and context in, 119, 121, 122, 233n35; as performance of displacement, 235n44; posters for, 111, *112*, *113*, 116, *117*, 117, 119, *120*, 235nn51–52; and squatting of Leung,

116; and xenophobic violence, 114, 115–16, 130, 234n43
"Squatting through Violence" (Mauss), 116
Steichen, Edward, 14
stereotypes: and Chi's *East Meets West*, 61; and expectations of "Asian American" cultural works, 17–18; and Lee's Project series, 173–74, 175, 176; and Min's *Make Me*, 42–43, *43*; and Nakadate's *Untitled* videos, 12
Stieglitz, Alfred, 14
Storm King Art Center, 76–77
Studio Museum in Harlem, 6, 38
Sturken, Marita, 148, 164, 234n36, 234n43
Sun, May, 58
Sunday Paintings (Kim), 102
Superslip (Lum), 143–44, *144*
"Surf's Up at China Beach" (*New York Times*), 149, 149–50, 151, 152, 164
Surf Vietnam (Leung), 148–61; and China Beach, 151, 239n23; collaborations in, 155–57, 160–61; commissioning of, 149, 154; and Gulf War, 148, 165; and identity politics, 154–55, 240n28; installations of, 150–51, *153–54*, 155–58, *156–57*, *159*, 160; number of surfboards in, 151; offsite components of, 163–64; opening of, 151–52; posters for, 164; as readymade, 164; and "return to Vietnam" trope, 152, 160; and "Surf's Up" *NYT* article, *149*, 149–50, 151, 152, 164; and twentieth surfboard, 157–58, *158*, 160; video component of, 150–51, 164–65; and Vietnam War, 148, 154, 155–58, 160–61, 165; and waiting, 150, 165
Sussman, Elisabeth, 45–51, 53–54, 221n46
Swingers (Lee), 168
Synecdoche (Kim), 50–52, *53*, 54, 106

Tanaka, Janice, 45
Tauke, Mary Beth, 125, 127

Tchen, Jack, 61, 72, 226n75
Teraoka, Masami, 58, 59, 66
terrorist attacks of September 11, 2001, 162
The Third Mind: American Artists Contemplate Asia, 1860–1989, 69, 227n86
Thirteenth Fold (Lum), 145
Thirteen Year Plan (aka *Earth*) (Hsieh), 167, 198–99
Those Fluttering Objects of Desire (Cheang), 222n57
300,000 Join in the Largest Demonstration in South Korean History after Mourning the Death of a Student (Lum), 127, 128, 129
Threshold: Byron Kim, 1990–2004 (Kim), 102
Time magazine, 49, 58
Time Piece (Hsieh), 89–94, 95–96, 167, 186, 187, 200, 228n86
Ting, Walasse, 69
Tiravanija, Rirkrit, 130–31
Tonkonow, Leslie, 183
Toshida, Mitsuo, 58
Tourists (Lee), 168
Trippi, Laura, 38, 42, 46
The Triumph of American Painting (Ligon and Kim), 104–5, 232n28
Tsai, Eugenie, 46, 97
Tseng Kwong Chi, 58, 61–63, 62
Tucker, Marcia, 38
Turner, Victor, 22
TV Clock (Paik), 79

Unbuilt, 131, 132, 162, 163
Ungkavatanapong, Toi, 58
Unmarked: The Politics of Performance (Phelan), 15
unnamable art, 28, 36, 171, 202–3
Unsettled Visions (Machida), 209n1, 225n67
Untitled (s.439, s.250, s047) (Asawa), 70
Untitled Film Stills (Sherman), 173
Untitled videos (Nakadate), 12

Venice Biennale of the U.S. Pavilion, 14
Vietnam and U.S. trade embargo, 150, 151
Vietnamese population: in Germany, 111, 114–16, 121; perceived as criminals, 235n55; refugees from, 160; squatting practice of immigrants, 112, 114, 119, 122; in the United States, 155, 156–57, 160; and xenophobic violence, 114, 115–16, 130, 234n38, 234n43
The Vietnam Trilogy (Leung), 130
Vietnam Veterans Memorial (Lin), 75, 77, 79
Vietnam War: and *Apocalypse Now* (1979), 149–50, 151, 152; average age of soldiers in, 151; and "China Beach" code word, 151; and Dahn's memorial, 210n12; and Leung's *Surf Vietnam*, 148, 154, 155–58, 160–61, 165; and Leung's *Warren Piece (in the 70s)* (Leung), 234n36; and Lin's *Vietnam Veterans Memorial*, 75, 77, 79; and "return to Vietnam" trope, 152, 160, 165; U.S. role in, 239n25; veterans of, 156, 161
Villa, Carlos, 65
Village Voice, 40
visibility: and colonial legacy revealed by cultural works, 43–44; and Desai, 225n66; mainstream, 1–2, 57; and multiculturalism, 1–3; museums and primary means of, 33; as promise of neoliberal multiculturalism, 28; and Protestant ethnic, 94–95; trading freedom for, 201
Volcker, Paul, 125

Wadsworth, 14
waiting: and Leung's squatting project, 111–12, 115, 118, 119; and Leung's *Surf Vietnam*, 165
Walker, Kara, 15
Wallace, Michele, 71–72
Wall Drawings. See *Whitney Philip Morris: Wall Drawings*

Wanted by Immigration Service (Hsieh), 88
Ward, Martha, 72
Warren Piece (in the 70s) (Leung), 130, 234n36
Wave Field (Lin), 76–77, 78, 79
The Wedding (Lee), 177, *179–80*
Wei, William, 213n32
Western Frontier (Yuho), 70
What You Lookn At? (Williams), 46–47
whiteness, 50, 181
Whitman, Richard Ray, 40, *41*, 217n17
Whitney Biennial, 1991, 45
Whitney Biennial, 1993, 26–27, 44–57; anxiety underpinning works of, 221n46; and *Arroz con Mango*, 75; artists represented in, 45–46; and *Asia/ American* (1994), 35, 58; and audience, 73; catalog of, 47; curators of, 48; and Godzilla's intervention, 44–45; influence on other exhibitions, 35; and multiculturalism, 35, 56–57; opening essay for, 47; reading room of, 52; reviews of, 49, 52–53, 223n59; themes of, 47; and underrepresentation of Asian American art, 44–45
Whitney Biennial, 1995, 46, 56
Whitney Museum, 1, 56, 219n27, 219n30, 224n64
Whitney Museum at Philip Morris, 97–100, *98–101, 107*, 107–9, *110*

Whitney Philip Morris: Wall Drawings, 97–100, *98–101, 107*, 107–10, *110*
Whorl (Ella and Emmett) (Kim), 106, *106*
Williams, Pat Ward, 46
Williams, Raymond, 28
Wilson, Judith, 39
With New Eyes: Toward an Asian American Art History in the West (1995), 65–66, 226n82
Wolf, Constance, 45
Women Artist Coalition (WAC), 37
Wong, Martin, 39, 66
Wong, Sau-ling, 86
Wong, Shelley, 86
World Trade Center, 162

Yamanaka, Lois Ann, 213n37
Yang, Alice, 36, 60
Yang, Jeffrey, 7, 8
Yau, John, 219n27
Yonemoto, Bruce, 39, 45
Yonemoto, Norman, 39, 45
Yoon, Soyoung, 235n44
Young Japanese (East Village) (Lee), 182
Youth Organizers Television (YO-TV), 47
Yuho, Tseng, 70
The Yuppie Project (Lee), 181, *182*, 184

Zarina, 58, 59
Zhang, Baochi, 58
Žižek, Slavoj, 10, 24, 200

ABOUT THE AUTHOR

Susette Min is Associate Professor at the University of California–Davis, where she teaches Asian American Studies, art history, curatorial studies, and cultural studies. She is also an independent curator.

Printed in the United States
By Bookmasters